# DREAM HOMES

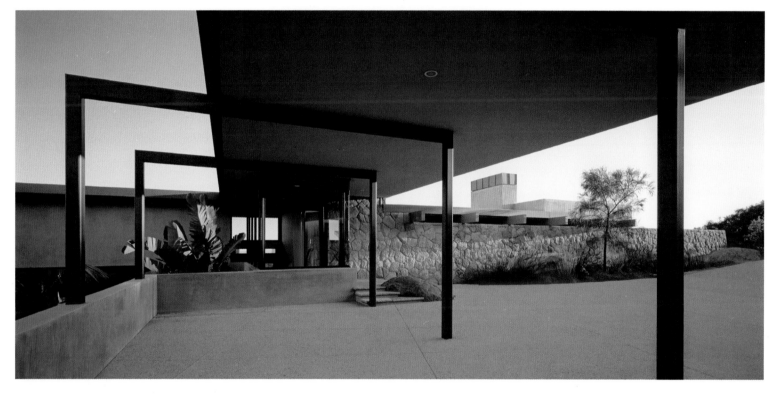

## COASTAL CALIFORNIA

AN EXCLUSIVE SHOWCASE OF THE FINEST ARCHITECTS, DESIGNERS AND BUILDERS OF CALIFORNIA'S CENTRAL COAST

*INCLUDING SANTA BARBARA, SAN LUIS OBISPO AND MONTEREY COUNTIES*

Published by

# PANACHE
PANACHE PARTNERS, LLC

1424 Gables Court
Plano, Texas 75075
469.246.6060
f: 469.246.6062
www.panache.com

Publishers: Brian G. Carabet and John A. Shand
Executive Publisher: Steve Darocy
Regional Publisher: Carla Bowers
Designer: Jonathan Fehr
Editor: Allison Hatfield

Printed in Malaysia

Distributed by IPG
800.748.5439

PUBLISHER'S DATA

*Dream Homes Coastal California*

Library of Congress Control Number: 2007937145

ISBN -13:   978-1-933415-50-5
ISBN -10:   1-933415-50-9

First Printing 2008

10 9 8 7 6 5 4 3 2 1

Previous Page: DesignARC, Inc., page 47
*Photograph by Ciro Coelho*

Right: Sorrell Design, page 137
*Photograph by Jim Bartsch*

Panache Partners, LLC, is dedicated to the restoration and conservation of the environment. Our *Dream
Homes* books are manufactured with strict adherence to an environmental management system in
accordance with ISO 14001 standards, including the use of paper from mills certified to derive their
products from environmentally managed forests. We are committed to continued investigation of
alternative paper products and environmentally responsible manufacturing processes to ensure the
preservation of our fragile planet.

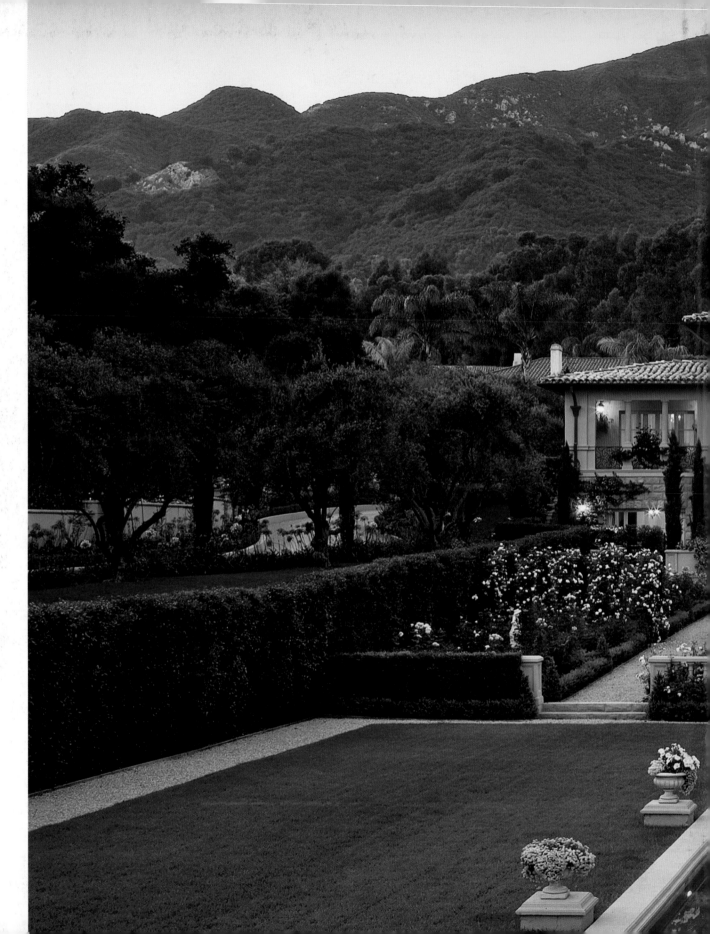

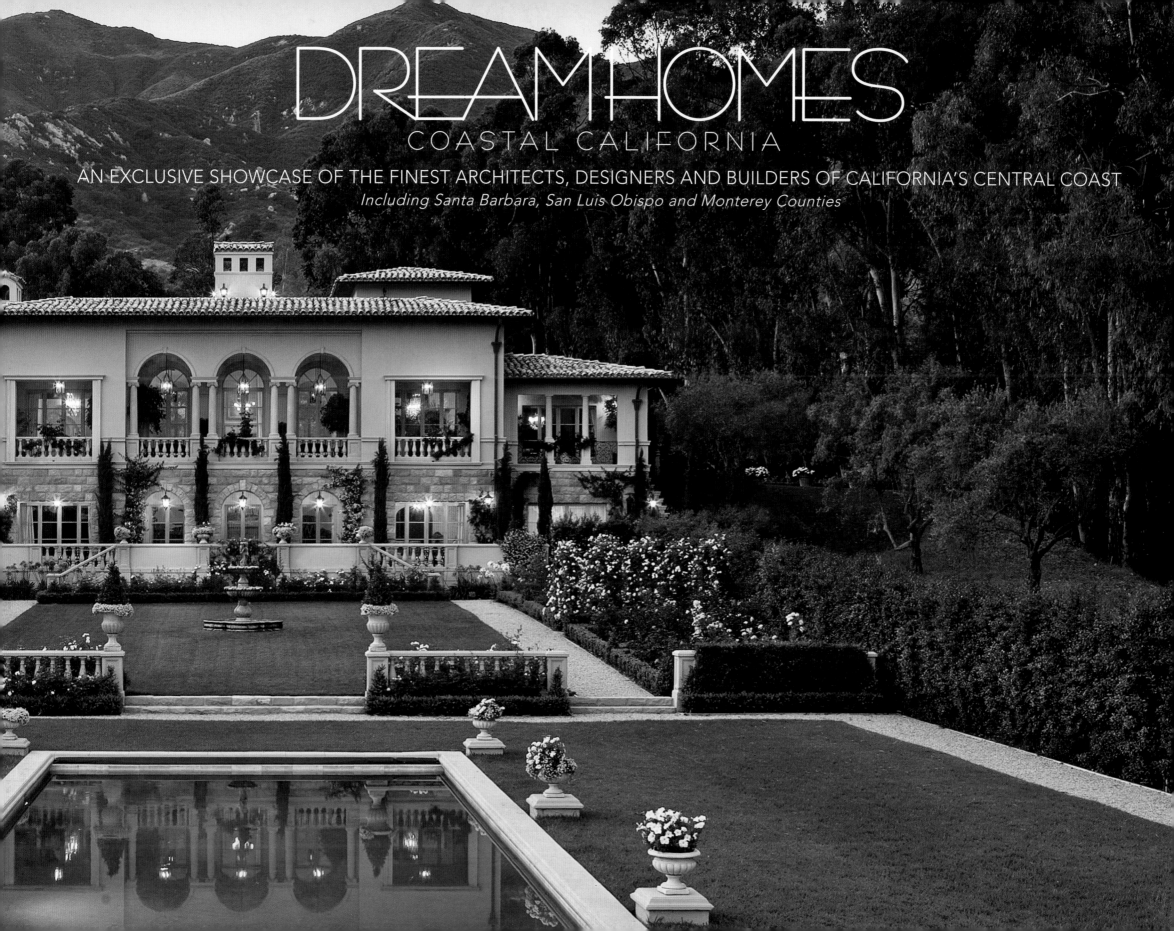

# DREAMHOMES
## COASTAL CALIFORNIA

AN EXCLUSIVE SHOWCASE OF THE FINEST ARCHITECTS, DESIGNERS AND BUILDERS OF CALIFORNIA'S CENTRAL COAST

*Including Santa Barbara, San Luis Obispo and Monterey Counties*

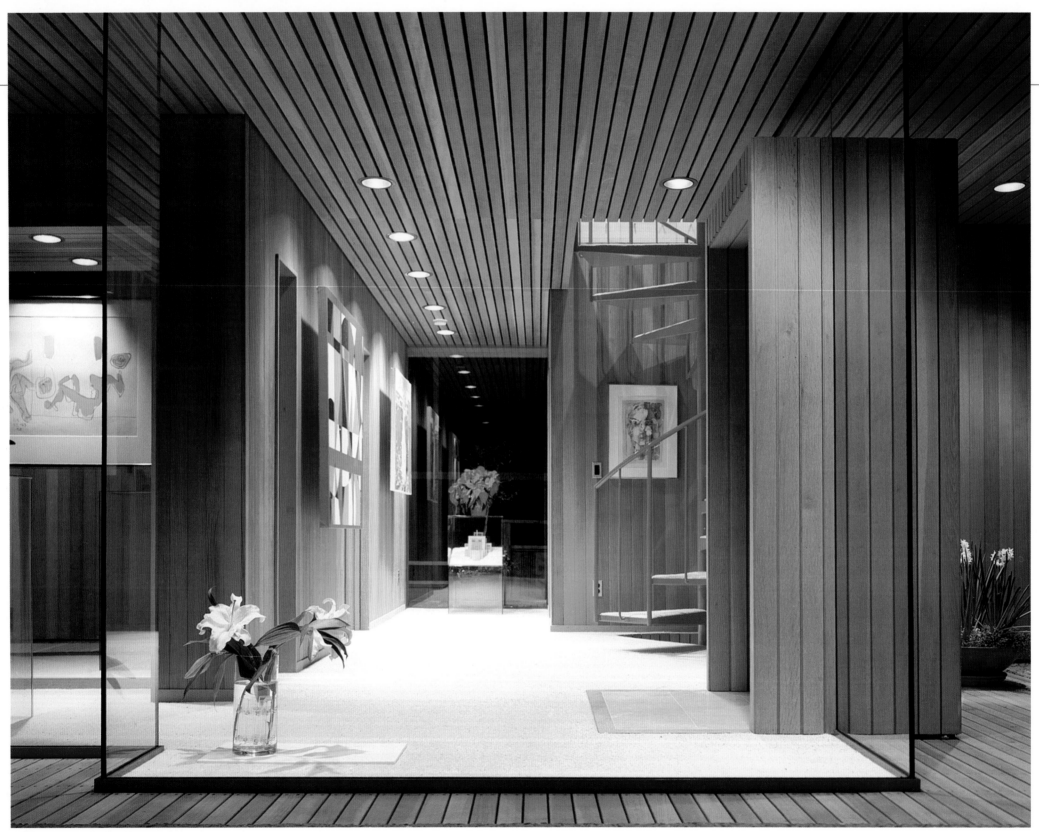

John Thodos AIA Architect, page 243

# INTRODUCTION

Architectural splendor abounds in the scenic region of coastal California. The wealth of architectural opportunities, as well as the region's breathtaking and diverse landscape, has lured creative minds at the top of their professions from around the globe.

*Dream Homes Coastal California* is a captivating assemblage of the work and philosophies of highly respected architects, designers and builders. The industry professionals featured on the following pages were selected for their remarkable talent, artistry and command of craft. From Monterey to Santa Barbara, these impeccable homes display thoughtful, sophisticated designs that epitomize their residents' lifestyles and stylistic proclivities. Each has evolved from its creator's unique historical and cultural knowledge, strict attention to detail and innate aesthetic sensibility coupled with hard work and a genuine passion for exceptional architecture and design.

From small additions to elaborate renovations, restorations and, of course, new construction projects, the architects, designers and builders of *Dream Homes Coastal California* are interested and well-versed in a wide range of styles—from timeless traditional designs to spellbinding, ultra-contemporary creations and everything in between. Though their ideas and approaches vary, all are bound by the quest to create distinctive residential environments that acknowledge their surroundings, contain ideally proportioned spaces and are sources of delight for those who dwell therein.

Whether potential homeowners wish to work with a boutique-sized firm or draw on the capabilities of a residential specialty studio within a large, general practice firm, there are plenty of excellent professionals to choose from. The stunning homes on the pages that follow display the architects, designers and builders' immense talents, yet the men and women of *Dream Homes Coastal California* measure their success through the happiness of their clients.

Enjoy!

*Brian Carabet and John Shand*
Publishers

Gray and Gray Architects, LLP, page 65

Hochhauser Blatter Architecture and Planning, page 77

Thomas Bateman Hood, AIA Architecture, page 183

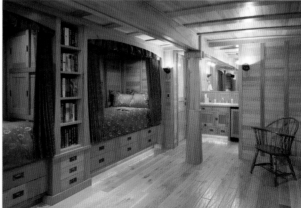

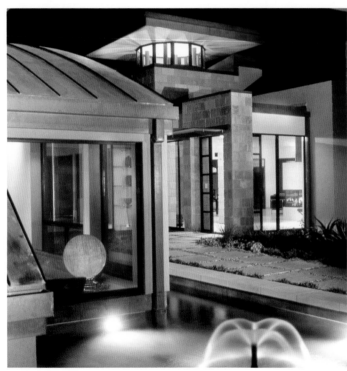

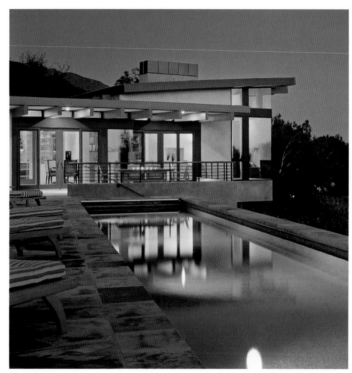

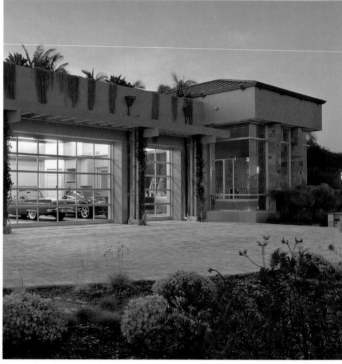

B³ Architects
Berkus Design Studio, page 21

DesignARC, Inc., page 47

Young Construction, page 159

# CONTENTS

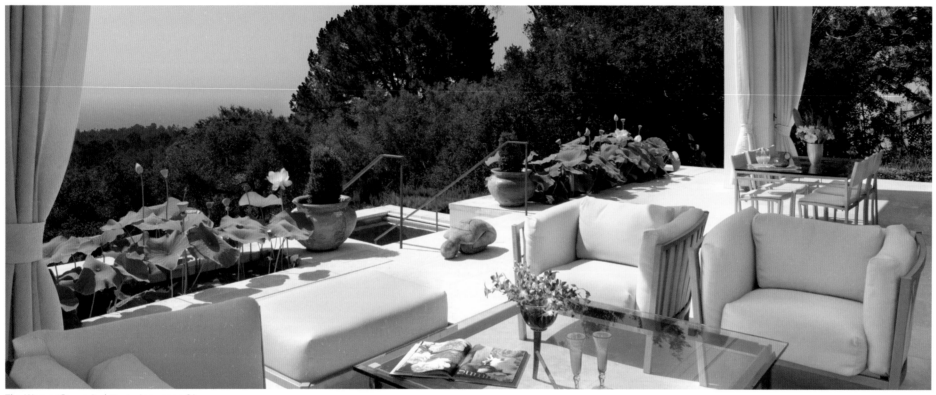

The Warner Group Architects, Inc., page 31

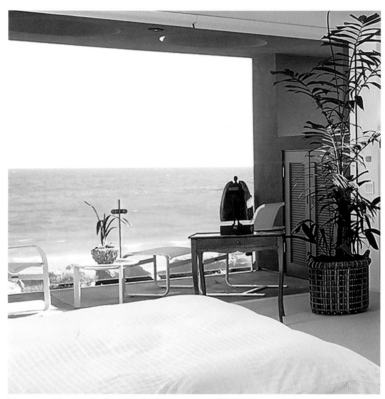

Neumann Mendro Andrulaitis Architects, page 99

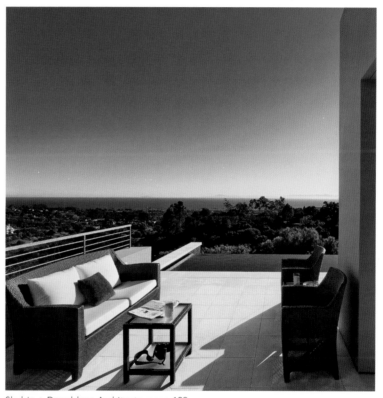

Shubin + Donaldson Architects, page 129

"A dream home should lure you in and cause you to stare, study, linger and contemplate. Yet what separates a good house from a great one is the seemingly little details, the pragmatic solutions to everyday problems."

—*Andy Neumann*

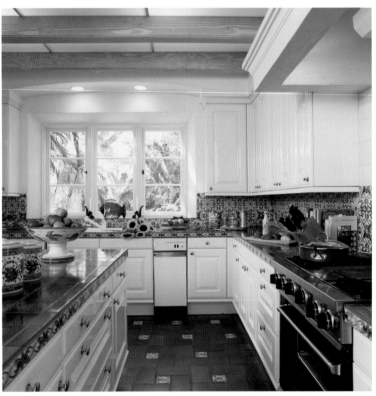

Thomas Bollay Architects, Inc., page 25

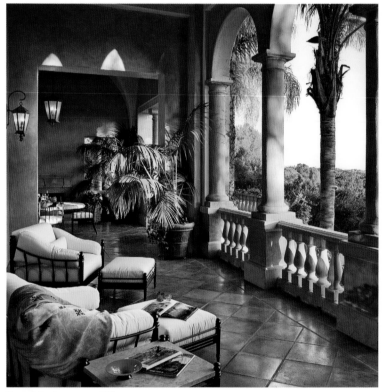

Sorrell Design, page 137

"Maintaining architectural authenticity requires an astute understanding of precedent, the graceful employment of proportion and a close attention to texture and detail."

—Mark Kirkhart

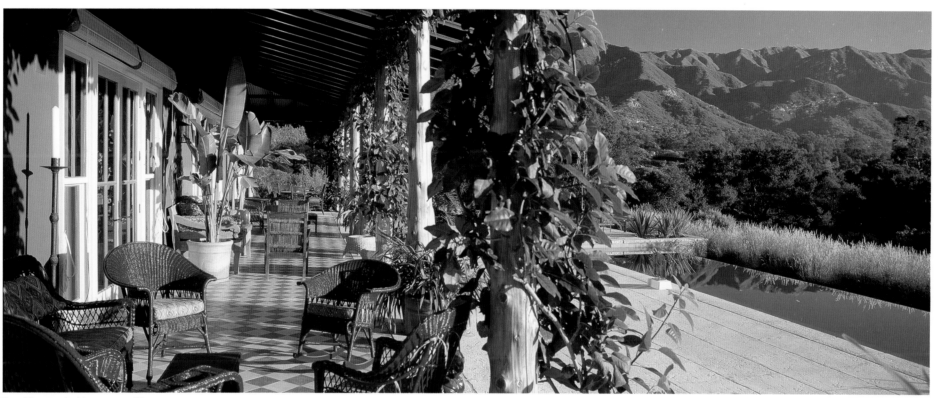

Tom Meaney Architect, page 93

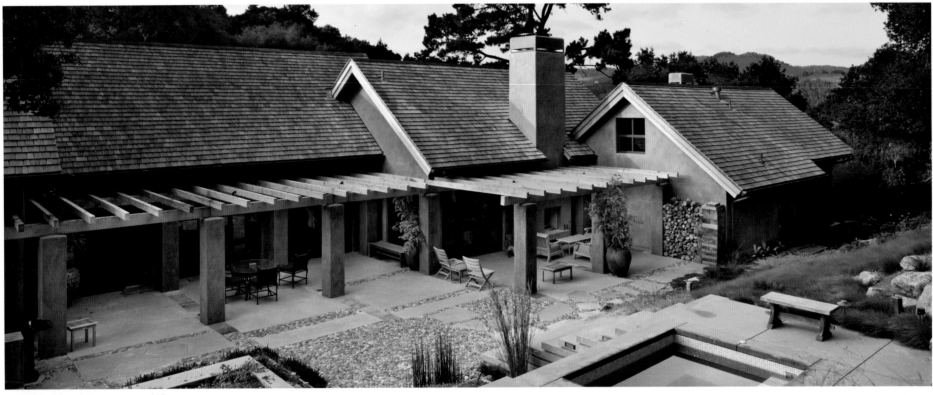

Carmel Building & Design, page 219

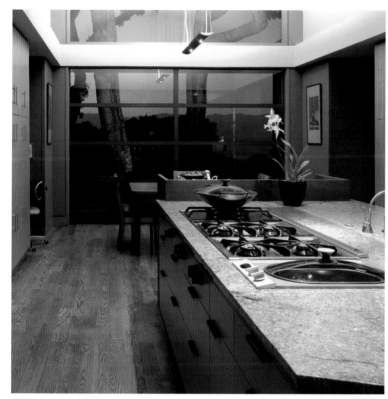

Fletcher + Hardoin Architects, page 175

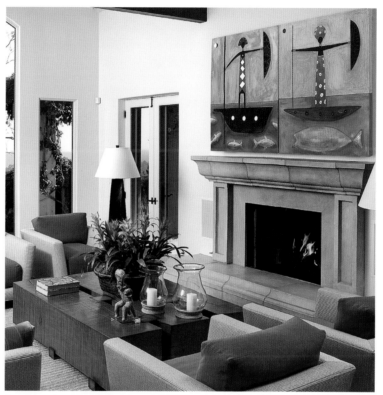

Ann James Interior Design, page 83

"Warmth can be created through copious use of wood and massive spans of glass that take advantage of natural light and California's impressive views."

—*John Thodos*

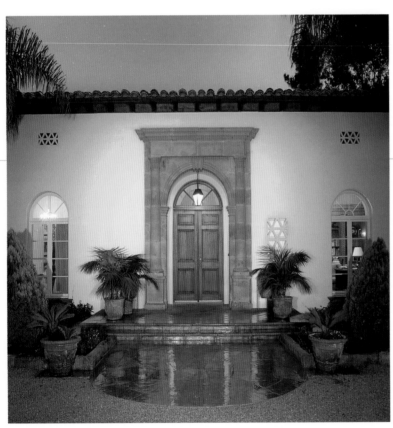

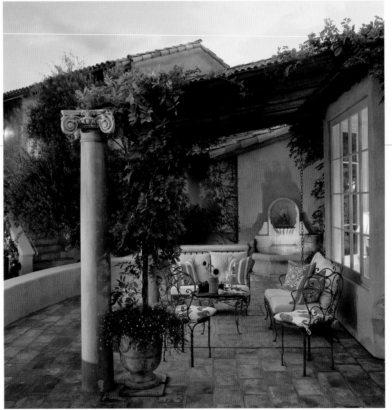

Santa Barbara Architecture, Inc., page 125

Christopher Dentzel Architects
The Office of Katie O'Reilly Rogers, Inc.
Giffin & Crane General Contractors, Inc., page 43

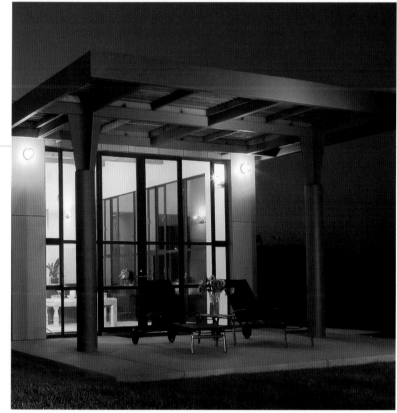

Hochhauser Blatter Architecture and Planning, page 77

# CHAPTER ONE

# SANTA BARBARA

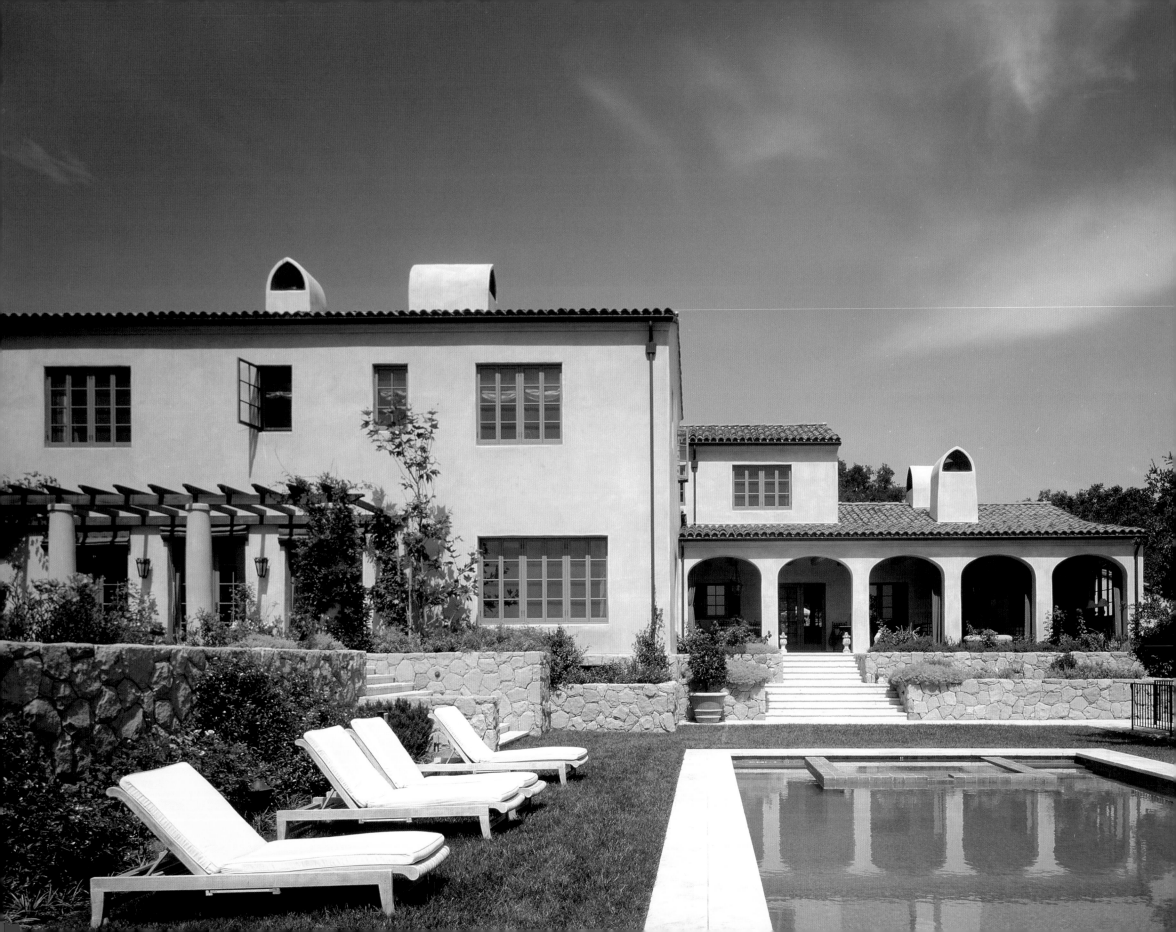

# Marc Appleton

Appleton & Associates Inc.

Architecture is a living art. As such, it cannot be created in a vacuum. For Marc Appleton, AIA, at least, it requires people, travel, historical perspective and a demanding marketplace to inform the work. And while being cognizant of the shifting tides of design is important, remaining true to the time-honored traditions of vernacular architecture and responding to his clients' unique situations is where the principal of Appleton & Associates places his priority.

Marc established his practice in 1976, after earning his undergraduate degree at Harvard, graduating from the architecture program at Yale and working under a handful of great architects, including Frank Gehry. In the 30-plus years since, Appleton & Associates has been featured in more than 100 publications—including the *Los Angeles Times*, *Architectural Digest*, *Town & Country* and the *Robb*

ABOVE:
Enjoyed from numerous interior spaces, the architecturally intriguing courtyard is punctuated by cheerful paint colors and plant life native to Los Angeles.
*Photograph by Alex Vertikoff*

FACING PAGE:
The west elevation of this Santa Barbara residence adjoins a grand loggia, terrace and sculptural pool, all surrounded by thoughtful landscaping.
*Photograph by Alex Vertikoff*

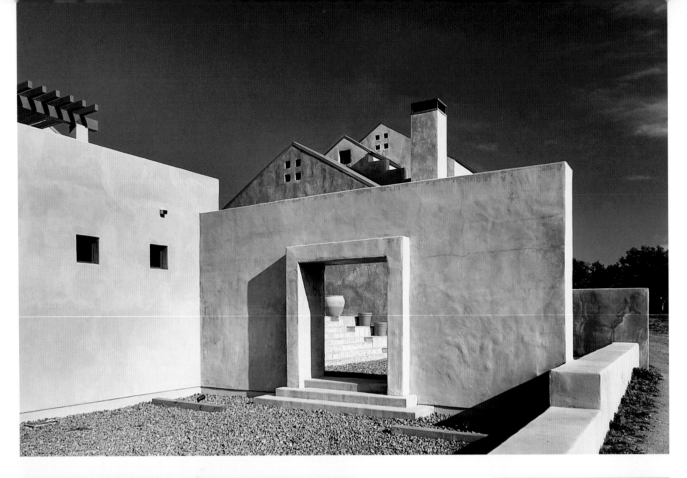

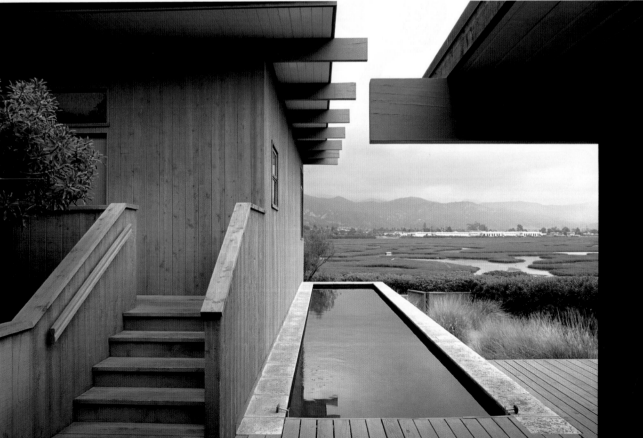

*Report*—and has been consistently named to the AD 100, *Architectural Digest*'s list of top designers in the world, since 1991.

To what does he owe such success?

There are numerous subjective factors, but Marc points to the fact that he and the nearly 30 other members of his firm, who work in atelier-like offices in Santa Barbara and Santa Monica, put a premium on distinctive designs and responsiveness to their clients. Each project starts fresh as a tabula rasa; from there the team assesses context, building site, history and client needs. The architects begin with an open mind and no preconceptions or judgments about where a project should go stylistically.

Style, Marc emphasizes, is not the issue. The important thing is that a design responds to the dreams of the client, the requirements of the program and the characteristics of each site. Though Marc's work can

TOP LEFT:
Residents and guests are welcomed via a striking entry courtyard to this Malibu home and studio.
*Photograph by Alex Vertikoff*

BOTTOM LEFT:
Clean lines and carefully chosen materials combine for a powerful design statement, as is evidenced by the lap pool and studio of this Carpinteria home.
*Photograph by Alex Vertikoff*

FACING PAGE:
Natural stone and distressed wood frame the relaxed yet elegant composition of this loggia, where the fresh air and sunshine of Santa Barbara can truly be savored.
*Photograph by Alex Vertikoff*

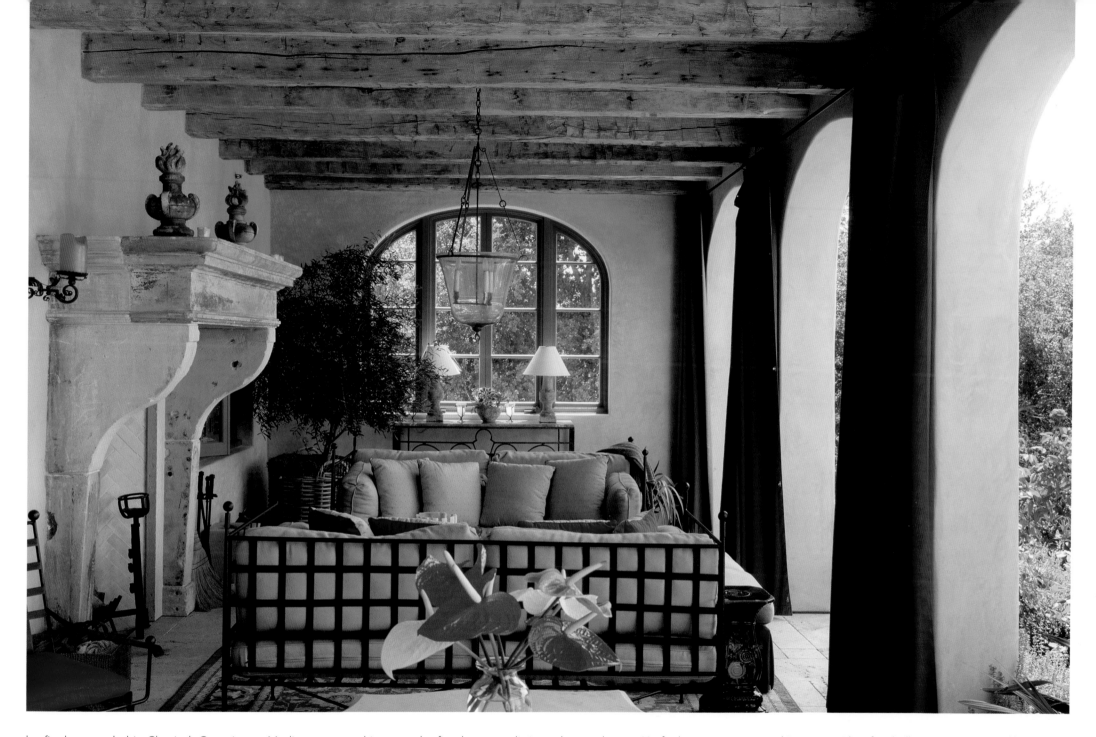

be firmly grounded in Classical, Georgian or Mediterranean architecture, the firm has no stylistic signature that has been repeated and refined throughout the years—leaving the door open for creative, client-specific interpretations.

This notion of avoiding trends is influenced not only by Marc's education, which stressed history as an active part of architectural practice, but also his extensive travels and the opportunity to leave a legacy. He finds contemporary architecture, with a few brilliant exceptions, self-absorbed and limiting, trying too hard to get noticed. Notoriety is not what Marc strives for, and tossing out the past in order to forge a controversial future is an exclusive rather than inclusive position. The architect jokes that if architecture can be considered cutting-edge then perhaps his career falls on the dull side of the blade. Not that clients or critics would ever agree.

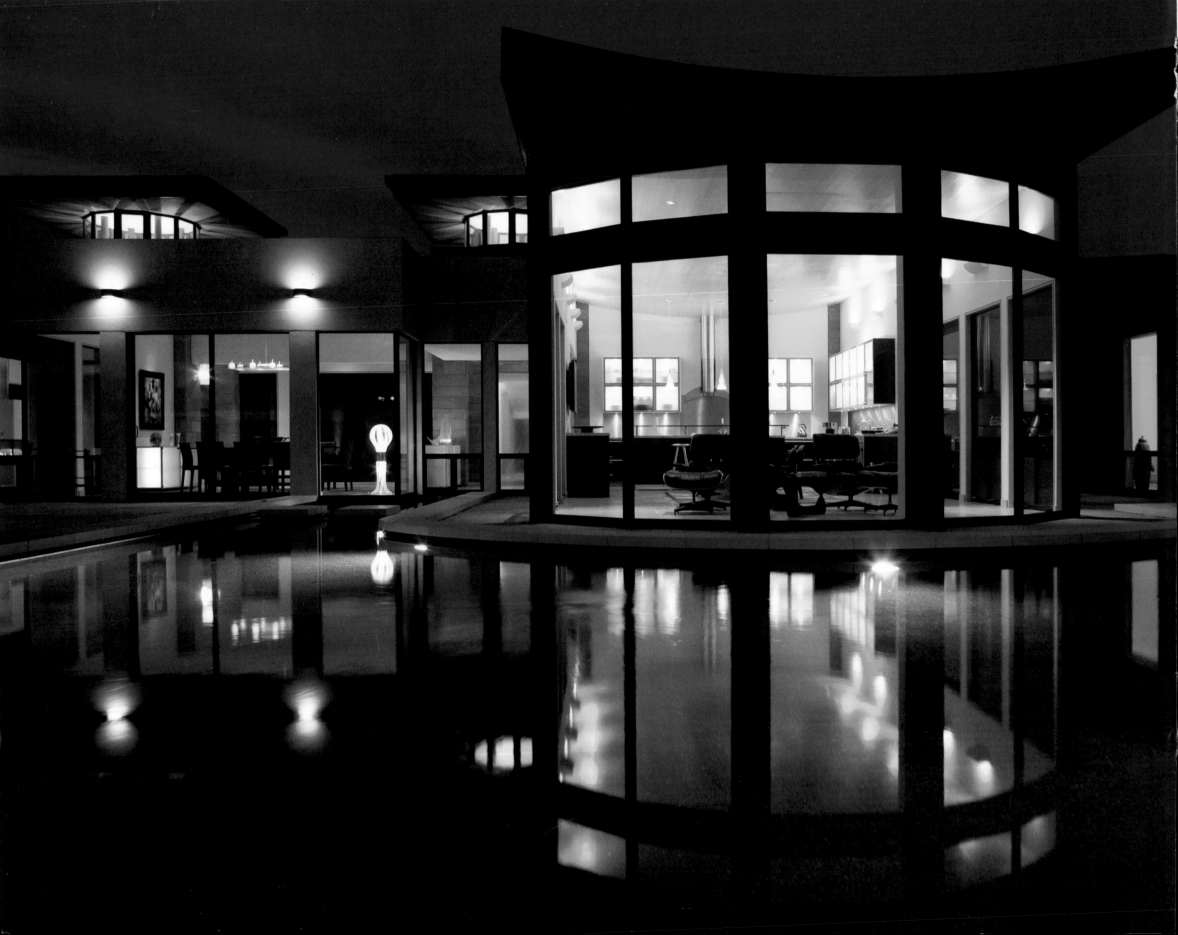

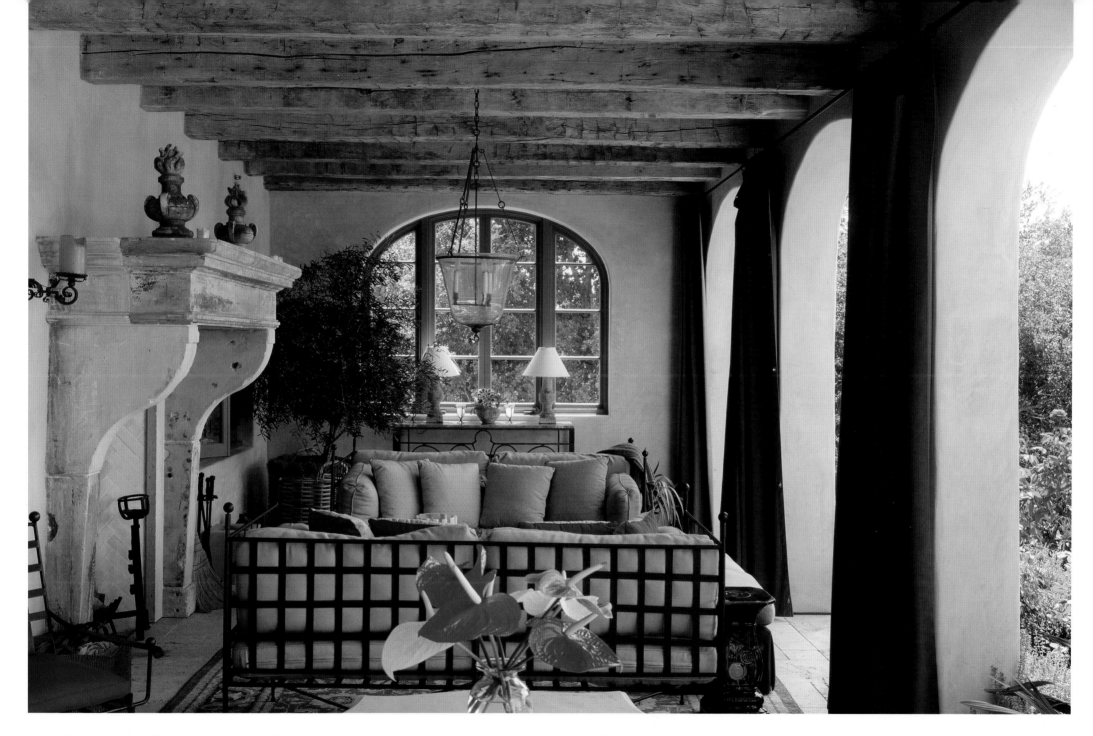

be firmly grounded in Classical, Georgian or Mediterranean architecture, the firm has no stylistic signature that has been repeated and refined throughout the years—leaving the door open for creative, client-specific interpretations.

This notion of avoiding trends is influenced not only by Marc's education, which stressed history as an active part of architectural practice, but also his extensive travels and the opportunity to leave a legacy. He finds contemporary architecture, with a few brilliant exceptions, self-absorbed and limiting, trying too hard to get noticed. Notoriety is not what Marc strives for, and tossing out the past in order to forge a controversial future is an exclusive rather than inclusive position. The architect jokes that if architecture can be considered cutting-edge then perhaps his career falls on the dull side of the blade. Not that clients or critics would ever agree.

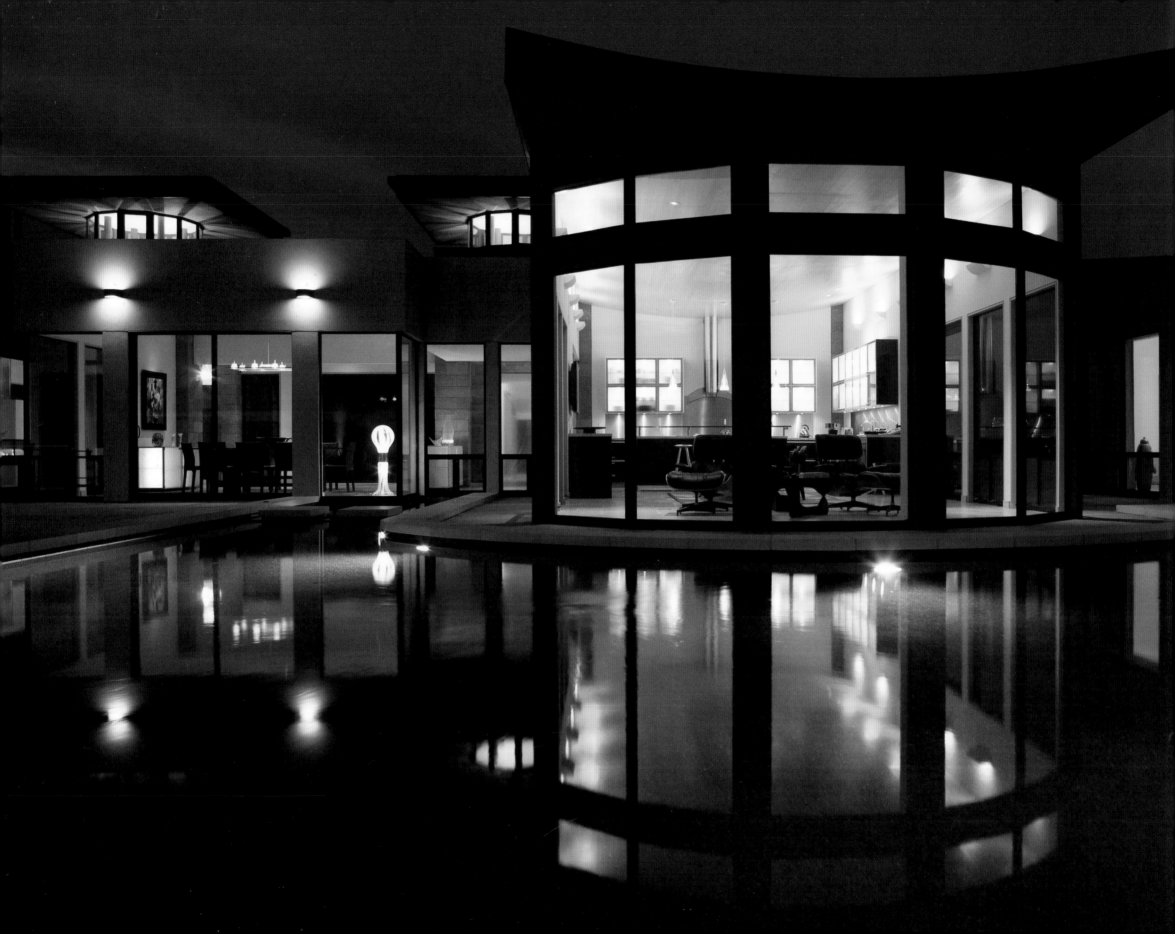

# BARRY A. BERKUS

B³ Architects
Berkus Design Studio

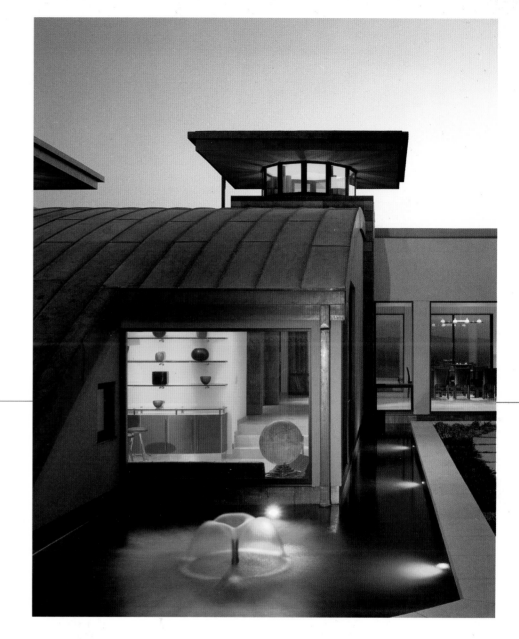

"Home to me is a place of refuge," says Barry Berkus, founder and president of B³ Architects and Berkus Design Studio. "It should stimulate one's soul and it should encourage the family to gather around the dining room table. It's a place where you should feel pride and a sense of belonging."

For more than 40 years, the architect has given each of his clients a place to call home. But his designs are more than walls and windows and rooflines, they are portraits of the people who live in them. They are memories made and stories written. Anchored in a specific time and place, buildings embody people's priorities, histories, personalities and outlooks, he says.

The creative process in the design stages of a custom home starts with long talks between architect and client detailing lists of wants and letters from the client describing the fantasy of home. It is only then that the sizable Berkus team can begin to turn language into architecture. The architect designs each

ABOVE:
A reflection pond surrounds the sunken gathering area, creating the impression of sitting below water. The water element visually extends the connection to the Pacific, which is visible through the home.
*Photograph by Peter Malinowski, InSite Architectural Photography*

FACING PAGE:
Contemporary forms reflected in the exterior water element create indoor-outdoor viewscapes of this Summerland residence.
*Photograph by Farshid Assassi, Assassi Productions*

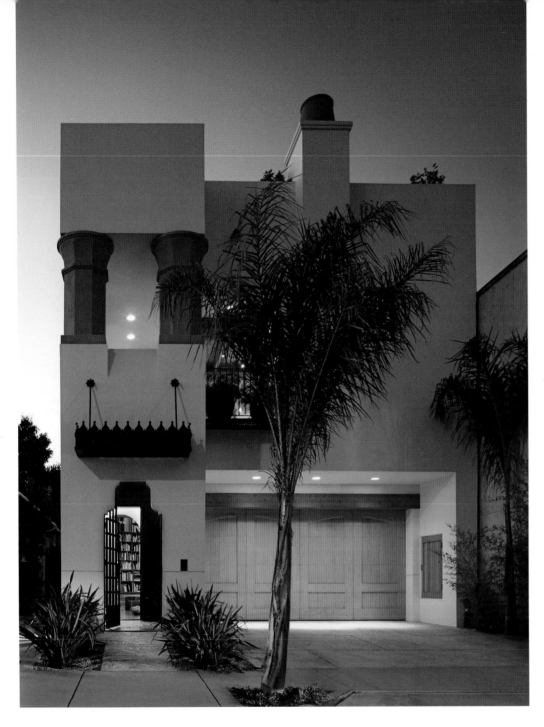

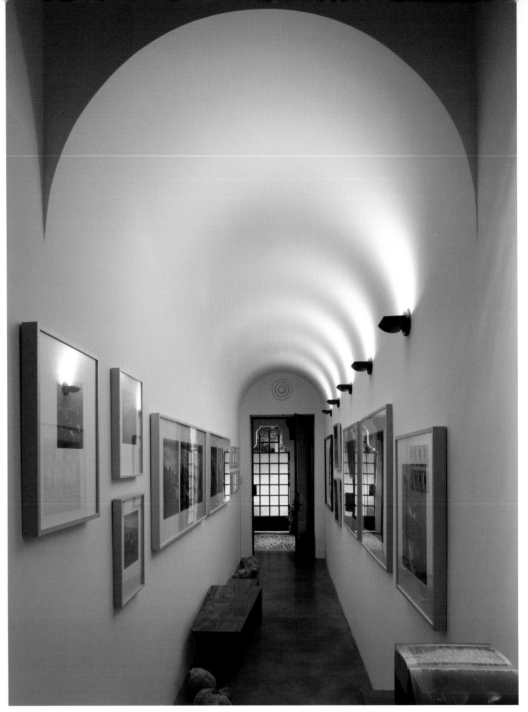

program from the inside out, carefully sculpting each individual part in a way that speaks to a need yet lends to the art.

Art is lifeblood for Barry. It has shaped his world. And art and architecture are inextricably linked in his mind. "In the methods I use as an architect to convert thoughts into buildings, I observe connections and parallels to techniques utilized by artists to translate ideas into images. In the mind's eye, buildings become paintings, sculpture becomes architecture, and reflections in glass and water become more than objects and surfaces."

Highly celebrated, Barry has been featured in *USA Today, Money, Architectural Record, Progressive Architecture, Art News,* and *Architectural Digest,* which named him one of the world's top 100 architects in 1991. In 1999, *Builder* magazine counted Barry among the 100 most influential individuals in the

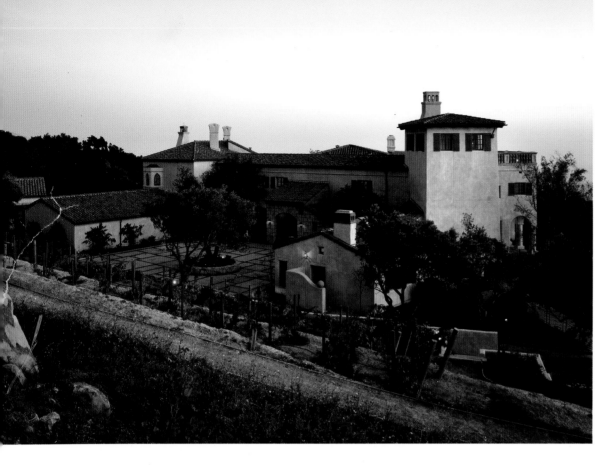

past century of American housing, and the readers of *Residential Architect* selected him as one of the 10 most significant figures of 20th-century residential architecture.

With such a list of accolades, Barry would be well within bounds were he an immodest man. But quite the opposite is true. You'd be hard-pressed to find a more unpretentious and caring person. And you're unlikely to find anyone with a more altruistic approach to work and life. "I don't think you're here to do your own thing," he says, "but to leave something behind and to help people enjoy a dream they didn't even know they had."

ABOVE:
Architecture surrounds a central courtyard, interpreting in Montecito characteristics of a Tuscan village.
*Photograph by Robb Miller, Robb Miller Photography*

RIGHT:
The vaulted interior hallway with a paneled bridge reflects the character and scale of Tuscan villas.
*Photograph by Robb Miller, Robb Miller Photography*

FACING PAGE LEFT:
This contemporary Santa Barbara residence reflects ideals of Austrian secession architecture with form trumping ornamentation.
*Photograph by Farshid Assassi, Assassi Productions*

FACING PAGE RIGHT:
The entry gallery connects the glass enclosed courtyard to the interior of this Santa Barbara dwelling.
*Photograph by Farshid Assassi, Assassi Production*

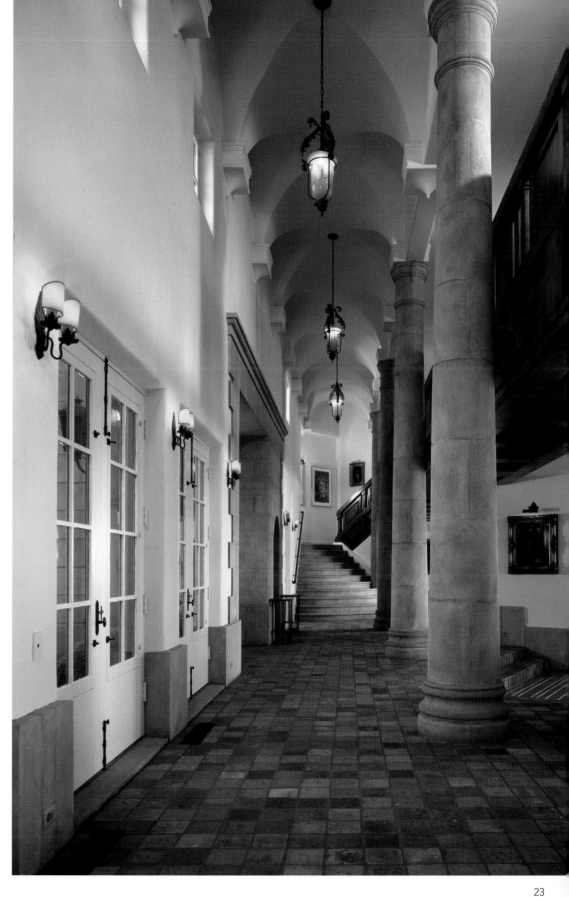

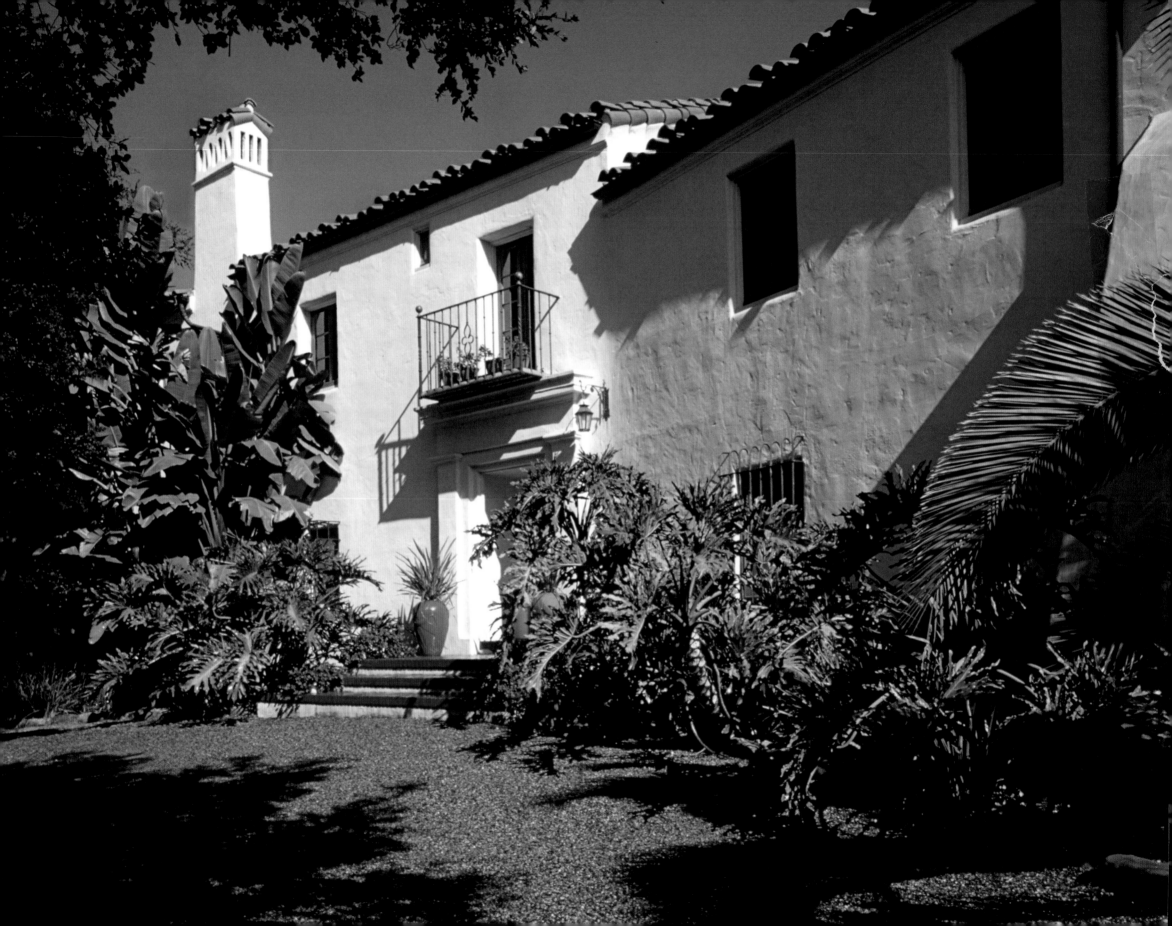

# THOMAS BOLLAY

Thomas Bollay Architects, Inc.

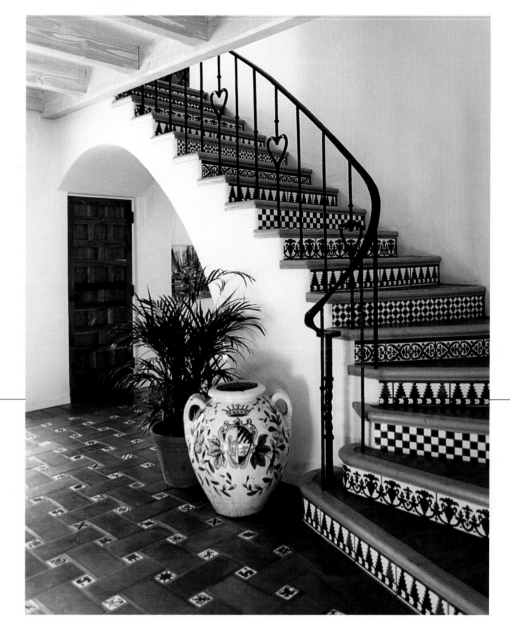

Thomas Bollay, AIA, calls his recreations of the romantic revival period of the 1920s and '30s his unique specialty. His interpretation follows traditionalist concepts and detailing while also including modernist sensibilities—designing homes that are for today's lifestyle yet have a sense of warmth and a strong connection to their gardens and environs. His homes portray a feeling of timelessness, reflecting less the work of an architect and more the richness of craftsmanship and tradition of an earlier time. His passion for exploring the imagery of the era has resulted in more than 200 completed projects that exemplify the finest of the styles of the time.

Tom's appreciation for revival architecture really began to take hold in the 1980s when he sat on the Architectural Review Committee in Montecito with noted architectural historian David Gebhard. David, who became a good friend, shared his thoughts of this romantic period and made his vast

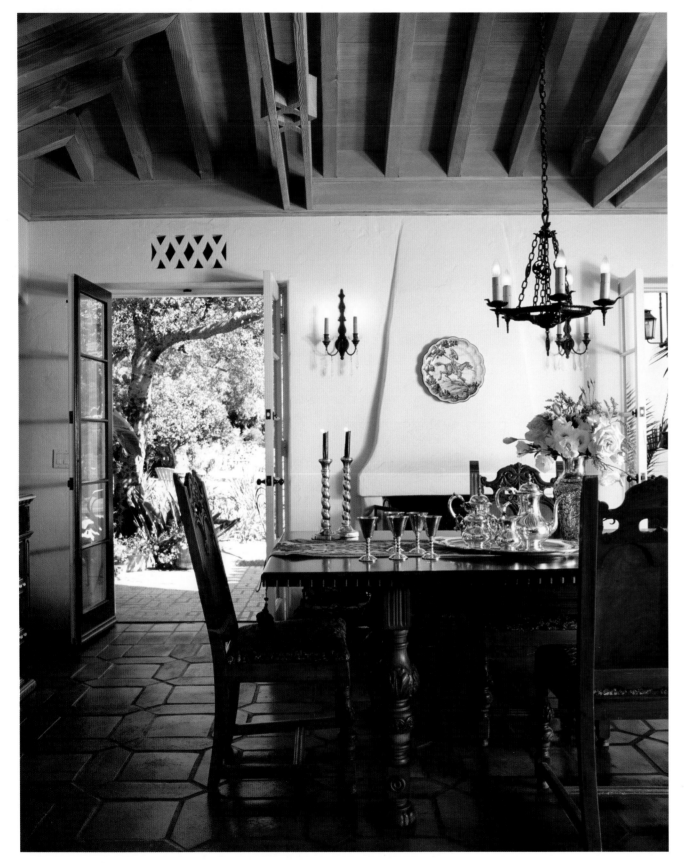

library on the subject available to Tom. Inspired by the wealth of knowledge, Tom began his own historic library, which now numbers hundreds of volumes, including original working drawings from many of the period's top architects.

From David's research of the era, Tom learned many aspects of how these architects were able to obtain such a high level of design. One that Tom mentions often is that architects of the '20s traveled extensively throughout Europe and made measured drawings and photographs of the rural farm buildings and gardens they were reproducing for their clients in the United States. Tom has traveled many of the same itineraries through Spain, measuring courtyards and loggias, and mapping out entire gardens so that he could better understand the scale for his work.

LEFT:
The intimate indoor dining room with typical Revivalist detailing opens through French doors to an inviting outdoor dining terrace.
*Photograph by Jeff Green*

FACING PAGE LEFT:
The kitchen has become the center of living in homes today. This space combines the hallmarks of the Spanish Colonial Revival style with modern efficiencies.
*Photograph by Jeff Green*

FACING PAGE RIGHT:
The breakfast area showcases a variety of romantic elements: a corner fireplace, large windows with thin steel mullions, floorplans conducive to garden views and decorative tile accents in the terracotta floors.
*Photograph by Jeff Green*

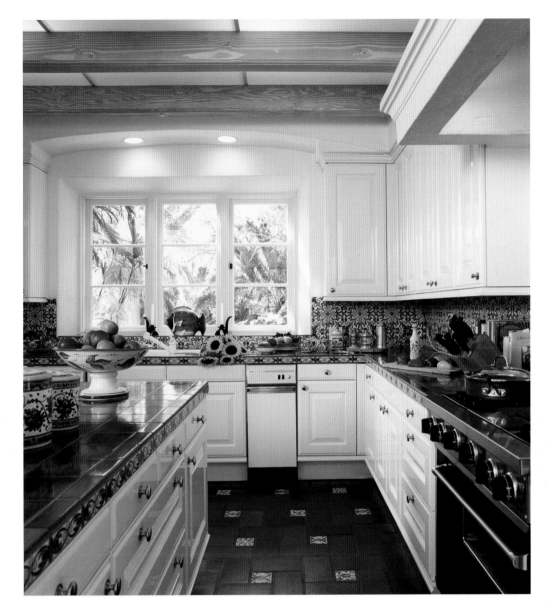

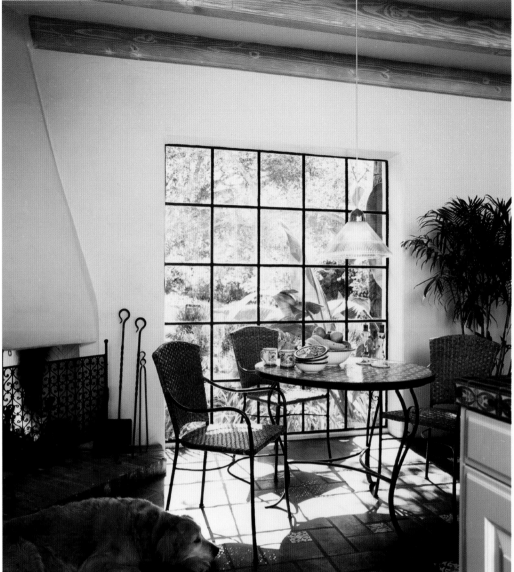

In all of this research, Tom learned that it is the scale of buildings that is paramount to their beauty and simplicity. While designing his own home in Montecito, Tom studied Spanish precedents as well as the plan and configuration, scale, and detail of the work of Santa Barbara's most highly regarded 1920s' architects: George Washington Smith, Joseph Plunkett, Reginald Johnson and James Osborne Craig. One thing he noticed about the many projects that he studied carefully was their success at creating an environment that felt right. Tom calls this the "human scale." With proper proportion and detail, buildings do not come across as imposing or diminutive but always feel comfortable and livable.

The houses that Tom designs are also distinctive and bold. Seeing buildings as a composition of light and shadow, he uses deep-set windows and varied massing to create his revival forms. Designing with an artist's eye, he creates designs with an unmistakably dynamic character. He treats each design holistically, simultaneously thinking of light, views, gardens, picturesque massing and floorplan: True style is not something that can be added as an afterthought.

Tom limits the number of projects he accepts so that he can stay intimately involved in each design from start to finish. Though every project is an original, created as a one-of-a-kind for each client,

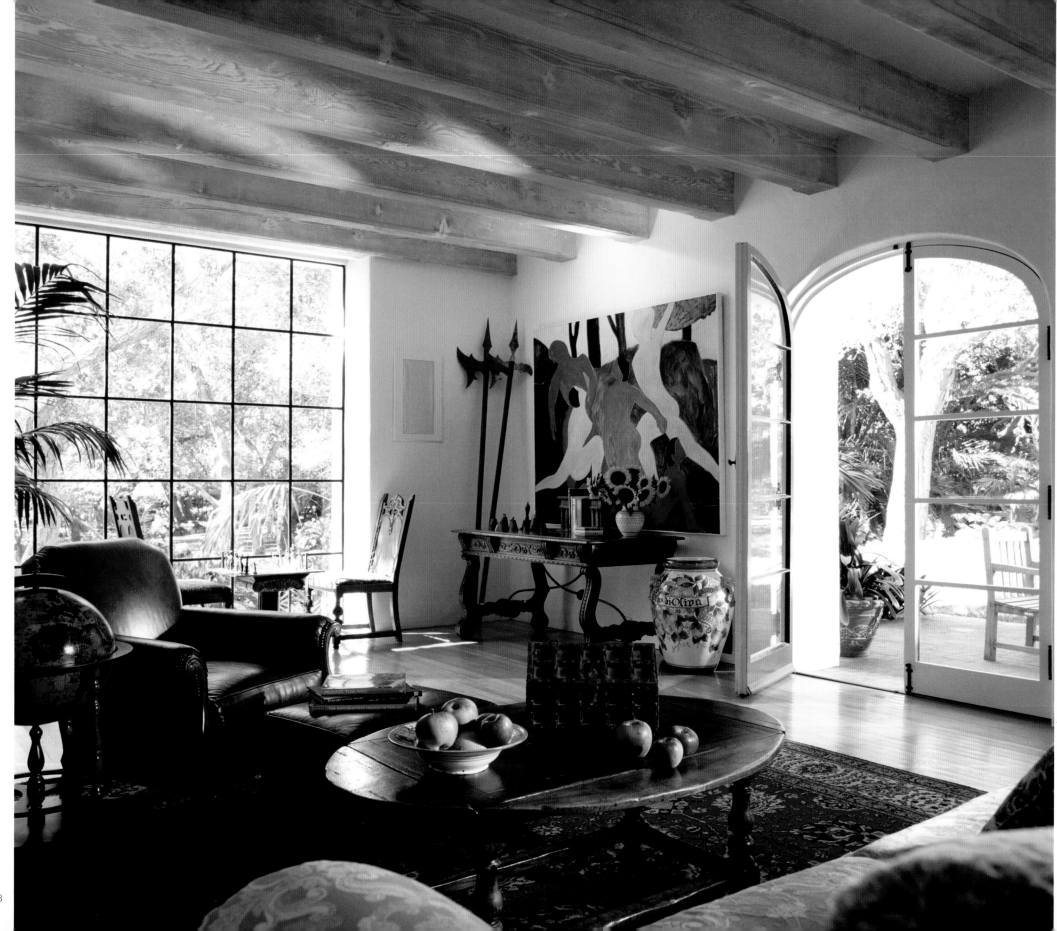

all of Tom's homes share similar elements. Typically, as in the '20s, the floorplans are L- or U-shaped, with windows on two or three sides of each room, providing cross-ventilation and a delightful, ever-changing quality of light. Asymmetry and unexpected details add to the charm, and in doing his own interior architectural detailing, he focuses on how different elements complement each other, creating balance and beauty.

Tom lived and traveled extensively throughout Europe as a child. During those travels, his family experienced Europe through the eyes of the local villagers, traveling by boat along the Mediterranean coast, getting to know the local people and taking in their culture. The coastal towns of Spain, Portugal, France, Italy and Greece continue to inspire his life's work.

RIGHT:
Outdoor dining at its best, this patio is an ideal retreat for a romantic dinner warmed by an outdoor fireplace.
*Photograph by Peter Malinowski*

FACING PAGE:
A large studio window and romantic French doors create interest and invite exploration of the gardens.
*Photograph by Jeff Green*

# THIEP H. CUNG
# JACK L. WARNER

The Warner Group Architects, Inc.

Successful projects go beyond the immediate and obvious needs. They require a balance of creativity and commitment to serve the long term interests of the client, the environment and the urban landscape. The Warner Group Architects is committed to focusing on innovative design solutions that exceed the needs and expectations of clients, from concept to completion. With a multidisciplinary team of dedicated professionals, the firm provides unparalleled vision and leadership to produce award-winning projects on time and budget.

Principal architects Jack Lionel Warner, AIA, and Thiep H. Cung, AIA, have produced a body of work spanning four decades that has been awarded *Architectural Digest*'s highest honor four times, The AD 100 World's Top Architects and Interior Designers and Top 30 Architects by the *Robb Report*. Their projects, no matter the scale or style, capture an architectural quality that is at once modern and classical.

LEFT:
This modern home on a hilltop in Montecito is a single-story design, with 15-foot-high wood-beamed ceilings—a wall of windows opens to a rear loggia, overlooking dramatic ocean and mountainside views.
*Photograph by Peter Malinowski/InSite*

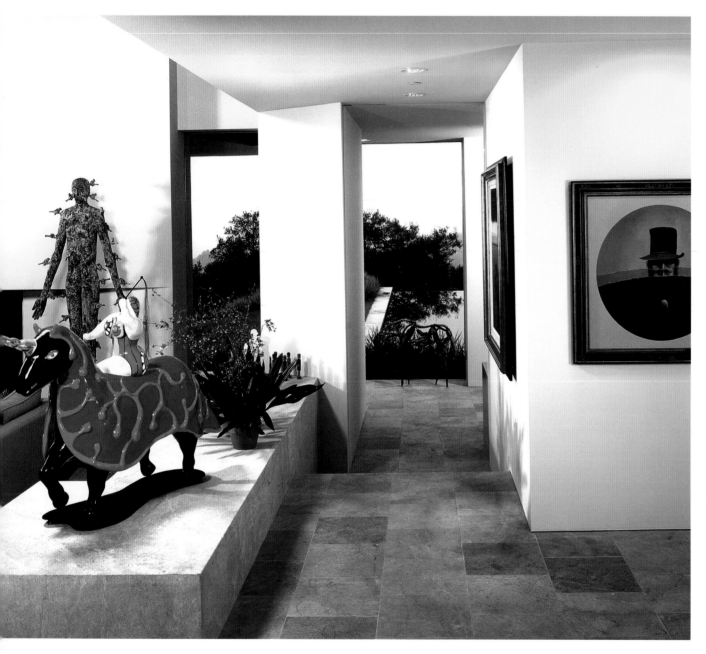
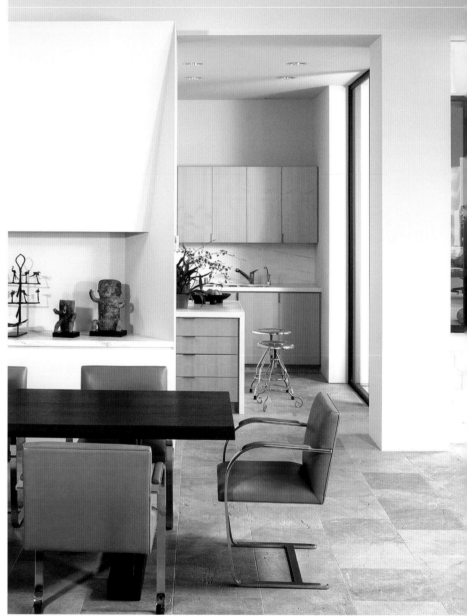

Founded in 1966, the Santa Barbara-based firm has a staff of 20 that includes architects, interior designers and landscape architects. Working as a team from conceptual design through the final installation of furnishing, their clients' ideas and desires are carefully crafted through the architects' vision. Intention and interpretation evolve into cohesive, detailed plans and emerge as dream homes.

Architecture, landscape and interior design—The Warner Group endeavors to meld interior spaces and exterior elements with the natural environment. An important distinction, as the combination of these attributes provides design continuity and the collaborative vision is executed in exquisite form.

The firm's work encompasses nearly every architectural style. From Classical to Modern, Italian villa to French chateau, the homes that the architects design are clean, strong and bold—sometimes traditional, sometimes contemporary—but never trendy. Within a contextual perspective, they develop and refine floorplans and capitalize on proportion and flow.

RIGHT:
Showcasing a fine art collection, the over-scaled main room was designed with deep recesses and bold, simple elements to bring the height of the room down to human scale.
*Photograph by Peter Malinowski/InSite*

FACING PAGE LEFT:
The strong lines are carried through the home and into the garden, where an infinity pool reflects images of the lush California terrain.
*Photograph by Peter Malinowski/InSite*

FACING PAGE RIGHT:
The kitchen, located just beyond the great room, is a refined workspace, flowing together as part of the large, open, circulating layout.
*Photograph by Peter Malinowski/InSite*

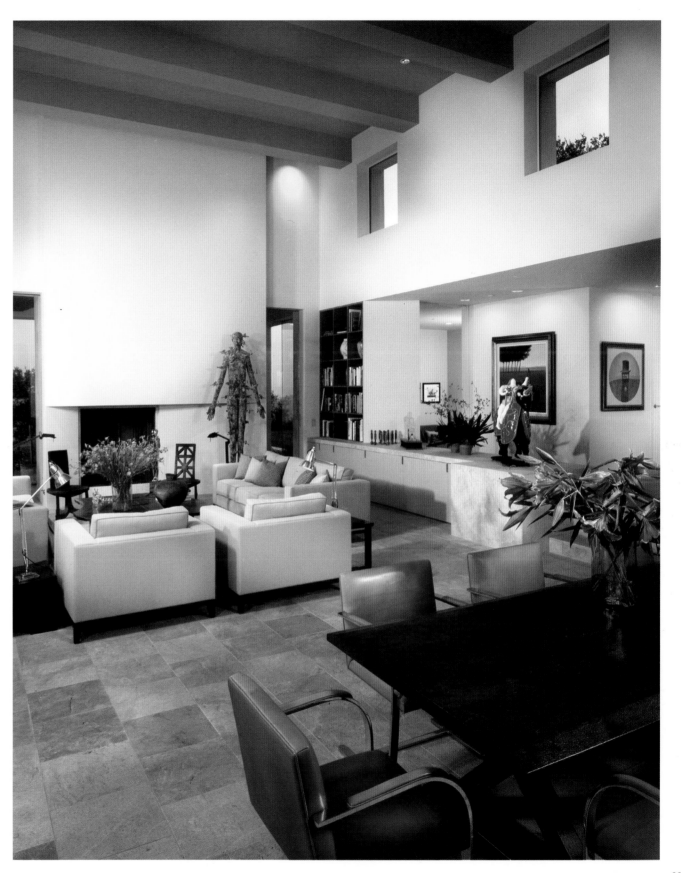

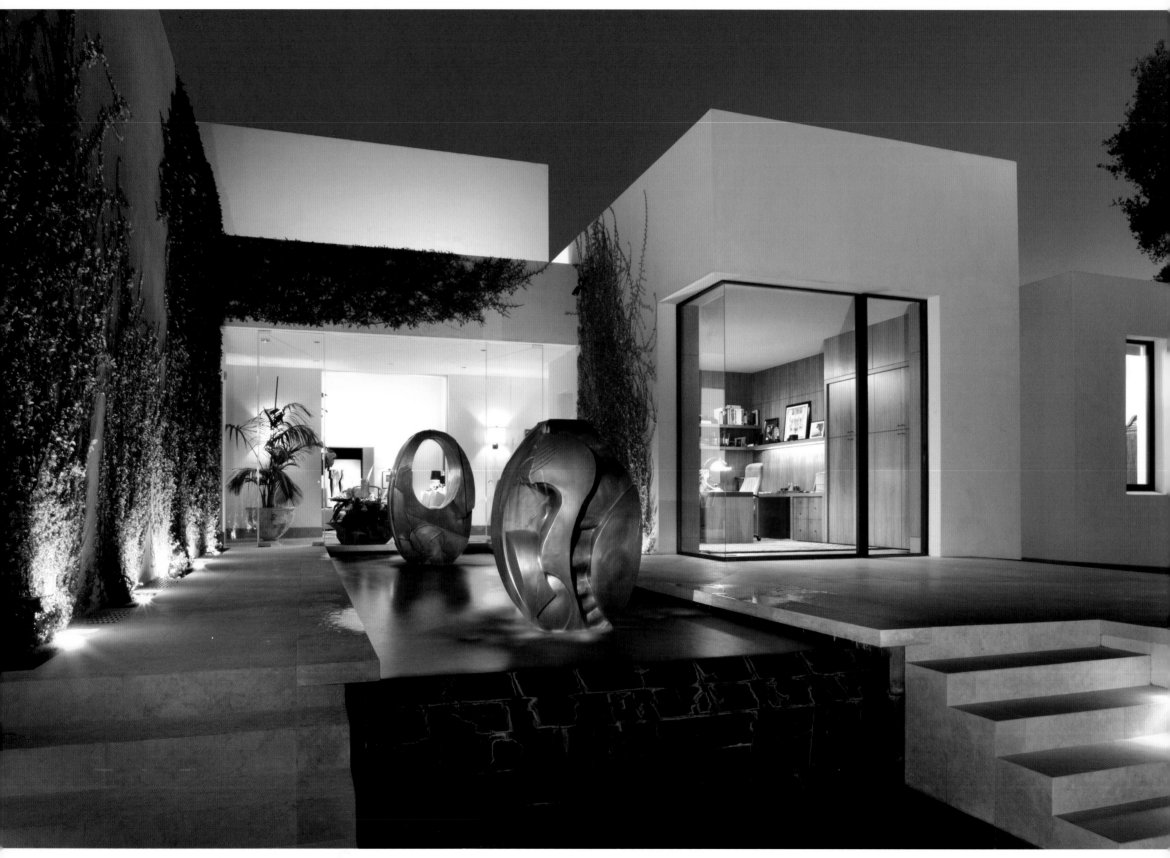

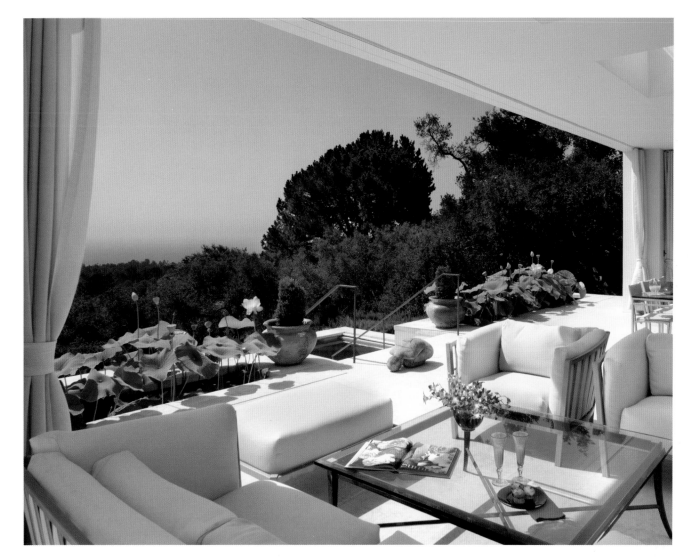

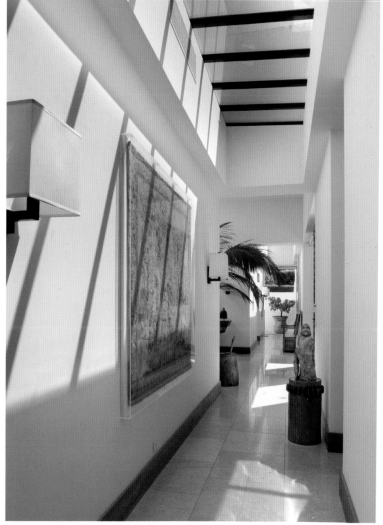

Before accepting new work, the firm meets with potential clients to assure that all parties involved embrace not only the design process, but one another. The close relationships that develop between the architect and client become an intrinsic aspect in creating residences carefully tailored to the clients' needs. The firm's philosophy is that a home is the greatest form of self-expression and should inspire its occupants and reflect their unique lifestyle.

The close collaboration over a three-year period with the owners of a four-acre Montecito hilltop property produced a modern showcase for their extensive art collection. Open rooms with high, beamed ceilings create viewports into adjoining spaces framing works by Picasso, Calder and Botero, and extend beyond to the dramatic ocean views. The rhythmic placement of clerestory windows lights the gallery-like spaces, which are warmed by the extensive use of natural limestone and honed marble. The home was built with high-tech, engineered materials at the owners' request to stand the test of time.

ABOVE LEFT:
Built on an isolated plot of land high above Montecito, this home has 360-degree views of flourishing green mountainsides and an endless sea.
*Photograph by Lawrence Anderson Photography*

ABOVE RIGHT:
The open airy flow of this home allows for sunlight to warm every passage.
*Photograph by Lawrence Anderson Photography*

FACING PAGE:
An infinity-edge pool reflects a paired art piece by Demetrios called *Joyous Resonance*, which is symbolic of the homeowners.
*Photograph by Lawrence Anderson Photography*

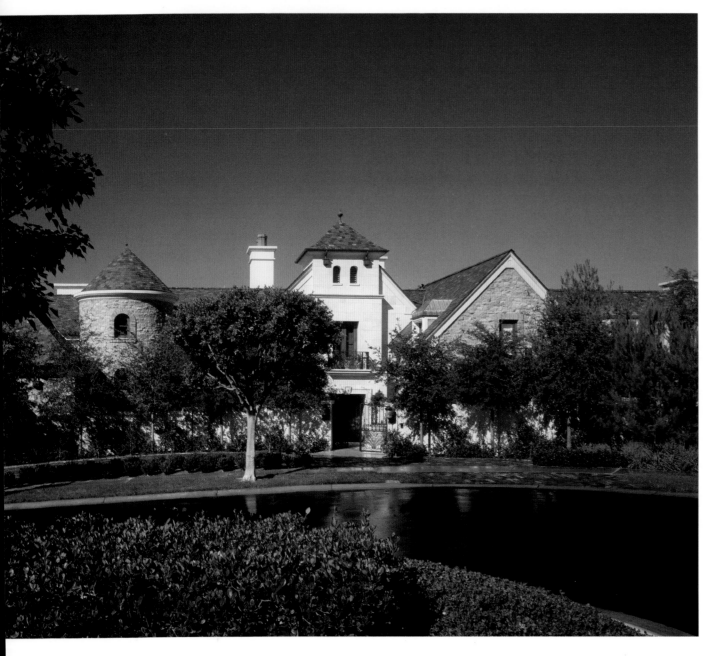

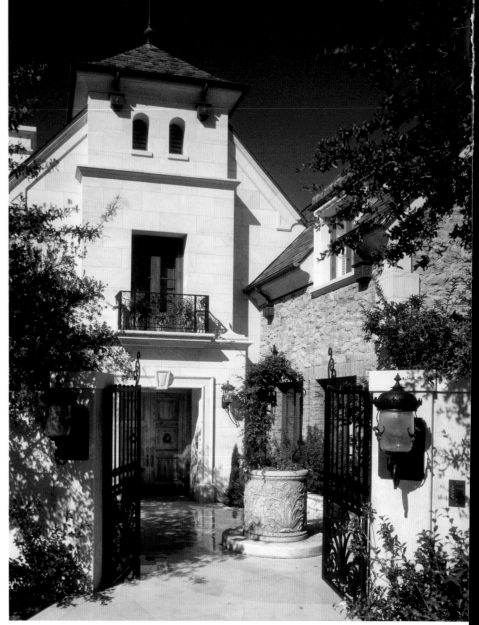

Another dramatic hilltop residence in Montecito was designed to capture views in all directions. The entrance gives a sense of seeing through the home; surrounded by glass, the rough-hewn, over-scaled doors were based on ancient Indian cabinetry. Each room and passageway in the home extends to the outside, surrounded by water in reflecting pools and lotus ponds. A pair of elliptical bronze sculptures, carefully positioned in an infinity pool, creates an optical illusion when viewed from the living space. The connection between interior space and the landscape beyond is seamless.

ABOVE LEFT:
The steep-pitched slate roof and copper accents nestled behind mature landscaping create a stately façade.
*Photograph by Eric Figge Photography, Inc.*

ABOVE RIGHT:
Large iron gates open to an interior courtyard paved in French limestone and antique marble that is replete with a wellhead centerpiece.
*Photograph by Eric Figge Photography, Inc.*

FACING PAGE:
The library wrapped in warm walnut paneling creates an elegant yet comfortable space for the homeowner to work or relax. Rich colors and textural fabrics balance the room's exquisite collection of antique furniture and accessories.
*Photograph by Wanelle Fitch Photography*

A Newport Coast couple, who traveled extensively in Greece, discovered an exquisite marble in an archaeological museum on Crete that became a dominant influence in their home's design. The firm made five trips to marble yards in Greece and Carrara, Italy, to select 30 types of stone for carved mantels, a dramatic curved staircase, even outdoor paving stonework, all shipped in 30 containers from Greece.

The firm specializes in challenging projects and spectacular sites, and its residential and resort work is seen in all of California's major coastal communities, as well as Hawaii, Central America and as far reaching as the Middle East. Difficult oceanfront and hillside sites have been transformed into breathtaking-view homes in Laguna Beach, La Jolla, Newport Beach, Malibu, Manhattan Beach, Bel-Air, Montecito, Hope Ranch, Santa Barbara, Carmel, Los Altos and Monterey. The firm takes on only three or four new projects each year, devoting full attention to a limited number of new clients, who are consistently referred by past clients, maintaining the high level of design integrity for which The Warner Group is reputed.

The Warner Group regards designing and building a unique home as a process and an adventure that depends upon a deep well of energy and enthusiasm. The ultimate objective is to translate the client's vision through the medium of design and architecture. Equally essential is the balance of inspiration and purpose required to create an elegant, livable space that the clients can call home, something that is intimate and wholly unto themselves.

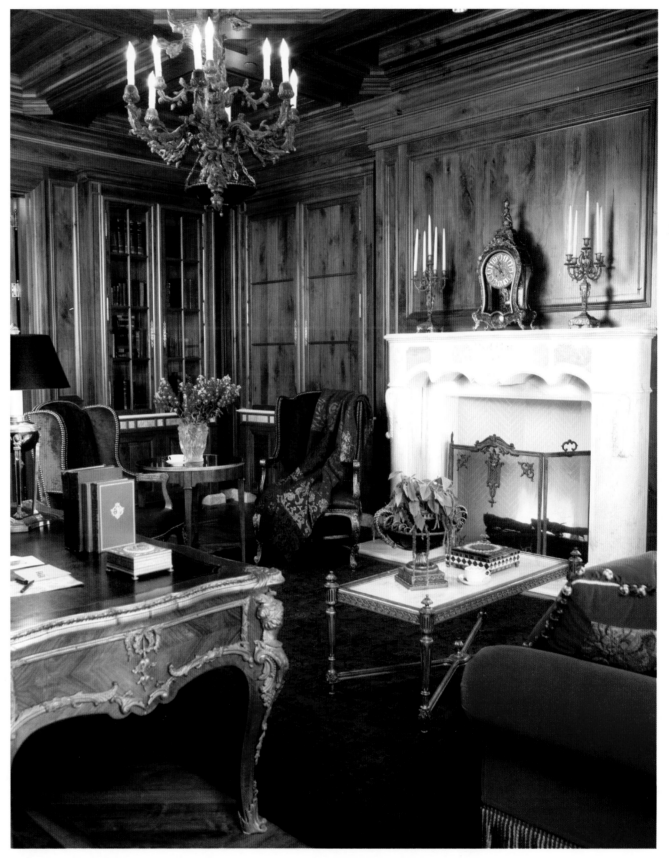

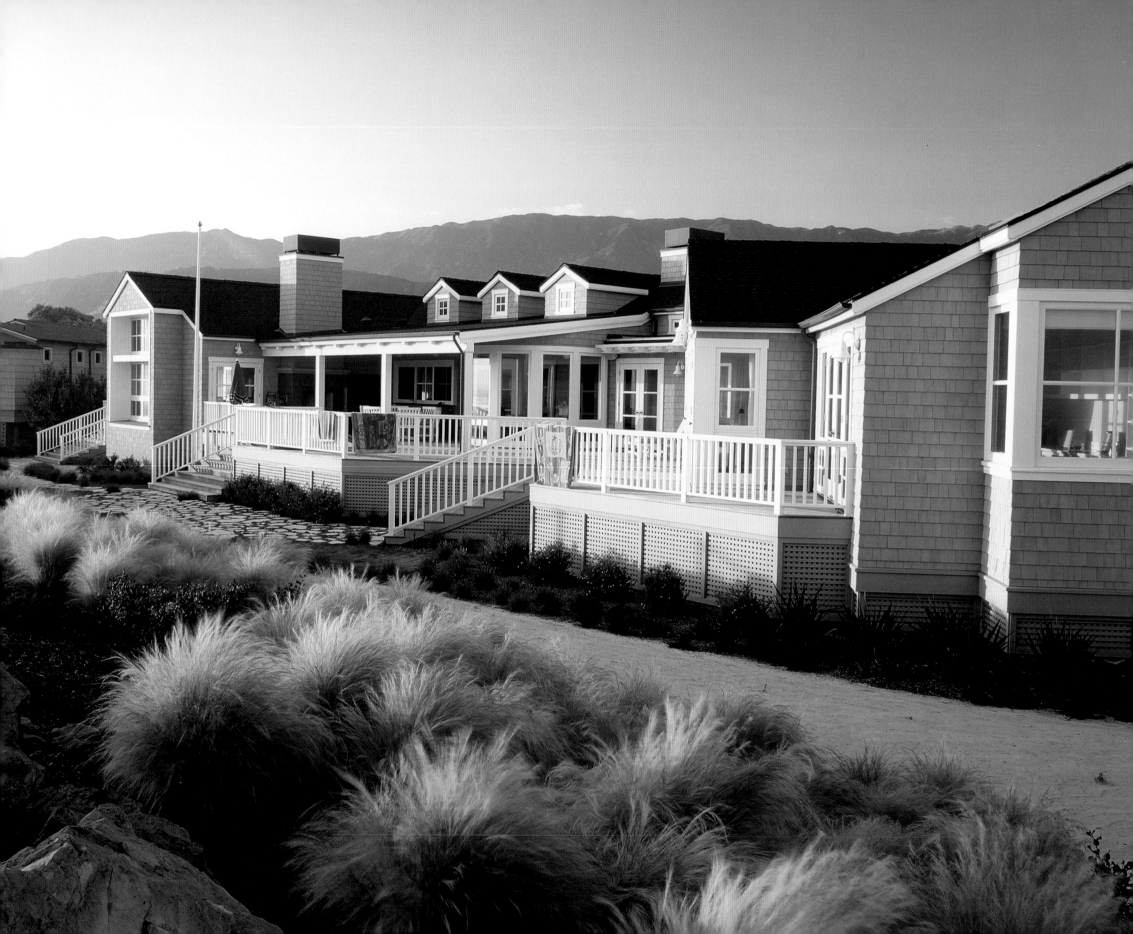

# DD Ford Construction, Inc.

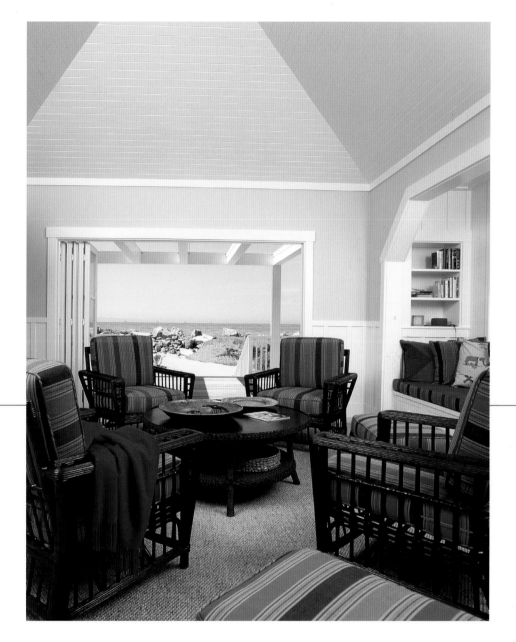

Fresh off a year of student teaching at Santa Barbara Jr. High School, Doug Ford chose woodworking over educating. The classroom did not live up to his expectations, and in 1979 DD Ford Construction was established.

The first few years at DD Ford were primarily focused on building cabinets and furniture out of a single-car garage along with one other employee. Clients appreciated Doug's craftsmanship and attention to detail so much, they persuaded him to take on bigger projects and business grew from there.

Today, the multiple-award winning DD Ford Construction employs 70 people who provide a wide variety of construction services including new home construction, remodeling, service and maintenance for completed homes, and finish carpentry and cabinetry services from its downtown Santa Barbara offices.

ABOVE:
The doors of this family entertainment room open completely to the ocean. The painted wood pyramid ceiling provides the space with incredible volume.
*Photograph by Bill Zeldis*

FACING PAGE:
Situated on the Pacific Ocean with the coastal mountains as a backdrop, this beautiful Cape Cod home is subtly infused with modern flavors.
*Photograph by Bill Zeldis*

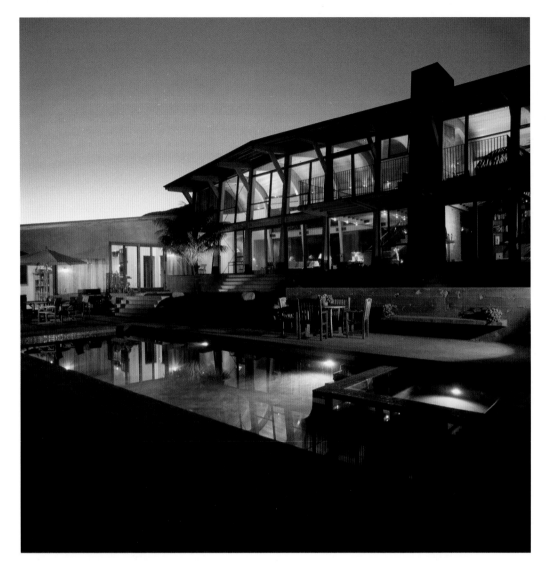

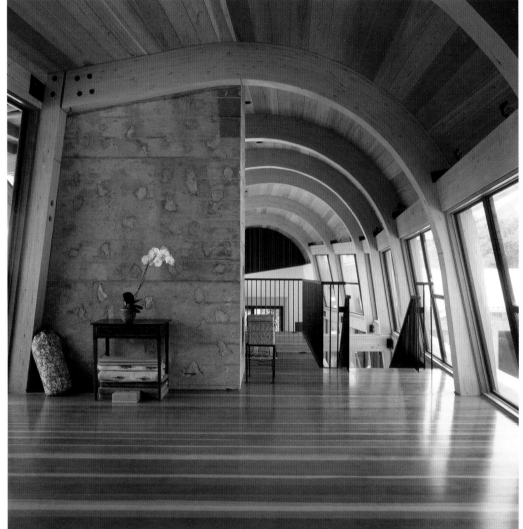

Its reputation for professional excellence as a custom home builder is directly due to the quality of its employees, tradesmen and management systems.

Operating with the dictum "Begin with the end in mind," DD Ford Construction's unmatched preconstruction process creates a project team built on the collaborative efforts of the client, design team and builder. During design development, DD Ford provides input on building assemblies, materials, products, schedule, budget and functionality. This preconstruction service is a key component in managing the balance and creativity of each design with a clear perspective on how each detail relates to the vision of the design team and client. This process is fun and rewarding for all participants, creating a foundation for the project team to successfully move forward into the building phase.

Once the project is underway, the DD Ford team works diligently to manage the construction budget, schedule and decisions to ensure efficiency and quality during the project's building phase. Using sophisticated project management systems coupled with proactive, caring personnel, the two-dimensional design is transformed into three-dimensional reality.

Fine homebuilding is a tradition and value shared by everyone at DD Ford, from their craftsmen and field crews to the office staff and management. They pride themselves in their ability to be flexible and responsive to the inspiration of clients and design team throughout the life of the project. They develop trusting and creative relationships by combining innovative solutions with rigorous attention to detail.

From preconstruction to maintenance, the company collaborates to ensure excellence at every level. And it is this comprehensive method that sets DD Ford apart as a builder. Though no project is exactly like another, they all benefit from this approach, as do the clients, whose happiness is the overriding goal of the firm.

DD Ford's client base of repeat, referral and service business is a living testimonial to their ongoing success.

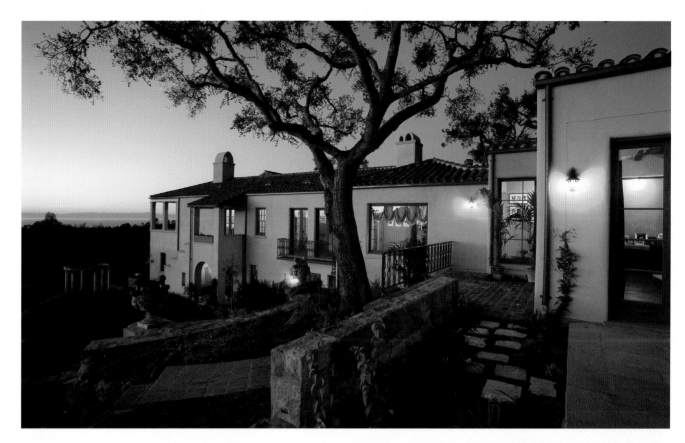

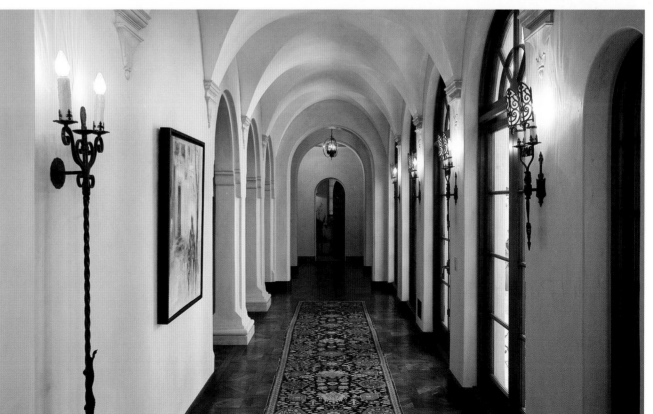

TOP RIGHT:
This historic Santa Barbara work of architecture was remodeled with care to maintain its heritage. The exterior architecture was kept intact while the interior was completely deconstructed, reconfigured and built back to maintain its rich vernacular.
*Photograph by Bill Werts*

BOTTOM RIGHT:
The new hallway lends itself to the time period, with antique lanterns, mahogany doors, walnut floors and groin vaults that terminate at hand-cast, detailed plaster capitals.
*Photograph by Bill Werts*

FACING PAGE LEFT:
This unique, contemporary residence is comprised of wood, glass and steel and is shaped like a wave with views of the ocean below and the mountains behind.
*Photograph by Bill Zeldis*

FACING PAGE RIGHT:
Bent wood beams, each with a different radius, inform this unique space, which is almost like the inside of an upside-down ship. Concrete mixed with natural stone combine to create a contemporary and natural look.
*Photograph by Bill Zeldis*

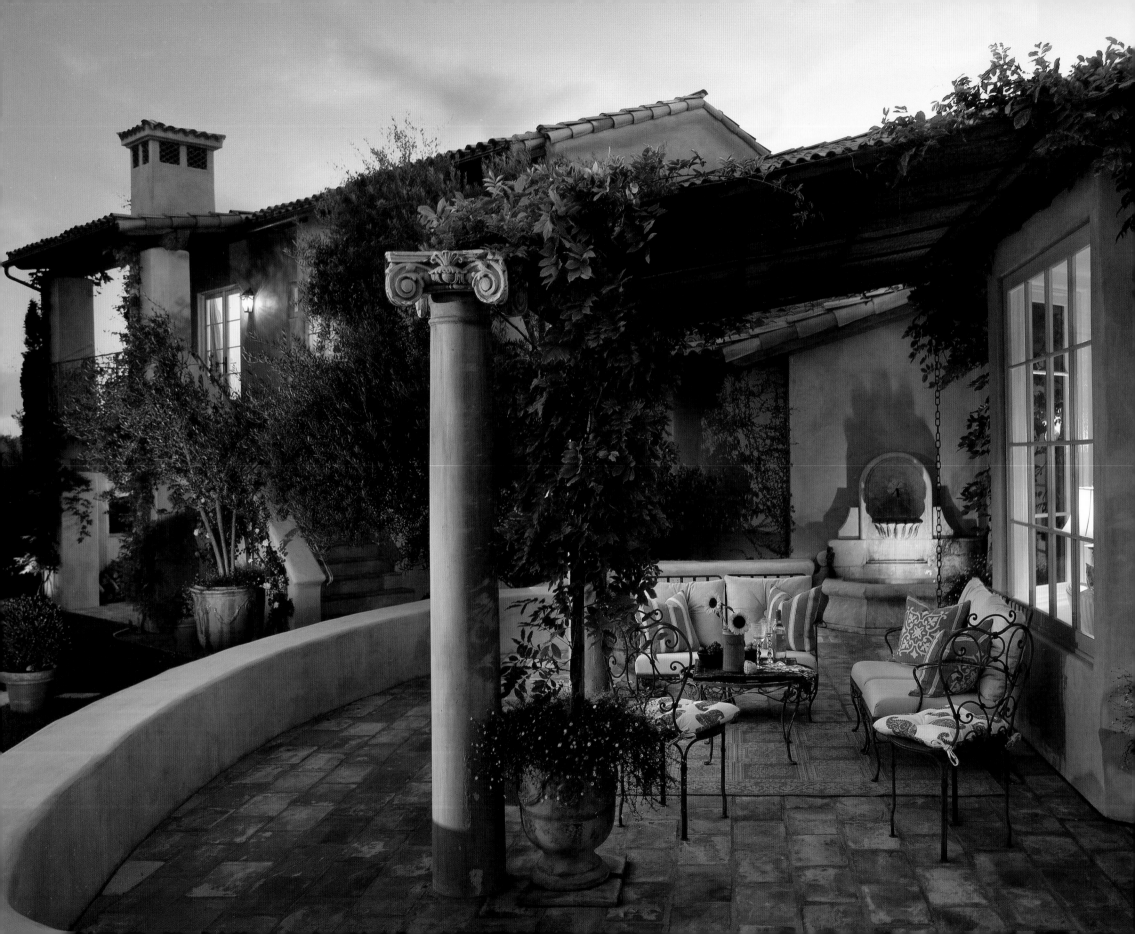

# CHRISTOPHER DENTZEL
# KATIE O'REILLY ROGERS
# GEOFF CRANE

Christopher Dentzel Architects
The Office of Katie O'Reilly Rogers, Inc.
Giffin & Crane General Contractors, Inc.

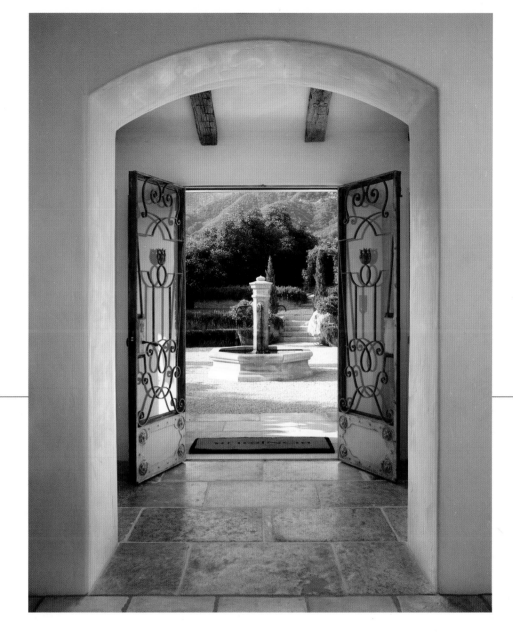

ABOVE:
Taking full advantage of the inherent strengths of the site, the design-build team of architect Chris Dentzel, landscape architect Katie O'Reilly Rogers and Giffin & Crane General Contractors created this French Mediterranean classic.
*Photograph by Jim Bartsch*

FACING PAGE:
Professional collaboration between architect, landscape architect and general contractors yielded a home that feels handcrafted and organic, as if it were built long ago.
*Photograph by Jim Bartsch*

The magical blend of fortuitous geography and location, 34 degrees north and 119 degrees west, creates Santa Barbara's ideal Mediterranean climate. The appeal of living in a temperate climate where the mountains meet the sea has led to a community of people who are there by choice. They expect their homes to reflect the uniqueness of their lives along California's central coast.

The local tradition of referencing Spanish and Italian architectural influences leads to clients, architects and builders reaching again and again for those familiar Mediterranean icons. Yet, there are regional subtleties and nuances to fine Mediterranean architecture. It is far more than just red tile roofs.

When clients have a clear vision and fond memories of a place and time they wish to experience in their new home, they need a team of professionals that respects the countless details that together result in the fulfillment of that dream.

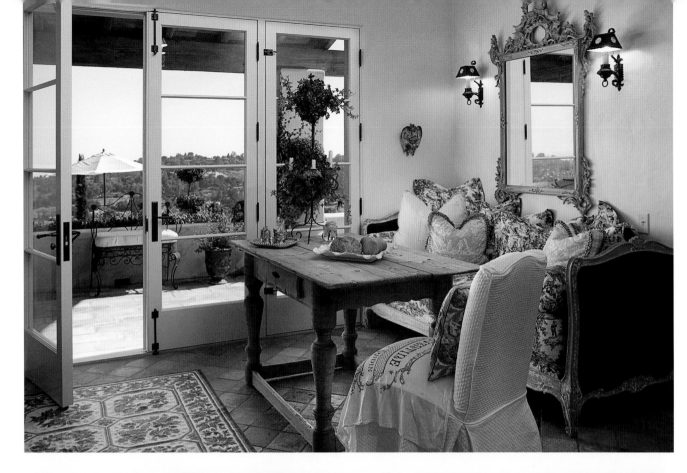

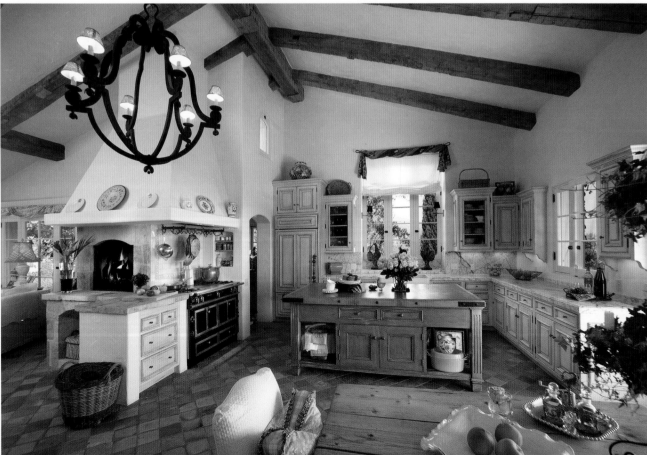

The design team of Chris Dentzel, architect, and Katie O'Reilly Rogers, landscape architect, had such clients: Travis and Tracy Shannon. The Shannons were taken with a chaparral-covered knoll overlooking Santa Barbara that was reminiscent of Provence. Having recently returned from the South of France, the Shannons were enchanted with the vistas and could imagine the French Mediterranean home of their dreams built on this special site.

Partnering with General Contractors Giffin & Crane, the team created a home and setting that, while completely current in terms of technology and comfort, is full of whimsy and appears to have been in place for years. Architect, landscape architect and builder together created the look, feel and setting that their client was seeking.

Inside and out, the home showcases many of the French architectural elements and artifacts the Shannons assembled from their trips to Europe. Their team embraced their vision and enhanced their wishes through focusing on the subtle details, such as 22 kinds of windows, the chiseling of hand-quarried local stone and the composition of outdoor living spaces nestled in various gardens.

The Shannons were delighted with the final result: a memorable French Mediterranean home situated on California's central coast. Tracy Shannon's own artistic contributions to perfect the interior design and landscaping authentic to the South of France added a signature touch to the completion of her dream home.

Paying homage to the craftsmanship, sensitivity and design of a bygone era, the Shannons' home will age well, certainly in keeping with the classic and timeless nature of Santa Barbara. It adds one more nuance, a French Mediterranean one, to the architectural vernacular language that makes up the city of Santa Barbara.

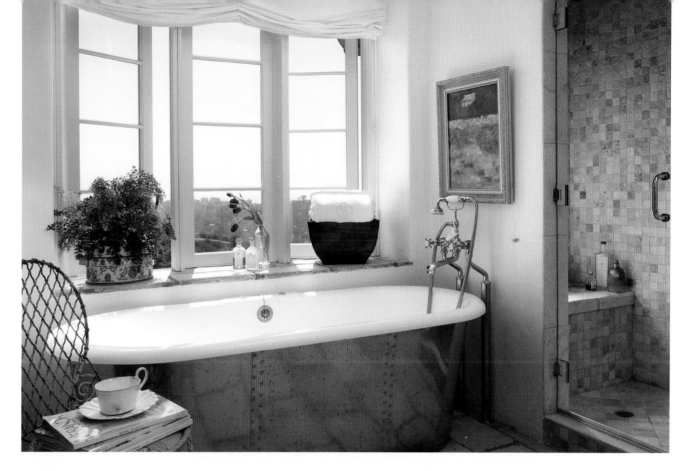

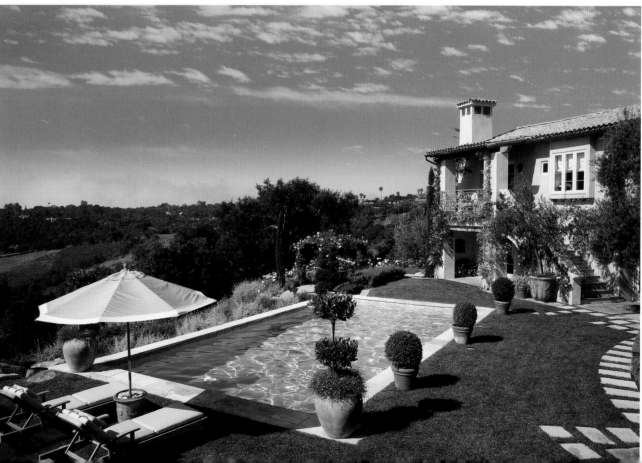

TOP RIGHT:
The challenge of creating private places with equal parts charm and warmth was overcome through collaboration between client and design-build team.
*Photograph by Jim Bartsch*

BOTTOM RIGHT:
Sited to take full advantage of early morning light and the sunsets, the house boasts landscaping that frames panoramic views.
*Photograph by Jim Bartsch*

FACING PAGE TOP:
The residents' collection of artifacts from the South of France provides the authentic feel of a French Mediterranean retreat.
*Photograph by Jim Bartsch*

FACING PAGE BOTTOM:
Architect Chris Dentzel, in conjunction with landscape architect Katie O'Reilly Rogers and Giffin & Crane General Contractors, created a French Mediterranean showcase that captures the clients' fond memories of southern France.
*Photograph by Jim Bartsch*

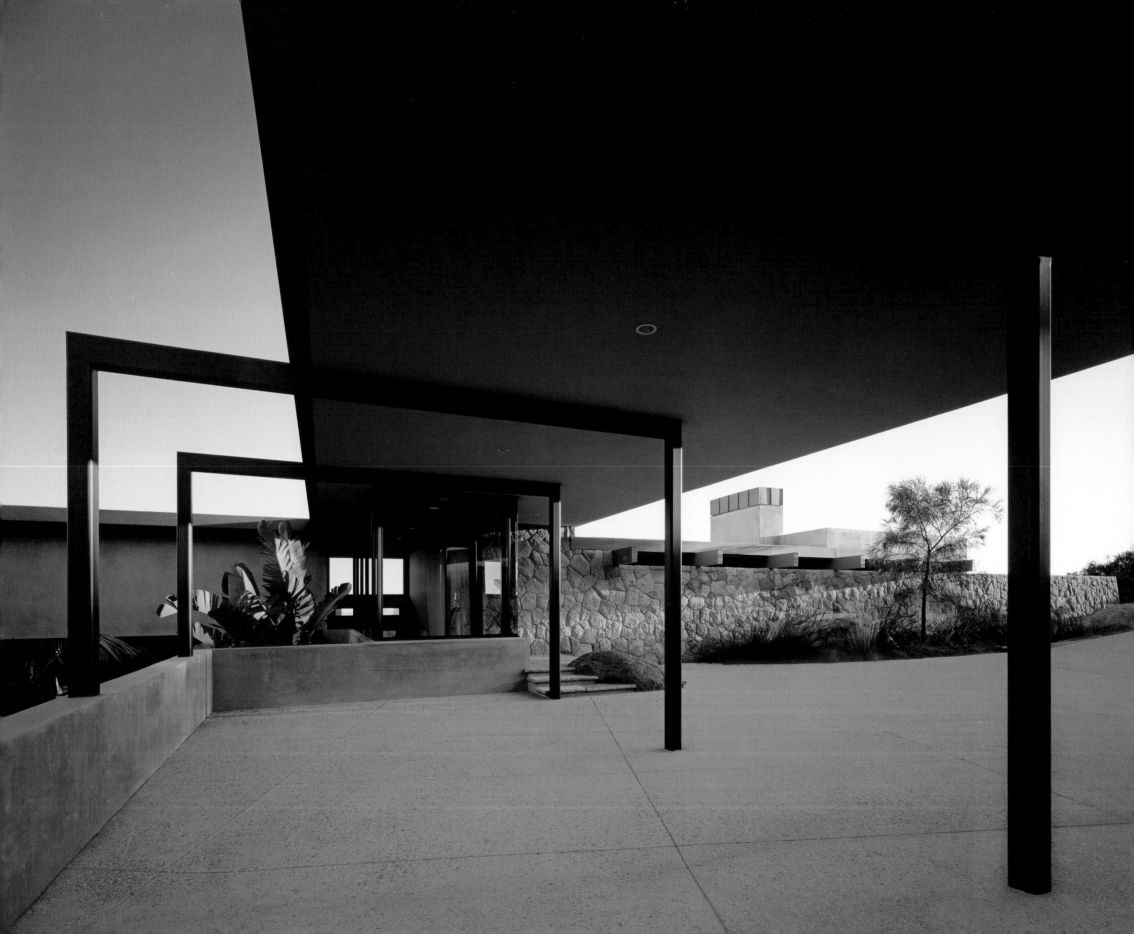

# DesignARC, Inc.

With offices in Los Angeles and Santa Barbara, DesignARC comprises 40 like-minded, progressive thinkers who share a genuine desire to research, learn and apply newfound knowledge to the project at hand. The company culture stresses egalitarianism and collaboration among colleagues, as well as a general willingness to seek and employ creative architectural solutions.

In the Santa Barbara office, projects are evenly divided between modern and traditional languages. The strong tradition of a Spanish-Revival architectural language in Santa Barbara is a consequence of its mild Mediterranean climate, the extant historical Spanish Mission and a unique moment in the city's history: the 1925 earthquake, which allowed a wholesale rebuilding of the city within the context of a nearly singular design language. "The employment of a Spanish-Revival language as a valid contemporary architecture suggests the necessity for heightened rigor and restraint," says

ABOVE:
Located in the arid foothills overlooking the Pacific Ocean and the city of Santa Barbara, this multilevel family compound was sited to take advantage of spectacular views. The living room expanse looks across a verdant valley and over the Channel Island Harbor to the ocean beyond.
*Photograph by Ciro Coelho*

FACING PAGE:
This modern house evinces a protective posture toward the street, presenting a battered stonewall as its principal face. The architectural experience begins with a simple and disciplined entry consisting of roof and steel spider-leg columns, and the house becomes progressively more transparent as one moves toward the living spaces—culminating in expansive views of ocean and harbor.
*Photograph by Ciro Coelho*

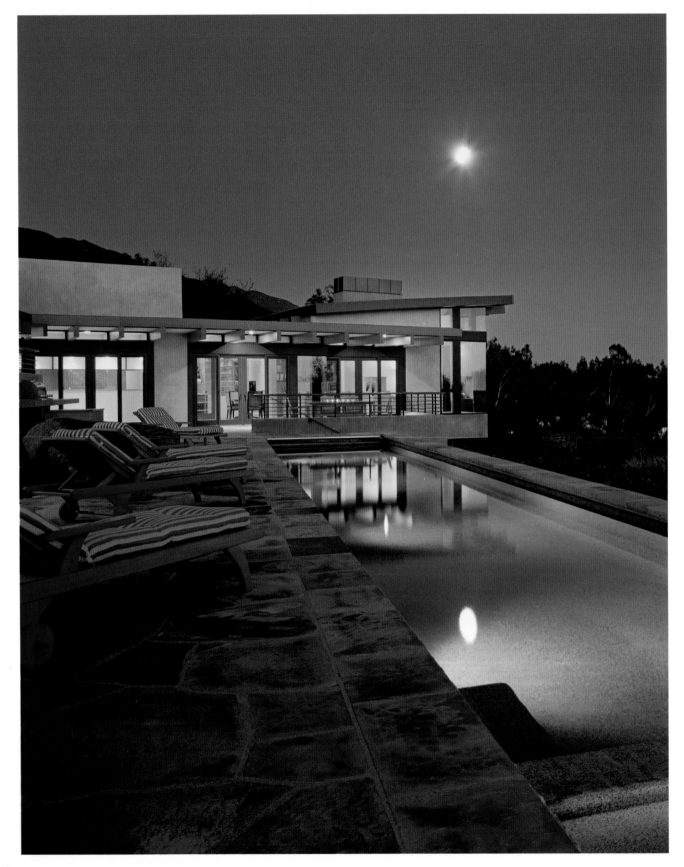

principal Mark Kirkhart. "For the work to retain its authenticity within this context requires an astute understanding of precedent, the graceful employment of proportion, and a close attention to texture and detail."

Nevertheless, many residential clients desire a contemporary approach to design, albeit one informed by Santa Barbara's rich history. The challenge of reconciling an aesthetic of the past with one of the present is mostly a function of careful study. Given the beauty of a place like Montecito, the natural inclination is to design large openings to capture the view. However, without large expanses of glass or mitered corners within the idiom of Spanish-Revival buildings, one must reinterpret the language to achieve an expansive view, not just create a large window.

Architectural design should not only respect the cultural climate, but must also respond to its physical environment. "Successful design solutions should underscore the sense of place," says Dion McCarthy,

LEFT:
In its stretch across the terrace, a lap pool visually, as well as emotionally, links the living rooms of both the main and guesthouse, creating a frame with these building wings in order to contain and understand the ocean to the south.
*Photograph by Ciro Coelho*

FACING PAGE LEFT:
As an addition to a historic Santa Barbara adobe home, a truncated oval wall defines the boundary at the lower level of this new art studio and guest quarters. Stone landscape terraces, built with material from the site, create a unified transition from the building to the steeply sloping hillside.
*Photograph by Russ Widstrand*

FACING PAGE RIGHT:
The upper-level art studio opens to an outdoor terrace, establishing a relationship with the hillside beyond and allowing outdoor work in the summer months. Materials include custom-tinted tile, hand-finished exposed concrete and an openly expressed wood ceiling.
*Photograph by Russ Widstrand*

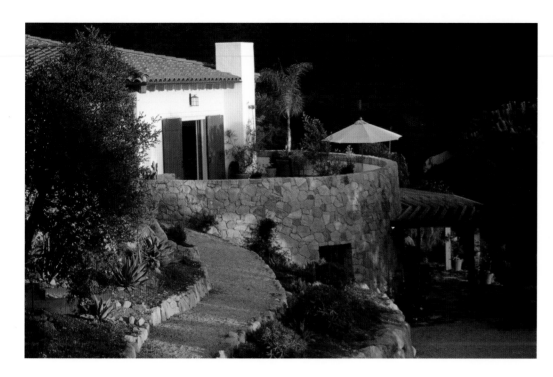

principal in the firm's Los Angeles office. "Our architectural work is always firmly rooted in an individual environment." To that end, the DesignARC architects begin each new project with a comprehensive exploration of the site, often visiting it on numerous occasions, during different seasons, and at various times of the day, to gain a thorough understanding of its unique qualities.

To date, the firm has received more than 30 design awards for Excellence in Architecture, including a 2003 Green Award for sustainable business practices. Although "sustainable" has become de rigeur, not only in architecture but also in our culture as a whole, the firm has long-embraced Green concepts. "We have been leaders in this area since the firm's inception," says founder Bruce Bartlett. "Being caretakers of the Earth's resources has been a goal of our office for quite some time." Having won a competition to design a natural resource center for Santa Barbara in 1980, the firm subsequently won a design award for the building after completion. The construction of that building cemented the architects' commitment to energy-efficient, environmentally sensitive, sustainable design.

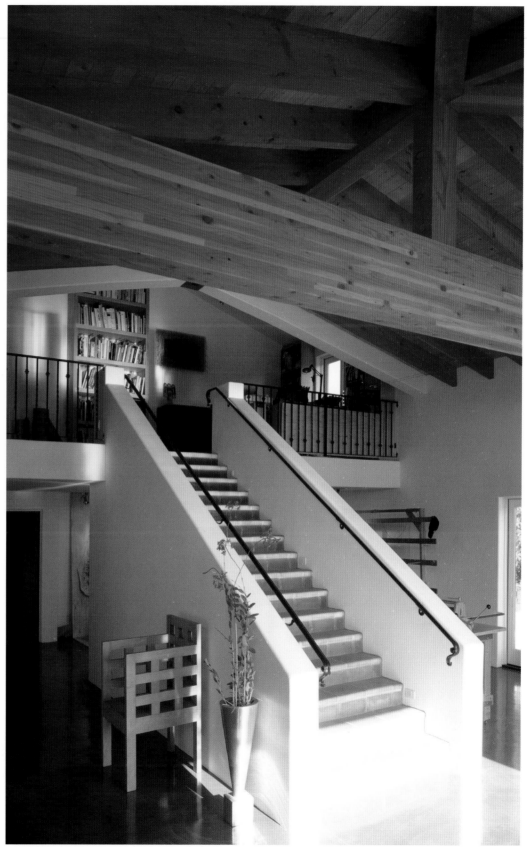

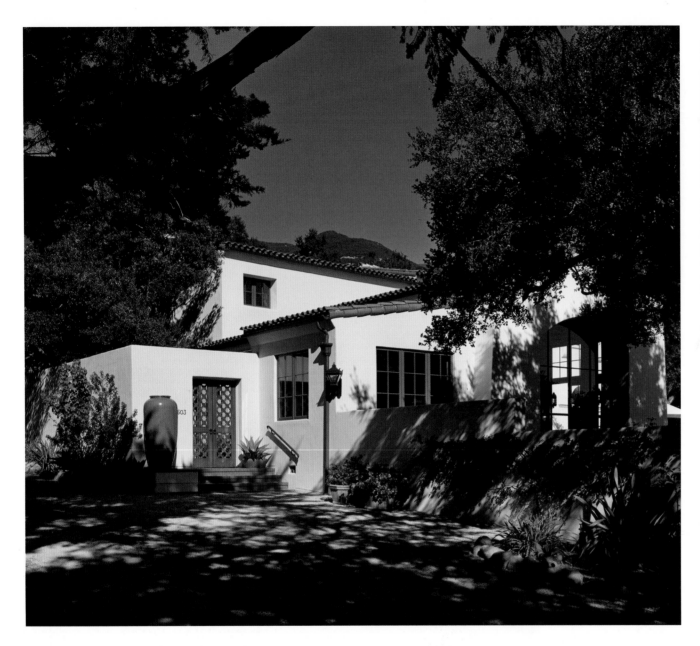

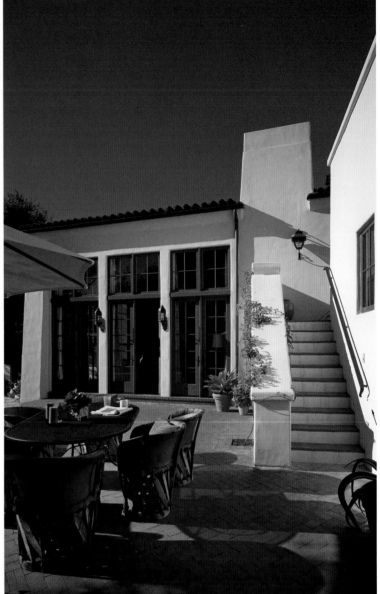

Creativity is the cornerstone of every DesignARC project. The architects and designers of the firm use their inventiveness to generate unique solutions that address the specific concerns of each project. With every design solution, success is achieved by approaching each project on its own merits, using innovative and proven sustainable technologies and believing that if you solve problems well, everything else takes care of itself.

ABOVE LEFT:
Tucked amidst a wooded glen in Montecito, this private residence takes its place among the graceful and genteel tradition of Santa Barbara architecture. The Spanish Revival architecture is characterized by its strong sense of mass, flat expanses of white stucco wall and deeply punctuated windows.
*Photograph by Ciro Coelho*

ABOVE RIGHT:
Elegant outdoor spaces become extensions of the inside, allowing all rooms to partake in a strong connection with the landscape. Tall glazed doorways link the living room with a sunny breakfast terrace, taking advantage of its Mediterranean climate.
*Photograph by Ciro Coelho*

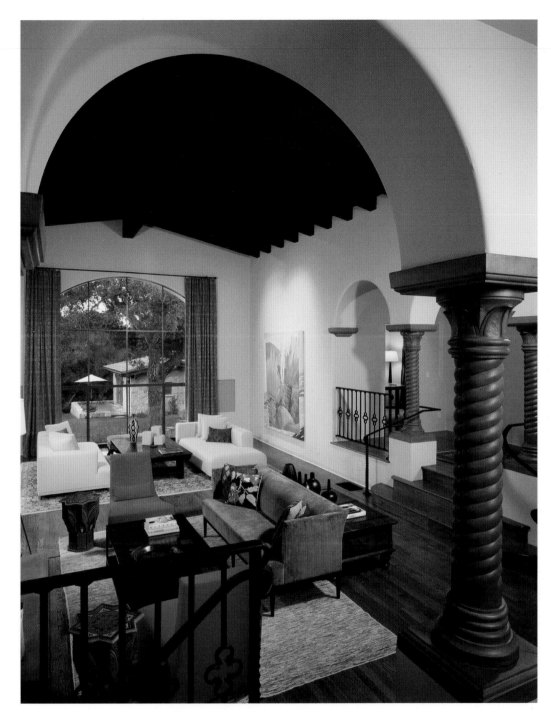

ABOVE LEFT:
An exercise in scale and proportion, the residence is imbued with classic detail and richness found in the Spanish Colonial architecture characteristic of George Washington Smith and others. Interior spaces are created through pure and varied geometric volumes and are elaborated by opened beamed ceilings, groin vaults and spiral columned arches.
*Photograph by Ciro Coelho*

ABOVE RIGHT:
With its reference to historical precedent, Spanish Revival architecture can be undeniably familiar, as well as tangibly rich. Considered sensitivity and pure spatial relationships combine in contemporary ways, showing that what is old can be new again.
*Photograph by Ciro Coelho*

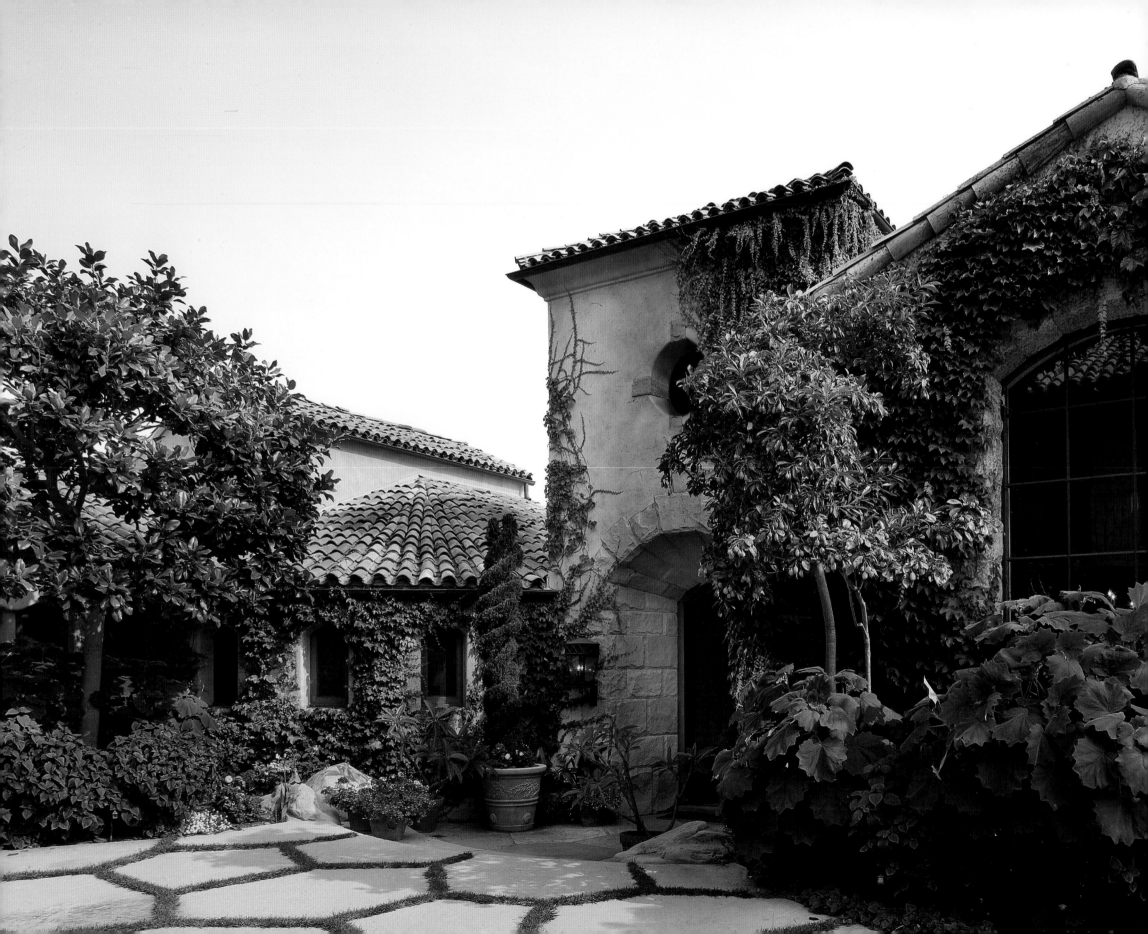

# Bob Easton

Bob Easton AIA Architect

ABOVE AND FACING PAGE:
Set high on a hill overlooking Montecito and the Pacific Ocean, this house was inspired by the residential architecture of Provence. The stone and plaster walls are draped with foliage and provide an intimate entrance to harmonize with the immense view that opens to the south.
*Photographs by Peter Malinowski*

Architectural form is determined by not only factors such as materials, technology and shelter from the elements, but by such intangibles as economics, beliefs, history and a society's social structure, writes Bob Easton, AIA, in his foreword to the book *Mediterranean Design*. These intangibles, including local traditions, determine architectural form more significantly than the tangibles. Designing with these factors in mind yields a multidimensioned architecture that resonates with community and landscape. And that is something that is very important to Bob, who specializes in fine residential and commercial design and interiors.

A native Californian, Bob relocated to Santa Barbara from the northern part of the state about 40 years ago—a move that he says changed his views and began his architectural liberation. Today, with offices in the Old Firehouse in the Upper Montecito Village near Santa Barbara, the 12-person firm of Bob Easton AIA Architect has designed projects in the most desirable areas of California and Arizona.

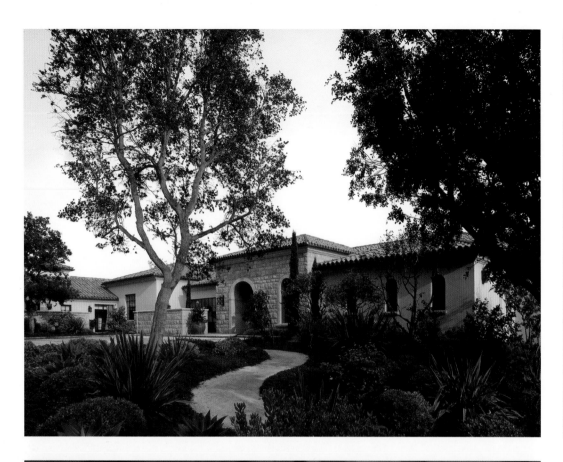

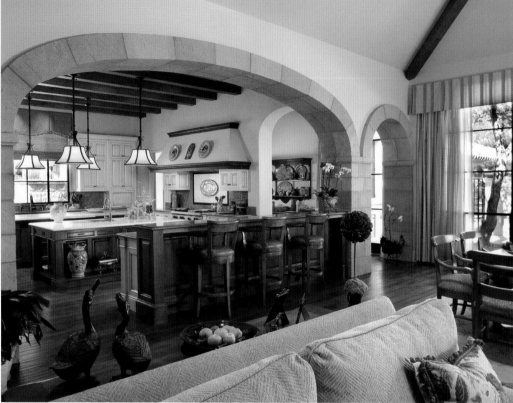

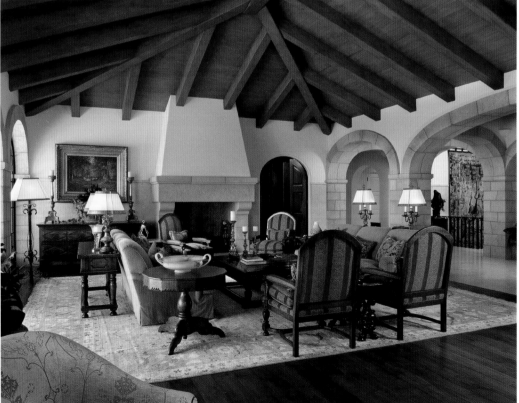

Like many architects of his generation, Bob was trained as a modernist. He studied with the famed Charles Moore, who introduced him to the idea of combining contemporary architecture with traditional architecture. And though Bob did not practice postmodernism, he did like the idea of combining the best of contemporary and traditional design. Uniting the openness of modern buildings with the familiar warmth and imagery of traditional spaces is a platform from which he continues to work.

TOP LEFT:
In the foothills of Montecito, this Mediterranean villa commands a view to the ocean and Channel Islands beyond. The entrance structure with its stone façade suggests a previous existence as on old olive mill. The property has many old olive trees as commercial orchards lined the Montecito foothills in the past.
*Photograph by Peter Malinowski*

TOP RIGHT:
Separated by a bar under the arch, the kitchen with double islands can be seen from the family room.
*Photograph by Peter Malinowski*

LEFT:
The living room is adjacent to an arched stone gallery and an entrance foyer beyond. A tapestry hangs in the stairway that leads to a lower floor with media room, wine cellar, playroom and gym.
*Photograph by Peter Malinowski*

FACING PAGE:
The house has arched stone loggias and an arched outdoor room.
*Photograph by Peter Malinowski*

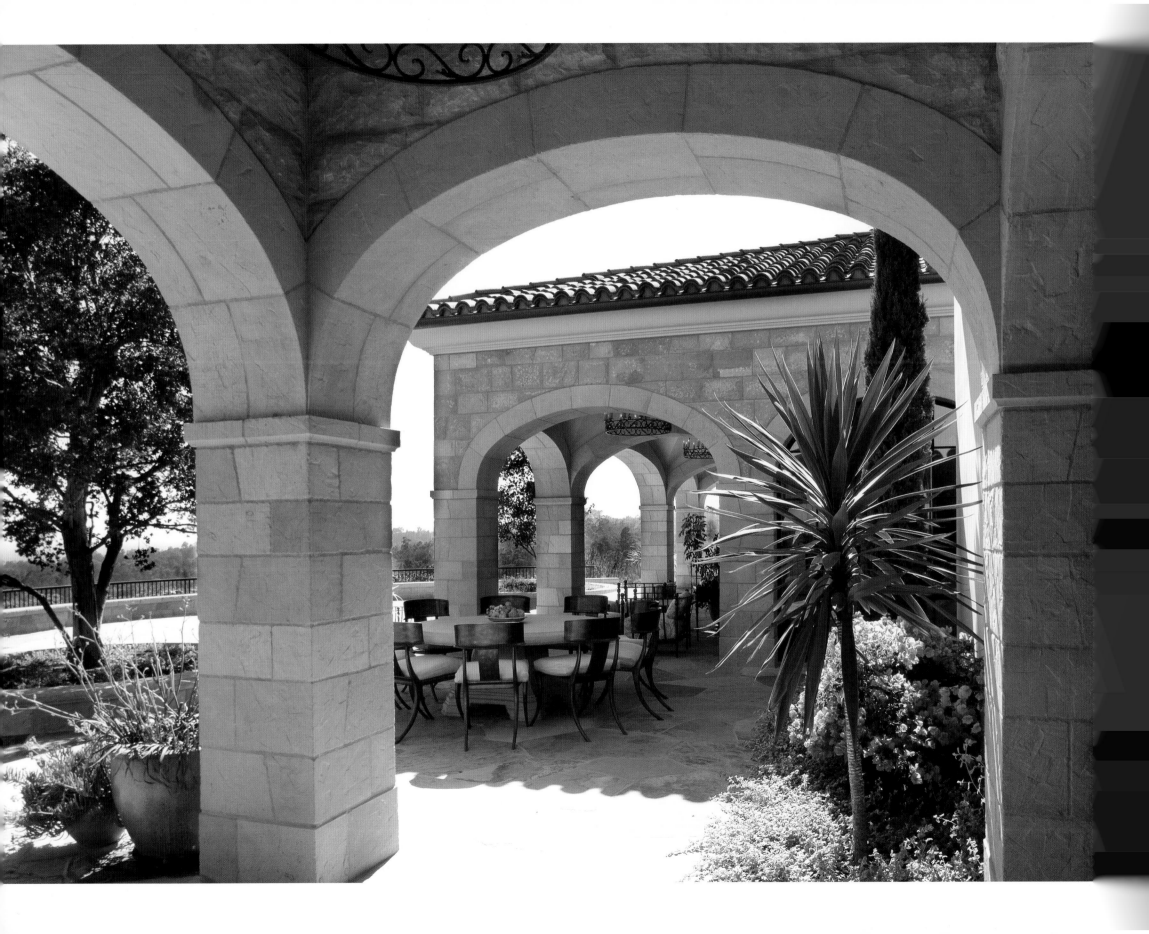

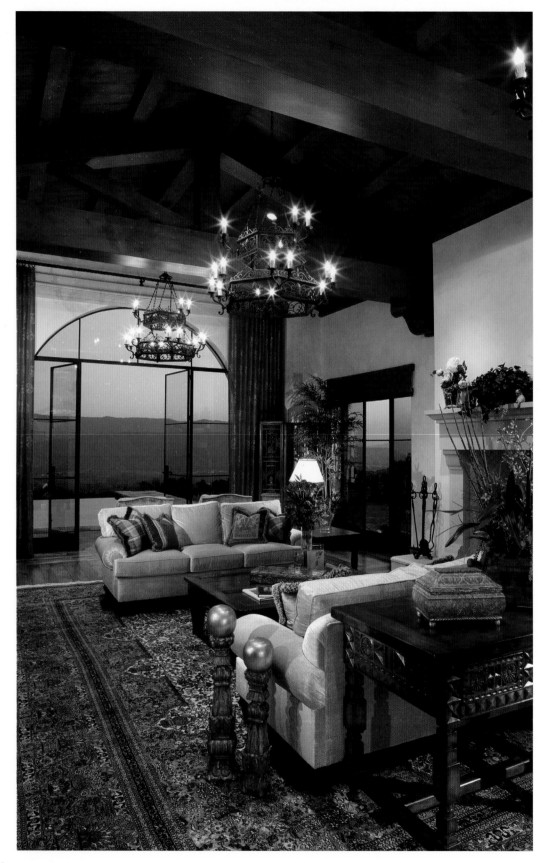

Bob designs in many styles. Traditional, contemporary or somewhere in between, the principles of good design—such as planning, form, proportion, materials and color, to name a few—can be realized in any style. And regardless of genre, he designs with a certain basic principle: to create a floorplan of rooms.

However obvious that might sound, it is not as simple as it seems. Modern architecture is very spatially oriented, Bob explains, which when applied to residential projects can be unsettling. Space and rooms are very different things. Space can be abstract; rooms, on the other hand, are the life and spirit of architecture. Rooms are what make a home comfortable; rooms are where we sit,

ABOVE:
This Spanish Colonial Revival house in Ojai surrounds an entrance courtyard. A majestic old oak is the centerpiece of the space.
*Photograph by Peter Malinowski*

LEFT:
Massive timber trusses and iron doors in the living room open to a view across an infinity pool to the valley beyond.
*Photograph by Peter Malinowski*

FACING PAGE:
Custom-made decorative tile arches, wainscots and an inlaid floor give Spanish character to the master bathroom.
*Photograph by Peter Malinowski*

where we repose, where we entertain friends and family. Flowing spaces can lack the qualities that make them restful or regenerative. Of course, the rooms must connect and flow, but in Bob's houses, when you are in the room you are decidedly in the room—something that is missing in a lot of modern architecture.

Appropriateness is also often absent in more modern buildings, and the architect delights in creating something that is well suited to a certain place. He rejects the belief that the only valid architecture is that which is forging the future, that the only legitimate architectural expressions have to be exploratory in nature. That is not to say that his designs are not current. To the contrary: Bob is a pioneer in integrating past and future. Blending old and new in a meaningful way is a justifiable approach to charting fresh territory. Not only that, it also produces a more holistic architecture that is more inclusive of more elements of culture.

Santa Barbara is the perfect place for Bob to practice his innovative brand of design. He loves living in a city that respects history and community. The area is fertile ground for people who are culturally aware and for clients who want homes that are harmonious with the environment. For the most part, residents want highly tailored houses that respect the environment and the neighbors. And that suits this architect just fine.

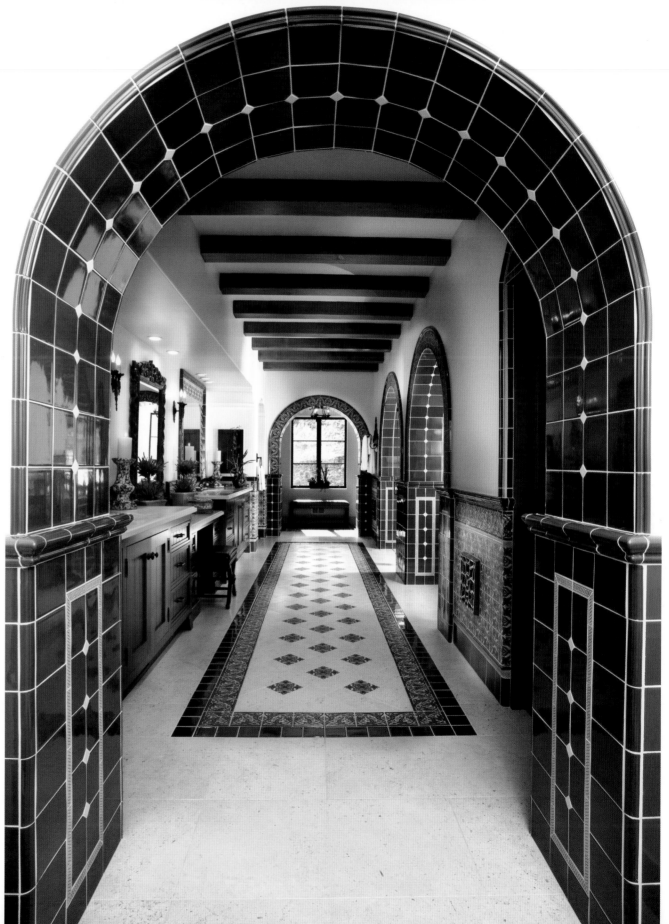

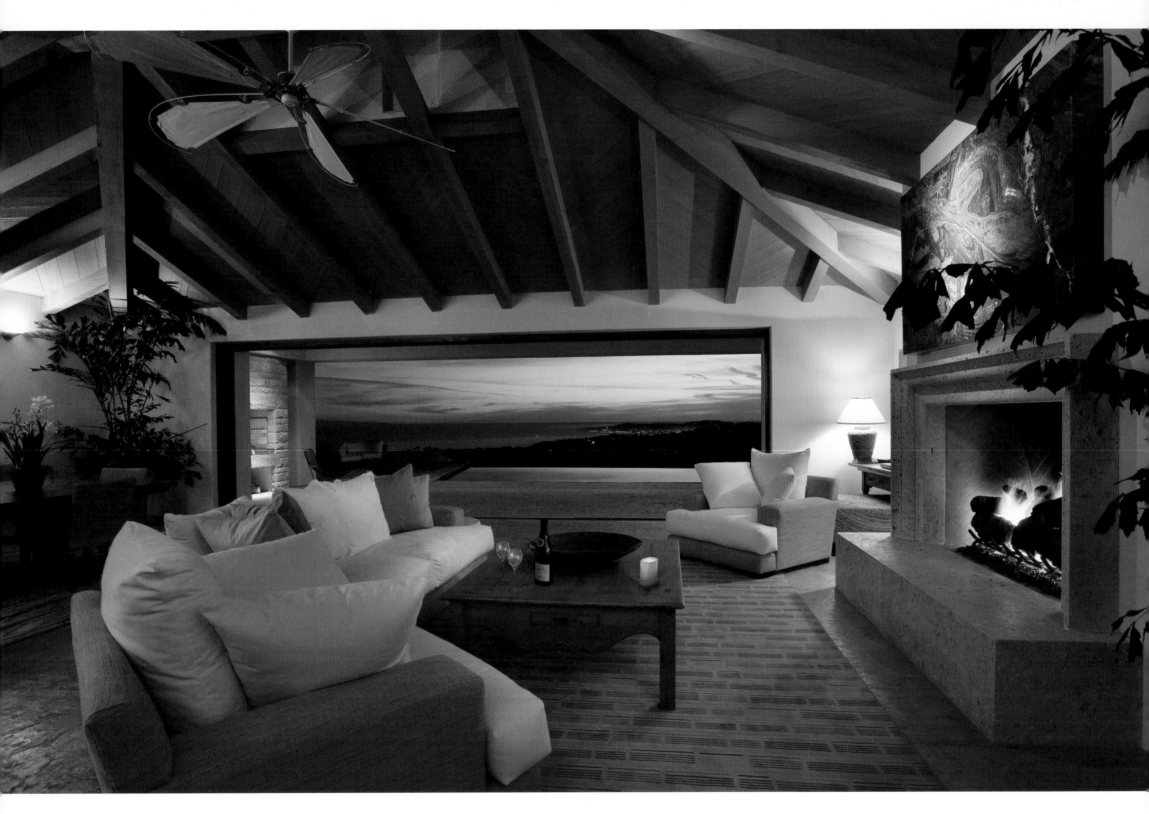

ABOVE:
This contemporary house at the eastern side of Montecito looks across an endless infinity pool to the lights of Santa Barbara in the distance. Sliding doors that pocket in the side walls create an opening to visually link the living room, pool and view.
*Photograph by Jim Bartsch*

Bob decided at the age of 8 that he wanted to become an architect. His great-grandfather was from Edinburgh, Scotland, and immigrated to San Francisco in the 1830s, where he owned and operated the largest cabinet and interior finishing factory during and after the Gold Rush. And though his father wanted Bob to follow in his footsteps in the sporting goods business, Bob began to pursue his dream even in high school, working with architects in Los Angeles and Hawaii before attending architecture school at the University of California at Berkeley and then the Architectural Association School of Architecture in London.

In addition to designing many great buildings in his more than four decades as an architect, Bob has also co-authored and designed several books, including *Domebook One* and *Domebook Two* (both out of print), *Shelter*, *Native American Architecture* (which won a number of awards) and *Santa Barbara Architecture*.

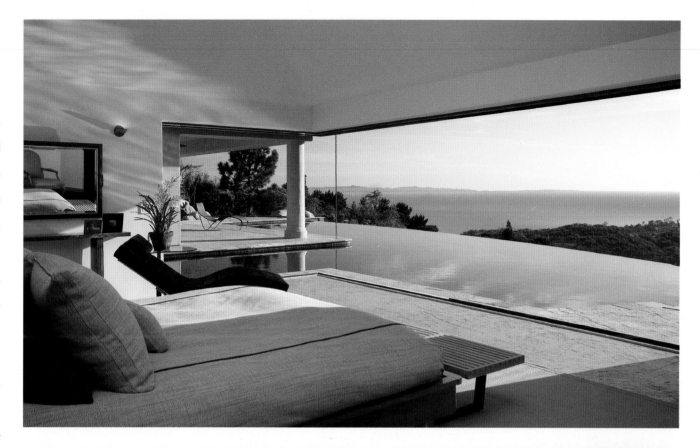

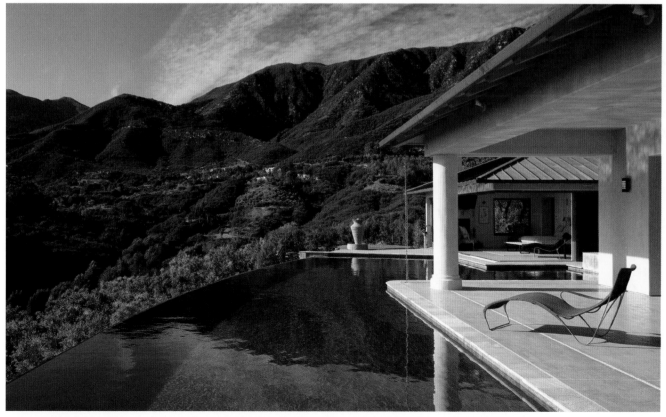

TOP RIGHT:
A master bedroom corner has doors that slide back along the edges of the pool with the ocean and Channel Islands beyond.
*Photograph by Jim Bartsch*

BOTTOM RIGHT:
The infinity edge wraps around to connect the house to the mountains as well as the ocean.
*Photograph by Jim Bartsch*

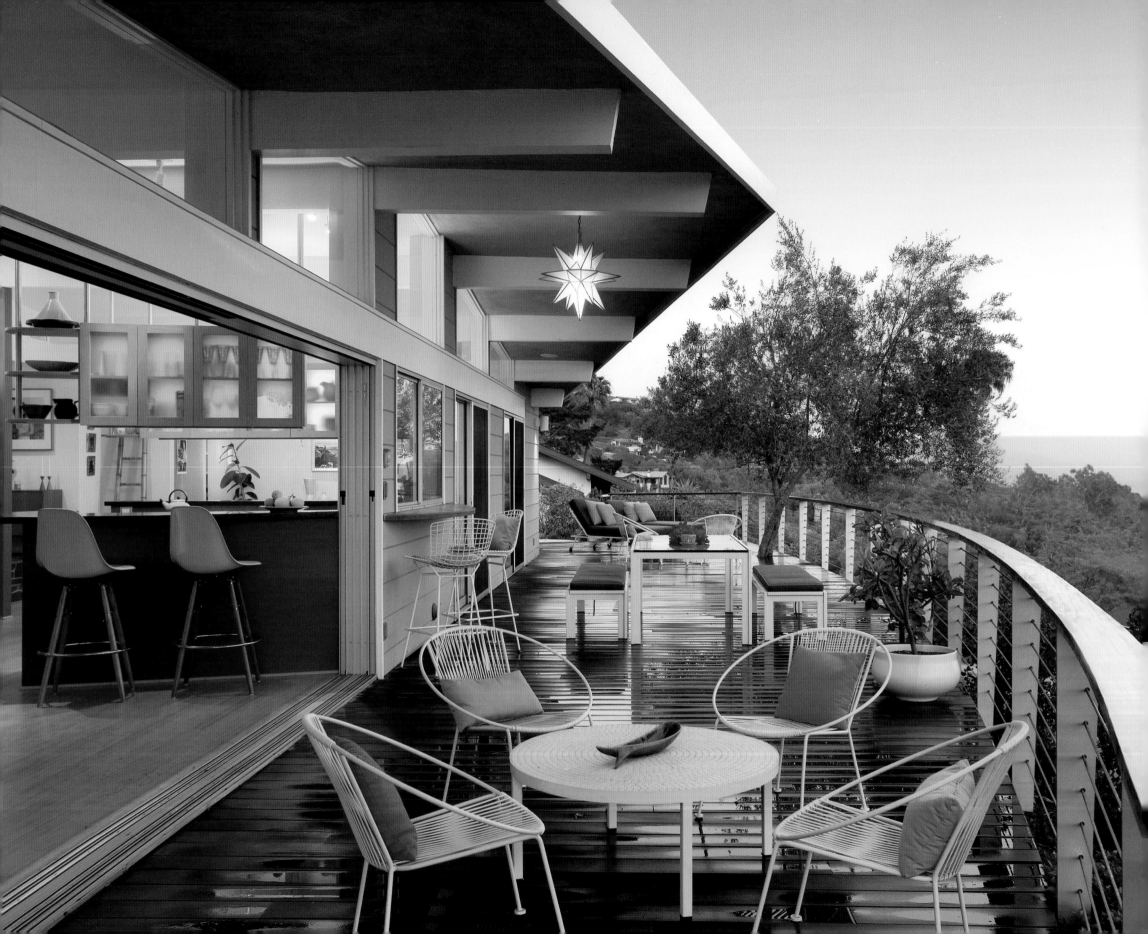

# CASSANDRA ENSBERG
# TOM JACOBS

Ensberg Jacobs Design

A thing of beauty is a joy forever. John Keats first wrote it. Cassandra Ensberg, AIA, and Tom Jacobs, AIA, principals at Ensberg Jacobs Design, live it. Those eight little words are the guiding precept behind all of their work.

The two met in 1989 at the Santa Barbara Museum of Art, where both were attending a lecture by a well-known landscape architect. Mutual interest, shared passions and professional chemistry were immediately apparent and the pair began working together, opening their design office in 1996. Today, they work as a team to bring beauty and ease into their clients' everyday lives.

Motivated by neither fad nor fashion, Cass and Tom create timeless buildings grounded in classic architectural principles. Similarly, their work is not defined by any one particular style; instead they work using a variety of motifs, always with an acute sense of composition, balance and contrast.

ABOVE:
Interlocking forms and bold colors guide the eye thru the atrium entry to the carport beyond. The niche artwork is by Channing Peake; the cat portrait, a Paris flea market treasure.
*Photograph by Jim Bartsch*

FACING PAGE:
The owner's vision when she purchased this existing house "with potential" was to transform it into her 1950s' dream home inspired by the work of the great modernist architects of the 20th century.
*Photograph by Jim Bartsch*

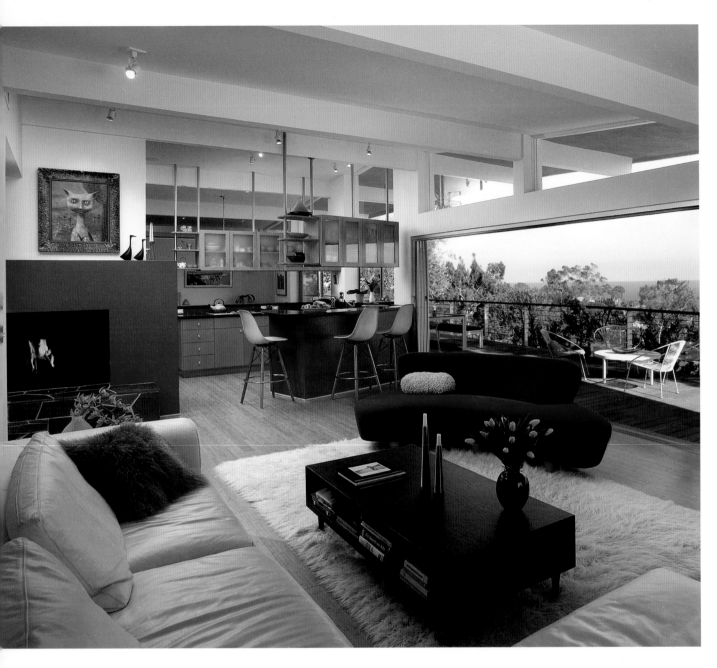

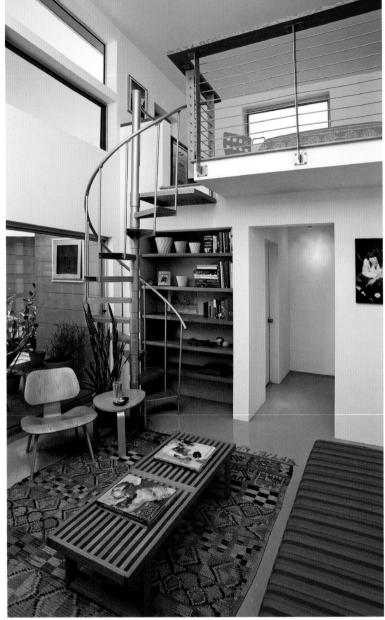

Though they might do one or two new houses each year, most of their work comprises remodels, a particularly challenging

genre of architecture that often requires the undoing of past mistakes and a deft hand to bring out the best in an existing

structure. The architects delight in lifting a house from lacking to lovely or transforming a problematic area into something

functional and practical. Likewise, most of the projects they take on are relatively small, and Cass and Tom encourage their

clients to keep them so. One way they do this is to give as much attention to outdoor spaces as to those inside, or, as Cass

likes to say, "The smaller the footprint, the larger the garden."

ABOVE LEFT:
Expansive ocean-facing living spaces with sliding glass doors merge the indoors
with the boat-shaped Ipe wood deck and spectacular Santa Barbara Riviera views.
*Photograph by Jim Bartsch*

ABOVE RIGHT:
The art studio and loft addition to the classic 1950s' carport opens onto the master
bedroom side yard patio and stunning ocean views.
*Photograph by Jim Bartsch*

Not a day passes that Cass and Tom are not out in their own garden. And as avid gardeners, they incorporate an indoor-outdoor aspect to every one of their architectural projects. They see themselves as coaches whose job it is to remind their clients to embrace outdoor spaces rather than enclosing them. They see gardens and landscaping as true extensions of their houses and try to create an analogous outdoor room for every indoor room, enabling the homeowners greater access to time outdoors with nature. They also bring the outside in with natural light, air flow and materials to create a seamless connection between indoor and outdoor worlds.

And though it might go without saying, it is worth noting that all of their designs are based around their clients' wishes. The architects' premier strength is their ability to listen and interpret those needs in a way that not only works but wows and inspires—and is a joy forever.

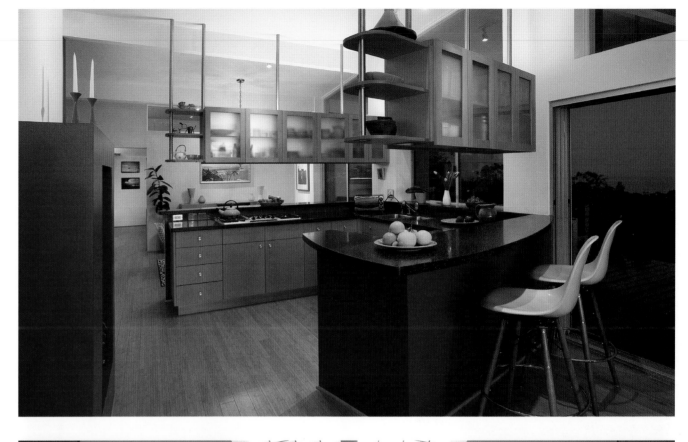

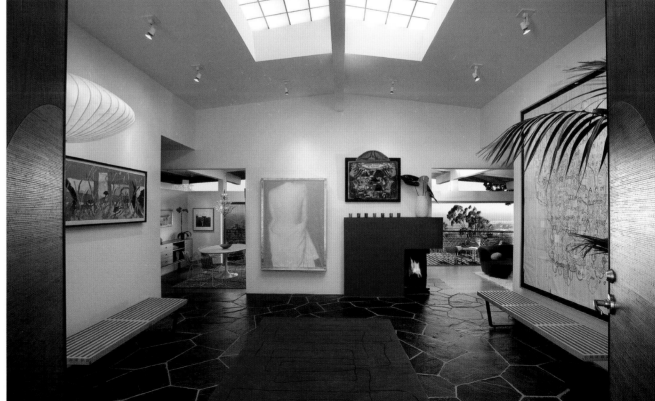

TOP RIGHT:
Bamboo flooring, maple cabinets and the solid plastic top reflect 1950s' materials and contribute to the rich color palette of the open kitchen and dining room beyond.
*Photograph by Jim Bartsch*

BOTTOM RIGHT:
Classic foyer design includes sculptural forms and surfaces, doors, a skylight, slate floors and Eames furniture. Artwork, from the left, is by John Jacobus, Jill Martin and Graham Gillmore.
*Photograph by Jim Bartsch*

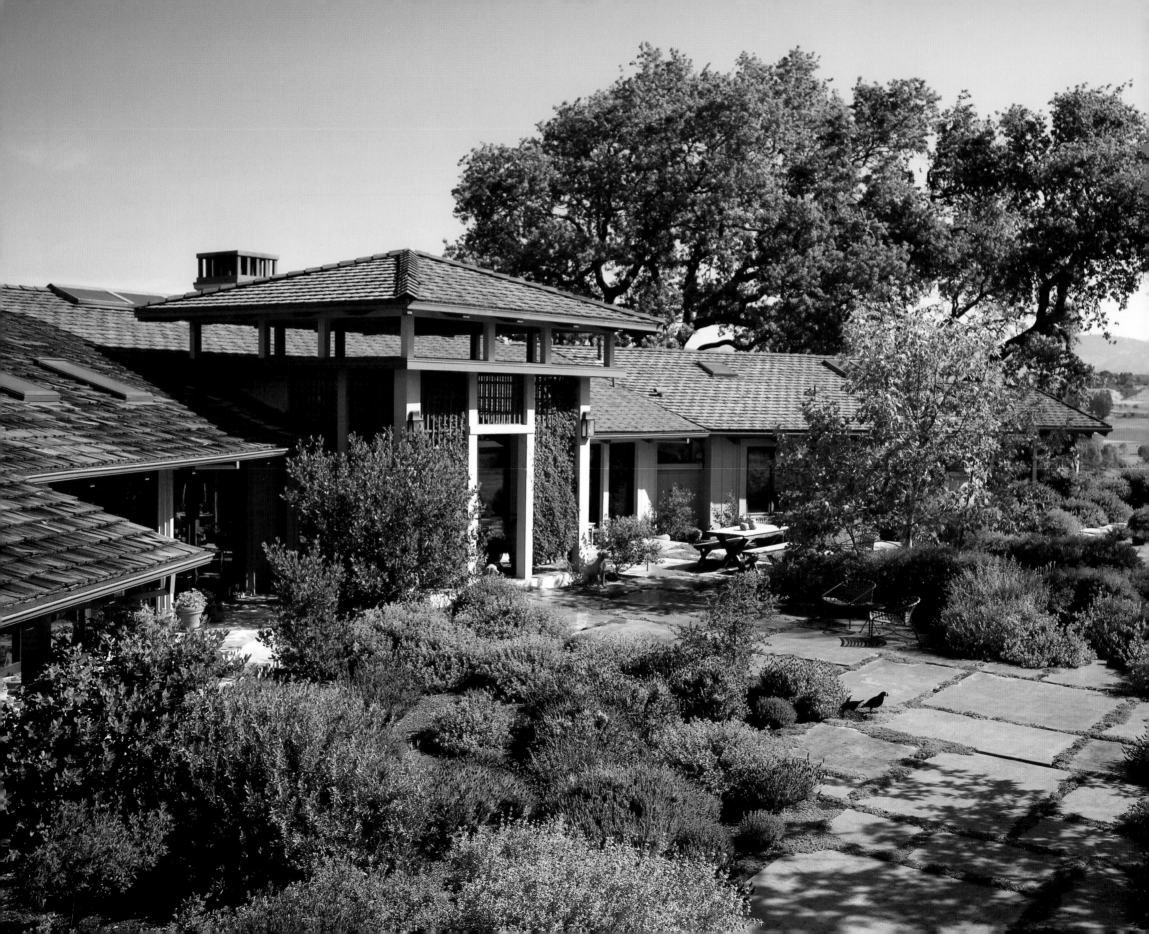

# PAUL GRAY
# MARTHA A. GRAY
# WILLIAM H. GRAY

Gray and Gray Architects, LLP

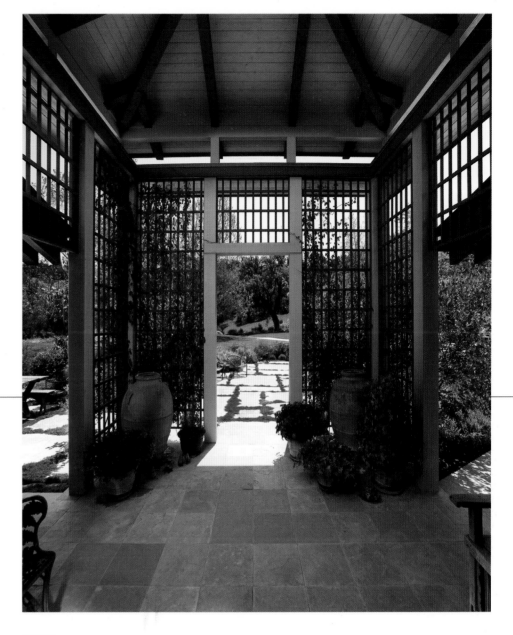

I n many applications and among numerous cultures, the number three holds a certain symbolism and significance. It is a pleasing and powerful number, and when clients go to Gray and Gray Architects in Montecito that is just what they get: a trio of architectural design talents dedicated to creating custom contemporary residences.

Though they are open to most any style, Paul Gray, AIA; Martha Gray, AIA; and Will Gray lean to the contemporary. However, their designs have a slant that is uniquely theirs and it could be said that their style defies definition: The architects like to take a vernacular form and reinterpret it in a contemporary way, so that the result is neither very traditional nor extremely modern.

ABOVE:
Vine-covered laths enclose the entry pavilion and create an outdoor room sheltered from prevailing winds, sun and rain while announcing the new entry.
*Photograph by Jim Bartsch*

FACING PAGE:
A remodel and addition in the Santa Ynez Valley includes a vertical entry tower that breaks the horizontal linearity of the existing residence.
*Photograph by Jim Bartsch*

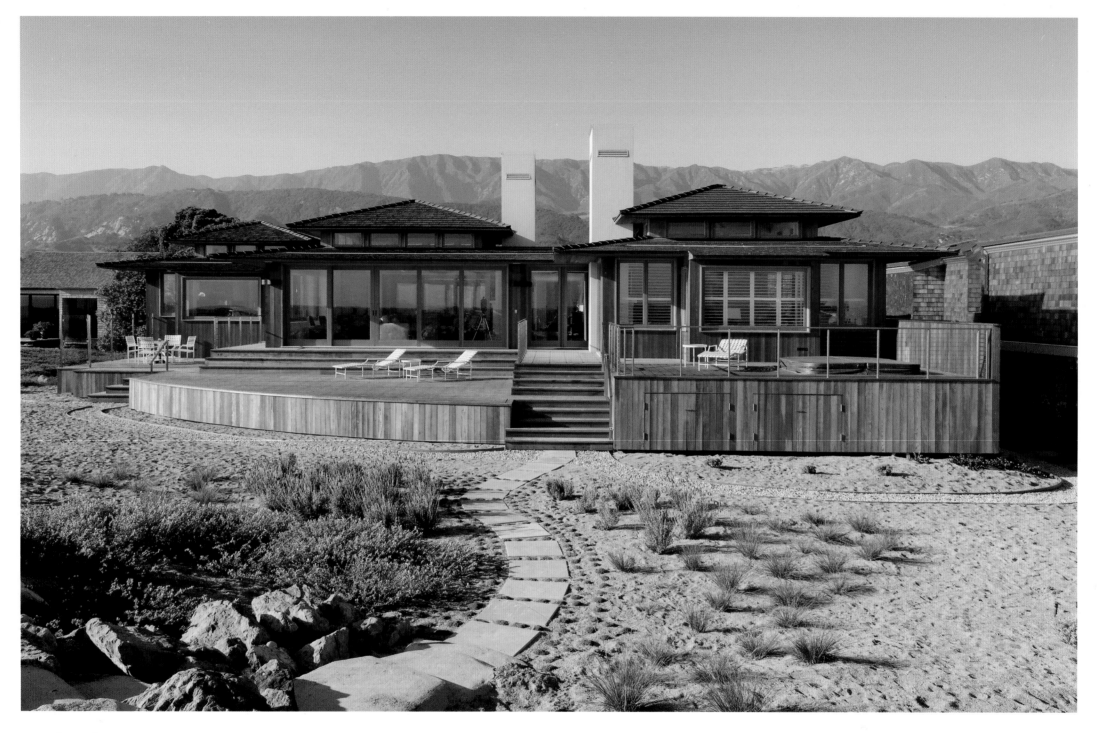

Regardless of genre, the houses that Gray and Gray designs are often a collaborative effort between the family members who rely on one another in all aspects of the design of the residences. They work hard to get to know their clients and the relationship of the proposed design to the site, taking care to capitalize on the natural brilliance of the latter. This means catering to the view, whether ocean or mountain, and manipulating light to affect the people inhabiting the spaces.

The architects are always open to new ideas and materials and pride themselves on taking chances and drawing their inspiration from unusual places. Recently they took their cue for a remodeling job in the Santa Ynez Valley from an old photograph of a water tower, indigenous to that area. The resulting lath house-style entrance does not look like the image, but it does have its origins there, and the owners absolutely love it. It is that kind of creativity that really

drives Paul, Martha and Will, whose simple, elegant designs have just the right amount of drama.

Gray and Gray was formed in 1999 when Martha and Paul parted with Warner and Gray Architects. Paul, a former partner of that firm for 27 years, also served on several of the area's Boards of Architectural Review; Martha, who earned her master's at the UCLA Graduate School of Architecture, had joined the firm in 1989. Realizing it was time for a change, the father-daughter team struck out on their own, welcoming son and brother Will, a graduate of the University of Southern California, to the practice in 2000. Their shared interest in inspiring architecture has become the common bond that has led the firm to its current success.

TOP RIGHT:
Large wood sliding pocket doors open all areas of the house to the central courtyard, with views of the ocean and mountains, while providing protection from prevailing ocean winds.
*Photograph by Macduff Everton*

BOTTOM RIGHT:
Early morning light washes the vertical cedar siding of the north elevation. The clerestory windows and hip roofed pavilions frame the entry and have views of the salt marsh and coastal range.
*Photograph by James Chen*

FACING PAGE:
Pavilions with clerestory windows and hip roofs set the fundamental style of this beach house. Large wood sliding doors open to two levels of decks and views of the Pacific Ocean, mountains and a salt marsh.
*Photograph by James Chen*

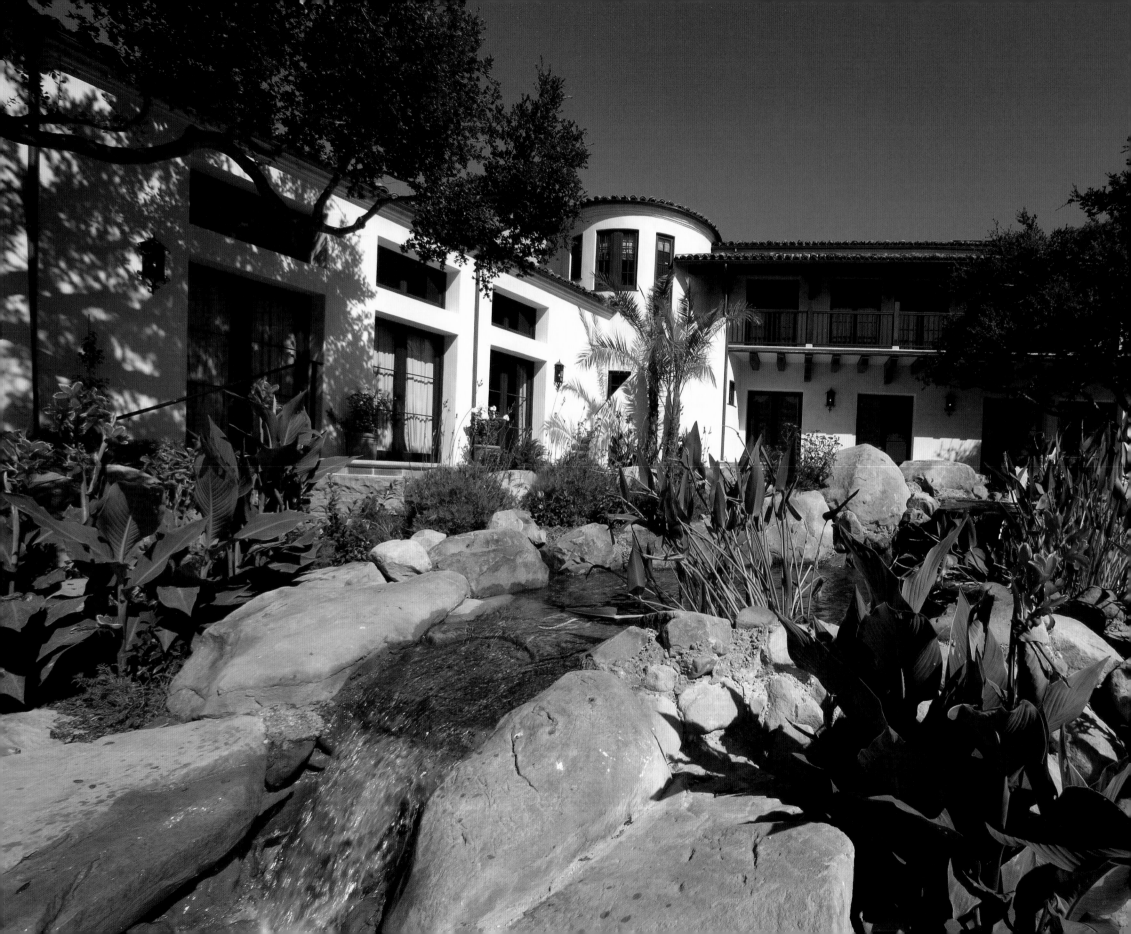

# WILLIAM H. HARRISON
# ANTHONY P. SPANN
# GREGORY L. PALMER

Harrison Design Associates

Sketching with his pencil at every opportunity, William "Bill" Harrison fell in love with art and architecture at the tender age of 12. An ambitious young man during his high school years, Bill gleaned his basic training in the field of architecture while apprenticing for a Macon, Georgia, architectural firm under the tutelage of Henry Dixon. It was this positive, early work experience that inspired him to turn a boyhood dream into reality.

Earning his degree in architecture from Georgia Institute of Technology, Bill subsequently opened his first design-build company in Atlanta, Georgia, in 1978. After 13 years of practicing the art of home designing and building, he then founded his own architectural firm, Harrison Design Associates, in 1991.

Today, with a hand-picked design team of more than 80 architects and designers, the company has strategically attracted the finest talent—from the United States and many foreign countries—who are prepared to plan, design and build fine residences and commercial projects for people

LEFT:
French doors, strategically placed windows and a series of terraces and loggias encourage outdoor living and maximize breathtaking views of the mountains and Pacific Ocean. Flourishing gardens with a cascading fountain of natural stone further complement the setting.
*Photograph by Franco Rossi*

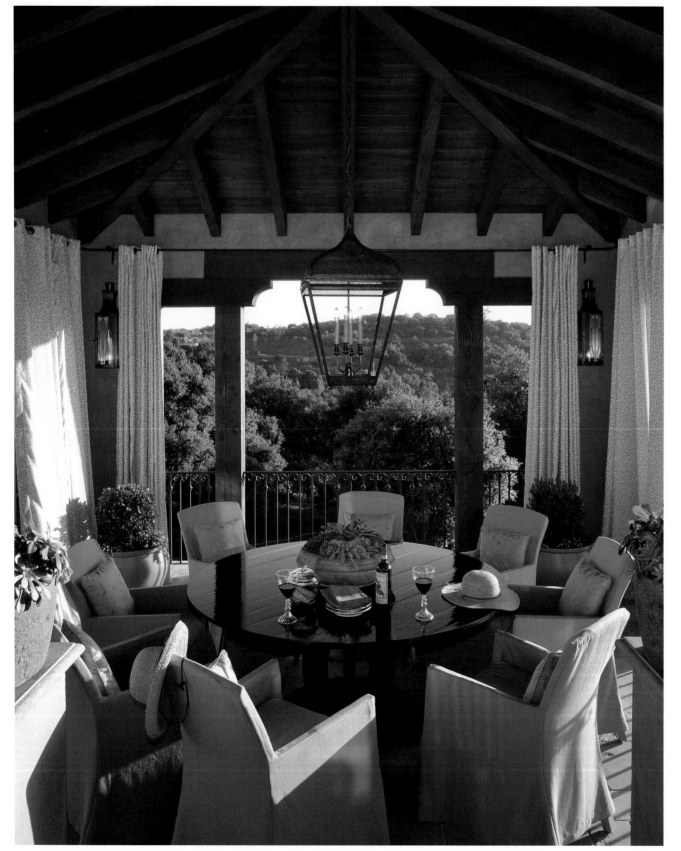

throughout the state of California. Harrison Design Associates has offices in Santa Barbara and Beverly Hills, California, as well as Atlanta and St. Simons Island, Georgia. Principals and veteran architects Tony Spann and Greg Palmer are the managing partners for the West and East Coasts, respectively. This well-built, innovative firm composed of individual operational studios works on architectural design projects throughout the contiguous United States and in several countries around the world.

The firm refers to its structure as a "we" team, knowing it takes quality individuals working in unison to run a successful organization. Above and beyond the architectural team and its residential and commercial projects are the many community organizations that the firm is dedicated to serving along the coast of California.

Giving back to the community is of utmost importance. From historical preservation of buildings and support for botanical gardens, to exacting renovation, beautiful, integrative additions and new structures, Harrison Design Associates is adding to the social and cultural tapestry of California, enriching people living in or near their award-winning designs.

LEFT:
Warm materials of wood, stucco and stone, unique details such as the timber ceiling and carved beams, and soft fabric panels create a terrace as luxurious and dreamy as the view it offers.
*Photograph by Jim Bartsch*

FACING PAGE LEFT:
The main stairway of this Mediterranean estate is a thoughtful composition of fine details—a curvilinear design, French limestone, wrought iron pickets, a brass railing and a three-radius plaster archway.
*Photograph by Eric Scott*

FACING PAGE RIGHT:
The gazebo's custom canopy of iron leaves and branches elegantly frames a view of the house from the backyard. The home's prevailing architectural style is a blend of Spanish and North African influences inspired heavily by the works of famed architect Addison Mizner. The exterior walls are composed of rough-textured stucco with a rusticated base of buff-colored Indiana limestone.
*Photograph by John Umberger*

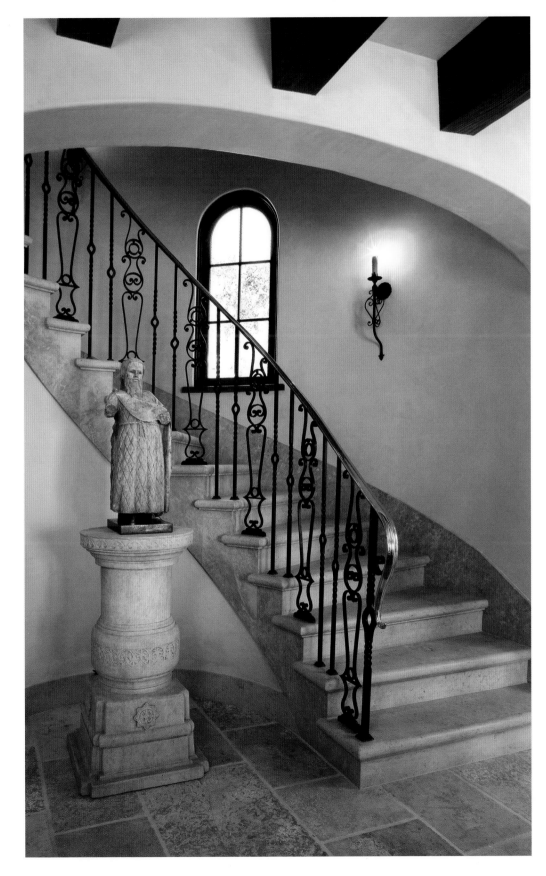

Harrison Design Associates has the rare luxury of drawing on the large firm's collective expertise and vast resources, incorporating quality construction methodology, historic knowledge, an affinity for genuine materials with old-world craftsmanship utilizing contemporary artisans to bring a dream home to life. Whether the firm is designing a 1,200-square-foot cottage, a sprawling 30,000-square-foot estate or an 800-square-foot porch addition, the commitment to excellence is consistent.

From private residences for prominent executives, professional athletes, entertainment moguls and real estate developers, to ecclesiastic and specialty commercial projects, the team strives to fulfill the dream of each and every client. It is a very personal experience and an honor to help each client plan, design and create a home to reflect his or her given lifestyle within the context of community. Moreover, quality architectural designs add to the social fabric of a community and offer something lasting for people to appreciate, giving them enjoyment, enlightenment and a sense of well-being and security.

Understanding that traveling to see original works in their native setting generates more authentic design inspiration than the most disciplined study of books and photography, the firm's leadership is committed to providing architectural tour experiences for professional staff prior to beginning intricate projects. As a result, the architectural team takes into

RIGHT:
The home's dramatic central hallway serves as an opulent gallery for selected works from the owner's vast collection of original art.
*Photograph by Deborah Whitlaw*

FACING PAGE:
Notes of extra elegance were reserved for the private side of this lush English manor-style house, where the rear façade has triple gables, side porches and wooden pergolas supported by Tuscan columns. The center covered porch introduces the curving lines of the Regency Period, evident in the openwork iron and copper trellis. Tennessee fieldstone and Kentucky limestone blend beautifully to create a subtle mosaic of muted blue-gray and brown.
*Photograph by Boutchine Studios*

careful consideration the environment and site selection, contextually integrating the architectural design.

The fundamental goal of each project is not only to interpret the clients' vision, but also to surpass what they can imagine. Creating the ultimate home and designing beyond expectations means working efficiently and using inventiveness, intelligence and analytical thinking.

Altogether, it is an exhilarating experience to use knowledge and ability, coupled with problem-solving skills and creativity, to develop an original design. It is this passionate spirit that lives and breathes in the firm every day. The diverse architectural team can design and build homes in a variety of styles borrowing from the classical past with an eye to the future, all the while building a reputation clients appreciate. This dynamic group strives to deliver the highest quality in all that they do and has the added benefit of drawing upon the partners and senior architects for their valuable expertise. Having a unique organizational structure, the architects and designers literally run their individual studios and serve clients directly under the umbrella of the firm allowing them to truly "own" each project from start to finish. In fact, the highest compliment has been from real estate professionals who affirm that the company has "raised the bar" for everyone working in the architecture and design industry. For more than 15 years, it is this professional respect and trust factor that wins Harrison Design Associates a loyal following.

RIGHT:
Solid Rouge de Roi columns with gilded Ionic capitals encircle the home's entry vestibule. From the entry, the view into the dining room features the room's antique Italian fireplace's surround and chandelier, gilded columns and shallow domed ceiling.
*Photograph by John Umberger*

FACING PAGE:
The front façade of this Beaux-Arts estate features 10 solid-shaft Indiana limestone columns, along with six pilasters, to support the ornately carved pediment and cornice of the covered front porch.
*Photograph by John Umberger*

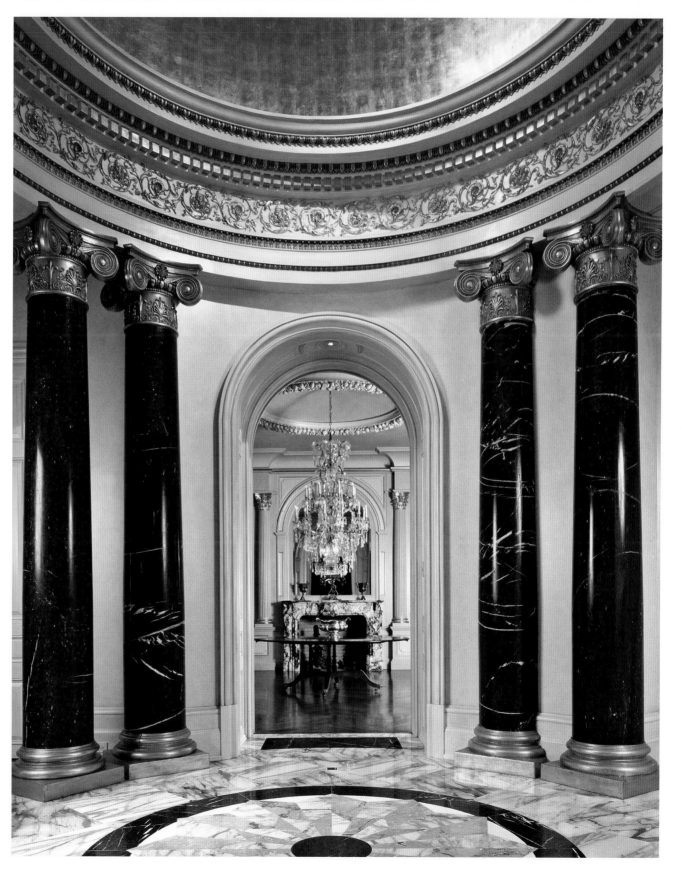

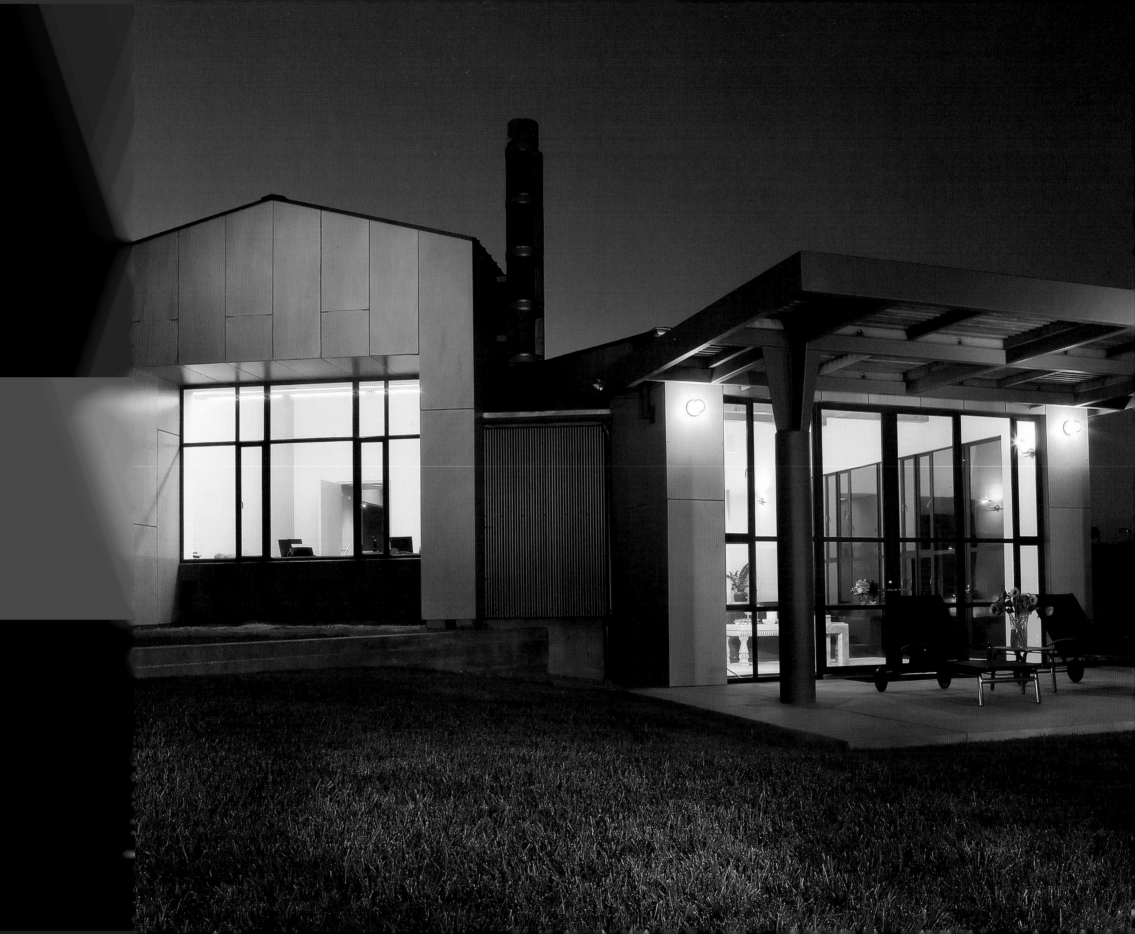

# JAN R. HOCHHAUSER
# JAY I. BLATTER

Hochhauser Blatter Architecture and Planning

If architecture is an art, then architects are artists. At least the good ones are. And it is easy to count Jan R. Hochhauser, AIA, and Jay I. Blatter, AIA, in that number. As co-principals in Hochhauser Blatter Architecture and Planning, they design buildings that do more than just shelter the inhabitants: They consciously craft structures, commercial and residential, that illuminate the lives of those they touch.

The pair, both of whom were raised on the East Coast and who met while attending Pennsylvania State University, started their small Santa Barbara-based firm in 1990, with a "couple of jobs and a dream in hand." Today, Hochhauser Blatter Architecture and Planning focuses on architectural design and land planning, and its portfolio includes municipal, institutional and private clients located throughout the United States. Although the firm's projects are geographically and stylistically diverse, they all exude a high degree of thoughtful design and artistic value.

In each of Jan and Jay's buildings, there is a melody, a rhythm that captures the imagination the way that a sonnet might. They characterize their work as sophisticated and sublime, adjectives that might also be used to describe the architects themselves. Whether a museum in Los Angeles,

LEFT:
A steel and wood trellis complements the primal forms of the terrace structure, which overlooks the Santa Ynez Valley.
*Photograph by P.H.O.B. Photography*

a four-acre retirement community in Sherman Oaks or a stately Tuscan Mediterranean home in Montecito, their designs are not gaudy or ostentatious but rather they emanate a dignified elegance that is simultaneously calming and inviting.

As both land planners and architects, Hochhauser Blatter is particularly concerned with how buildings integrate into their environments. Therefore, its professionals are attentive to landscaping and emphasize the notion that their design compositions extend beyond the building's edge. They insist that their buildings flow inside-out and vice versa, so that the experience of the building and site is a harmonious one. That is why, in addition to marrying a structure to its site, they involve themselves in the landscaping leading to and surrounding it, noting that sometimes the architecture of a home may be minimal and that it is the environment around it that can make it significant.

Many of the custom homes that the pair designs—for they share creative and administrative responsibilities somewhat equally—are on exciting properties with breathtaking mountain or ocean vistas that beg to be showcased. And in doing so, these architects are able to take advantage not only of the scenery but also the light. They make every effort to design in a way that is sensitive to the nuances of the site and the changing position of the sun during the day, thus using it as an element in their art. Their work clearly demonstrates a tremendous talent to compose form and space within a landscape while employing a rich palette of materials and textures.

Another important part of their work: details. Spectacular detailing separates great from good architecture, and historical references that are not appropriate compromise the integrity of a home. Though their work is innovative in a multitude of styles, it all has one thing in common:

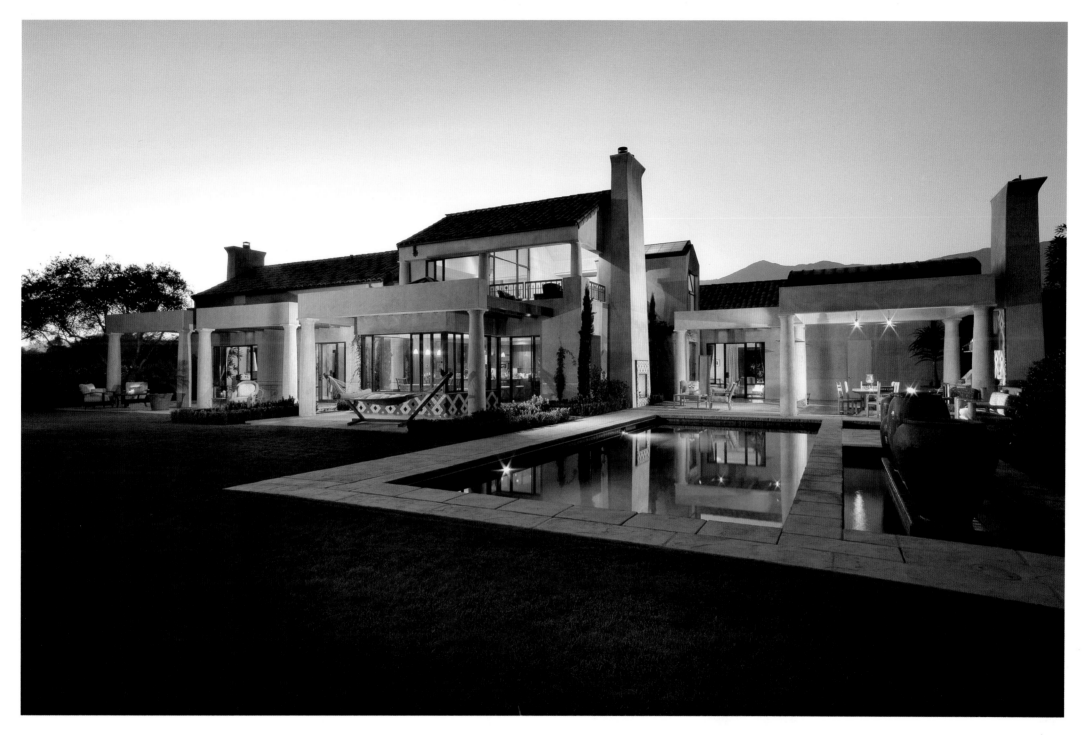

ABOVE:
Mediterranean vocabulary graces this contemporary composition as the dance between indoor and outdoor spaces unfolds.
*Photograph by Groupthreephotography*

FACING PAGE TOP:
Pure geometry is articulated into the natural hillside as the serpentine walk invites guests to enter.
*Photograph by Greg Voight*

FACING PAGE BOTTOM:
The natural sandstone terrace embraces an Ionic vocabulary of architectural forms.
*Photograph by MJW Photography*

a grounding archetypal thread and relevant details that are never arbitrary. And it sometimes seems as if the architects will stop at nothing to accomplish this goal. In order to manifest their architecture, they often need to interface with artisans, vendors and manufacturers in the United States and abroad, and if the situation calls for a specific bronze extrusion for a contemporary guardrail available only in Australia, that is where they will go.

And as you might expect, there is no way these architects are simply handing over their drawings to a builder and walking away. They insist on extensive involvement during the building process to ensure that the builder exacts their designs. Subjective interpretations can compromise the architects' and clients' visions, and Jan R. Hochhauser and Jay I. Blatter would never leave art to chance.

ABOVE LEFT:
The oversized bookcases and the fireplace that opens to an upper-level loft create an interesting composition of form and a dramatic interior for this mannerist residence.
*Photograph by Brooks Photography*

ABOVE RIGHT:
The dialogue of light, form and materials creates a rich composition in this dynamic living space.
*Photograph by James Ku*

FACING PAGE TOP:
The strong natural concrete wall defines a zen-like entry court on this hillside residence.
*Photograph by P.H.O.B. Photography*

FACING PAGE BOTTOM LEFT:
A classic Santa Barbara Mediterranean is embellished by the lush gardens of Montecito.
*Photograph by Brooks Photography*

FACING PAGE BOTTOM RIGHT:
Informed by bold geometry, the expansive limestone terrace is protected from the sun by retractable sails of white canvas.
*Photograph by Greg Voight*

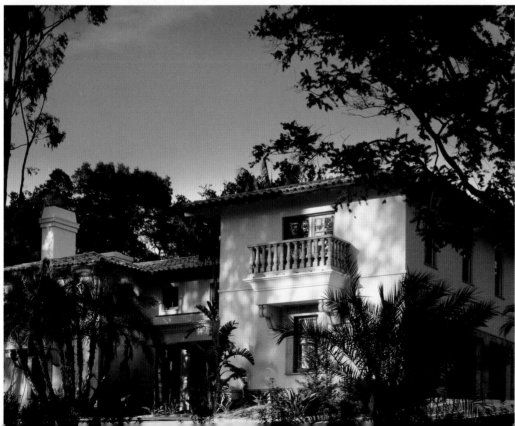

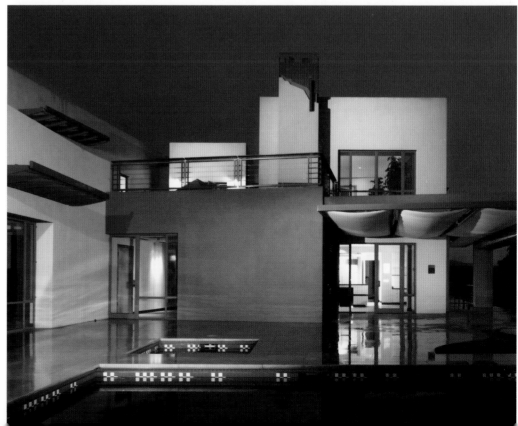

# ANN JAMES

Ann James Interior Design

ABOVE:
The interior of an art collector's Montecito home was designed to feature some of the resident's favorite pieces.
*Photograph by Jim Bartsch*

FACING PAGE:
Lush greenery and ocean views are enjoyed from the terrace of this Montecito vacation home.
*Photograph by Jim Bartsch*

Ann James may not have realized it at the time, but when she was rearranging furniture in her childhood home, she was paving the way for her design career. As a girl growing up in Los Angeles, she loved decorating (and redecorating) her bedroom, and when she became an adult there was no question what she wanted to do. Interior design was a calling.

After attending art school in her hometown, Ann wound up in the interior design department at UCLA. From there, she began to eke out a living, getting a foot in the door wherever she could, designing for free and working in fabric showrooms as a sample girl. Eventually she landed a job with a Los Angeles company that made high-end furniture reproductions. It was while there that an established interior designer recognized her talent and hired Ann as his assistant. After a three-year apprenticeship with the designer, she formed a design partnership that lasted a decade before opening her own firm, Ann James Interior Design, in 1980.

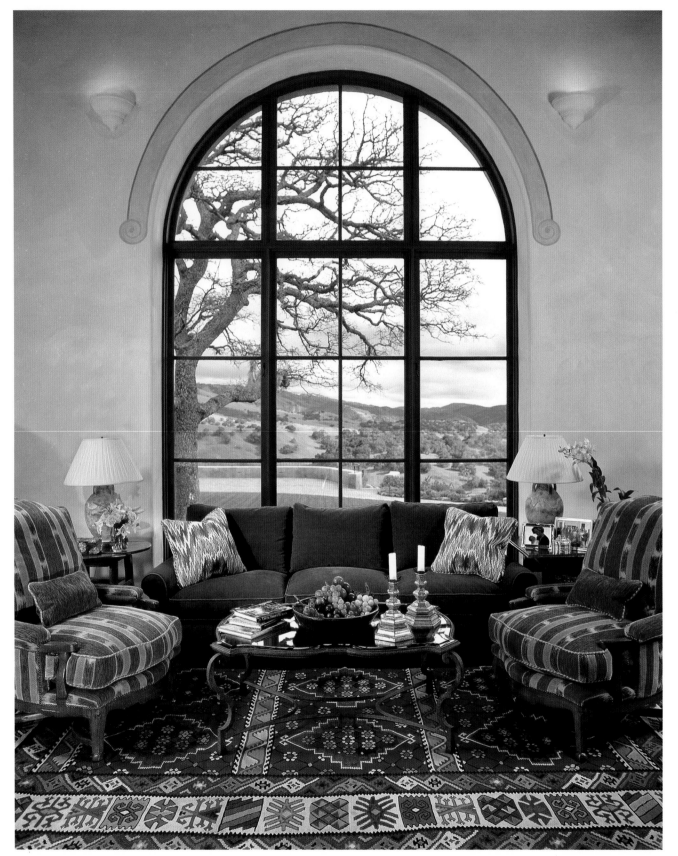

Known for creating exceptional homes, the Santa Barbara-based designer has been working in the Southern California area for more than 30 years. Ann has built a following of clients who are as varied and diverse as the interiors she creates for them. Her interiors range from the latest in contemporary design to those with a more traditional approach. No two projects look alike, therefore, she has absolutely no signature style. Her designs do share some similarities though: The thread that connects her work is attention to detail and quality and an emphasis on comfort and livability.

Her projects are concentrated in the western United States, where people lead informal lives oriented toward time outdoors. It is a way of living that she completely understands and is able to incorporate into her work. Because of that she also gets involved in the furnishing of outside spaces. All of her designs are relatively clean and uncluttered, emanating a restful character that is key to her work.

She believes that designing a home should be a collaborative endeavor between client and designer. Ann's goal is to design unique interiors that reflect the individual tastes and lifestyles of the people who live in them. Working with a client to create a home that becomes his or her own personal expression is the designer's ultimate

LEFT:
Symmetry and rich colors inform the design of the living room of a Spanish Colonial ranch in Carmel Valley.
*Photograph by Jim Bartsch*

FACING PAGE:
The warmth of the architectural elements and the natural environment is echoed in the furnishings and their arrangement in this Montecito vacation residence.
*Photograph by Jim Bartsch*

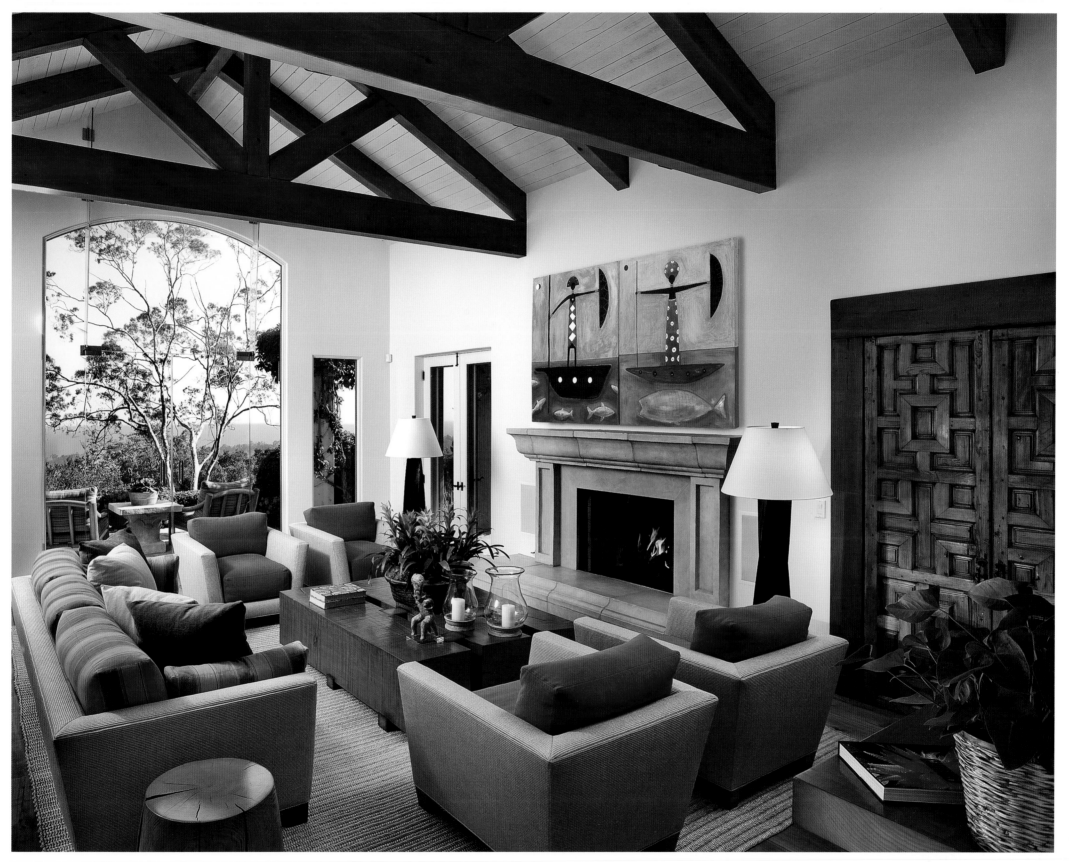

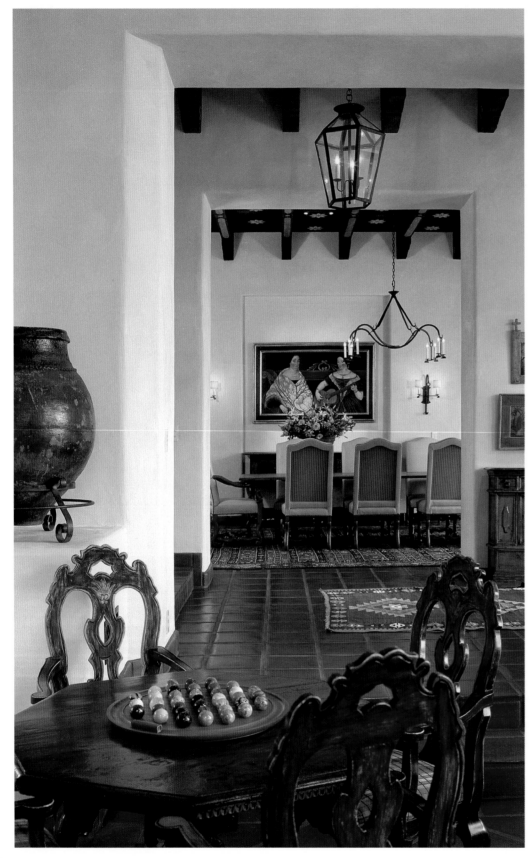
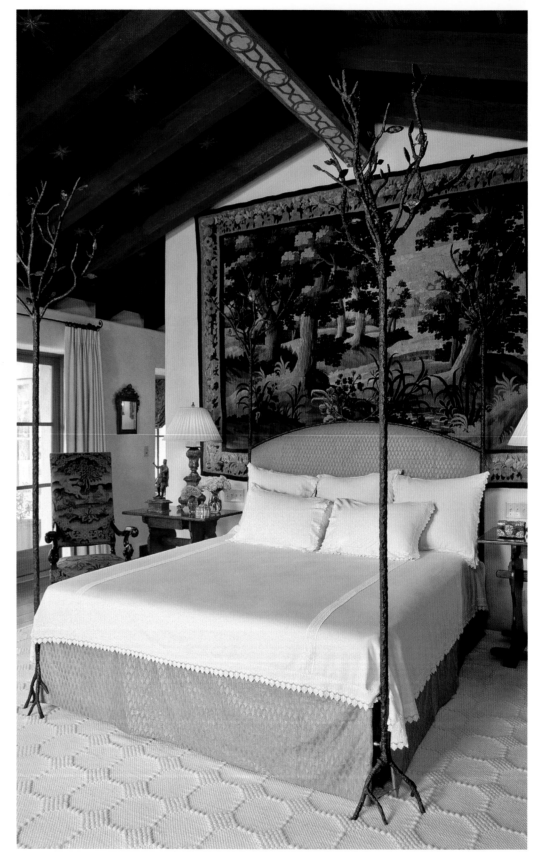

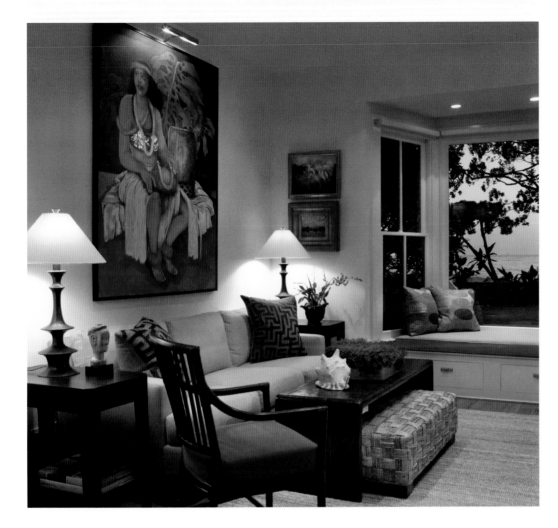

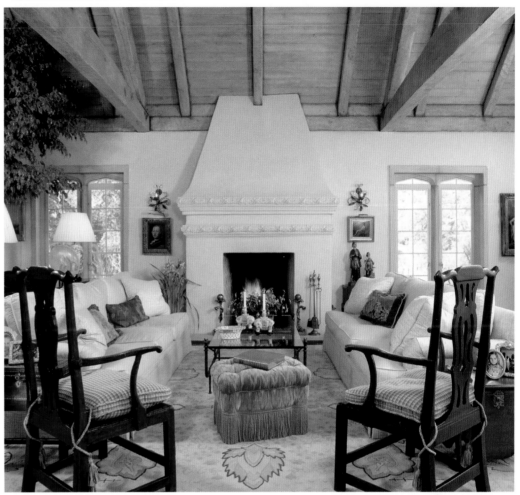

reward. Ann loves discovering her clients' motivations, then creating for them something they want but would be unlikely to produce on their own. How does she manage this? Lots and lots of talking and a process of elimination.

By showing her clients things like fabrics, colors, furniture, artwork and architecture, Ann learns what they like and do not like. It is not necessarily a fast process, and often she learns more from the latter. For example, one of her clients balked at every Louis XV chair Ann showed her. What she was really objecting to were curvy lines, but she could not articulate that point; she knew only that she did not like the chairs. Ann gave the client a home full of straight-lined furniture, and the lady was utterly delighted. But uncovering that penchant for extremely tailored things took a while.

The ability to mine her clients' deepest desires—even desires they do not know they have—is Ann's greatest strength. The success of her designs depends largely on the rapport she builds with her

clients. It is absolutely vital that designer and client be compatible. And it is an added advantage if the client is open to the best that the designer can bring to them. When it all comes together, exceeding expectations is the easy part.

ABOVE LEFT:
Light and airy, the living room design of this Carpinteria beach cottage captures the essence of the home's locale.
*Photograph by Jim Bartsch*

ABOVE RIGHT:
Located in Montecito, this English Tudor abounds with 18th-century antiques placed in an elegant setting.
*Photograph by Jim Bartsch*

FACING PAGE LEFT:
The living and dining rooms are visually connected in this Carmel Valley Spanish Colonial ranch.
*Photograph by Jim Bartsch*

FACING PAGE RIGHT:
A voluminous ceiling adorned with richly painted details, along with the custom-designed bed and 18th-century tapestry, informs the master bedroom of a Spanish Colonial ranch.
*Photograph by Jim Bartsch*

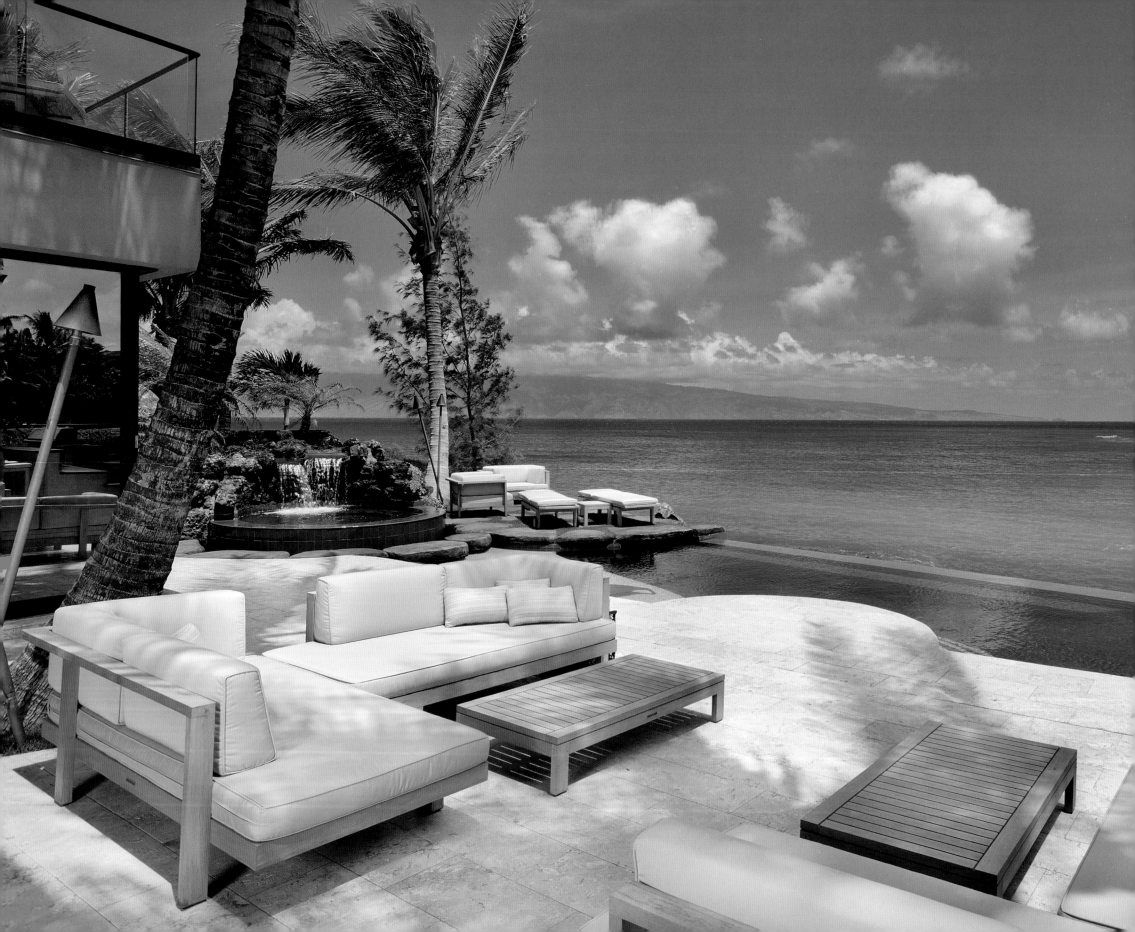

# JAMES LeCRON
# KAREN ARRI-LeCRON

Arri/LeCron Architects, Inc.

Meeting to discuss design with James LeCron, AIA, and Karen Arri-LeCron, AIA, is like sitting down with old friends. If it is late enough in the day, they might break out a bottle of syrah, pour you a glass and lean back with their own while listening intently to you talk. Getting to know their clients is crucial to their design work, and they want client meetings to be relaxed and fun. Otherwise, they ask, why bother?

The pair met in Lake Tahoe, where Karen, a graduate of the University of California Berkley, was following her dream of resort design. Jim moved there to work after graduating from the Southern California Institute of Architecture in Los Angeles. The couple hit it off and in 1988 returned to the Los Angeles area. They opened their Santa Barbara-based firm, Arri/LeCron Architects, shortly thereafter and began providing the personalized service for which they are known.

LEFT:
Embracing sweeping views of neighboring island Molokai, this Maui oceanfront estate epitomizes indoor-outdoor living.
*Photograph by Luxury Retreats*

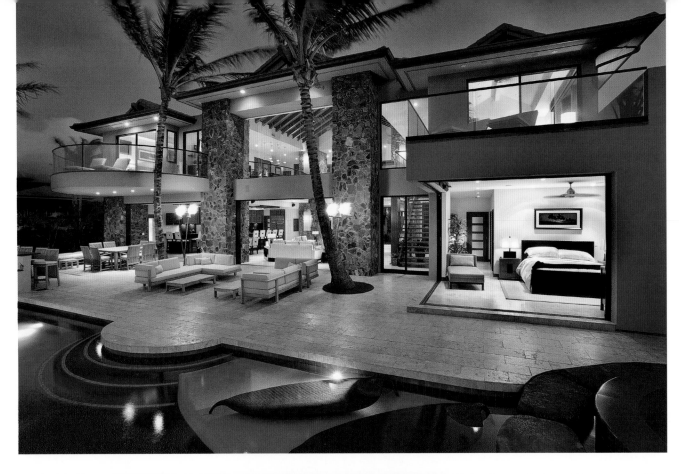

Jim and Karen focus on high-end residential homes in California and Hawaii. And for them, architecture is more than just a business, it is a personal commitment to maintaining an understanding of their clients' needs and an opportunity to realize their clients' dreams—which, in turn, effectuates their own.

Using their considerable talents and without injecting their own egos, the architects concentrate on turning fantasy into reality. Each works on every house they design, and as a husband-and-wife team they can offer their clients twice as much as they might were they working alone. It is an advantage that does not go unnoticed: Other couples often appreciate the fact that they bring both masculine and feminine perspectives to their projects or that there is a choice in whom to confide.

The fact that many of their clients will commission a dream home only once in their lives is never far from the architects' minds. Jim and Karen, therefore, make quality a priority. That means remaining true to authentic details while adapting them to the California lifestyle. It also means giving their clients the best possible result for their budget, whether $2 million or $12 million.

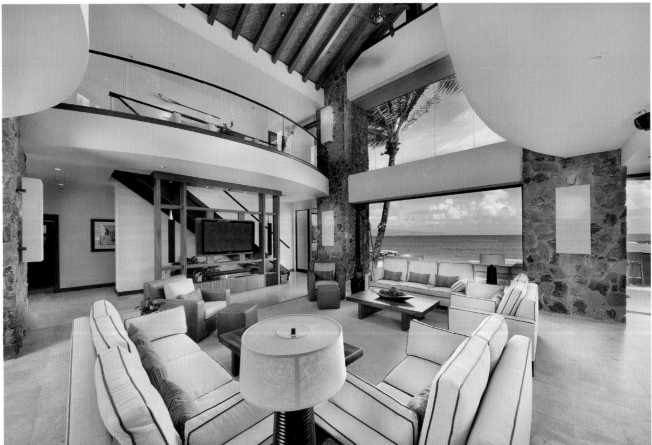

TOP LEFT:
This oceanfront Maui estate utilizes natural materials blended with modern open architecture to embrace the spectacular surroundings.
*Photograph by Luxury Retreats*

BOTTOM LEFT:
Floating mezzanines hover over the great room allowing all interior spaces to interact with the outdoors and the sea.
*Photograph by Luxury Retreats*

The couple travels extensively to glean firsthand knowledge of various styles and carefully considers how each space in a house will be used and how it will flow and function, individually and as a whole. Of course, they design to make the most of the assets of each home site. And through the entire process, which can sometimes take years, Jim and Karen want their clients to have a good time.

For that is what dreams are made of.

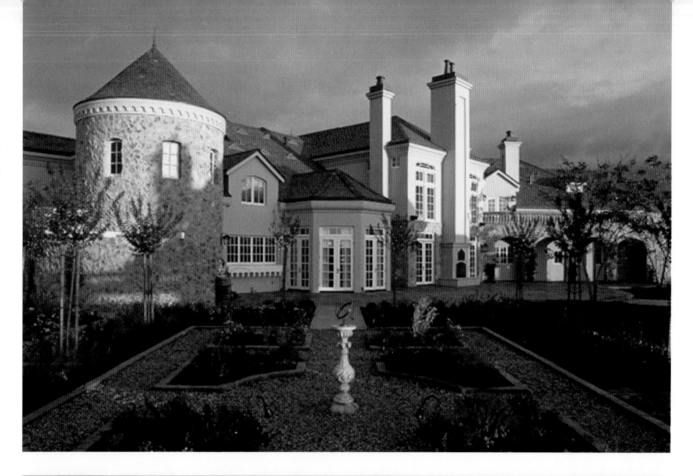

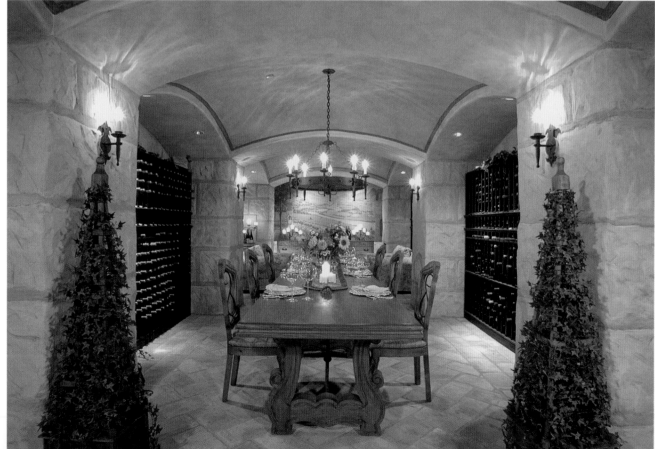

TOP RIGHT:
This Country French chateau in the Santa Barbara wine country combines California flair with Old World refinement.
*Photograph by JGL*

BOTTOM RIGHT:
The subterranean wine cellar is also an elegant place for special winemaker dinners and entertaining.
*Photograph by JGL*

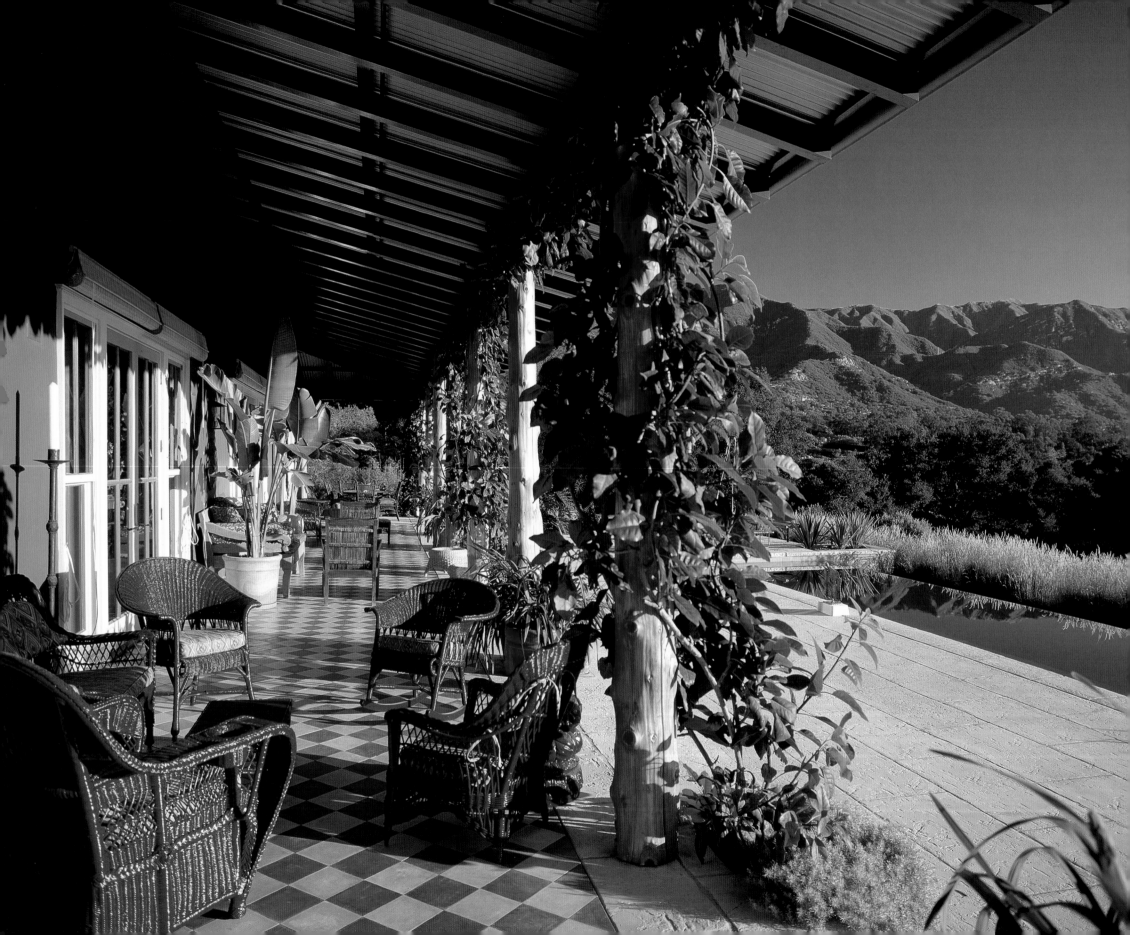

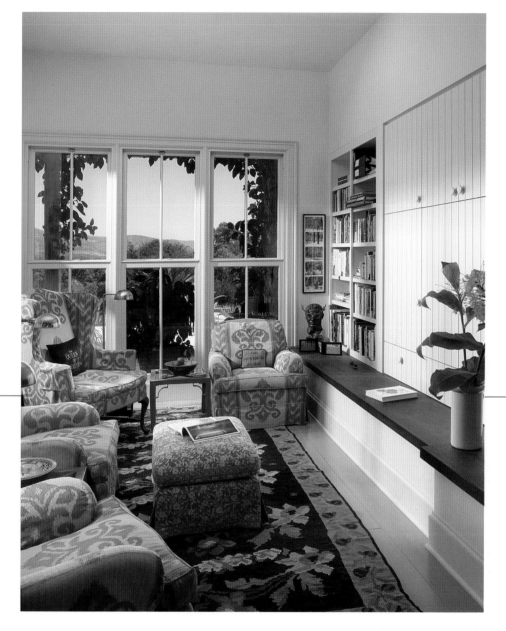

# Tom Meaney

### Tom Meaney Architect

One of the first things a person notices about Tom Meaney, AIA, is his sense of humor. A lighthearted, convivial man, he engages the world with a smile on his face and checks his ego at the door. Personally Tom is a joy, and it is a quality that translates well in his professional life. One client called working with the architect "a blast," saying, "he helped us see that it can be fun to build a house, so much fun that if he had not done it so well the first time, we would want to do it again." And that statement is testament not only to his demeanor but also his talent.

It is true: Tom enjoys his work. He also loves to design houses that speak directly to the needs of his clients and their sites.

ABOVE:
An intimate sitting area off the kitchen takes advantage of the mountain views and morning light.
*Photograph by Jim Bartsch*

FACING PAGE:
This tropical plantation-style home features a corrugated metal roof and a wraparound veranda, which frames views down the coastline.
*Photograph by Jim Bartsch*

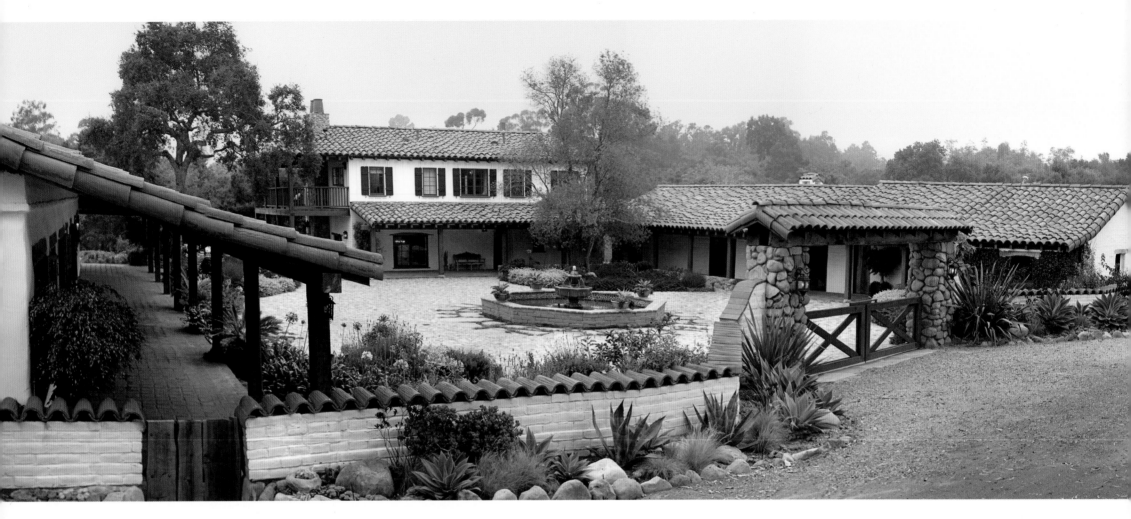

The architect, who is also a painter, realized the possibility of combining his passions for art and architecture while studying in Rome with the University of Notre Dame. It was while sketching the ruins of the Pantheon and walking Michelangelo's Piazza del Campidoglio that he first understood what he was meant to do. And after working at a couple of large architectural firms, in 1988 the Santa Barbara native opened his own practice in his hometown and recently in Carmel.

It is a boutique business focusing on high-end residential projects, and with just six employees, it is about as big as Tom ever wants it to get. His emphasis on keeping his firm small is driven by the desire to give every client personalized service and every project intense supervision—priorities that he will not compromise. Tom insists that he is the lead contact on every job; he attends client meetings and spends time at every site, ensuring that the process and the product are of the highest standards.

Tom's designs are as sophisticated as his clientele, who are a demanding lot. Their tastes run to the conservative, and the houses he designs are mostly an interpretation of traditional styles—whether for a 7,000-square-foot farmhouse in the

ABOVE:
At the client's request, the adobe structures of this horse ranch are a literal interpretation of early California hacienda architecture.
*Photograph by Holly Lepere*

FACING PAGE LEFT:
Handmade products like adobe, tiles, and heavy timber milled on site evoke the quality, details and finishes of construction in the mid-1800s.
*Photograph by Holly Lepere*

FACING PAGE RIGHT:
Vintage light fixtures, reclaimed beams, handmade Mexican roof tiles, and stone gathered from the property are included in the palette of materials.
*Photograph by Holly Lepere*

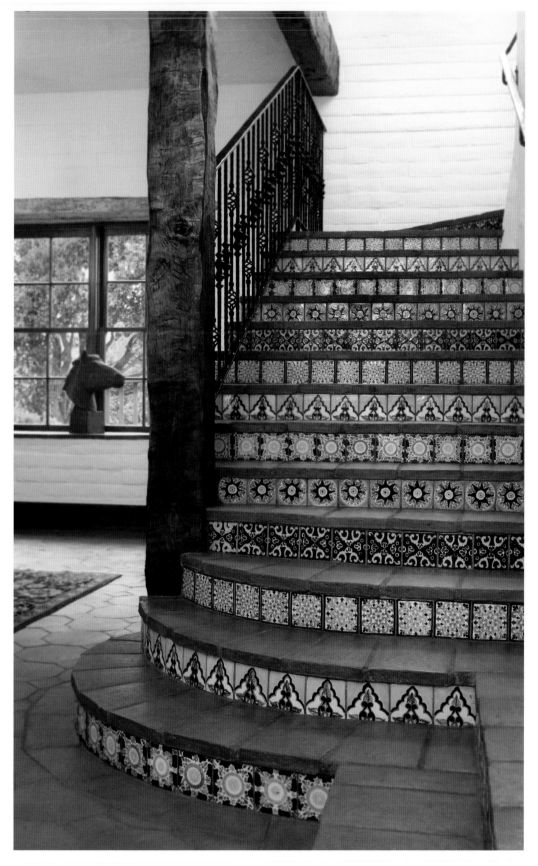

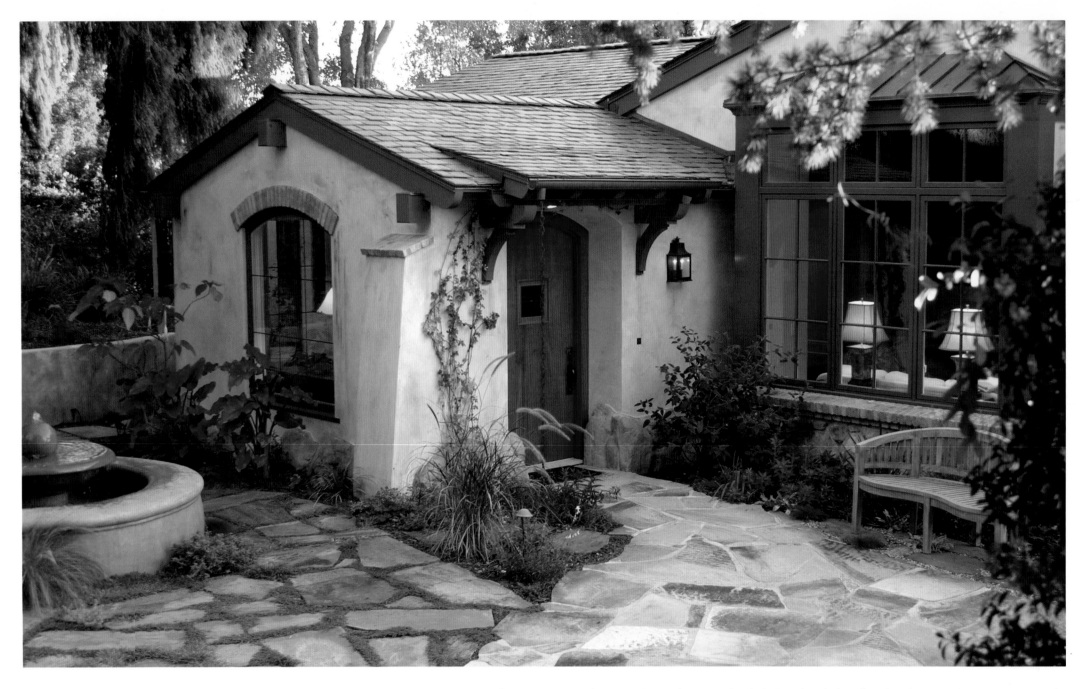

Carmel Valley or a 3,800-square-foot Montecito hillside home inspired by the colors and lifestyle of southern France. Regardless of genre, Tom's designs are always well-suited for their respective sites, relating to views and topography and natural light. His approach to design is always the same: an appreciation for the finer points and subtle expression of concepts and components.

Painting and drawing being his first loves, Tom learned from those arts how to balance color, proportion and texture. He learned where to push contrasts and about the power of opposites. He learned to meet his profession with a light hand and, therefore, his designs are never overwrought but crafted with subtlety and grace. They are creative within the framework of the chosen style and they are always full of fresh ideas and solutions.

Tom calls himself a natural-born problem-solver, and his education helped develop that skill. The key to coming up with solutions starts with listening. The architect is an engaging communicator, something that serves him well when he is getting to know new clients and identifying their

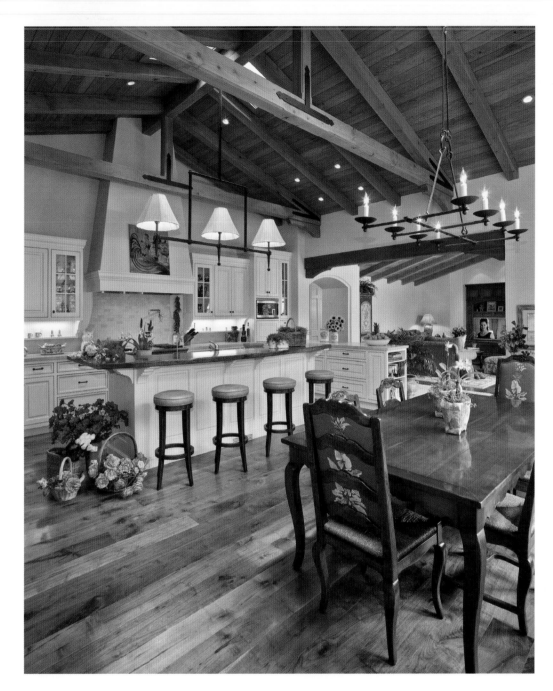

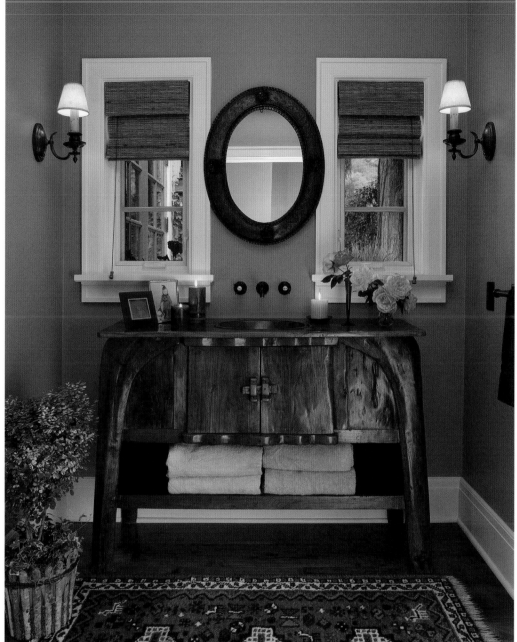

particular wants and needs. It is a necessary ability when walking clients through the sometimes lengthy design process and exploring with them various options. Ideas beget ideas, and Tom starts every job with a blank page and an open mind. It is a tack that quickly gains the clients' confidence and trust so that the architect can use his expertise to give them what they want—but even better.

ABOVE LEFT:
The main kitchen, dining and family areas flow together and spill out onto a terrace overlooking the sunny yard and distant views.
*Photograph by Jim Bartsch*

ABOVE RIGHT:
Found objects integrated into the design help to reinforce the casual quality of the home.
*Photograph by Jim Bartsch*

FACING PAGE:
The design objective—to create a home that projected an informal and welcoming feeling to arriving guests—was achieved through a strict attention to details and scale.
*Photograph by Holly Lepere*

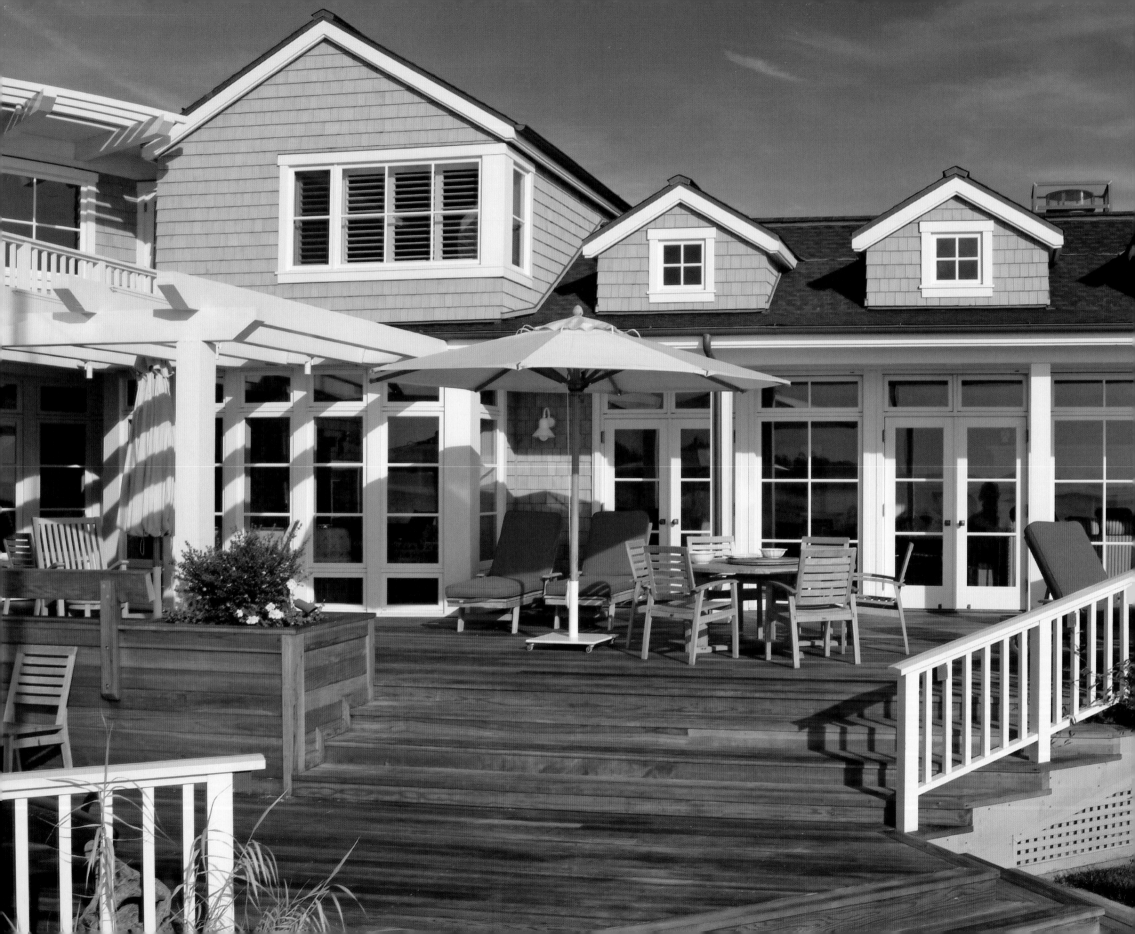

# ANDY NEUMANN
# DAVE MENDRO
# MARY ANDRULAITIS

Neumann Mendro Andrulaitis Architects

It is difficult to turn away from the work of Neumann Mendro Andrulaitis Architects. Whether in person or merely in photos, the homes that the firm builds are captivating. Like true masterpieces, they lure you in and cause you to stare, study, linger, contemplate. So when you hear senior partner Andy Neumann, AIA, say that a lot of what the firm does is not photogenic, it is hard to imagine what he means.

Of course, the picture-perfect houses Andy and partners Dave Mendro, AIA, and Mary Andrulaitis, AIA, design are for living in, not just looking at. And what Andy is talking about are things like laundry chutes and appliance garages and storage for logs next to a fireplace—practical details that make a house function at a high level for its occupants. They are not the stuff of glossy magazine covers, but rather they are pragmatic solutions to everyday problems. Such seemingly little things separate good houses from great ones.

LEFT:
Both refined and casual, the beach house's cedar shingles add an informal feeling conducive to the Southern California beach lifestyle.
*Photograph by Bill Zeldis*

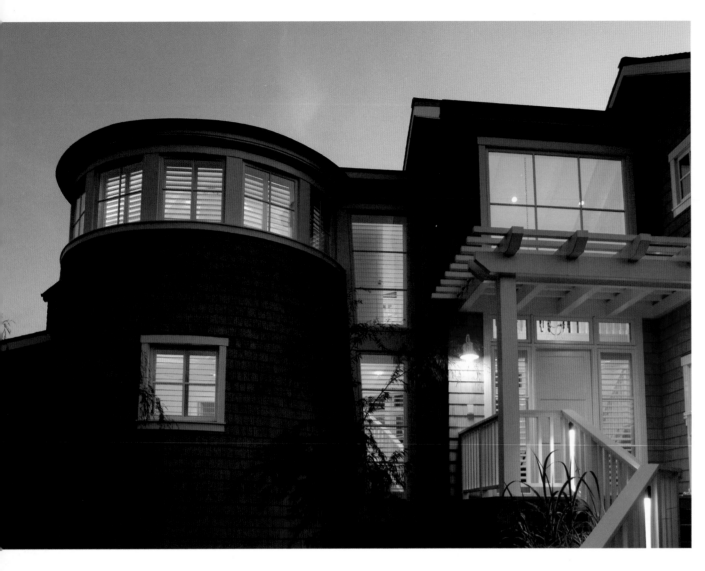

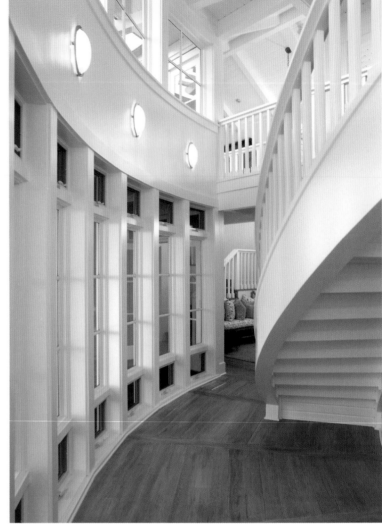

Andy, Dave and Mary know greatness does not come easy, and they pride themselves on putting tremendous thought into every project so that it functions on a variety of levels. It is easy to make a house look dramatic, but to make it comfortable for day-to-day living is an art—one at which the hard-working team excels. To wit: The partners have a dozen or more awards to their names, their work has been featured in such publications as *Architectural Digest* and *Sunset Magazine*, and their portfolio includes the stunning oceanfront homes of well-known names in the entertainment industry.

With about 20 projects of various sizes at any one time, they emphasize quality design irrespective of scale or scope. And though they design in a range of styles, the architects do prefer contemporary projects for their open-ended sense of discovery and excitement. And constantly doing something new and never repeating an older solution keeps them energetic and provides opportunities to learn and grow, never allowing stagnation to slip in.

ABOVE LEFT:
A rounded tower element houses a study above the media room. The shingles continue into the interior to strengthen the geometry.
*Photograph by Bill Zeldis*

ABOVE RIGHT:
A curved hallway leads one from the two-story entry to the main living spaces. A curved stairway is attached to the side of the tower.
*Photograph by Bill Zeldis*

FACING PAGE LEFT:
A sculptural study looks down on the entry while the translucent skylight ceiling floods the entry with light, creating a courtyard feeling and linking two separate wings of the house.
*Photograph by Julius Shulman*

FACING PAGE RIGHT:
Barn-like elements give the house a rural feeling with a fresh, contemporary interpretation. A second-story bridge leads directly from the detached garage to the entry.
*Photograph by Julius Shulman*

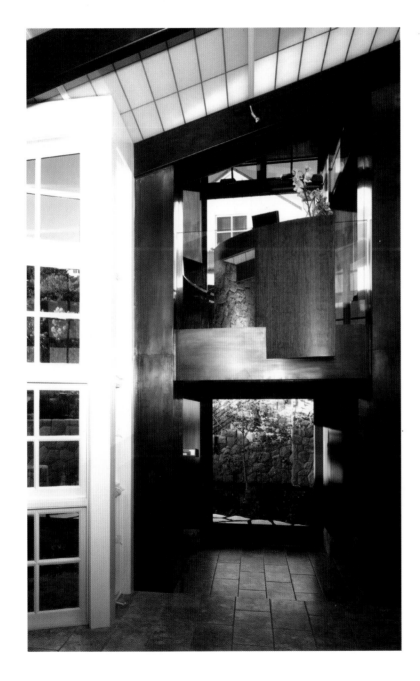

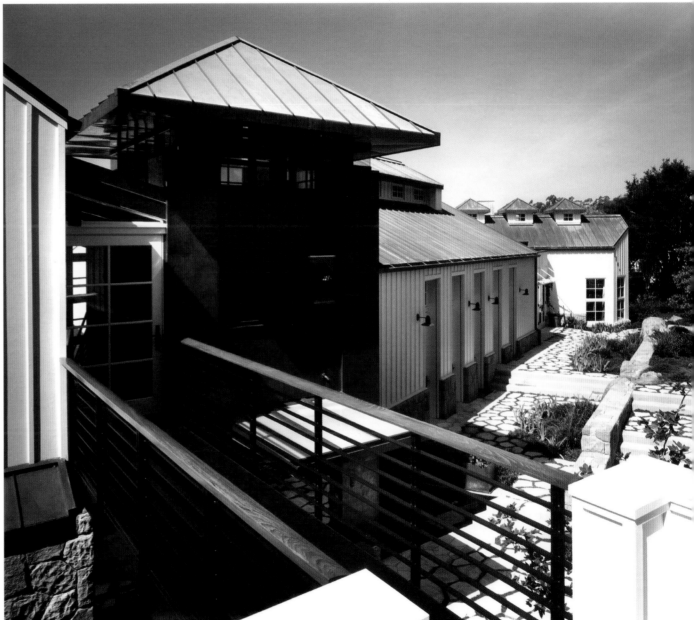

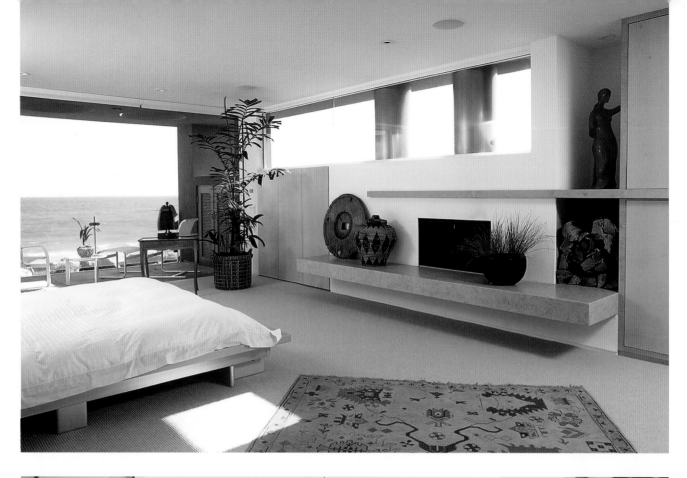

Without preconceived parameters and rules about what a house should look like, Andy, Dave and Mary are free to respond directly to the issues without compromising their creativity or having to force their solutions into a given envelope. For this reason they feel that their houses evolve in a more organic manner than they otherwise might and can more naturally relate to the sites and address their clients' programs.

The client is the cornerstone of the design process at Neumann Mendro Andrulaitis. Although the firm has done some commercial and public work—at the Santa Barbara Zoo and on the corporate headquarters of QAD, for example—dealing directly with the end user is one of the joys of custom residential architecture. As facilitators of dreams, Andy, Dave, Mary and their support staff of 10 have learned to really listen to their clients and relish their demands and insights.

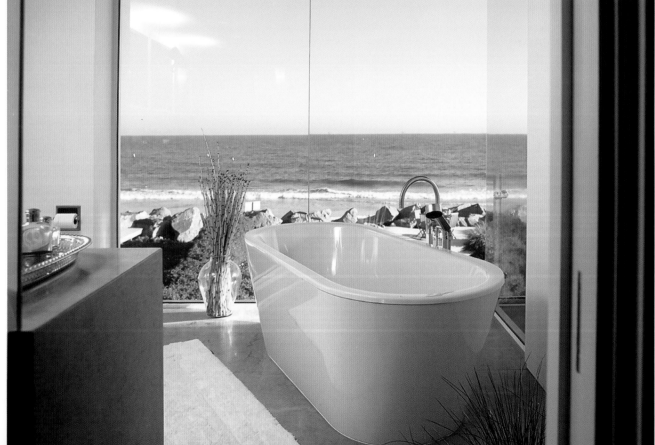

**TOP LEFT:**
The all-white interior has a wonderful light quality, making the house feel warm and intimate. Its sense of scale and proportion balance the minimal aesthetic of the white walls, stainless steel elements and the limestone hearth.
*Photograph by Bill Zeldis*

**BOTTOM LEFT:**
With breathtaking views of the Pacific Ocean, privacy is instantly achieved with motorized blinds in this bathroom with an unmatched backdrop.
*Photograph by Bill Zeldis*

**FACING PAGE:**
Minimal and contemporary in design, this beach house maximizes the openness to the ocean beyond. Although its location is narrow, it feels open and spacious.
*Photography by Bill Zeldis*

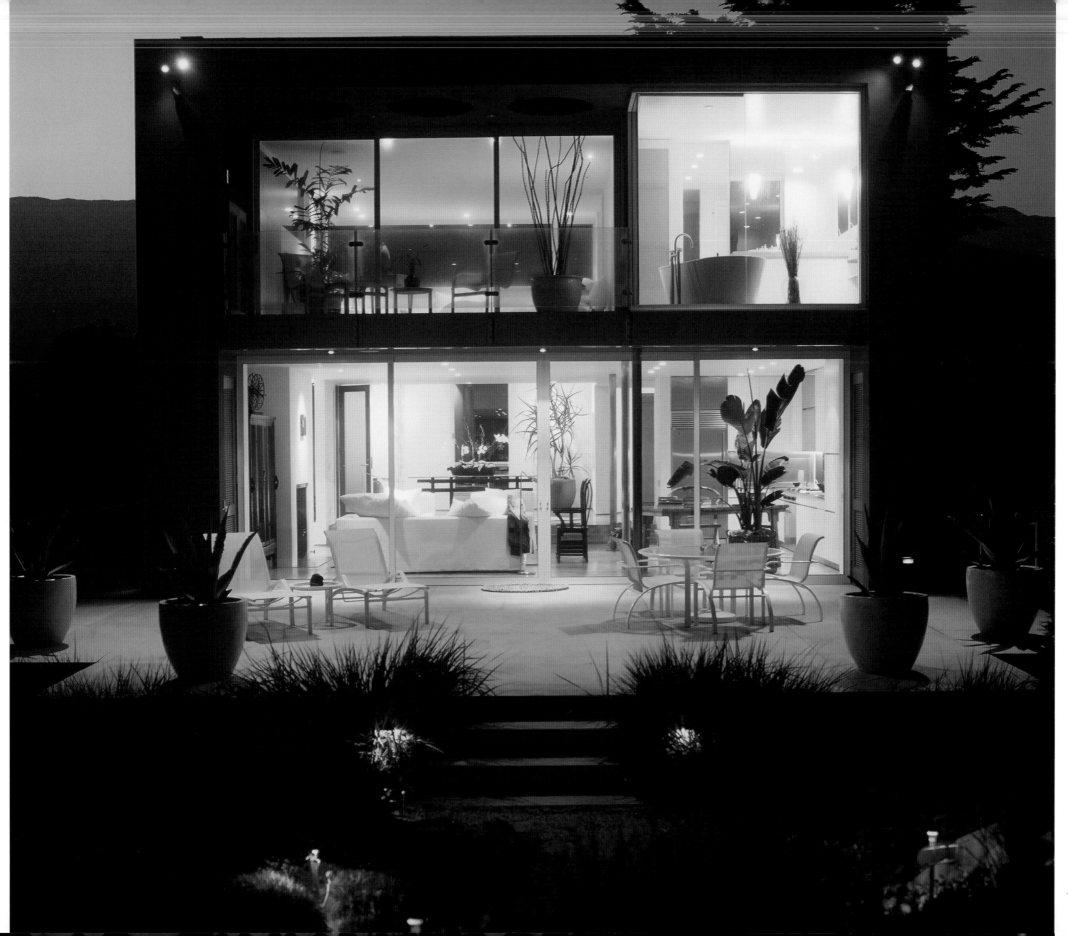

The client can give a project a unique direction, Andy explains, and following that direction can produce exciting results. Embracing different points of view enriches the firm's work. For example, a recent client wanted his beach house to have gills—openings on the side walls to allow ocean sounds and breezes into the house. It is unlikely that the architects would have come up with that themselves, but they plan to pursue the design and see where it leads. Another example is a client who wanted a two-story library, not something that the architects normally would consider, but they went with it, and in the end had to admit that it was the nicest room in the house.

A close second to the client in the designs of Neumann Mendro Andrulaitis are the sites. The architects feel strongly about context and designing to the landscape and the neighborhood. Their designs evolve from the inside out and their buildings respond to their environments: trees, rocks, views, sun. The idea is to link a house to its site and have it grow from the site. To the degree that you can connect to the site, the house will have a sense of timelessness and permanence, which can be further enhanced by choosing materials that weather well.

LEFT:
A sculptural composition of forms overlooks the Pacific Ocean in this contemporary Santa Barbara beach house. The curved clerestory element helps balance the light throughout the home.
*Photograph by Farshid Assassi*

FACING PAGE:
A freestanding mahogany boat element houses the pantry and laundry room. The curved limestone wall forms the spine of the house, separating the bedrooms from the more public living areas. The curvilinear building form responds to the line of the beach cove on which the home is situated.
*Photograph by Farshid Assassi*

The architects take their work very seriously yet have managed to foster a casual studio atmosphere in their Carpinteria offices, 12 miles south of Santa Barbara. The three came together 20 years ago when Dave and Mary went to work for Andy at Seaside Union Architects of Santa Barbara, where he was founder and partner. In 1993, they followed Andy when he struck out on his own, with Andy Neumann Architect, and 10 years later they established the current iteration of their partnership. They offer comprehensive services from design conception through construction, including planning, programming, design, regulatory agency approval and construction administration services.

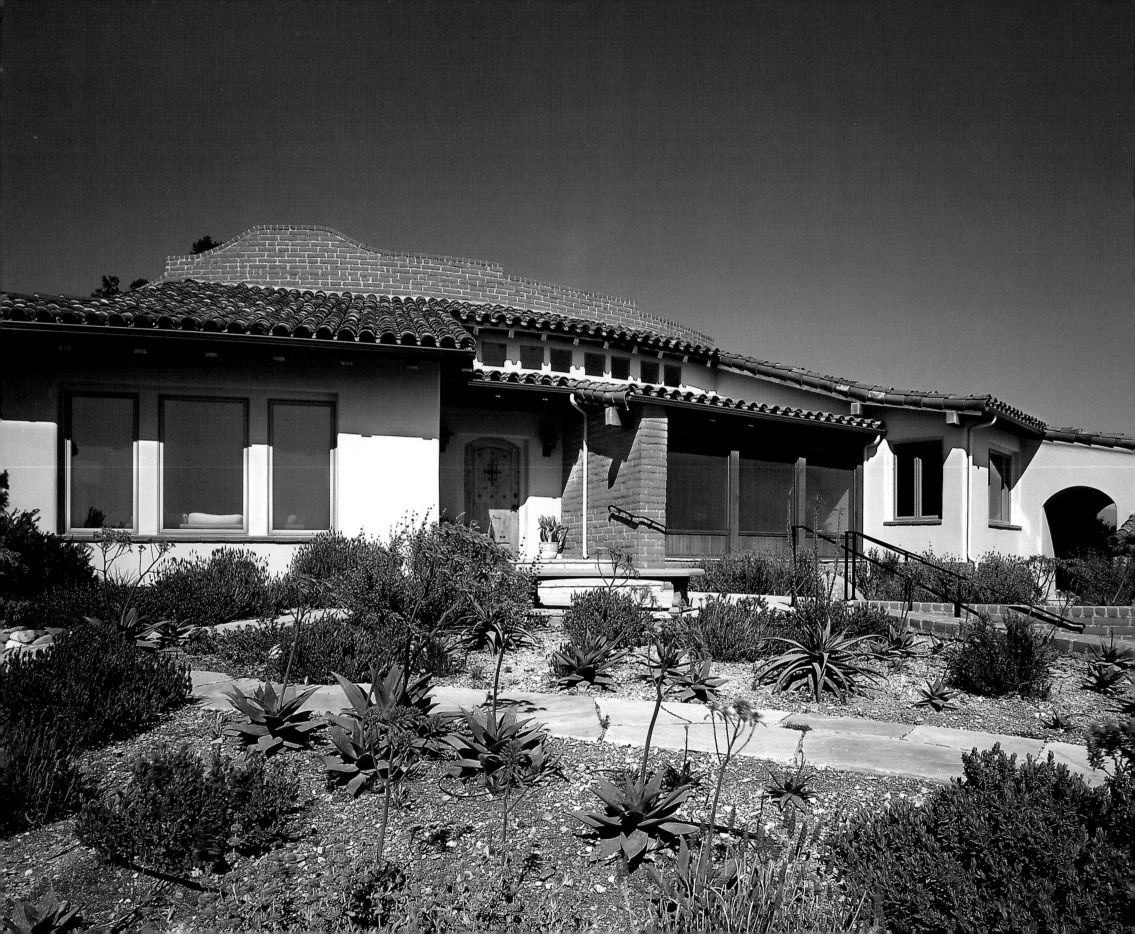

# TOM OCHSNER

Thomas Ochsner Architects

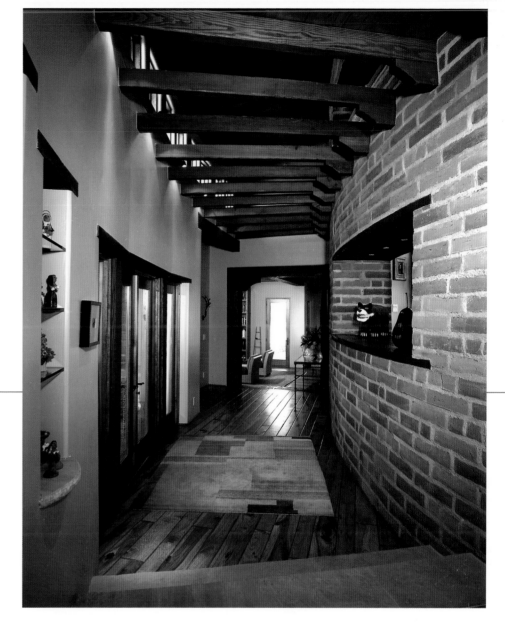

Tom Ochsner, AIA, is an artist. Not just in the way all architects are artists. But rather like Michelangelo was an artist: He first began creating with a mallet and a chisel.

Tom apprenticed as a wood sculptor during his childhood before turning his eye to something he thought he could make a living at. In the years since, he has become one of Santa Barbara's finest architects, designing dream homes for the most discerning clientele.

After 20 years in business, he has his own dream project in mind: A rural site in Santa Barbara County, populated with mature oak trees and surrounded by rolling hills. A client who says, "Give me something wonderful," and allows Tom free reign. He would create for them a house that is a natural response to the site, he says, with a vernacular that is appropriate to the region. The house would have gentle curves

ABOVE:
A central 3-foot-thick adobe wall forms an S-shaped spine through the house, allowing internal spaces to step down on both sides.
*Photograph by Lone Pine Pictures*

FACING PAGE:
This Santa Ynez Valley residence wraps around the existing hilltop site and uses materials indigenous to the area.
*Photograph by Lone Pine Pictures*

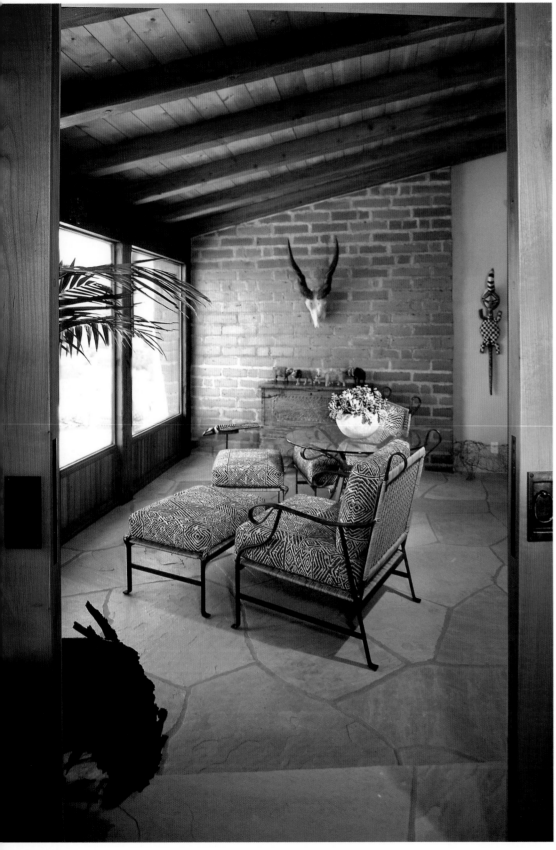

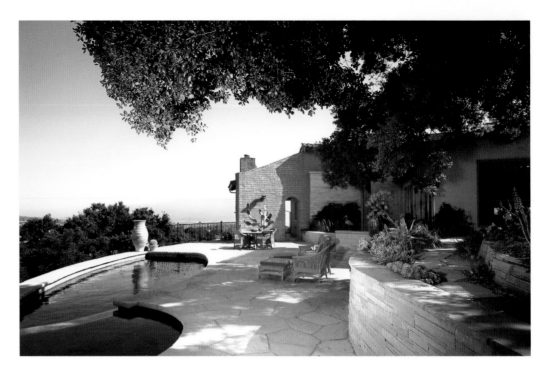

to mirror the rolling hills; it would comprise natural materials like adobe and stone and wood; and it would be low slung, with a profile and silhouette compatible with the site. The form would work in concert with the setting without relying too much on preconceived ideas. The materials would give the impression that they truly belonged to the region. The house would strongly reference both environment and owner.

That is not to say that the award-winning architect does not get a rush out of giving his clients what they want. He absolutely does, as most of his clients have a very specific vision. Maybe they do want to do something sympathetic to the surroundings or maybe they've only just returned from Europe and they have a concept of authenticity. Either way, the real thrill comes from exceeding their expectations: "What I want is to take what they want and make it extraordinary. I put an emphasis on realizing their dreams, all the while devising solutions for incompatibilities, be it within the house or with house and environment. In the end, I want them to look at what I create and say, 'It's even better than what we envisioned.'"

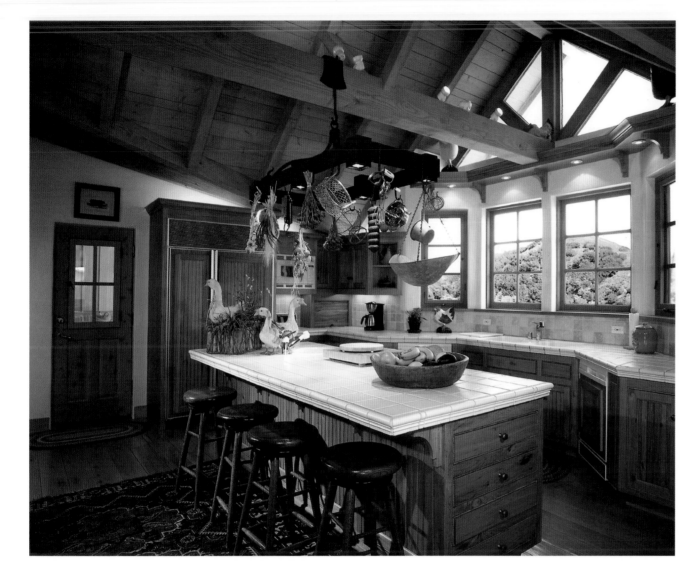

His is a small practice—just five people—and in a year's time he will complete between 10 and 15 projects, both large and small, sometimes having spent at least that amount of time producing the drawings for a single home. "You can't rush it," he says. "My clients go into this dreaming of their ultimate home. Often they are not willing to compromise on materials or budget. So I approach the design process with a very cautious, careful, long-term, let's-do-it-once type of thinking."

And the results are nothing short of spectacular.

ABOVE LEFT:
The layering of beams in the kitchen provides both drama and intimacy.
*Photograph by Lone Pine Pictures*

ABOVE RIGHT:
The structural system for this residence was inspired by regional agricultural structures and is repeated in various ways throughout the residence.
*Photograph by Lone Pine Pictures*

FACING PAGE LEFT:
The screened porch off the dining room is a pleasant place for relaxing after dinner and enjoying the vibrant sunsets of California.
*Photograph by Lone Pine Pictures*

FACING PAGE RIGHT:
This exterior space was designed around an existing oak, which provides a wonderful sense of connection with the natural site.
*Photograph by Lone Pine Pictures*

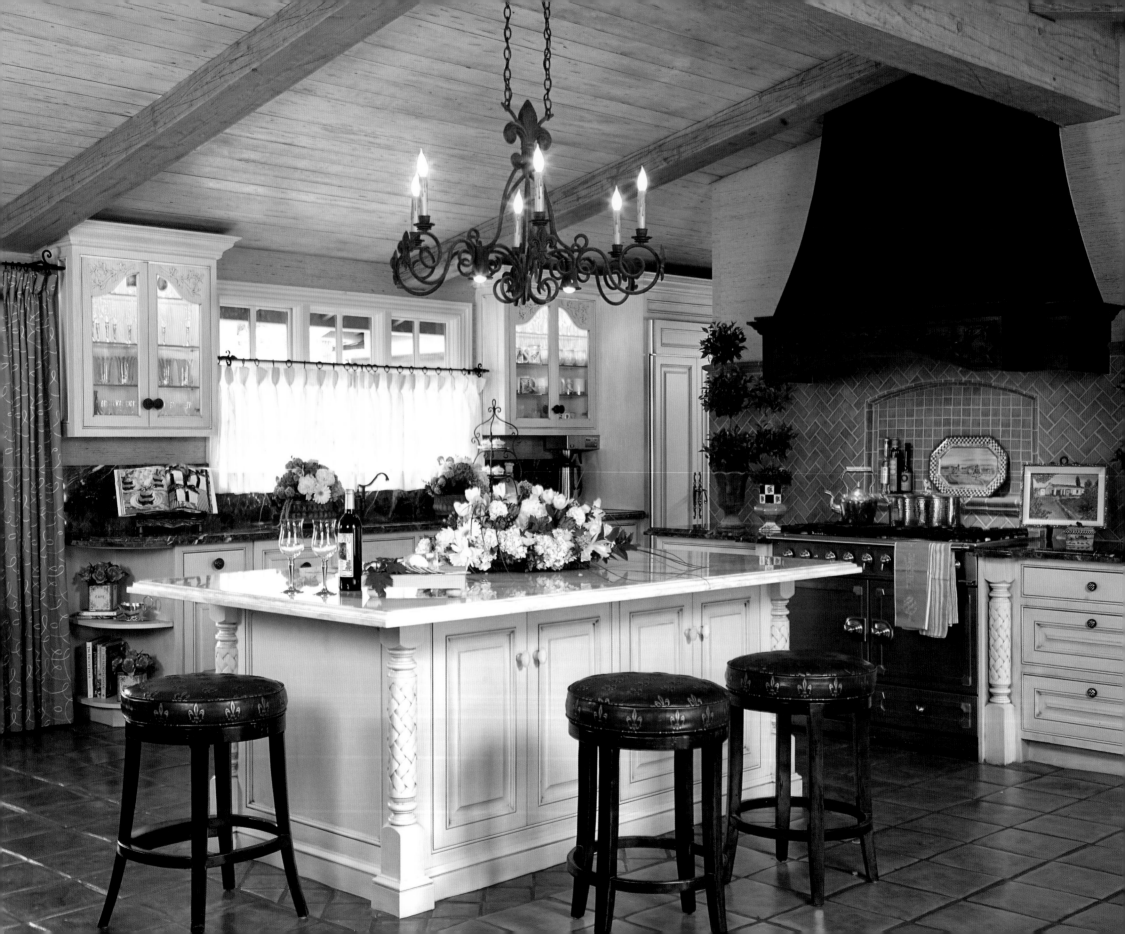

# ROXANNE HUGHES PACKHAM

## Roxanne Packham Design, Incorporated

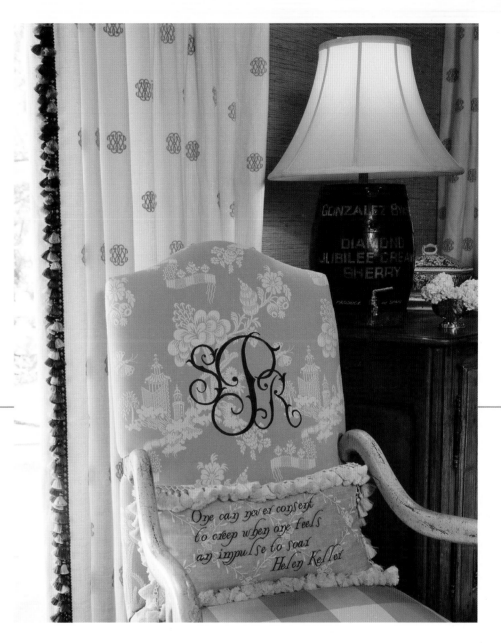

If there is a design gene, Roxanne Hughes Packham, ASID, has it. Good taste and creativity run in her family, and the vivacious 39-year-old grew up among talented thinkers and successful entrepreneurs. Roxanne's maternal grandfather was Allan Adler. The "Silversmith to the Stars" counted as clients the likes of Paul Newman; today, his patterns are collector's items and are carried by Ralph Lauren. His work is on permanent display at the Los Angles County Museum of Art, Huntington Library in Pasadena and the Smithsonian in Washington, D.C. Her maternal great-grandfather, Porter Blanchard, a sixth-generation silversmith, was equally talented and is one of the most renowned silversmiths of the Arts-and-Crafts era. His work is also on display at LACMA and The Huntington Library. Together with her business-minded father, a successful shopping center developer, they inspired her as a child and continue to motivate the interior designer today.

ABOVE:
Every detail is important. A favorite quote is embroidered on the pillow—a unique touch. The drapery fringe is from Scalamandré.
*Photograph by Mark Lohman*

FACING PAGE:
This gorgeous French Country kitchen, replete with Walker Zanger tile and a cherished painting of the homeowners' first home in Puerto de Santa Maria, Spain, has a contemporary bent. Construction by Schaub Pacific. Cabinetry by California Designers Choice.
*Photograph by Mark Lohman*

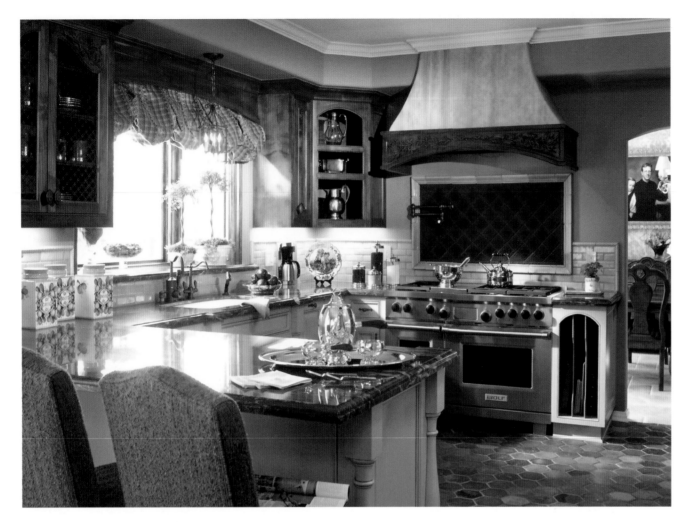

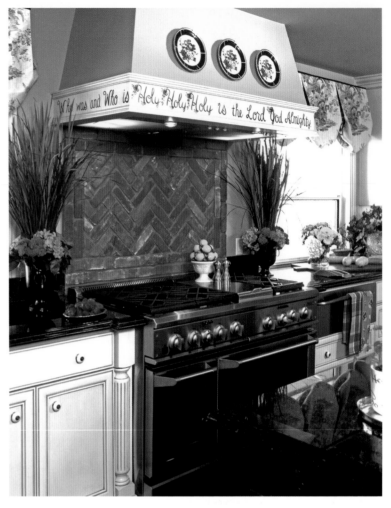

Roxanne remembers nights spent at her grandparents' home while attending the University of Southern California, where the burgeoning designer dreamed up jazzy dresses for friends and sorority sisters. Her grandfather's design advice on the projects she completed then and later at the Los Angeles Fashion Institute proved life-changing. "He told me: 'Good designers know when to stop,' and 'Don't goop it up.' It's some of the best advice I've ever gotten," she says. And, of course, they are tenets of her work today.

With clothing and jewelry on her mind, the native Californian's dream of becoming a designer began to take shape in Paris, France, where she attended the Paris Fashion Institute and the Sorbonne and often found herself in the audience at couture shows at the House of Dior, Yves St. Laurent and Louis Ferraud. But conversations with one of her design mentors, Joan White, led her down the path of interior design. She liked the idea of making something that would last longer than a couple of dresses. Since "home" and all that the word inspires is central to her life, she finds immense satisfaction in creating interesting homes where her clients will live, love and create lifetimes of memories.

ABOVE LEFT:
The French Country kitchen's gorgeous hand carving was custom designed by Roxanne. All hardware is antique from France; the pavers are from a French farmhouse. Construction by Mark Varnum.
*Photograph by Mark Lohman*

ABOVE RIGHT:
Brick warms up the space, yet provides a transitional backdrop for all seasons, while the clients' favorite *Bible* verse provides custom inspiration for the family each day.
*Photograph by Mark Lohman*

FACING PAGE LEFT:
A cozy place to have orange juice and read the paper, this breakfast nook has an antique French pastry table and buffet made with doors brought back from a trip to France.
*Photograph by Mark Lohman*

FACING PAGE RIGHT:
At once cheerful and sophisticated, this Southern Plantation dining room was designed for clients who love to entertain and show true Southern hospitality. Built by homeowner Dave White.
*Photograph by Mark Lohman*

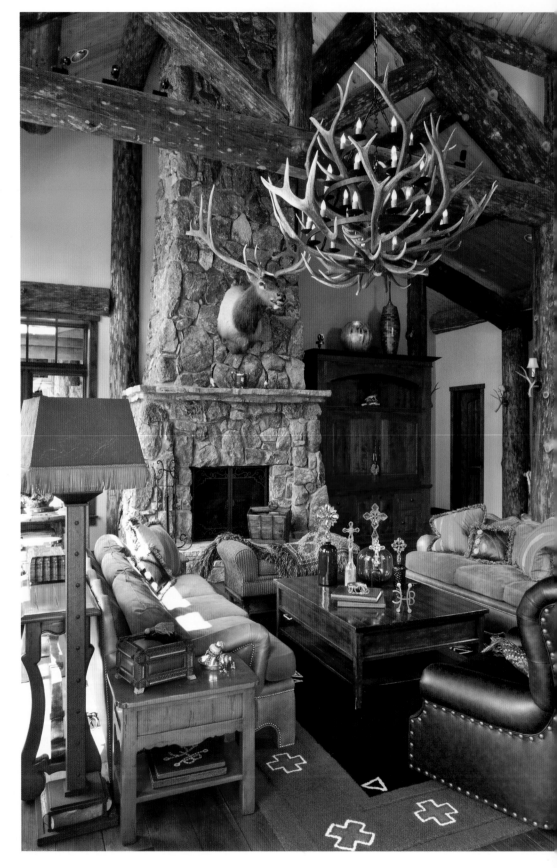

Clients can count on seeing Roxanne's European influence in her designs. A self-described Francophile, she lived not only in France but also Spain, which gave her an eye for detail and one-of-a-kind pieces with a history and flavor with which new things have a difficult time competing. Antiques and vintage accessories are important parts of the rooms and schemes throughout most of her homes, whether for Federal-style manse or Southwestern mountain ranch. She loves exquisite fabrics and custom-made furniture and invests a great deal of time and energy finding just the right pieces for each job, sourcing antiques dealers around the world rather than catalogs or the large gift markets. It is not inexpensive to have a designer, and she will not give her clients anything run of the mill.

Equally important to Roxanne as creating a beautiful home for her clients is making the design process enjoyable for them. What should be a joyous and exciting time in a person's life is too often stressful and difficult, but Roxanne's aim is to give her clients a design journey that is positive, uplifting and life-affirming. She takes pride in being not only a designer, but also her clients' greatest ally, looking out for their best

RIGHT:
The master suite entrance has a custom chest, books hand-wrapped in leather and an antique Native American beaded bag. The custom frame with fringe and railroad tie nailheads makes a fabulous conversation piece.
*Photograph by Mark Lohman*

FACING PAGE LEFT:
Simply stunning, the breakfast nook of a lodge-style home has a custom chandelier, custom table base and antique serving pieces from Germany. Jeff Masters Construction, Mammoth Lakes.
*Photograph by Mark Lohman*

FACING PAGE RIGHT:
Details such as custom branding on the leather placemats, window treatments and matching "branding" embroidered on towels and blankets and painted on books create unique, visual impact.
*Photograph by Mark Lohman*

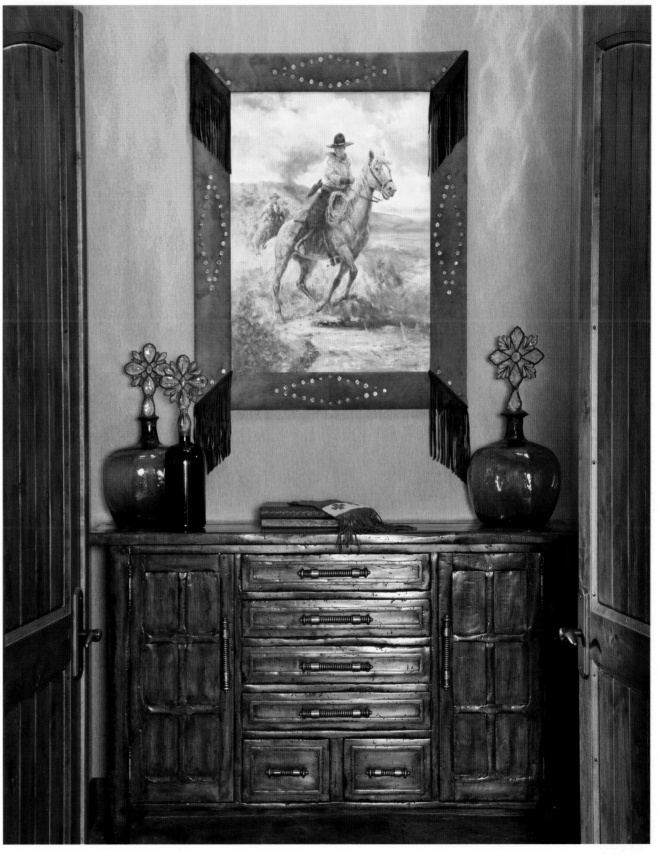

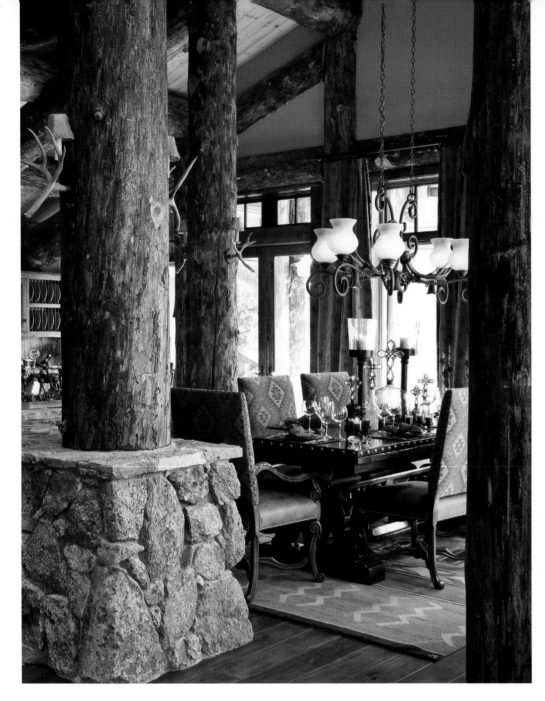

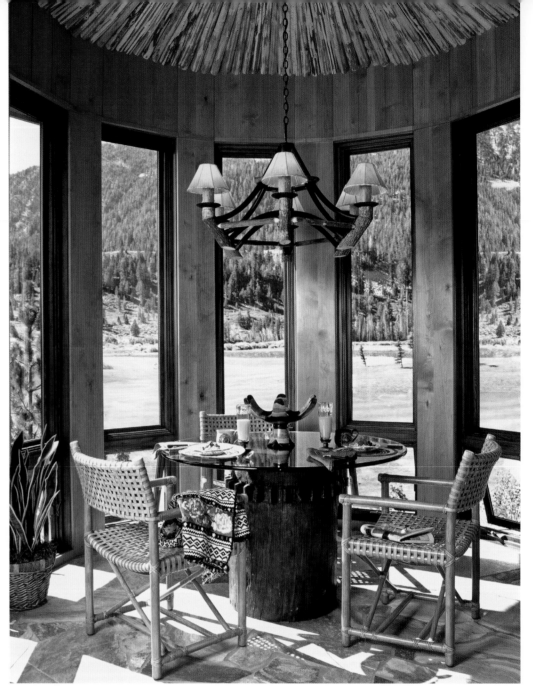

interests every step of the way, from authenticity and detail to cost. And she has a stable of highly skilled subcontractors—like the beader who worked on the costumes for the "Pirates of the Caribbean" movies—who are honest, ethical, reliable and know how to stay on budget and schedule.

The designer takes on only as many jobs as she can personally design herself—that means just three to five large projects start to finish each year. Limiting her business in this way allows her to attend every detail herself, spending months locating the exact right pieces and doing the best possible job. Not that it necessarily takes a long time. She is a very decisive person: She knows what is right when she sees it. For Roxanne, design is instinctive. Not to mention a family tradition—exactly what Roxanne hopes to impart in every home she designs. "I want to set the stage for others to pass their heritage down through the generations. My mission is to use design to give people a backdrop to instill their legacies around the table, be it formal dining room or outdoor picnic."

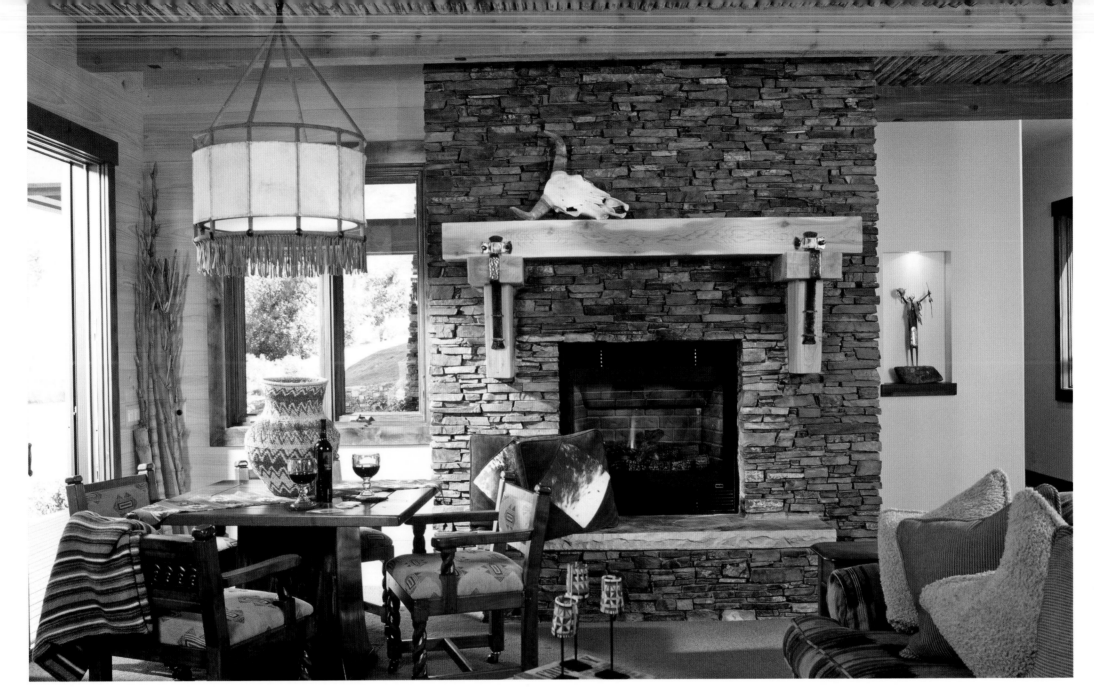

Interior design is not the only way Roxanne shares her talents. Privately, she loves teaching her daughter and her friends about fashion design and her son about art and architecture. She has also written a book, *Shopping in Spain and Portugal*, and her work is featured in numerous books on kitchen and bath design as well as in many magazines, including *California Homes*.

ABOVE:
Designed with her sister, designer Michele Hughes, and mother Linda Hughes, a designer in her own right, the family room of their mountain home features custom iron work and lighting. Architecture by Carl Schneider, CSA, of Santa Barbara.
*Photograph by Mark Lohman*

FACING PAGE LEFT:
The dining room boasts a chandelier with the clients' initials hidden in the ironwork and large glass that beautifully catches sunlight on a gorgeous day. The custom-made silver is by the designer's grandfather's firm, Allan Adler Inc.
*Photograph by Mark Lohman*

FACING PAGE RIGHT:
Built by Jeff Masters Construction, this Santa Fe-inspired home features a split latilla ceiling, a custom chandelier, contemporary chairs and a table with an antique wheel from the East Coast used as the base.
*Photograph by Mark Lohman*

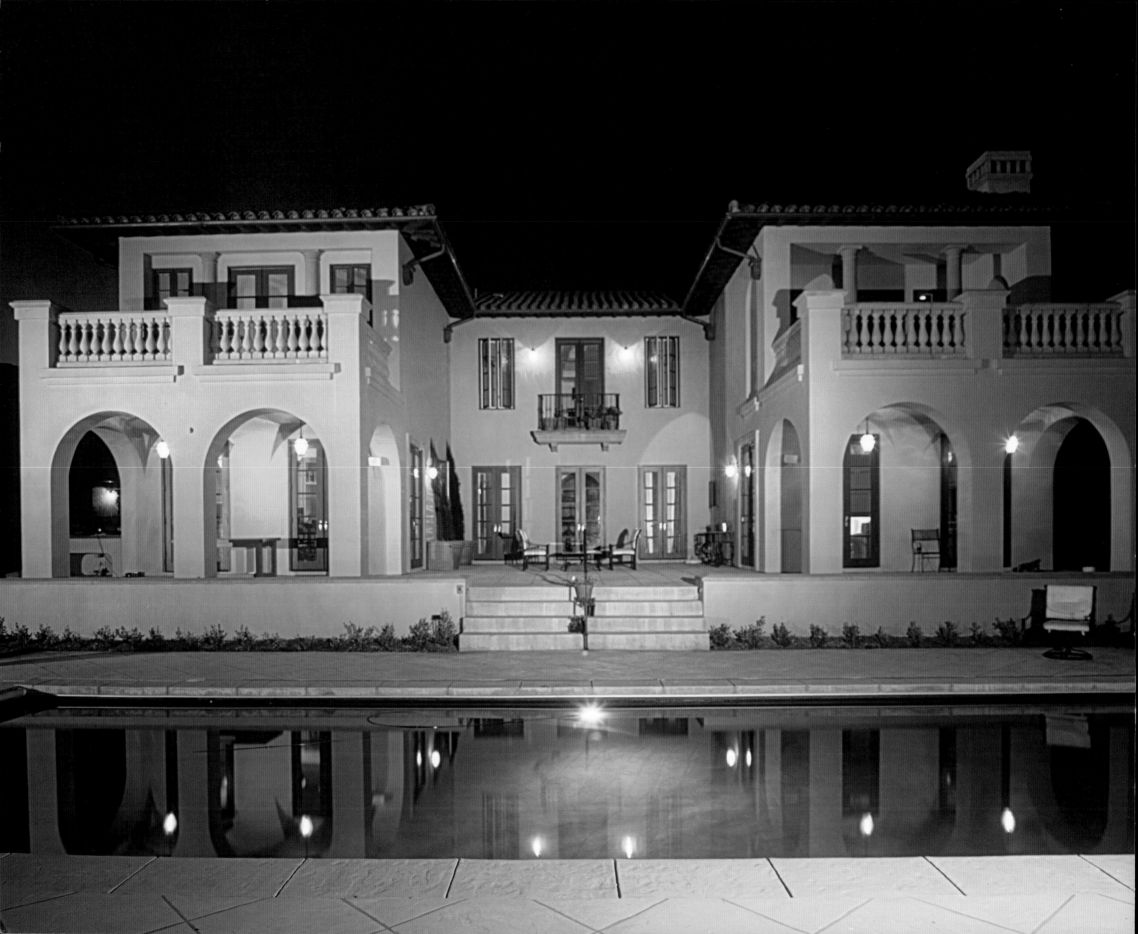

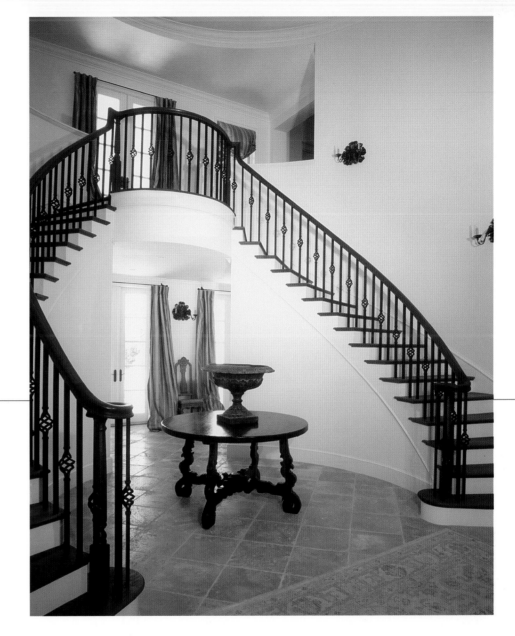

# CARL SCHNEIDER

CSA Architects

Disparate points of view make the world interesting. Varied perspectives give life texture and meaning. They also lend a challenge to an architect's work. And it is the individual ideas about what is important and necessary that makes the job exciting and rewarding for Carl Schneider, AIA. "Everyone has a different take on how to live," he says. "No two families want the same thing." The little nuances are the clues to unraveling the mystery of someone's perfect home—and then giving it to them.

Carl's experience encompasses nearly three decades in the field of professional architecture. He founded CSA Architects in 1993 and has since developed a diversified practice that specializes in residential work, including lavish custom homes, and is focused in the western United States.

The award-winning architect—he received the Pacific Coast Builders Conference Award of Merit in the category of Best Custom Residence under 6,000 square feet and the Las Casitas Housing Excellence

ABOVE:
Hand-forged iron rails, rich hardwood stairs, honed limestone floors and curved plaster walls embrace guests as they enter the home.
*Photograph by Lone Pine Pictures*

FACING PAGE:
Expressing the true warmth and grace of a formal Tuscan villa, the matching second-floor terraces overlook the pool and ocean beyond.
*Photograph by Lone Pine Pictures*

Award for Best Custom Home by the New Mexico Home Builders Association, among others—is not locked into a certain style. He does, however, find satisfaction in taking older, traditional styles and reinterpreting them with contemporary elegance.

That enthusiasm for mixing old and new may have been influenced by one of his early mentors, the respected Barry Berkus. Carl credits his time working with Barry with stirring his creativity and instilling in him a high level of professionalism. He continues to draw on his experiences from that time, striving to blend traditional and contemporary styling with the of-the-moment wants and needs of his clients.

Another early influence: his grandfather. A third-generation Californian, Carl grew up in Sonoma County. His grandparents lived in the far northern part of the state, on a 400-acre ranch set among the lava beds. He recalls his grandfather building a series of 15 hay barns using lava rocks as the foundations and large tree trunks for the structures, and bearing witness to such creation seeded Carl's architectural aspirations.

In a bit of a tribute to those old barns, Carl recently completed a project in Mammoth Lakes that incorporates a large rock discovered during excavation as part of the foundation—an interesting and sustainable treatment for the deck off the master bedroom.

LEFT:
Rectangular plaster forms punctured with horizontal and vertical openings interplay with subtle color shifts to create an ever-changing display of light and shadow.
*Photograph by Scott Zimmerman*

FACING PAGE TOP:
Upon arriving at the motor court, the peaked form pays homage to the nearby Mount Olympus.
*Photograph by Scott Zimmerman*

FACING PAGE BOTTOM:
The volumes interconnect from first to second floor, creating an interesting play of light and form. The polished concrete floors are one of the many sustainable features expressed.
*Photograph by Scott Zimmerman*

As do many firms today, CSA believes that designing projects with natural, sustainable features is in the best interest of both client and community. In fact, CSA designed the first building in Santa Barbara County that incorporates a geothermal loop system for heating and cooling. A more recent project includes a hot water radiant floor heating system and a photovoltaic system on the roof. But like everything else in the design process, the extent of Green depends on the client.

Clients are the priority at CSA. And they choose the firm both for design and service. Carl believes that even the simplest project requires an artistic hand. In some projects aesthetics and personal character rise to the top. In others, it is communication and function that take the stand. Regardless, the professionals at CSA believe in balancing functional problem solving, communication, artistry and desire to achieve a successful project. And they pride themselves in providing the best service possible.

Carl has kept his firm small—six people—and takes on only as much as he can handle personally in order to provide undivided, personal attention to each project. At larger firms, a project might be handed off numerous times through the process, but Carl stays on every job from start to finish, making himself available by phone or email around the clock and fostering the client-architect connection from first meeting to move in.

"Design is important. Design sells. That's absolutely part of the equation," he says. "But in the end this is a service-oriented profession. If you can make your clients happy, they'll tell someone."

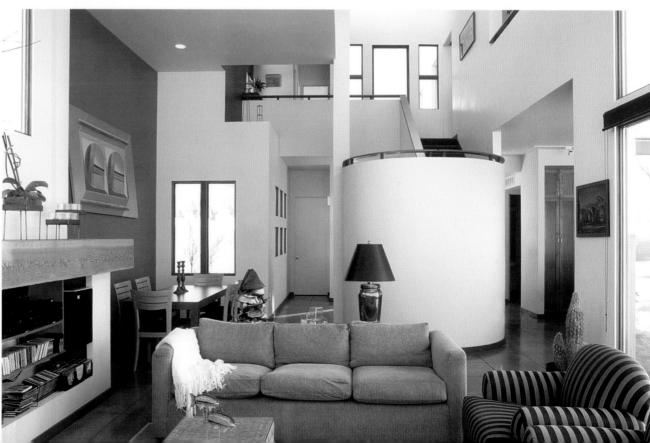

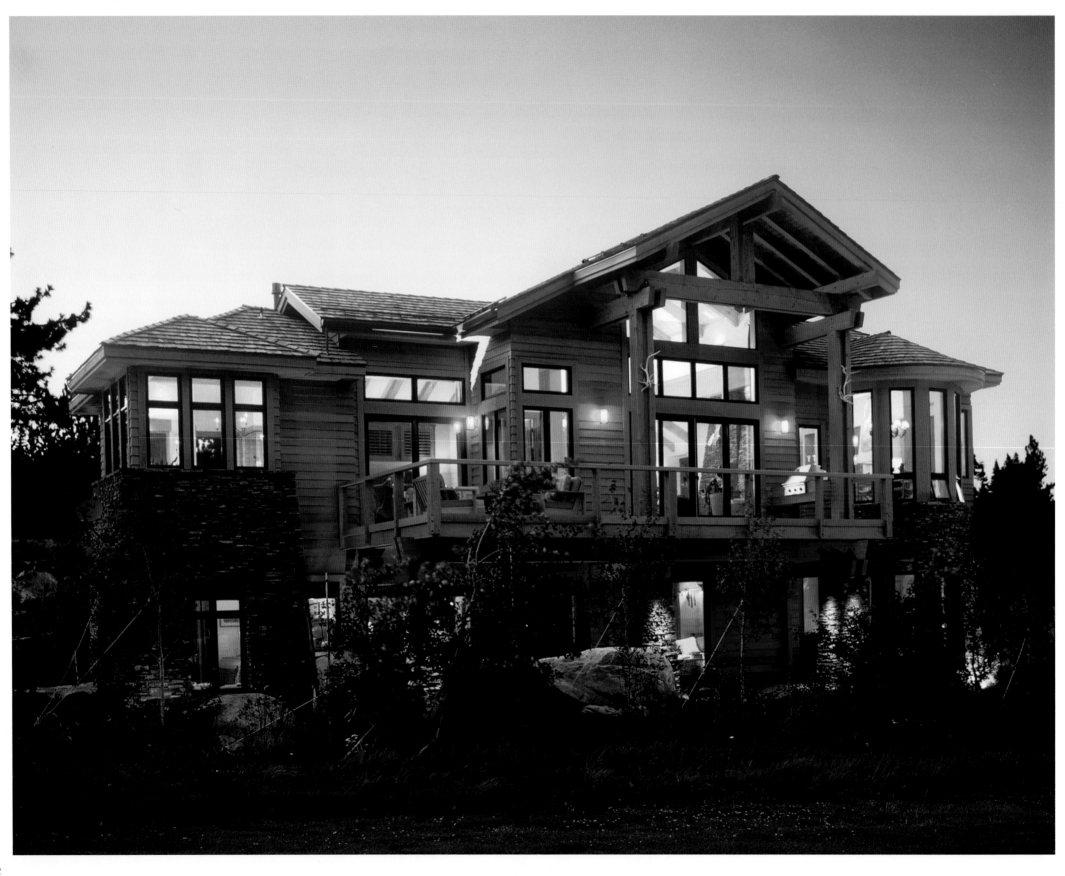

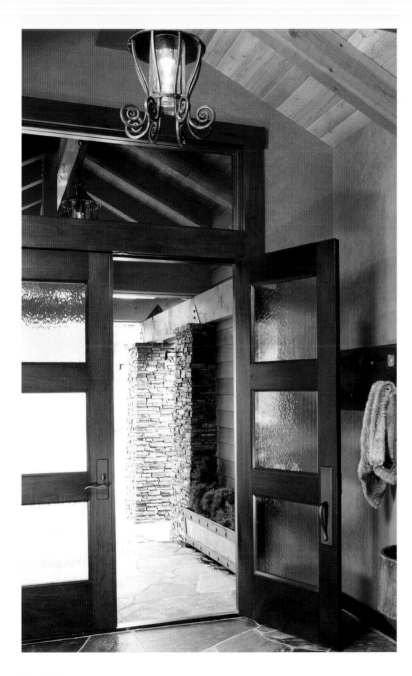

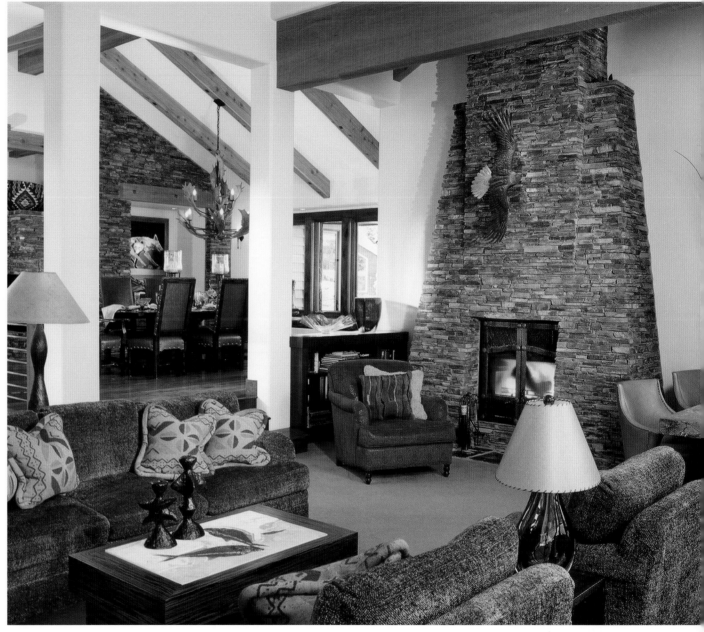

ABOVE LEFT:
Custom interior features—designed by the interior design team of Linda Hughes, Michele Hughes and Roxanne Packham—match the architecture's high level of detail.
*Photograph by Mark Lohman*

ABOVE RIGHT:
The exterior's stacked stone forms and cedar timbers lend themselves to the home's warm, friendly ambience, making it well-suited to serve as a showcase for the owner's varied art collection.
*Photograph by Mark Lohman*

FACING PAGE:
At dusk, stacked stone forms, timber framing and the warmth of the interior are expressed to the golf course and the Sherwin Mountains beyond.
*Photograph by Mark Lohman*

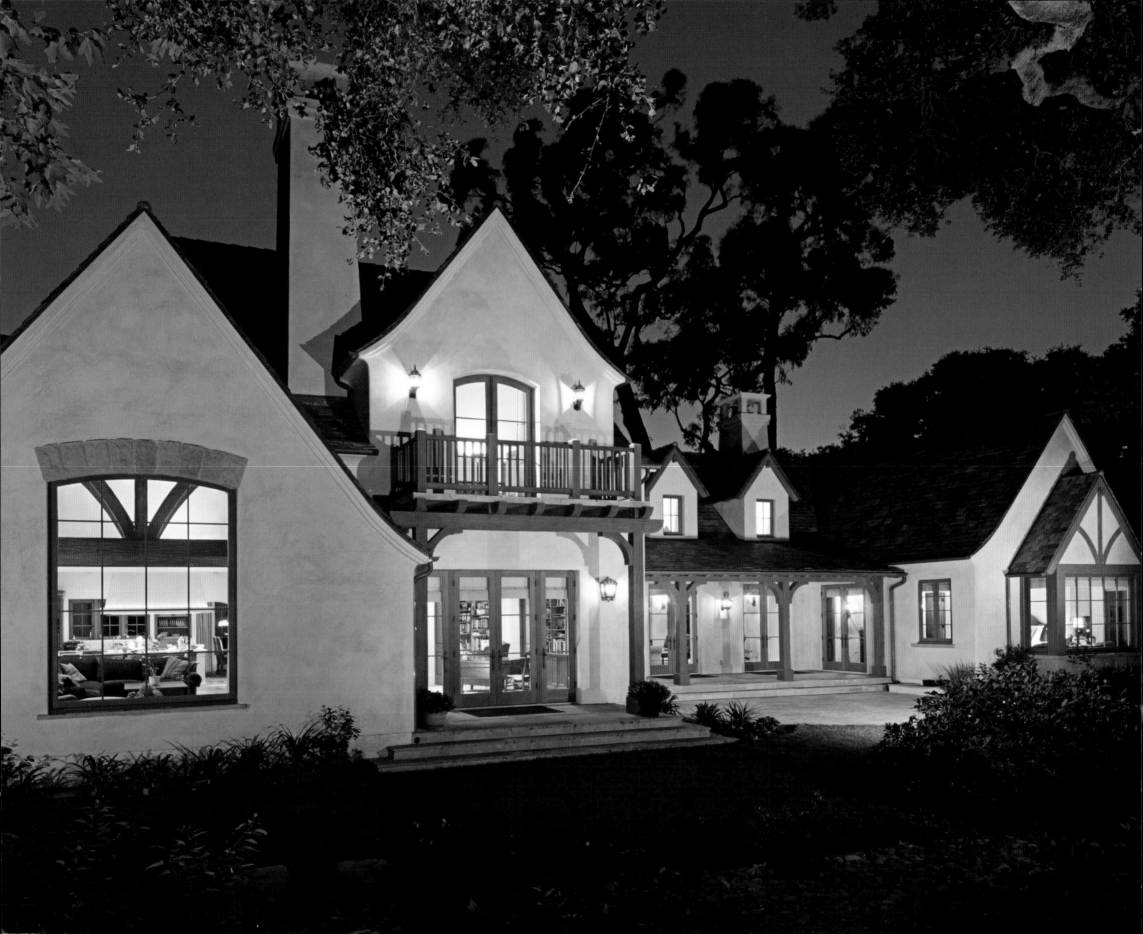

# ROBERT P. SENN

Santa Barbara Architecture, Inc.

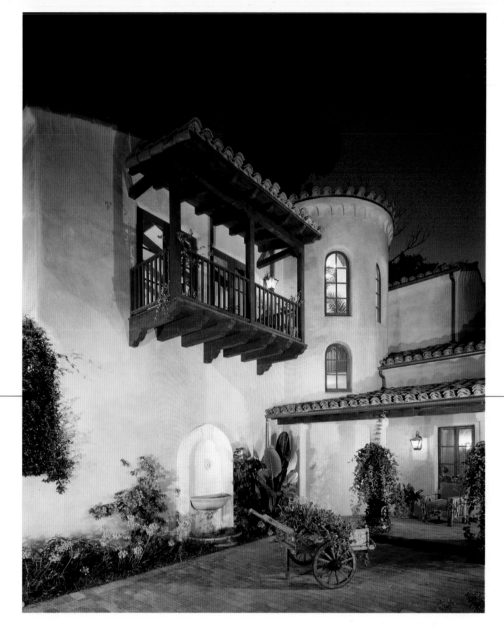

Robert Senn, architect, is one of the lucky ones. He has been committed to architecture since he first saw Palladio's Villa Rotunda on a family vacation to Italy at the age of 12. His formal education culminated in a Master of Architecture at the University of Washington in Seattle after which he returned home to Santa Barbara, California, where, for more than two decades, he has designed luxury homes, estates and gardens. As a native of the area Robert has an innate understanding of the history, lifestyle and architectural nuances that make the area special. In the last decade Robert has completed custom estates and major renovations to fine properties in Santa Barbara, Montecito, Hope Ranch, Brentwood and Pacific Palisades. He continues to study both traditional architecture and emerging technologies as they relate to fine residential architecture.

ABOVE:
Designed in the Spanish Colonial Revival vernacular, this Montecito Valley Ranch home features a Monterey-style balcony off the master suite, a circular stair tower, traditional courtyard and handmade two-piece barrel-tile roof.
*Photograph by B&K Photography*

FACING PAGE:
Located in a Montecito oak woodland, this multigabled French Country home has authentic detailing, heavy timber framing and a slate roof.
*Photograph by Waldo Winters, Perrin Mutchnick*

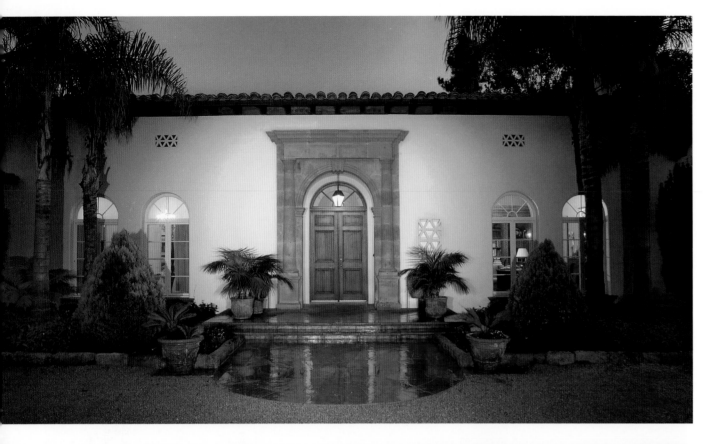

With the goal of impeccable authentic design, his firm, Santa Barbara Architecture, specializes in traditional architecture including Tuscan, Spanish Colonial Revival, French and English Country, as well as American Vernacular styles, such as Craftsman and Cape Cod. His firm also draws from classic estates of the '20s and '30s, which gave birth to the most exquisite residential architecture in Southern California. These estates looked to Europe for historical roots and a sense of poetry and romance. It is this sense of poetry and romance for which Robert has an extraordinary passion and talent.

Robert believes traditional architecture is timeless. He honors the look and feel of traditional European homes by incorporating courtyards, loggias, thick walls, arches, beamed and vaulted ceilings, Old World hardware and antique finishes. His desire is to create authentic homes and gardens that, when finished, have the look and feel of a historic property. Robert feels it is critical for his homes to be faithful to their historical style. At the same time they emphasize modern, open floorplans and natural light with the use of multiple French doors, large traditional windows and extensive outdoor entertaining areas.

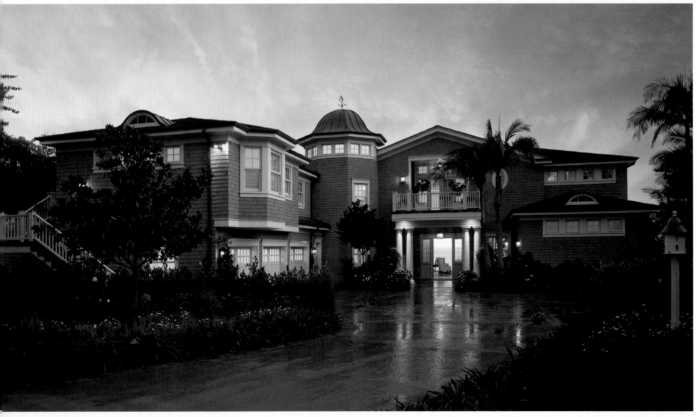

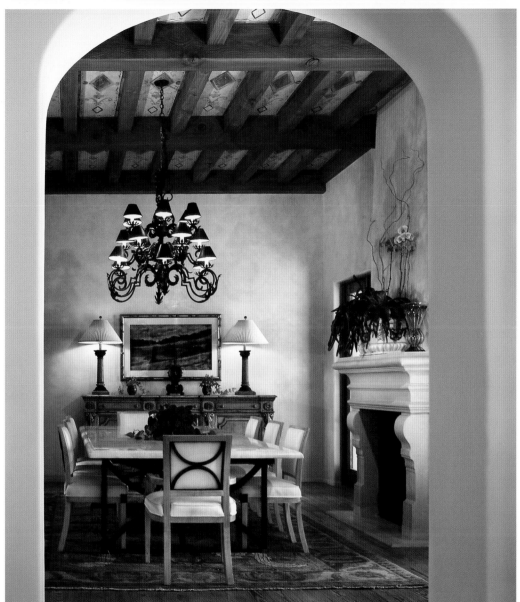

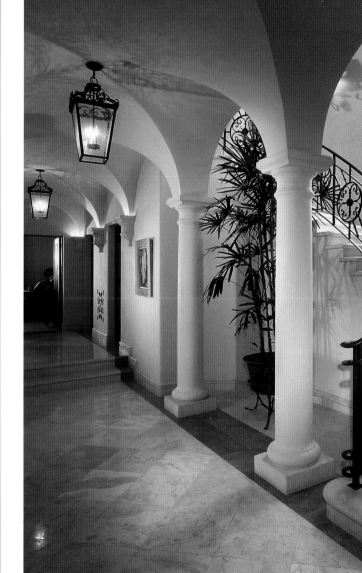

Robert's clients are more impressed with simple elegance rather than ostentatious designs. They have traveled the world and appreciate Old World authenticity. Robert provides that authenticity while accommodating their modern lifestyles. The tagline for Robert's firm is: "Making history one dream at a time"; it is a statement that conveys his commitment to fulfilling his clients' dreams, as well as honoring architectural traditions of the past.

ABOVE LEFT:
The Roman-style dining room of a White Stallion Ranch residence in Thousand Oaks features a hand-carved mantle, beamed and stenciled ceiling and antique walls.
*Photograph by Deco Group*

ABOVE RIGHT:
In this groin-vaulted hall, travertine columns and slab stair treads are accented by the elliptical wrought iron railing.
*Photograph by Deco Group*

FACING PAGE TOP:
This Tuscan-style home boasts a hand-carved Italian Renaissance stone entry surround. The proportions of the Birnam Wood Country Club residence's entry and Roman arched doors and windows were inspired by Palladio's I Quattro Libri dell'Architettura.
*Photograph by Group 4 Photography*

FACING PAGE BOTTOM:
A copper domed stair tower and eyebrow windows complete the architecture of this Cape Cod, Shingle-style oceanfront home in Carpinteria. Enchanting views of the Pacific are showcased by the living room's 30-foot-wide opening featuring lift and slide pocket doors.
*Photograph by Jim Bartsch*

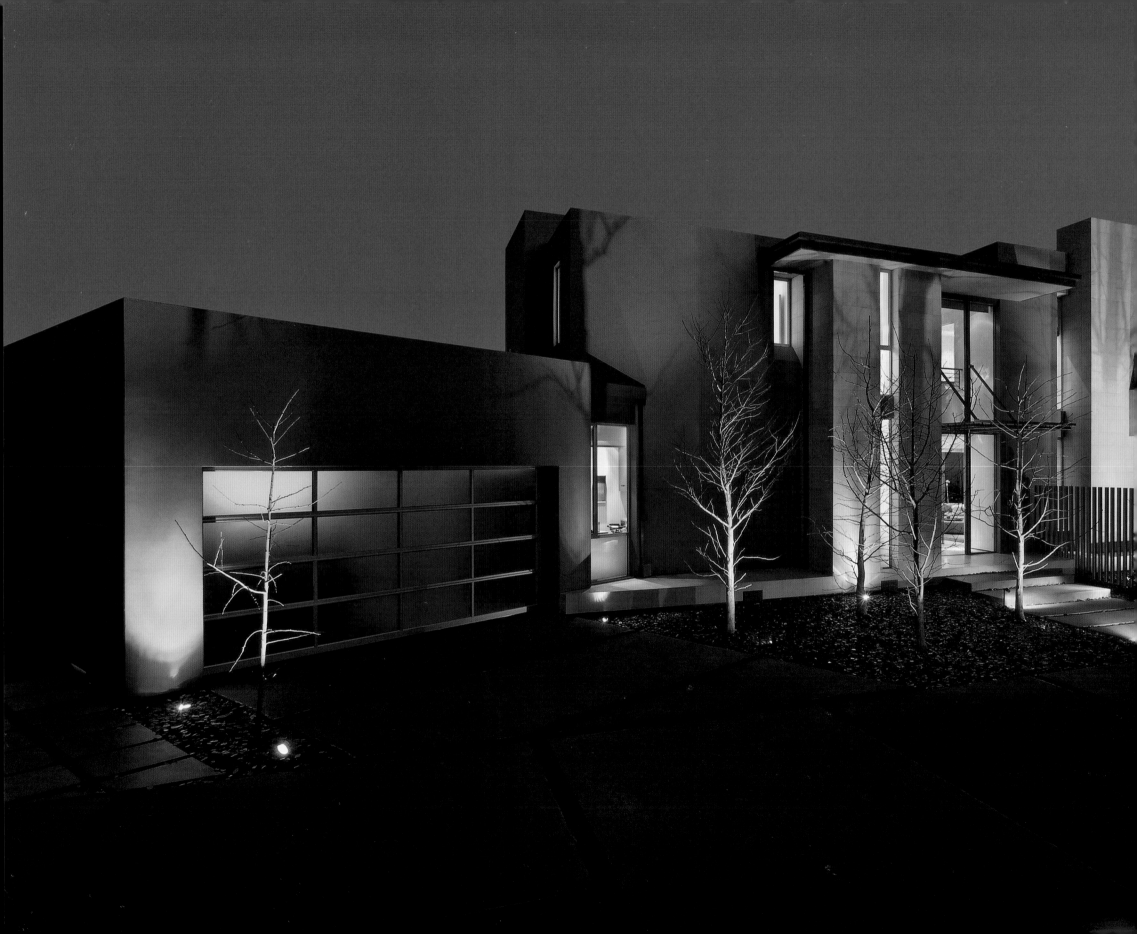

# RUSSELL SHUBIN
# ROBIN DONALDSON

Shubin + Donaldson Architects

Sustainability is an idea with multiple resonances. It is a philosophy that increasingly shapes the human experience, informing everything from legislation to produce selection. For Shubin + Donaldson Architects, sustainability is more than a philosophy of architecture. It is a challenging responsibility. Principals Russell Shubin, AIA, and Robin Donaldson, AIA, adhere to the belief that the more they build, the better the planet can become. As paradoxical as this thought may seem, the firm's passionate team of architects reinforces this belief by continually designing spaces and experiences that enhance environmental, social and intellectual well-being.

The firm's success is facilitated by its collaborative studio environment, which encourages and promotes an atmosphere of experimentation and intellectual discourse. Its commitment to technological and artistic exploration fuels the search for creative, innovative and process-oriented design

LEFT:
The monumental scale of this residence comes from the juxtaposition of heavy monoliths and transparent surfaces.
*Photograph by Ciro Coelho*

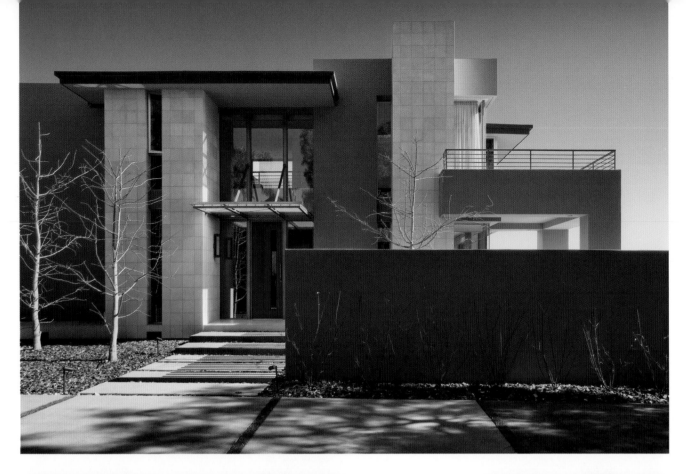

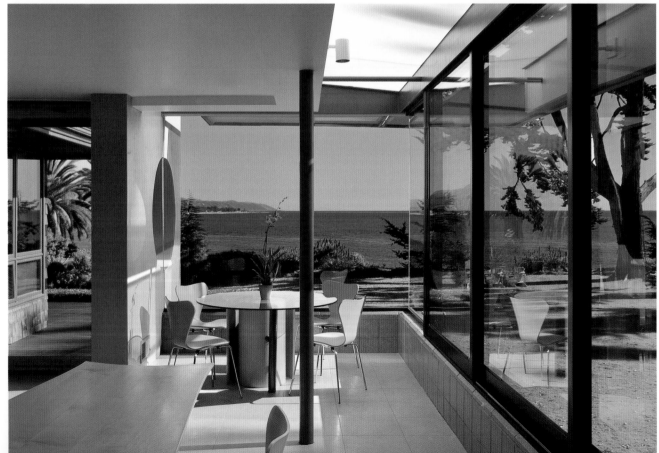

solutions. With base offices in Culver City and Santa Barbara, California, and an additional studio in Baja, Mexico, the firm collectively conceives and develops residential, commercial and civic commissions throughout and beyond these regions.

Shubin + Donaldson demonstrates a singular reverence for each site, believing that environmental stewardship requires respect for a project's natural habitat and ecology. A rigorous analysis and thorough investigation of concept-shaping elements, such as landscape, light and views, inform and define the formal, structural and experiential direction of each design. With every design, the Shubin + Donaldson team explores the unique features of each individual site, effectively expressing its valuable attributes while enhancing the user's experience of the finished project. By remaining so closely attuned to a project's surroundings, the architects promote an architecture that imbues the site with a heightened sense of identity.

TOP LEFT:
This modestly sized house appears monumental because of perceived space that is captured by expansive views and integrated living with the outdoors.
*Photograph by Ciro Coelho*

BOTTOM LEFT:
In this residence a "glass pavilion" was created to establish a direct relationship with the site.
*Photograph by Ciro Coelho*

FACING PAGE:
The view though the front door of this residence sets up an almost cinematic relationship with the ocean in the distance.
*Photograph by Ciro Coelho*

Each project is individually and particularly conceived—precluding a homogenized style—and reflects the pursuit of a refined clarity. The principals contend that powerful expression should not necessarily imply elaborate or complex design. Rather, the firm's award-winning designs encourage simplicity, deriving bold and dramatic solutions from both context and clients.

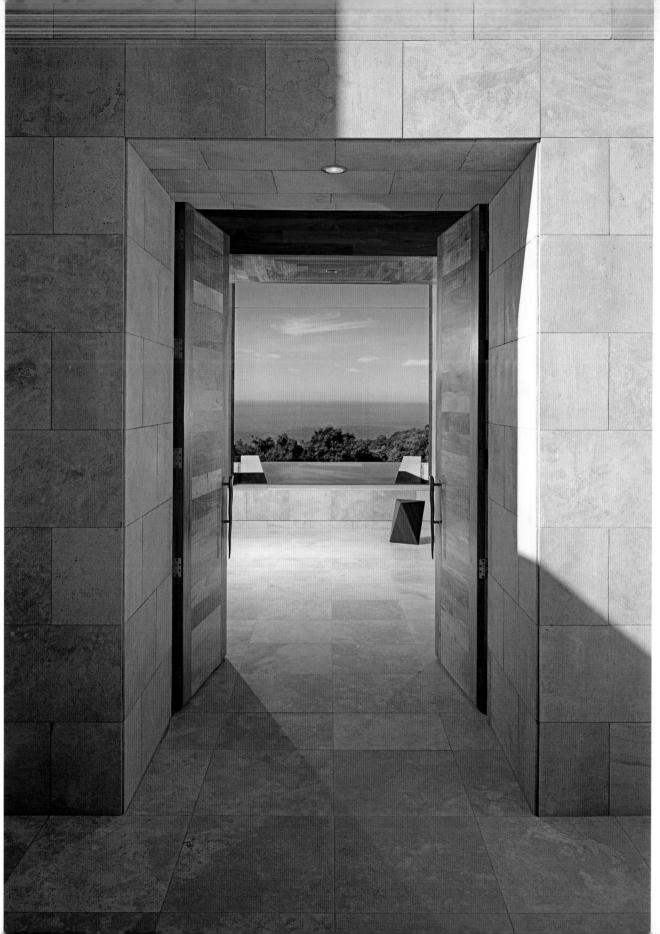

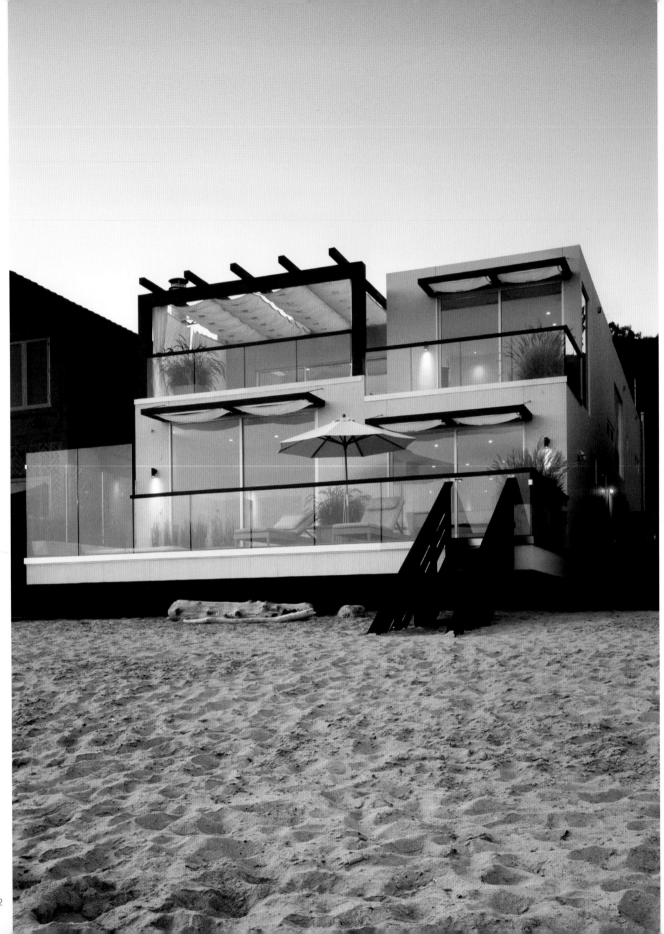

The team affirms that its clients are indispensable to each project, aiding as conceptual catalysts in the development of every design. Shubin + Donaldson contends that fulfilling clients' needs and desires, while providing meaningful and responsive designs that bring them joy, is a fundamentally sustainable principle. To truly endure, a design must not only be regionally appropriate, but also functionally and aesthetically fulfilling to its users. The team strives to create designs that complement and support the lives envisioned by each client.

LEFT:
This residence is meant to mediate between the density and chaos of the Pacific Coast Highway, and the experience of living on the edge of the Pacific Ocean.
*Photograph by Tom Bonner*

FACING PAGE TOP:
This outdoor room can be modulated with adjustable sail material surfaces to capture various degrees of view, privacy and sun.
*Photograph by Tom Bonner*

FACING PAGE BOTTOM:
This residence carefully choreographs the public and private aspects of living on the beach. The master suite provides dramatic views of the ocean without relinquishing any privacy.
*Photograph by Tom Bonner*

Shubin + Donaldson believes responsible and efficient design consideration is a strong determinant in the future of architecture. The architects maintain that there are passive and active strategies to Green design, in terms of the technical aspects and the outward expression of the design. The team works to integrate all building elements into a cohesive design that thoughtfully respects the site and landscape. Responsible techniques and consideration are essential to each design concept, allowing the design team to maintain functional, aesthetic and intellectual integrity, in harmony with the desires of the clients.

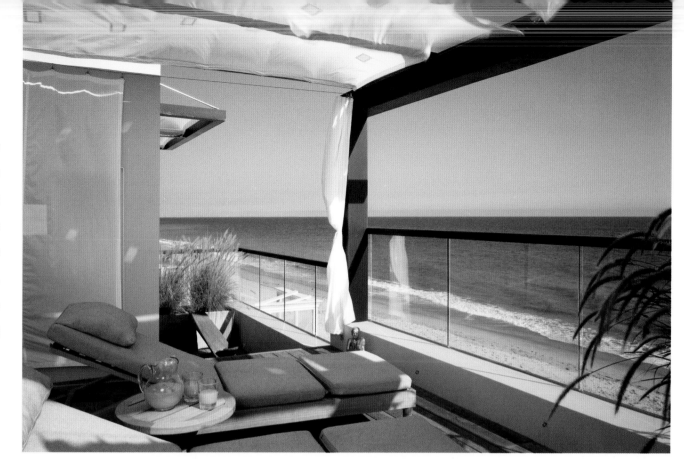

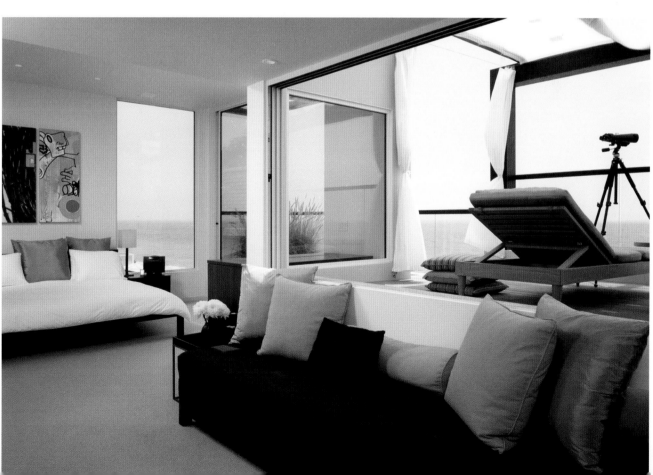

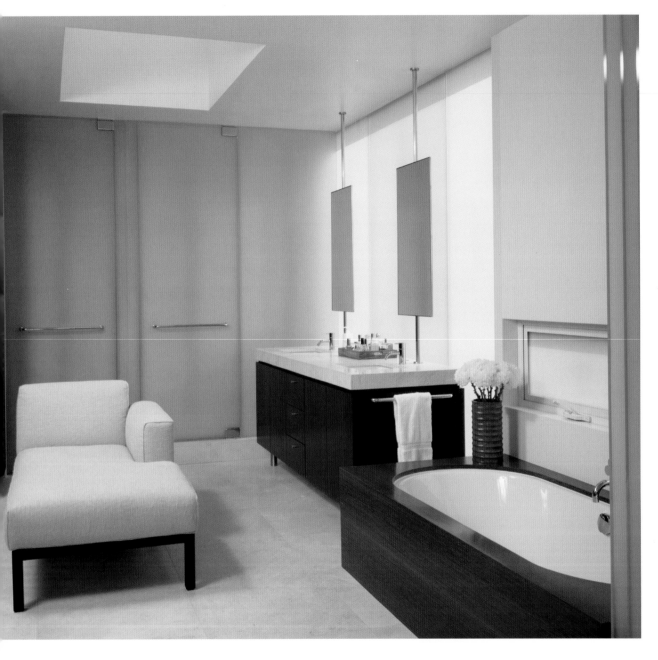

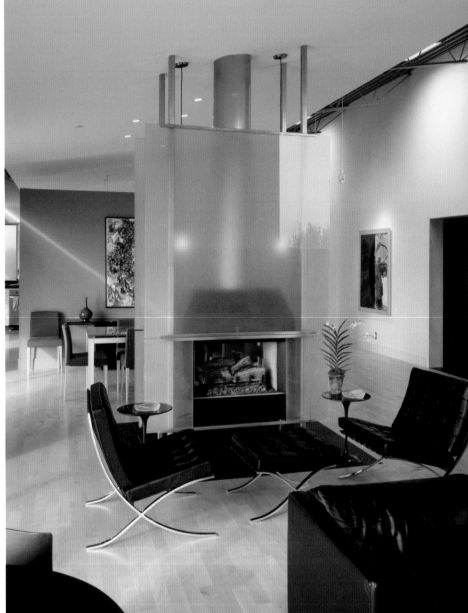

The scope of Shubin + Donaldson Architects' efforts is broad-reaching. From creating artful custom homes to participating in the design of sustainable communities, the firm maintains a deep interest in the positive effects that its projects can have on community growth while preserving local character and ecosystems. Recognized by numerous national and international publications and with multiple design awards from the American Institute of Architects, Shubin + Donaldson Architects is making a profound impact on the profession. The firm's intelligent, efficient and evocative architecture confirms that environmental considerations and comfort can harmoniously coexist.

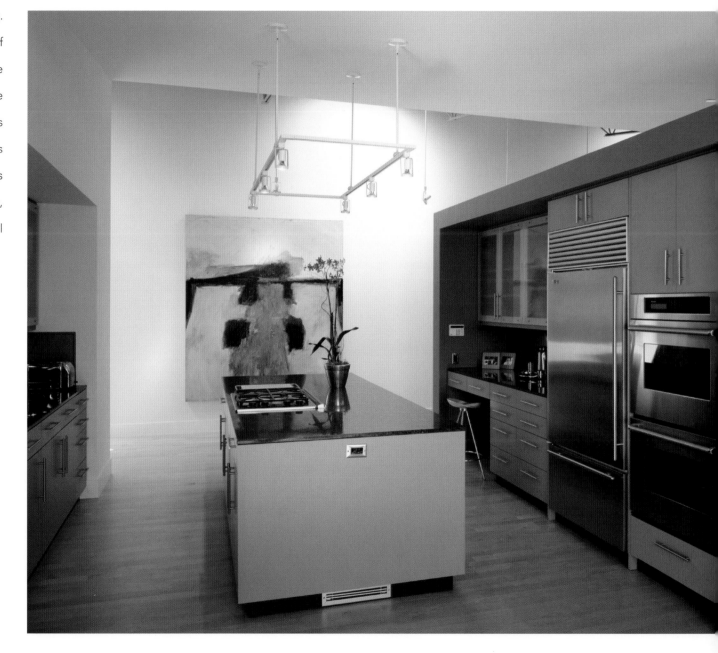

RIGHT:
The kitchen of this residence blends utility with clean aesthetics and a gallery corridor that passes along its far end.
*Photograph by Tom Bonner*

FACING PAGE LEFT:
The master bath of this residence was designed to function like a luxury spa nested within a private home.
*Photograph by Tom Bonner*

FACING PAGE RIGHT:
This residence borrowed basic warehouse technology to create a suburban loft for housing a stunning collection of Southern California art.
*Photograph by Tom Bonner*

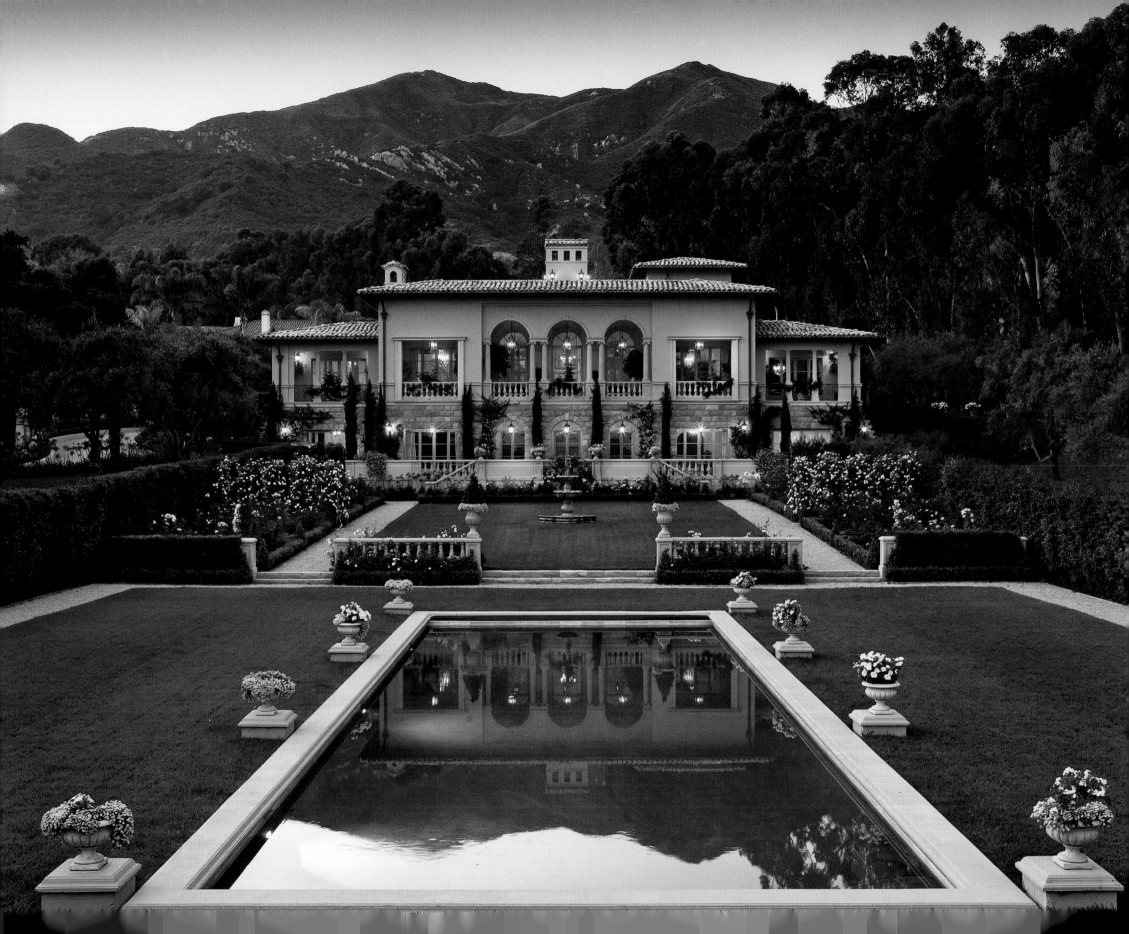

# Jon Sorrell
# Mary Lou Sorrell

Sorrell Design

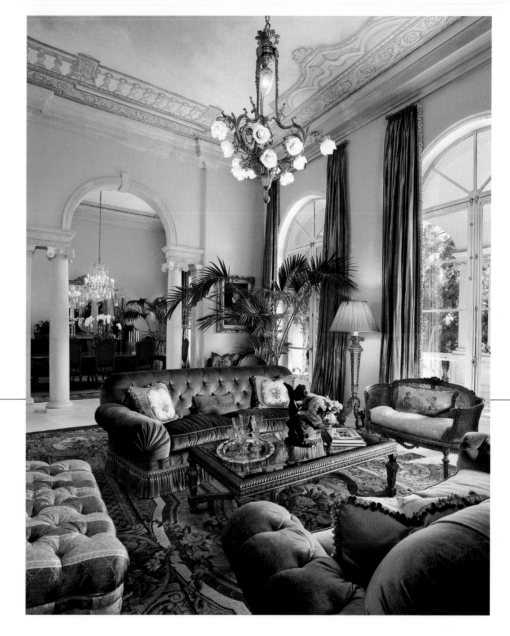

ABOVE:
Antique lighting fixtures, ceiling murals and classical detailing comprise the living room of Villa Beaumont.
*Photograph by Jim Bartsch*

FACING PAGE:
Villa Beaumont is an Italian-Renaissance country villa and gardens, in the genre of 16th-century architect Giacomo de Vignola.
*Photograph by Jim Bartsch*

The appeal of historical architecture has led many knowledgeable homebuyers in Santa Barbara to search Montecito or Hope Ranch for an original George Washington Smith, Reginald Johnson or other surviving examples of Montecito's golden age of architecture. Unfortunately, the search all too often ends with the realization that the home they seek is probably unattainable, or far too expensive for their budget.

One alternative is to recreate in a new home what is admired in the old. Another is to remodel an existing, generic Ranch-style or contemporary home, restyling it into one with historic validity. To those ends, many communities are dotted with new historic-style homes, some better than others, but in most cases the recreations fall short. This is because it is difficult for the untrained eye to see why a collection of architectural elements has not added up to an architectural masterpiece. The

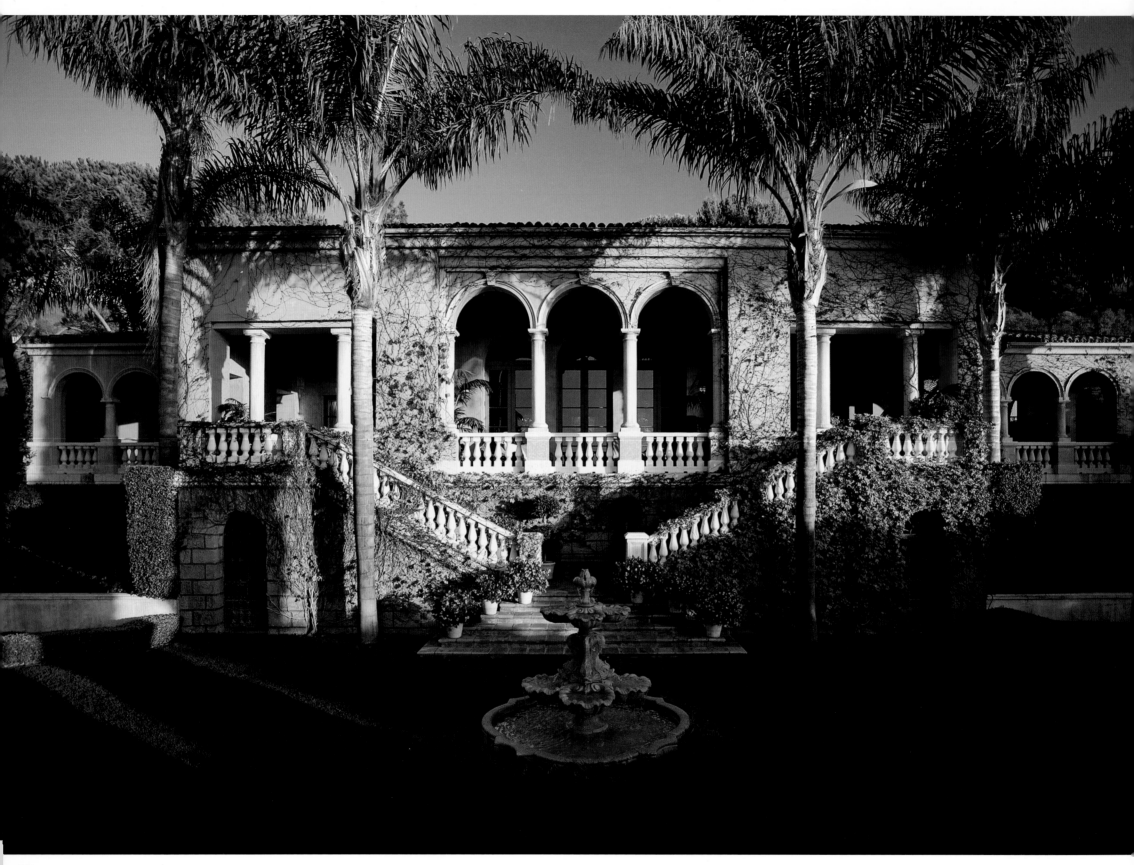

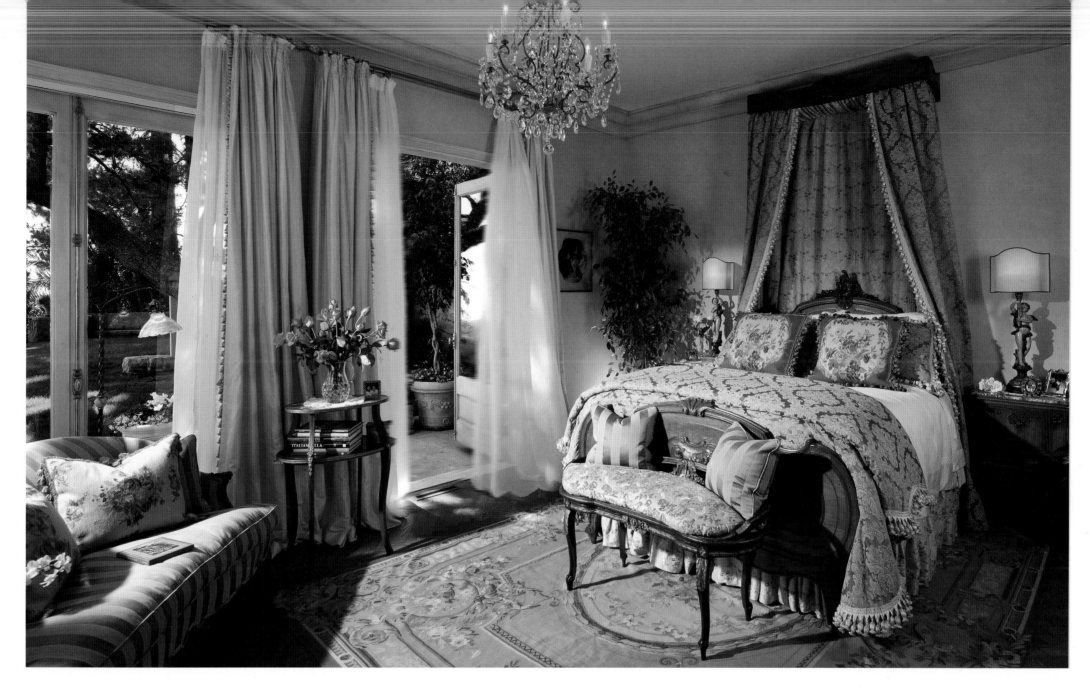

arches and tile roof are there, the multipaned windows, Tuscan columns and cornice mouldings are in place. Yet the all-important elements of proportion and scale are missing. While often quoted, truly, "God is in the details."

Jon and Mary Lou Sorrell, a husband-and-wife team, have each been designing historically inspired homes for almost 30 years, with upwards of 100 completed examples between the two of them. Sorrell Design, located on Coast Village Road in Montecito, includes the services of two licensed

ABOVE:
A very refined, Neoclassical residence and gardens, Villa Vecchia, in upper Montecito, has expansive sea views from its master suite.
*Photograph by Jim Bartsch*

FACING PAGE:
Only 17 years old, but looking 200, Il Paradiso is a small Renaissance villa and gardens in Montecito, inspired by the 16th-century Villa Farnese at Caprarola, Italy.
*Photograph by Jim Bartsch*

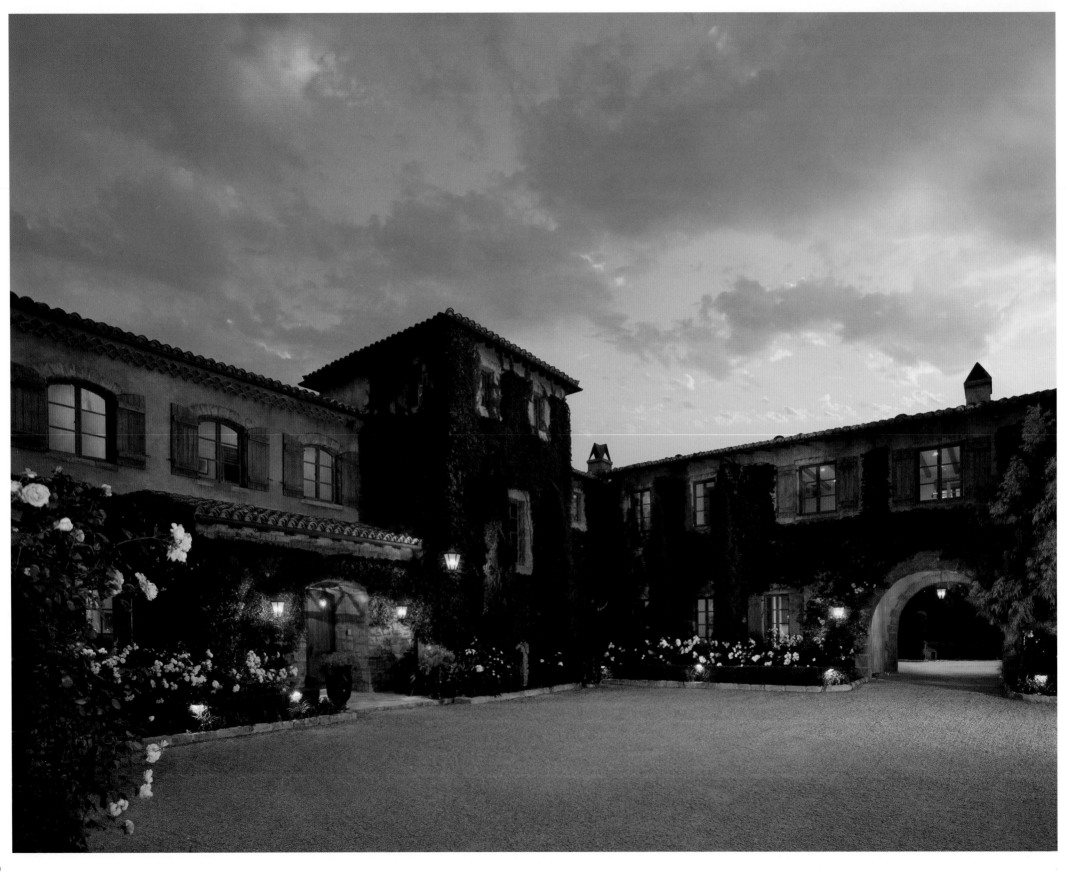

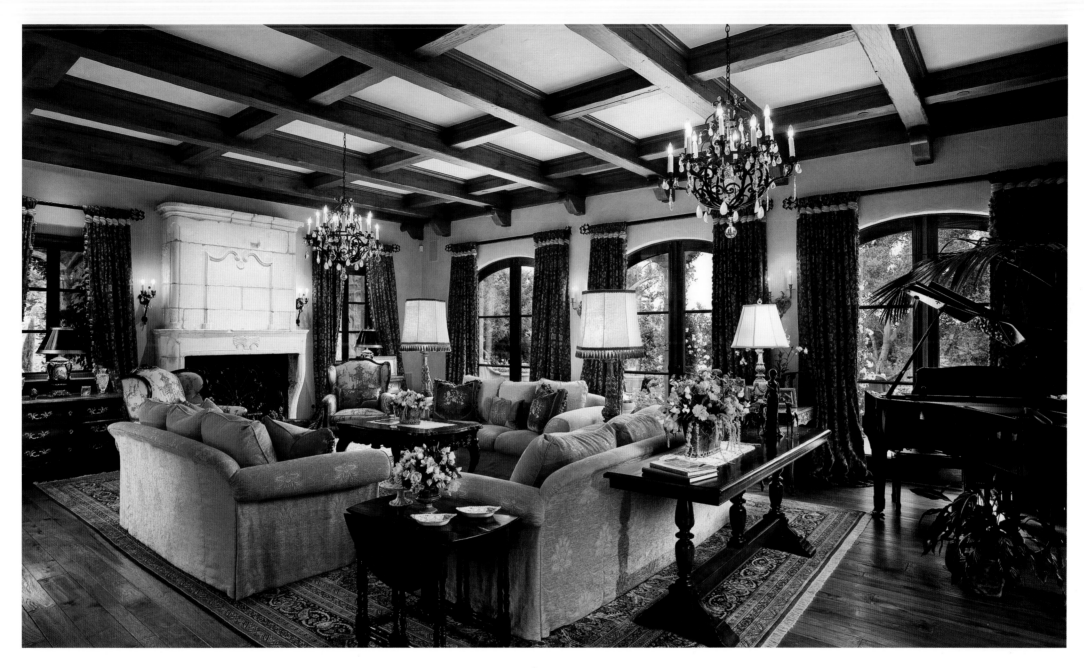

architects, a degree-holding landscape designer and an interior designer/decorator, along with several CAD specialists and draftspersons. Though small in size compared to many design firms, the combined talents of Sorrell Design's team have led to a body of timeless architectural design, second to none in coastal Santa Barbara, Montecito, Hope Ranch and the surrounding environs.

While the preponderance of Sorrell-designed homes over the years has been of the Mediterranean genre—the signature style of Santa Barbara—it has always been a challenge to overcome

ABOVE:
The grand salon of La Vie en Rose has a 17th-century limestone fireplace—one of seven in the home—centuries-old beam work and French doors that lead to the gardens.
*Photograph by Jim Bartsch*

FACING PAGE:
La Vie en Rose, an 18,000-square-foot, stone Provençal manor house, has seven acres of enchanting gardens and took five years to design and construct.
*Photograph by Jim Bartsch*

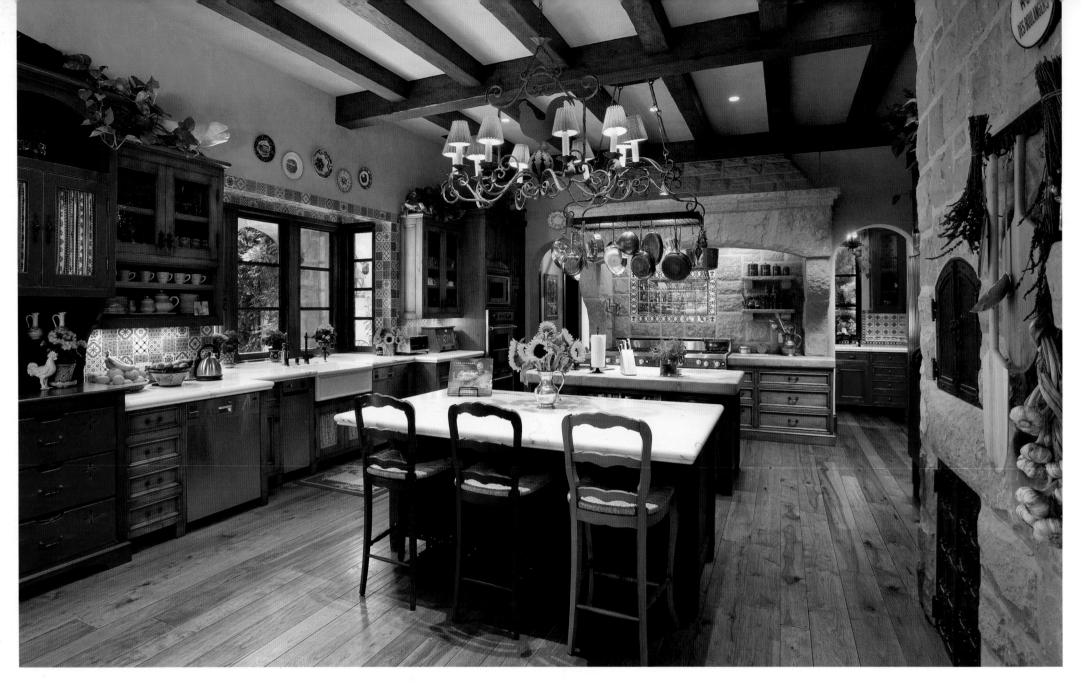

the shortcomings of most historic homes. These failures typically include dark interiors, over-compartmentalization, kitchens designed for staff, less than adequate master bedrooms and baths, and lack of true indoor-outdoor living areas. The firm's forte are southern-facing loggias and tree canopies to temper the California sun, rather than pulling the drapes, plus maximum views and door access to gardens and exterior entertaining areas, without compromising historic proportion and scale.

Included among Sorrell Design's clientele have been the heads of two major motion picture companies, entertainment industry celebrities, corporate leaders, billionaires and an extensive list of "normal" clients desiring the most authentic recreation of historic-style homes in the Santa Barbara area. Most of Sorrell Design's clients have come to the firm by referral, few by competing against other practitioners on a basis of fee.

Unlike many practicing architects and designers, who have rarely—if ever—built a home for their own account, Jon and Mary Lou have designed and built numerous such projects, learning budgeting, construction efficiency, field design improvement and cost control in the process. Such work place experience is invaluable, like an experienced surgeon, who has mastered his art, as opposed to one who knows the fundamentals but has actually performed few surgeries "hands on."

Besides the years of experience and the consequential portfolio of beautiful projects, Sorrell Design's team effectively offers clients a far easier approach to the design and construction of their new home, since all phases—architecture, landscape design and interior design/décor—are handled within one firm. The resultant "single signature" design stands a far greater likelihood of "work of art" status than the typical input from separate design professionals.

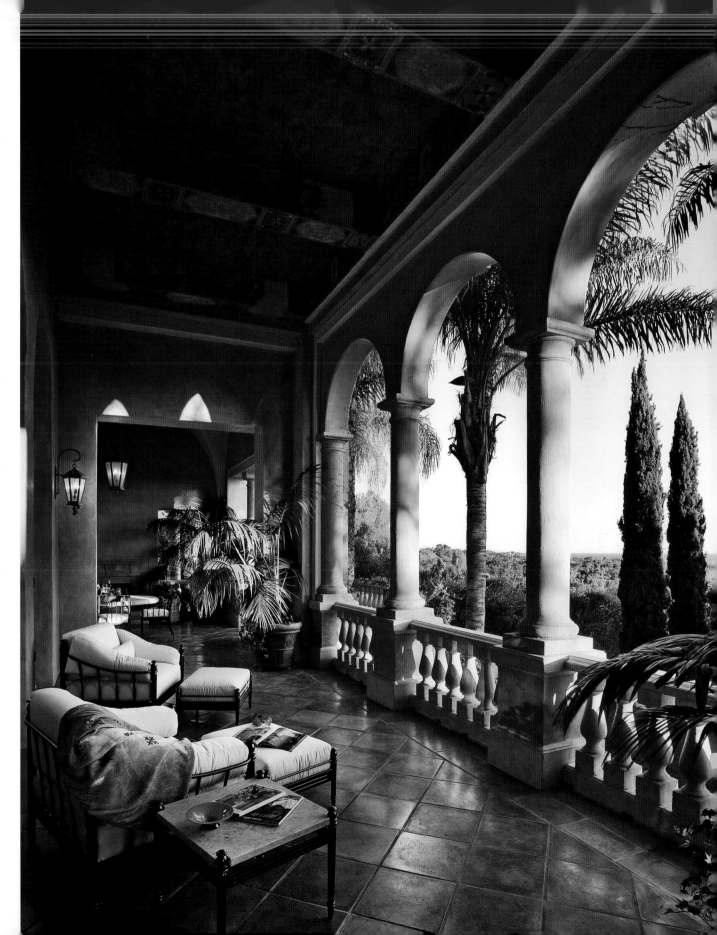

RIGHT:
The grand, ocean-view loggia of Il Paradiso oversees the expansive formal gardens.
*Photograph by Jim Bartsch*

FACING PAGE:
The La Vie en Rose kitchen, has Carrera countertops, ancient beams and an extensive use of native sandstone quarried on the site.
*Photograph by Jim Bartsch*

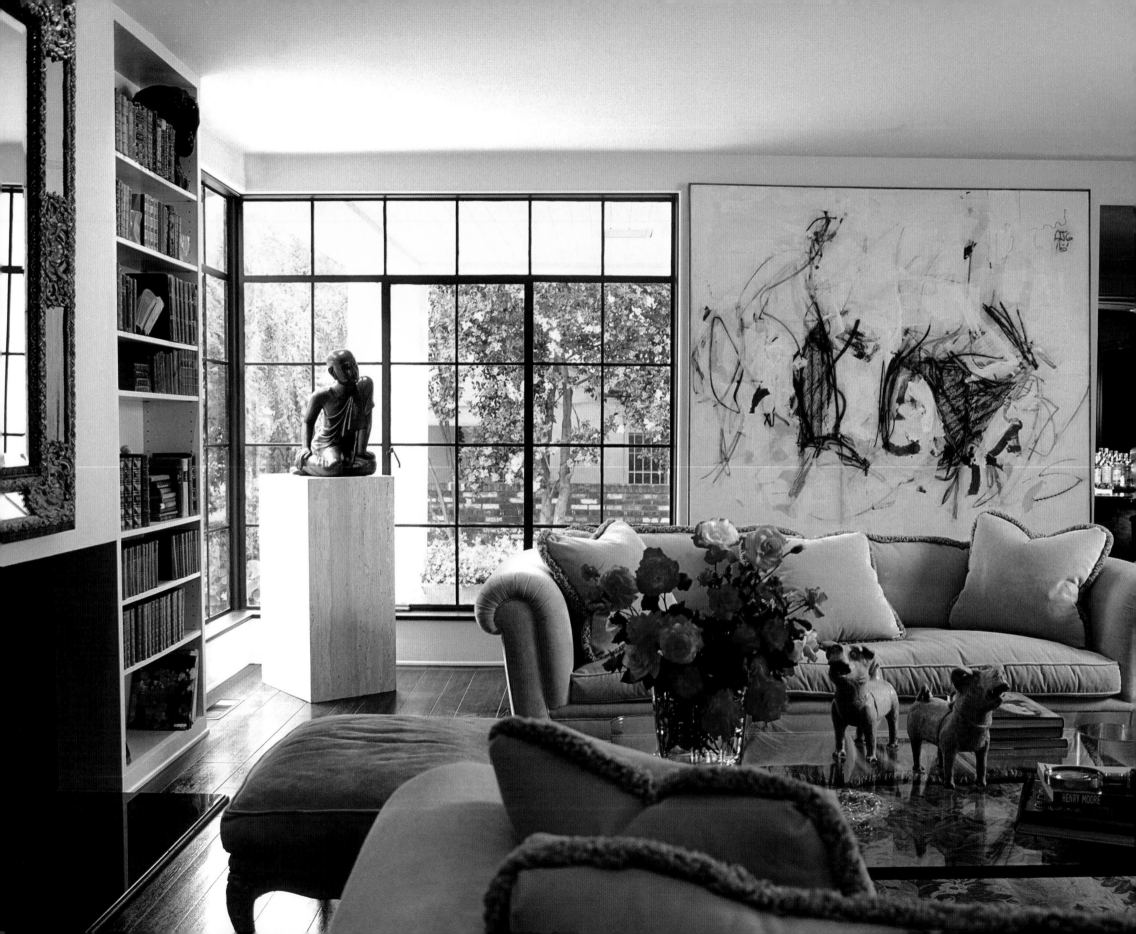

# MARK WEAVER

### Mark Weaver & Associates, Inc.

ABOVE:
Inspired by the 1940s, the interior's design highlights artwork by William T. Wiley.
*Photograph by Diane Woods*

FACING PAGE:
This elegant, casual living room was created to showcase the homeowner's collection of eclectic artwork and artifacts.
*Photograph by John Vaughn*

From a classic Paul Williams house in Beverly Hills to a traditional, antique-filled Brentwood residence; from an art-filled Tuscan villa for a Montecito family to a sophisticated townhouse on London's Cheney Walk, Mark Weaver & Associates has brought out the best in hundreds of distinctive residences throughout California, the United States and abroad.

In his 30-plus years as an interior designer, principal Mark Weaver has earned an impeccable reputation as well as a sophisticated clientele that comprises about 80 percent repeat clients—weighty testament to his considerable talent and congenial personality. He earns lavish praise from those for whom he designs, including one client who says Mark "calms nerves and creates miracles."

And those miracles take many forms. Mark creates houses from the ground up, working with architects, contractors and landscapers and helping clients make hundreds of decisions; he does remodels, in

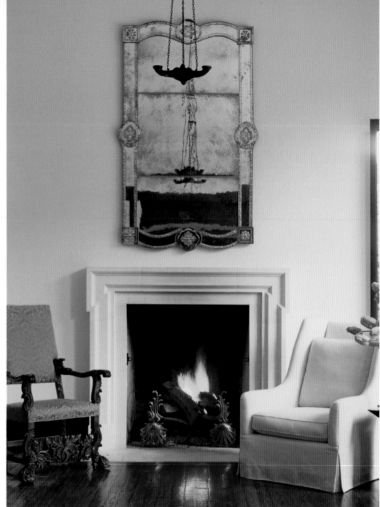

which he remedies existing problems; and he can be called in to simply transform a space from plain to pretty. Mark does not have a "look" but rather every project is client driven, and rather than identifying with a particular genre, the designer likes to characterize his style as attention to detail, quality and sense of scale and proportion. Whether in Nantucket or New York, California or Kauai, he does not design to the day's fashion, but rather to what is right for the residence and its architecture, setting and surroundings.

Working with a small team and drawing inspiration from the house he is working in, Mark tends toward interiors that are uncluttered and tailored, with a realistic mix of luxury and practicality. Clients range in age and lifestyle, providing him with the opportunity to be creative and original for a wide range of people. Resources all over the world allow for an infusion of the unexpected, and the designer takes shopping trips abroad several times a year to find the perfect pieces. He loves the depth and mood created when ancient pieces and antiquities are mixed with modern pieces and modern art. Adding a couple of 19th-century antiques to an otherwise contemporary room, for example, can lend it edge and drama and prevent it from being too studied.

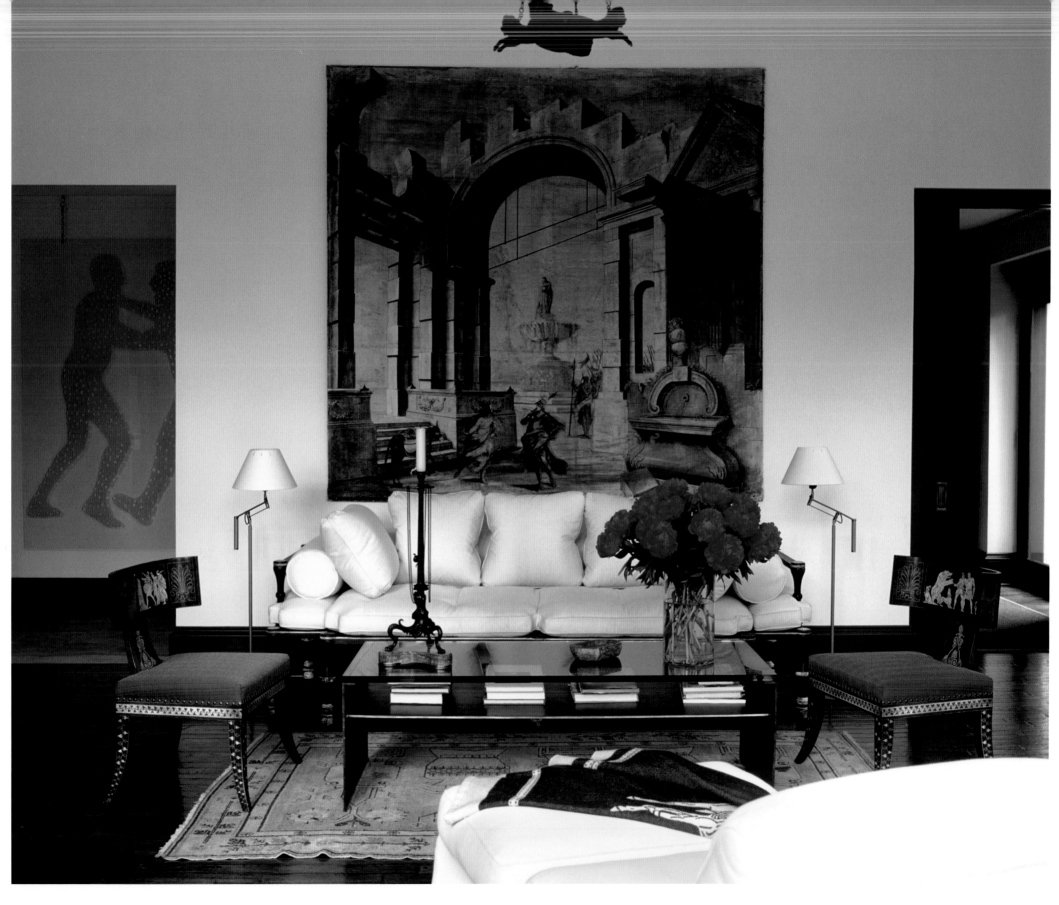

Successful design is always an active collaboration between designer and client. To that end, Mark approaches every project with an open mind and a willingness to listen to the client. He is quick to note that he is not the sole proprietor of brilliant ideas, and in determining the direction of a project, he allows everyone a voice. Sometimes, something seemingly irrelevant can become the driving force in a design, helping the designer to deliver work that is utterly unique.

Mark opened his interior design practice in the early 1970s and today has offices in Santa Barbara and Los Angeles. A native of Southern California, he began his career when the field of interior design was in its infancy and has watched it go from an exclusive privilege for the wealthy few to a media phenomenon and right of the masses. Clients are more knowledgeable about colors and textures and scale. They appreciate details and materials, they know great design when they see it, and they have ever-increasing demands.

The designer finds the heightened awareness challenging and exciting, and interacting with his clients is the part of his job he enjoys most. And though the design journey can be a long one, Mark understands how to smooth the way. Making clients feel comfortable, sorting through their myriad likes and dislikes, discovering their personal style, then giving them spaces where they will feel relaxed and nurtured is the most rewarding part of the profession for this interminable talent.

RIGHT:
This Tuscan villa in Montecito is replete with a pool pavilion and beautifully manicured gardens.
*Photograph by Robert D. Vallely*

FACING PAGE:
The gracious terrace overlooks the California countryside and the ocean beyond.
*Photograph by Tim Street-Porter*

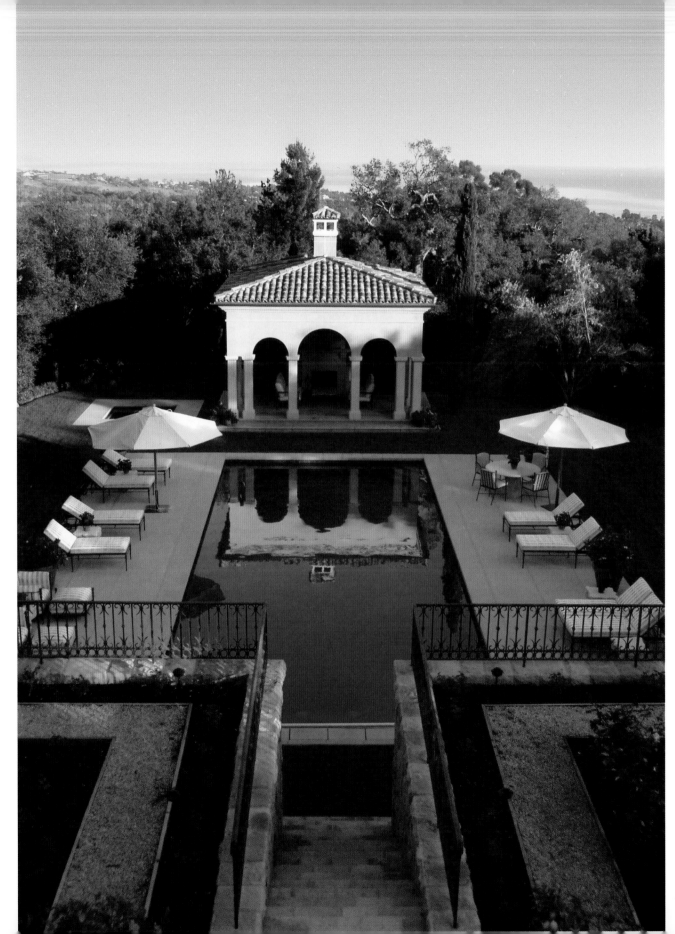

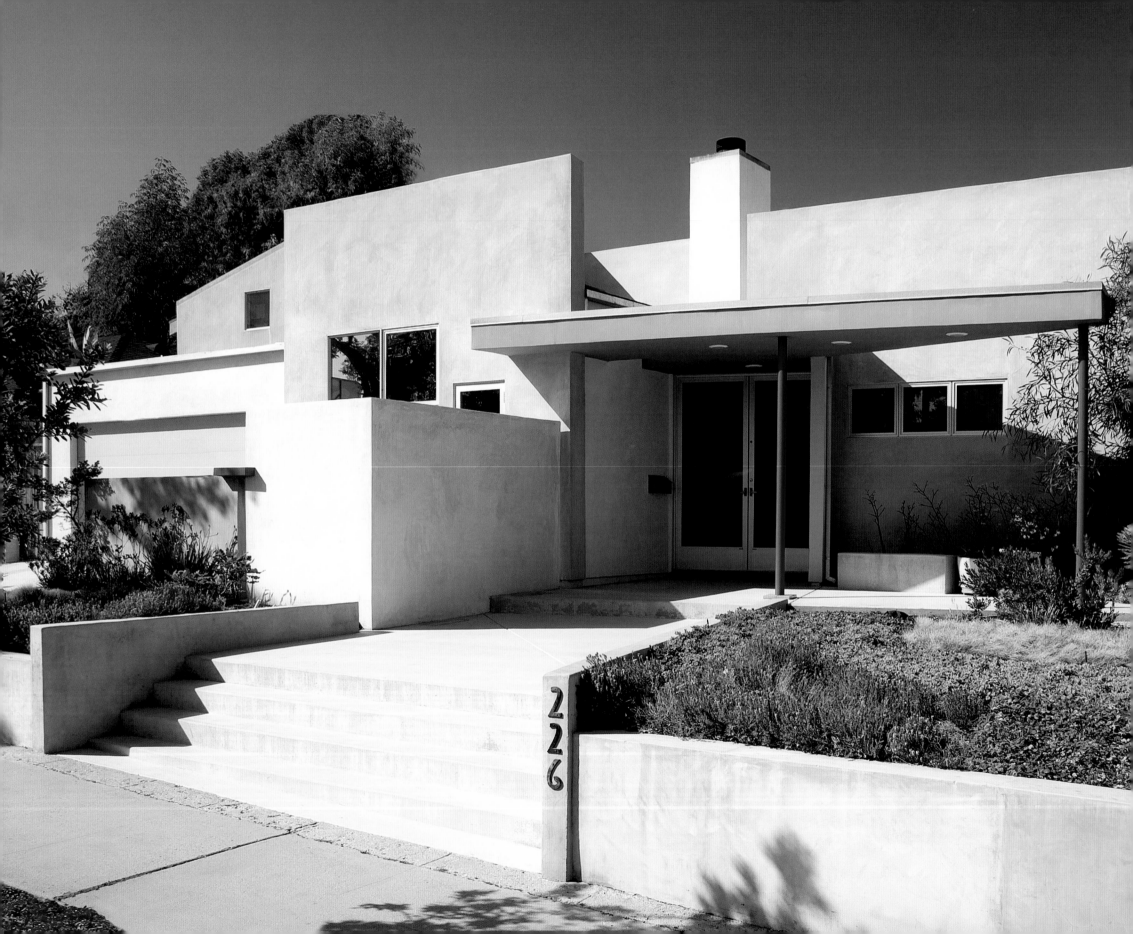

# MARK WIENKE

Mark Wienke Architect, AIA

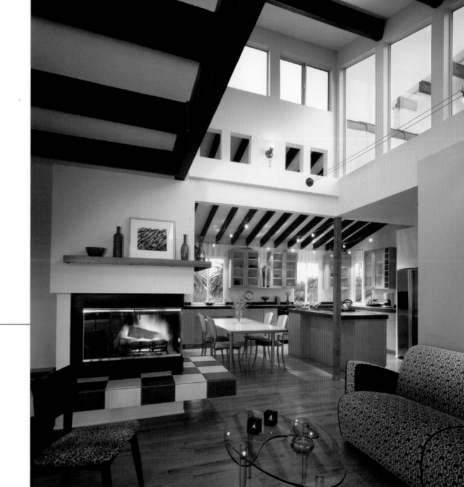

Whether you are talking about food, fashion, people or architecture, layers are key. They make things interesting, add depth and texture, and draw us in, often surprising and delighting us.

Mark Wienke, AIA, has found that using this design technique allows him to create wonderfully light-filled spaces. Fundamentally modern in technique and spirit, the houses that Mark designs are creative, exciting and innovative. Each is a complex and deliberate layering of forms and spaces. Planes and elements overlap to engage and delight. It is a deliberate act of choreography that invites you in and entices you throughout the homes.

Mark received recognition early on in his architectural career, when, as a student at the University of Illinois at Chicago, his thesis project team was awarded the prestigious Franklin R. Smith Memorial Award. After graduation, he was awarded the Roche Scholarship to study architecture in Europe. Upon

ABOVE:
A clerestory window tower "pop-up" that floods in natural light and provides cross ventilation was utilized in the great room of the 1,900-square-foot Wienke-Cohen house.
*Photograph by Art Gray*

FACING PAGE:
The 2,100-square-foot, one-story house uses a green roof plane to create a porch as well as provide a connection between distinct elements.
*Photograph by Jim Bartsch*

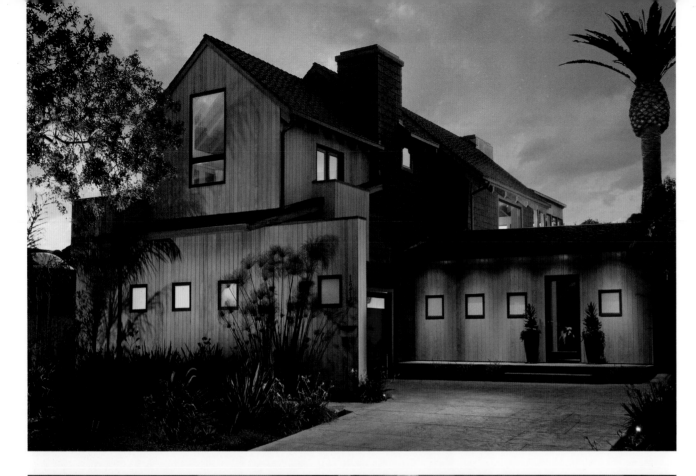

his return, he began his professional career working for Skidmore Owings and Merrill in both the Chicago and Washington, D.C., offices. He eventually returned to the Chicago area, where he opened a highly successful design-build firm. In 1988, he, along with his wife, photographer Nancy R. Cohen, and their two dogs, moved to Santa Barbara. After working as a senior designer for two prominent Santa Barbara firms, Mark opened his own architectural firm in 1998.

Today Mark's practice includes a variety of notable residential projects in the Santa Barbara area and throughout the United States. Each of his buildings is a definite original. Mark does not focus on the past and instead creates fresh, contemporary spaces that are dramatic, filled with light and fun to be in. Though his portfolio includes some historical derivatives, Mark uses these styles to create hybrid designs that meld traditional forms and contemporary ideas.

With every project, visual and spatial delight is the overarching goal. The architect calls his work clean and well-proportioned, minimalist in approach, reductive, but not decorative. What those adjectives do not tell you is that it is also layered with attention to place, detail and materials. It is purposefully unpretentious, playful and considerate of owner and environment—the perfect stage for a lifetime of inspiration.

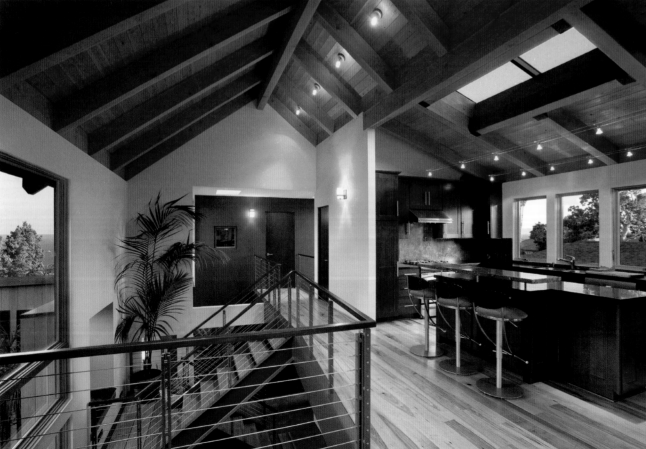

TOP LEFT:
This 2,300-square-foot residence has been designed around a one-story entry wing that bisects the house between the front entry forecourt and the rear private garden area.
*Photograph by Jim Bartsch*

BOTTOM LEFT:
Looking from the great room toward the kitchen and stair presents an exquisite composition. The stair is an exciting sculptural element at the center axis of the home.
*Photograph by Jim Bartsch*

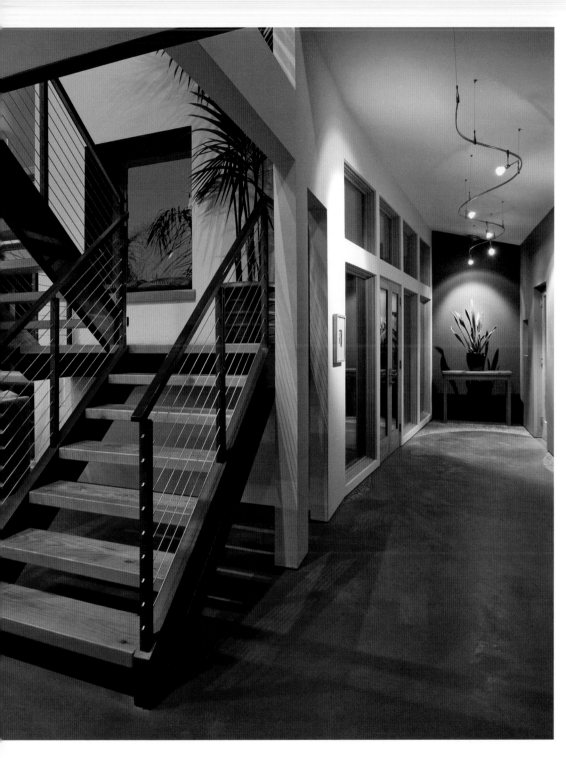

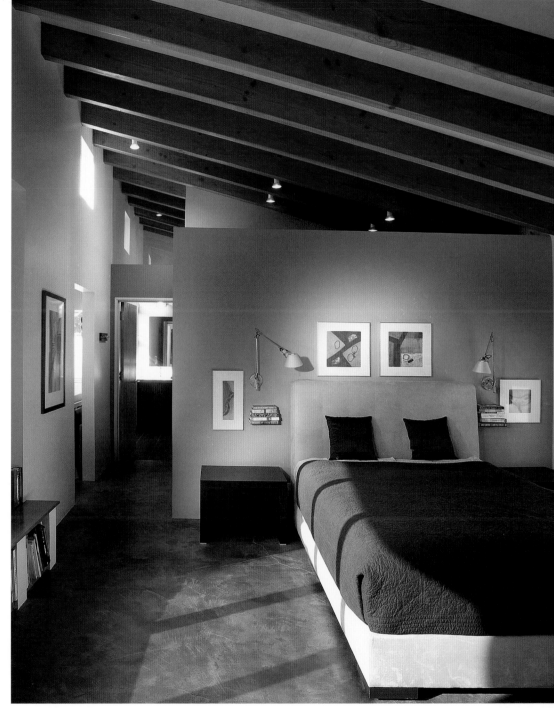

ABOVE LEFT:
The residents' 20-year-old cat, Jack, likes to hang out in the bay window of the stair landing, overlooking the garden.
*Photograph by Jim Bartsch*

ABOVE RIGHT:
The master bedroom wing of this private residence is a simple shed with varying layers of planar elements and forms within, using natural sustainable materials.
*Photograph by Jim Bartsch*

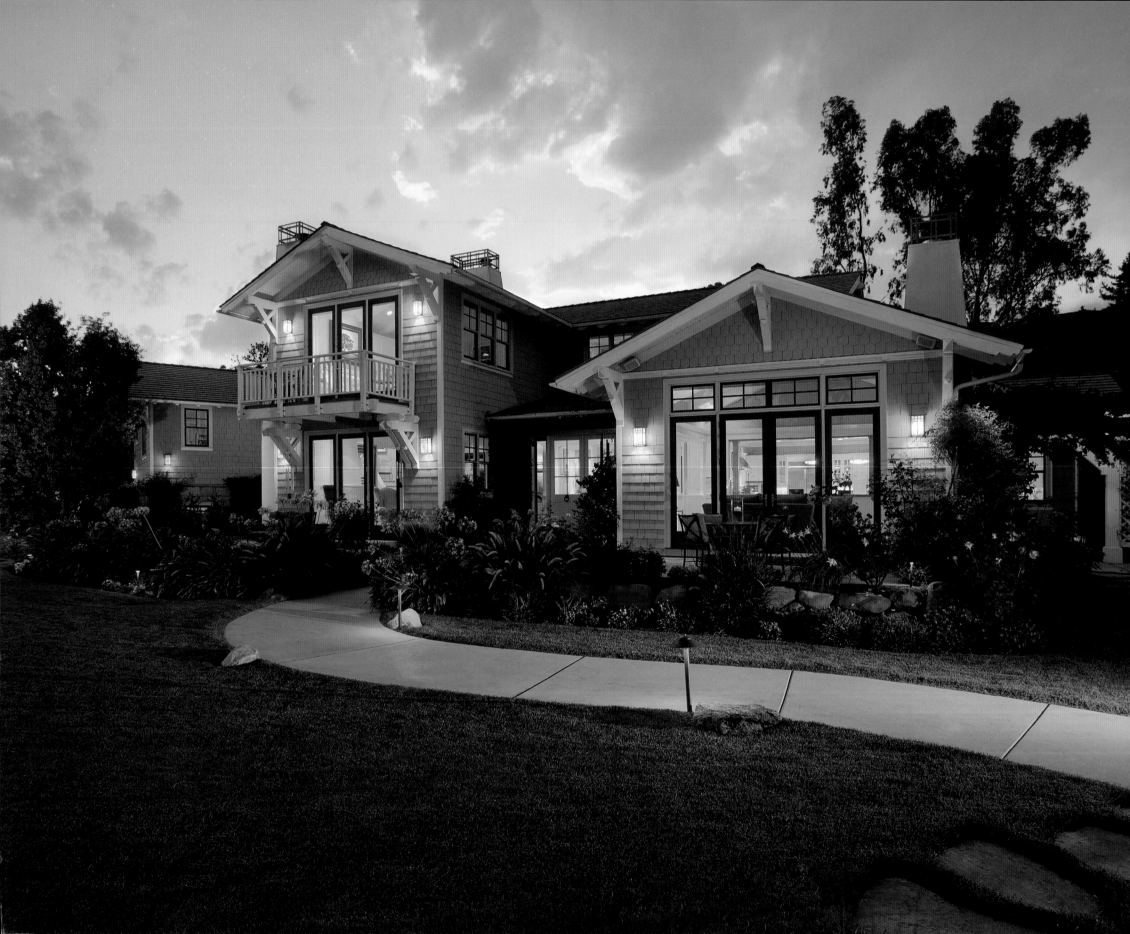

# WILLIAM S. WOLF

Pacific Architects, Inc.

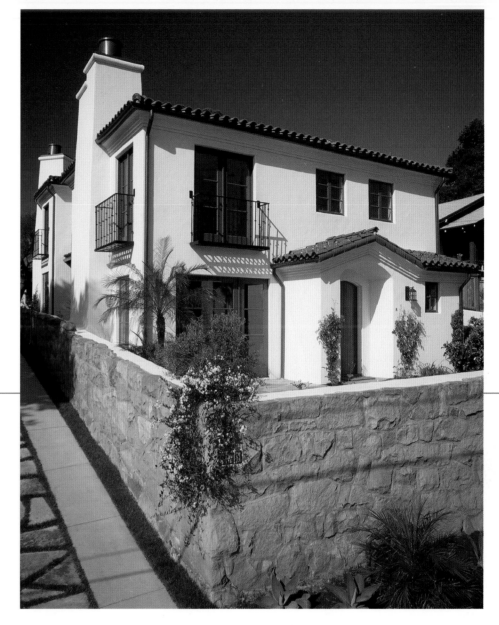

Homes are a team effort. If it takes a village to raise a child, it takes a quorum of talented professionals to design and build them. With more than 25 years of experience, William Wolf knows this well. It is why he has surrounded himself with talented people charged with helping him realize his clients' dreams, and it is why he emphasizes the art of design, commitment to a quality built environment, technical expertise, strong project management and personalized service.

As managing principal of Pacific Architects, Bill Wolf has attracted a mix of residential, commercial and institutional clients seeking an architect's expertise ranging from small-scale renovations to multimillion-dollar projects—all of which embody the finest architectural standards, while maintaining a humanistic philosophy and sense of scale. The client base ranges from individual homeowners to internationally based businesses. No matter the calling, size, scope or style, however, the goal is always the same:

ABOVE:
This Santa Barbara home was inspired by 1920s' Spanish Colonial styling. The multifamily living units' south and east façades boast spectacular views of the Santa Barbara Riviera.
*Photograph by Jim Bartsch*

FACING PAGE:
As comfortable as it is beautiful, this Craftsman-style, Santa Barbara residence has sweeping southern panoramas of the Pacific Ocean. Its details resonate an elegant warmth.
*Photograph by Jim Bartsch*

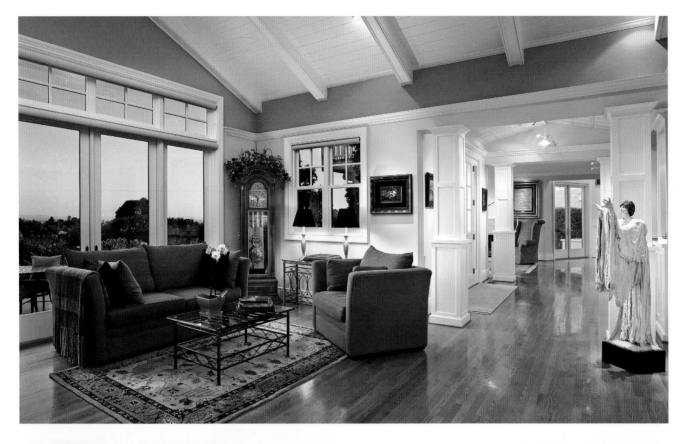

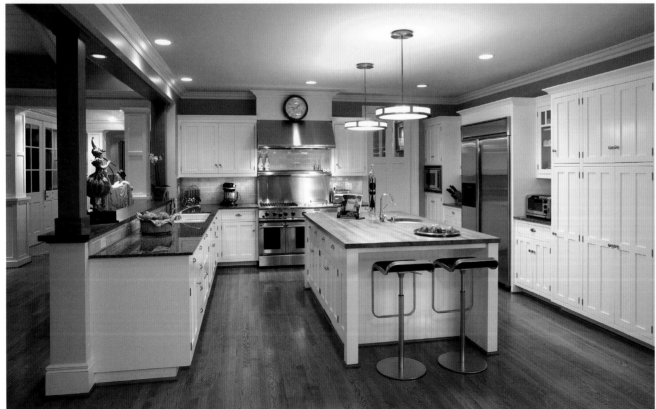

Approach every project with a fresh eye, meticulous attention to detail, a keen appreciation for environmental and economic concerns and a strong belief in a collaborative effort.

Bill has a do-unto-others design philosophy: The things he wants in his own home—a place that feels safe, warm, cozy, inviting—are the things he wants to convey in the homes he designs for his clients. He does this through seeking to create original, thoughtful and distinctive solutions tailored to his clients' unique requirements, circumstances and personalities. He often leans to circular or curving elements, if not in the building then in its site in order to impart a natural balance with the environment. The project site, the appropriateness of a design for its context, the impact of the project on the environment and the collaboration with the client are what make for successful architecture. The results are designs that not only work physically and harmoniously, but emerge from a place rather than appearing imposed upon it.

Bill received his architecture degree from California Polytechnic State University in San Luis Obispo and worked with established firms in Los Angeles and Santa Barbara before opening his own practice in 1989. The qualities he seeks in his design work are imagination, diversity, timelessness, environmental sensitivity and a sense of place. These things come naturally for the award-winning architect, who realized his sensibilities of an artist and technical aptitude at a very early age—traits that balance one another, making for a well-rounded and grounded professional.

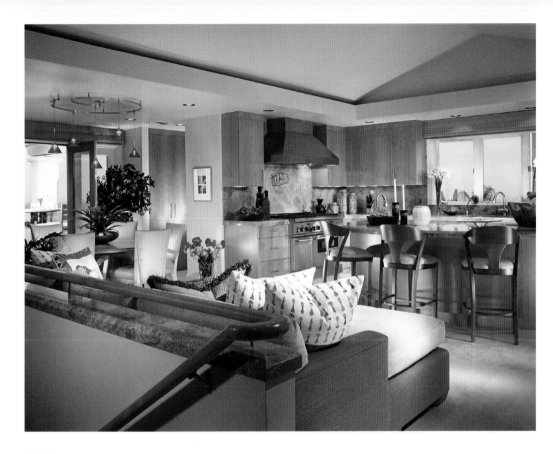

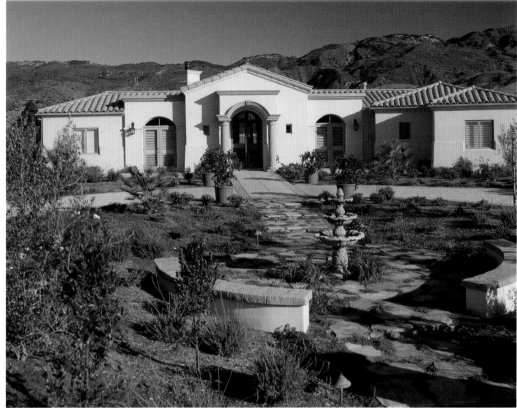

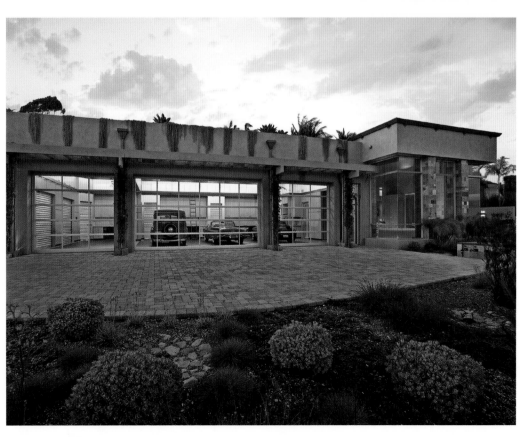

ABOVE:
Expansive views of the city below, the Pacific Ocean beyond and the Santa Ynez Mountains complement this open, modern Santa Barbara residence's kitchen, family room and dining space.
*Photograph by Jim Bartsch*

TOP RIGHT:
This hilltop Mediterranean home in Santa Barbara has spectacular views and features contemporary appointments that complement an Old World craftsmanship that trademarks eras of the past.
*Photograph by Jim Bartsch*

BOTTOM RIGHT:
Nestled into the hillside, this 2,700-square-foot, high-tech garage in Santa Barbara houses an impressive car and motorcycle collection. It is replete with four car bays, a television/bar/entertainment area, a rooftop deck and an outdoor terrace with fireplace.
*Photograph by Jim Bartsch*

FACING PAGE TOP:
The family room with dramatic south-facing views to the Channel Islands has a cozy fireplace and is adjoined by formal and informal rooms to the right. The home is located in beautiful Santa Barbara.
*Photograph by Jim Bartsch*

FACING PAGE BOTTOM:
The bright and spacious gourmet kitchen of a Santa Barbara home features an eat-in island with storage as well as custom millwork, flanked by the dining areas and family room.
*Photograph by Jim Bartsch*

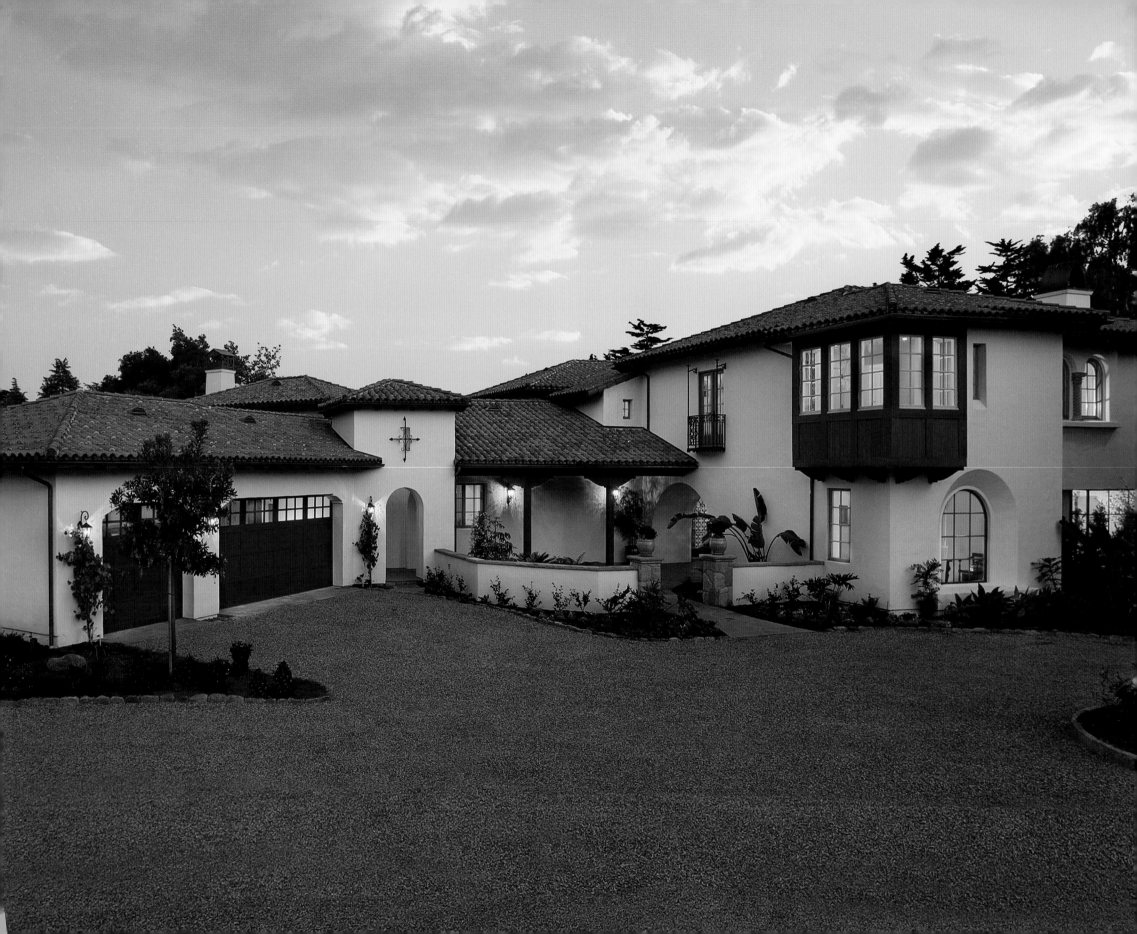

# BOB YOUNG
# DAVID YOUNG

### Young Construction

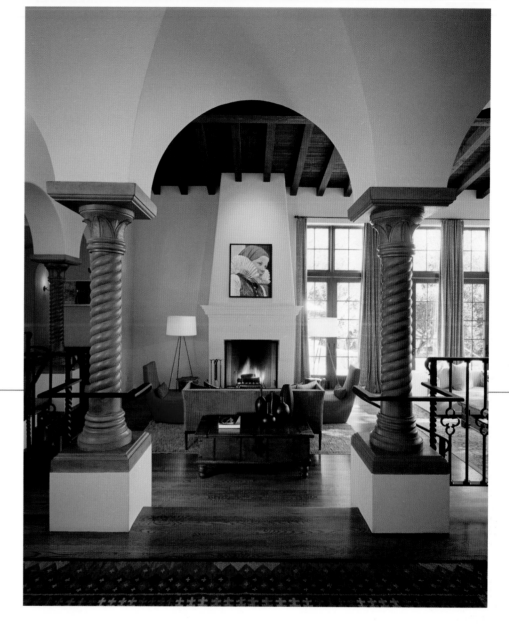

ABOVE:
Boasting voluminous ceilings, this entry also features richly stained wood floors, exquisite iron work, groin vaults and hand-finished columns. Architecture by DesignARC.
*Photograph by Ciro Coelho*

FACING PAGE:
The exterior detailing, including the red tile roofing and wrought iron work, echoes 1920s' Spanish Revival-style design. Architecture by Jeffrey Berkus Architect, Inc.
*Photograph by Jim Bartsch*

Among the most sought after construction companies in Santa Barbara is Young Construction. Brothers Bob and Dave Young have worked together for nearly three decades and have completed some of the finest award-winning residences and commercial projects to be seen in and around Santa Barbara.

Many would argue that Santa Barbara is one of the most magnificent places on Earth. For more than 10,000 years people have enjoyed the unparalleled weather and stunning beauty of the south-facing coast.

For this reason, Santa Barbara has always been a magnet for the fortunate and successful in nearly every field. Building design and construction is no exception. Sterling examples of traditional

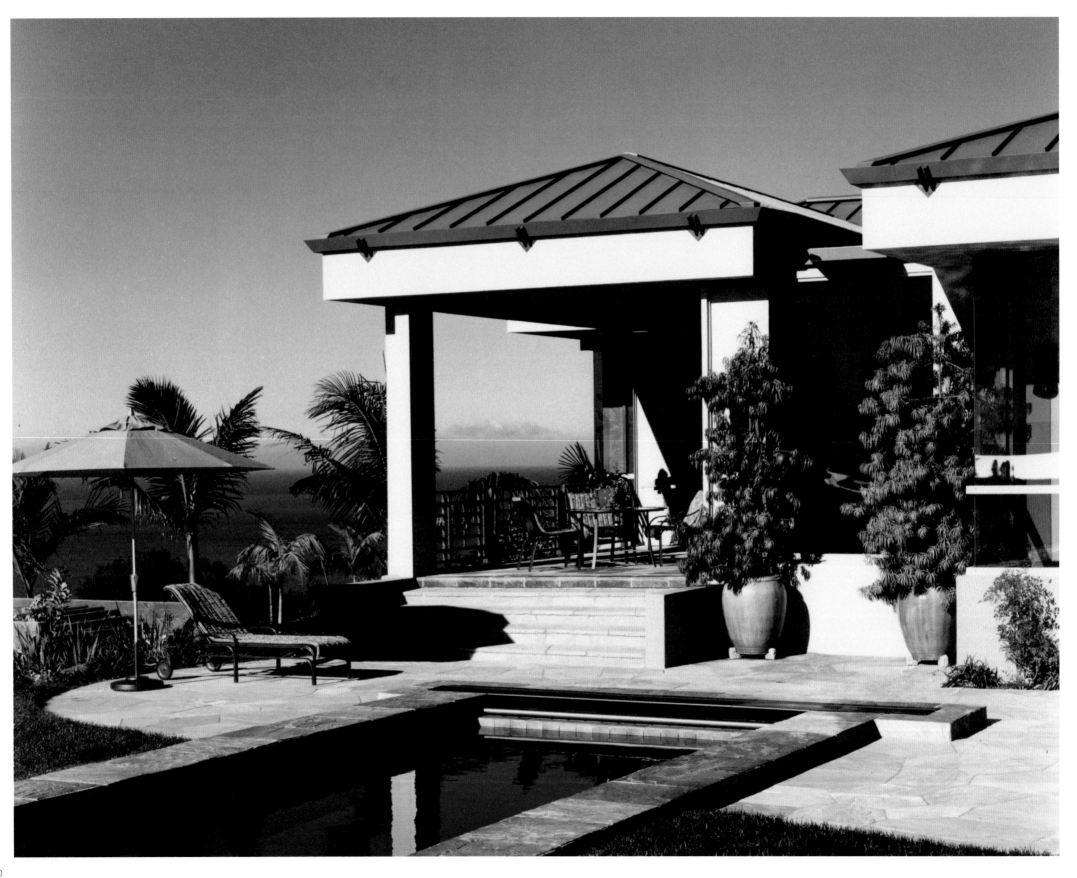

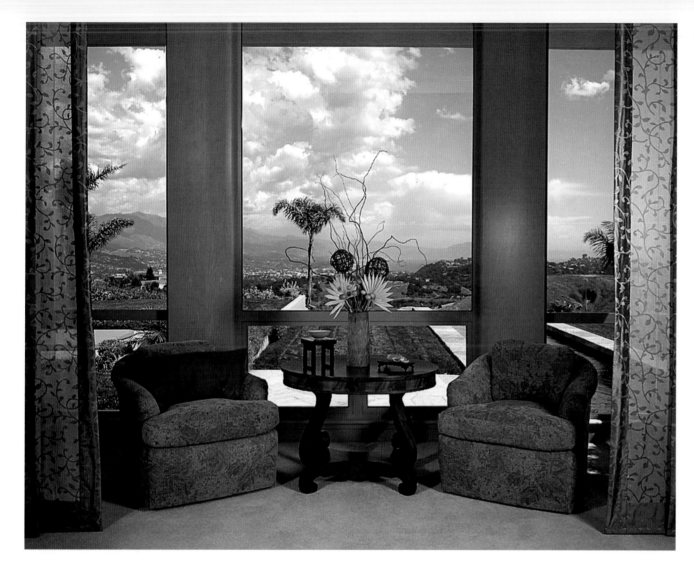

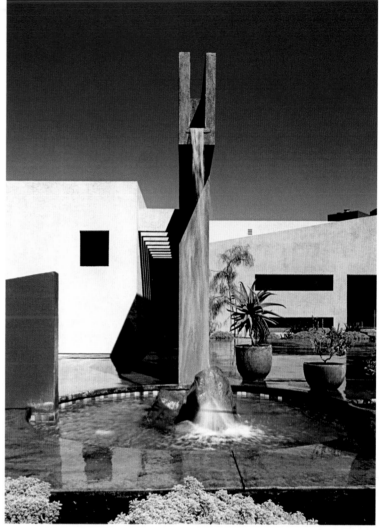

Mediterranean estates as well as cutting-edge contemporary designs are mingled and somehow unified in this haven just north of Los Angeles.

How then, does Young Construction set itself apart from the several successful and motivated construction companies fortunate enough to be working in this market? Superior quality, financial responsibility and successful time management are givens in this upper tier of fine builders.

Bob and Dave believe that the answer is enjoyment and peace of mind—two things perhaps not anticipated by clients entering the unfamiliar and sometimes daunting world of construction. The brothers know that when people are included in the process that familiarity, clarity and team-playing can make the course of action interesting, instructive—and fun!

ABOVE LEFT:
Gracious views abound: the ocean to one side, the city and harbor to the other. Architecture by Jeffrey Berkus Architect, Inc.
*Photograph by Peter Malinowski*

ABOVE RIGHT:
Modern Mexican in design, this courtyard has multiple water features. Architecture by Landry Design Group, Inc.
*Photograph by Conrad Johnson*

FACING PAGE:
This modern design possesses the ambience of an island resort. The Pacific Ocean serves as a backdrop for the infinity-edge pool. Architecture by Jeffrey Berkus Architect, Inc.
*Photograph by Peter Malinowski*

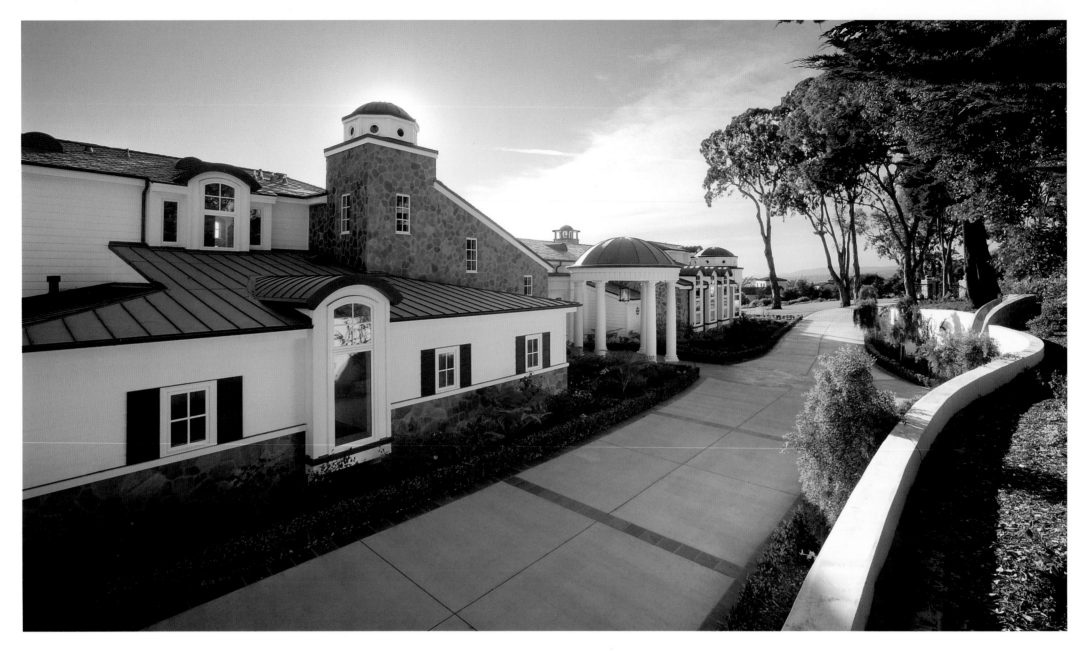

With both feet planted firmly in the 21st century, Young Construction avails itself of the latest technologies with respect to construction management. In the office, the database network ensures that project managers, supervisors and financial personnel are continuously up to the moment with cost and scheduling information. Required aspects of that information can then be made available to clients, architects, engineers, subcontractors and material suppliers through an online construction management web-based program. This allows for a level of communication and transparency that has proven incredibly effective for rapid-fire problem solving in the field and makes contract and financial information immediately accessible from the office.

Accessibility is another cornerstone concept embraced by the Young brothers. They understand the imperative nature of making themselves and their project managers and supervisors available so that important decisions can be made in the most timely and effective way. Clients are welcomed to all aspects of the amazing process of custom building and find that they can feel connected even though they may be traveling—even in far-off places. If the World Wide Web can reach there, so can the daily details of their building projects.

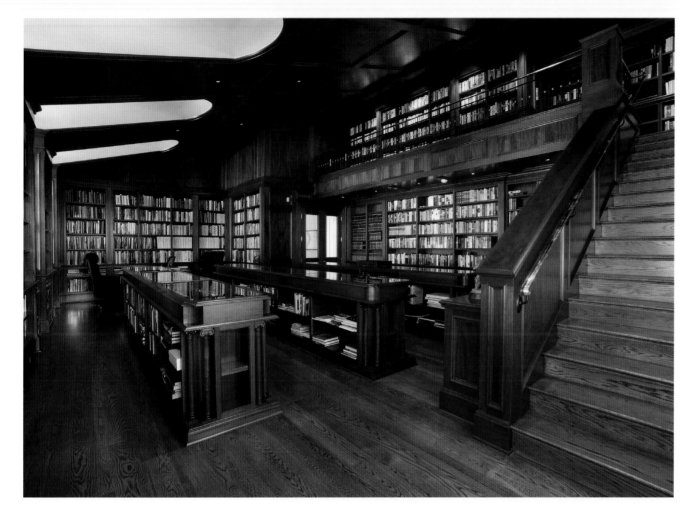

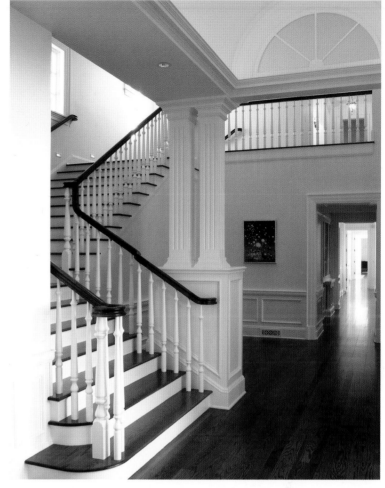

Finally, there are the people at Young Construction who truly are responsible in such large part for easing what can be the most challenging course of construction. Men and women with decades of experience support one another in an environment that fosters longevity and mutual respect. Whether speaking with a 15-year veteran or new addition to the Young Construction family, owners, vendors and professionals can anticipate courtesy, competence and even a cheerful voice on the phone.

Bob and Dave feel exceedingly fortunate to be working at this time in this place. They count among their satisfied customers many friends and even neighbors. It is not uncommon for clients to repeat their experience with Young Construction with either an expansion of previous work or an entirely new project. These are true testimonials of the success of their working relationships: repeat customers and employees who stay.

ABOVE LEFT:
A vast 2,100 square feet, this library swanks stunningly crafted mahogany display cases, bookshelves and paneling. Architecture by B³ Architects and Berkus Design Studio.
*Photograph by Mehosh.com*

ABOVE RIGHT:
Wide and elegant, the main staircase has custom rails, balusters, panels and fluted columns. Architecture by B³ Architects and Berkus Design Studio.
*Photograph by Mehosh.com*

FACING PAGE:
Sweeping views of the Santa Barbara Channel and islands are enjoyed from this modern Monticello home, which is topped with a slate and copper roof and clad in wood and stone veneers. Architecture by B³ Architects and Berkus Design Studio.
*Photograph by Mehosh.com*

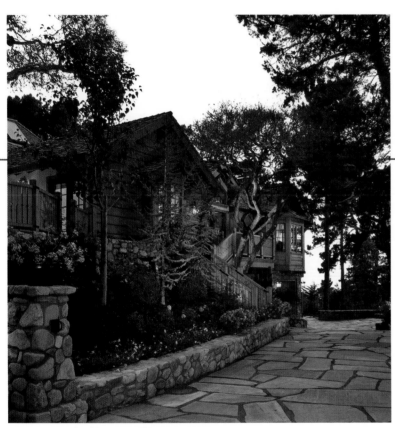

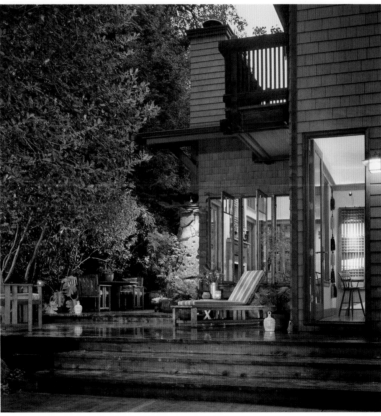

Saroyan Masterbuilder, page 229

Thomas Bateman Hood, AIA Architecture, page 183

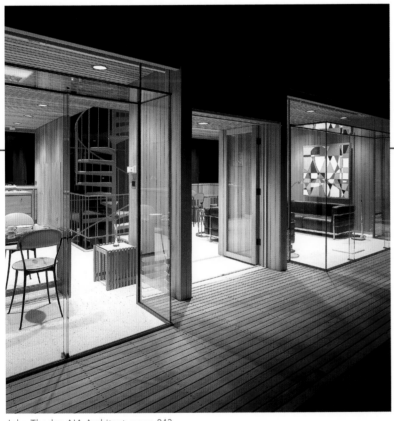

John Thodos AIA Architect, page 243

# MONTEREY/CARMEL

# MARY ANN CARRIGG

### Carrigg's of Carmel

ABOVE:
Built-in and freestanding architectural and design elements create an ideal background for the residents' collection of fine art.
*Photograph by Chris Gage*

FACING PAGE:
Large windows, graciously arched at the top, afford passersby a sneak peak at the myriad design and decorative elements within the Carrigg's Dolores and 7th showroom.
*Photograph by Chris Gage*

Mary Ann Carrigg, Allied ASID, is one of those rare people whose talents seem endless compared to most. As a young student, she was passionate about painting, using watercolor and oil, and sold many of her works. She took an interest in theater and starred in numerous musicals and comedies. She shared her talents in set design with numerous theater companies. Within a short time Mary Ann combined her passion for writing and formed MAC Productions, writing, directing and producing her own musical comedies, winning numerous Elly awards.

She had her first design showroom in Roseville, California, at the age of 25. Understanding scale and enjoying laying out floorplans, she became a self-taught architect, building more than 50 beautiful custom homes as well as designing five homes for a subdivision in Northern California.

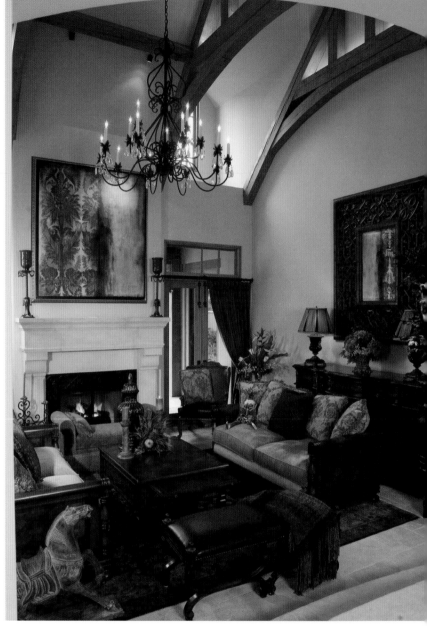

Mary Ann's love for interior design grew when she moved to Carmel, and in just a couple of years, with her husband, Ray Rankin, who also is gifted in design, opened their furniture showrooms, Carrigg's of Carmel, located on one square city block in the charming town near the sea. In addition, she opened a design studio that houses thousands of fabrics that her clients can peruse while going over floorplans and discussing ideas for creating their own dream homes.

She is a recipient of the ASID Design Excellence Award, an honor that appears well deserved when you walk into her galleries full of distinct furnishings from around the world. Handcrafted dining tables, luxurious beds, overstuffed sofas, consoles, crystal

ABOVE LEFT:
Sumptuous, softly hued fabrics, unique lighting elements and furniture with the character of a bygone era inform this sunlit sanctuary.
*Photograph by Chris Gage*

ABOVE RIGHT:
Inspired by Old World elegance, this living room feels intimate despite the grand ceiling volume.
*Photograph by Chris Gage*

FACING PAGE:
Architectural details elevate the eye up and around this strikingly designed, conversation-conducive space. Strong forms are softened by warm colors, unique lighting elements and a variety of floral arrangements.
*Photograph by Chris Gage*

chandeliers, unique lamps, antiques, silk pillows, artworks, tapestries and other accessories imported from all over the world are mingled with more modern domestic pieces, many of which were designed by Mary Ann or are exclusive to her stores.

Mary Ann keeps things interesting in her work by blending different styles. The rooms she creates are specific to the people who will live in them. As a designer, she enjoys seeing people in her showrooms lingering and imagining the space as their own and finding the perfect things. Whether you live out of state or out of the country, Carrigg's offers a design service that is rare: Mary Ann will design your home without having to physically see it. As a builder, she is accustomed to working with blueprints and can provide her clients with custom furniture and accessories by having their plans sent or faxed to her. She typically provides clients with three options for their homes and ships them everything they need to create the look they have always wanted.

If you are fortunate enough to visit her showrooms, look high and low so that you do not miss a thing.

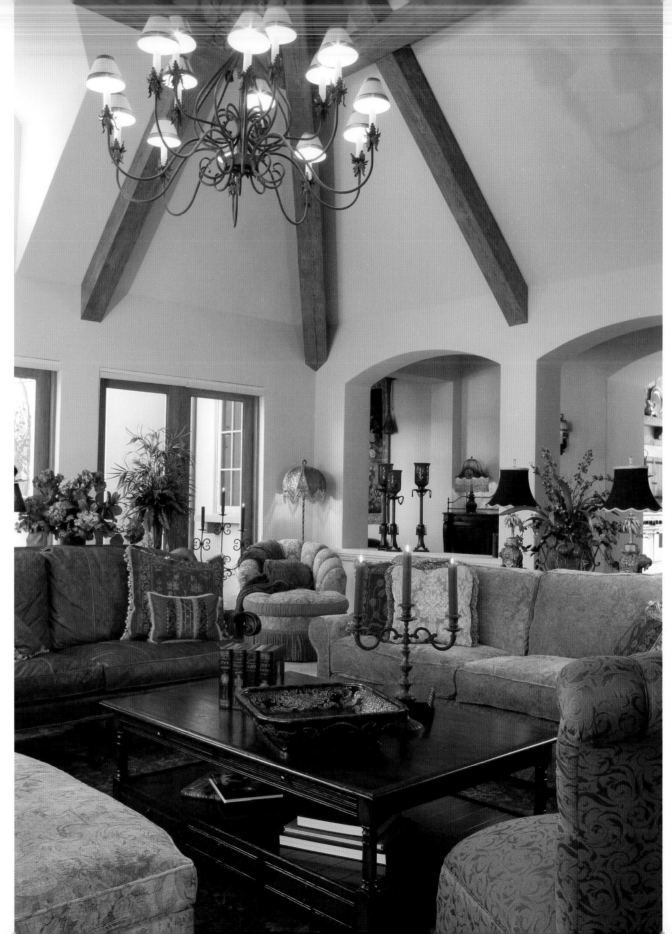

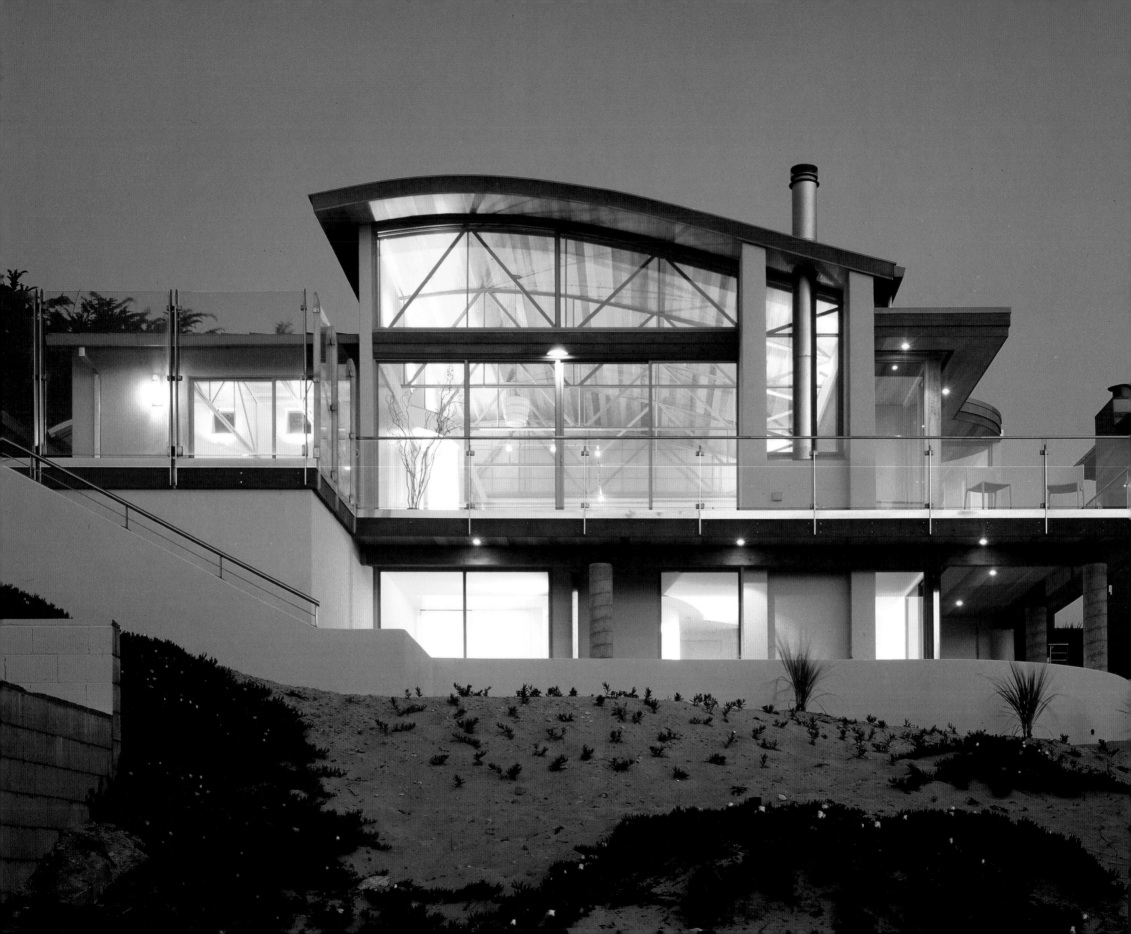

# GRETCHEN FLESHER
# BILL FOSTER

Flesher + Foster Architects

In the world of residential architecture, a dream can often start with a doodle. And in the right hands, a scrawl on a scrap can be transformed into a grand manse or a cozy bungalow that reflects its owner's very lifestyle and personality. Those hands just might belong to Gretchen Flesher, AIA, and Bill Foster, AIA.

The pair met on the job and started Flesher + Foster Architects about 20 years ago. Their practice focuses on residential architecture—a combination of new homes and remodels, as well as historic preservation and multifamily dwellings—along the California coast, and their work varies in style, though the principals admit a love of modern design.

Regardless of style, Gretchen and Bill take their cues from their clients, the neighborhood and context of the site. It is their goal to create something unique to a property and the people who will live there. To

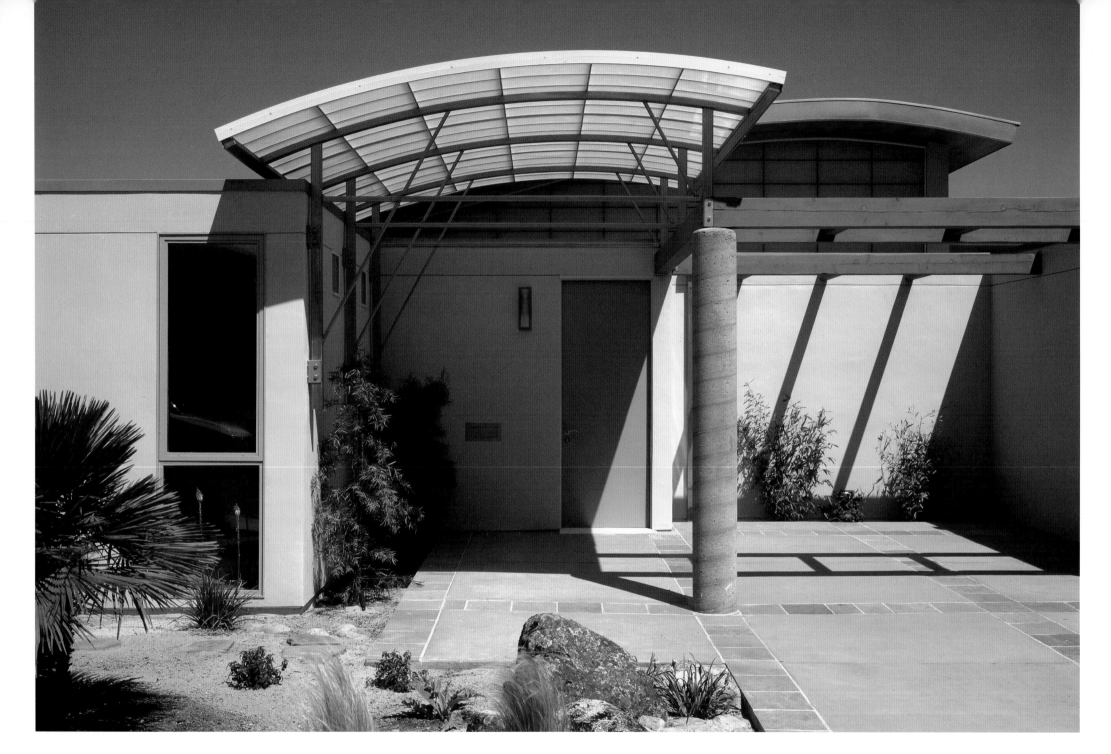

ABOVE:
With its street-side entry courtyard and translucent entry canopy, the residence is designed to offer privacy.
*Photograph by Russell Abraham*

FACING PAGE LEFT:
Glass wraps around the corner of the upper-floor living area to capture oblique coastline views.
*Photograph by Russell Abraham*

FACING PAGE RIGHT:
Each evening the residence offers magnificent sights as it catches the last rays of the setting sun across
Monterey Bay.
*Photograph by Russell Abraham*

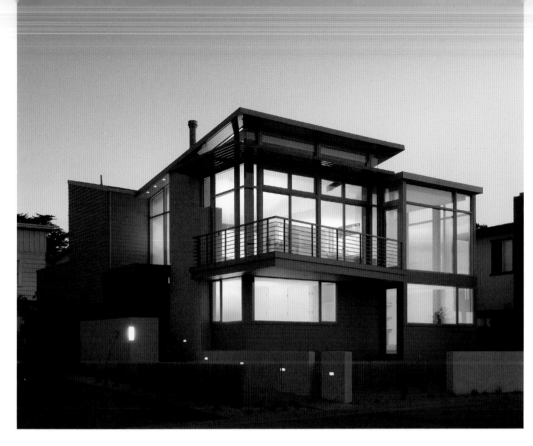

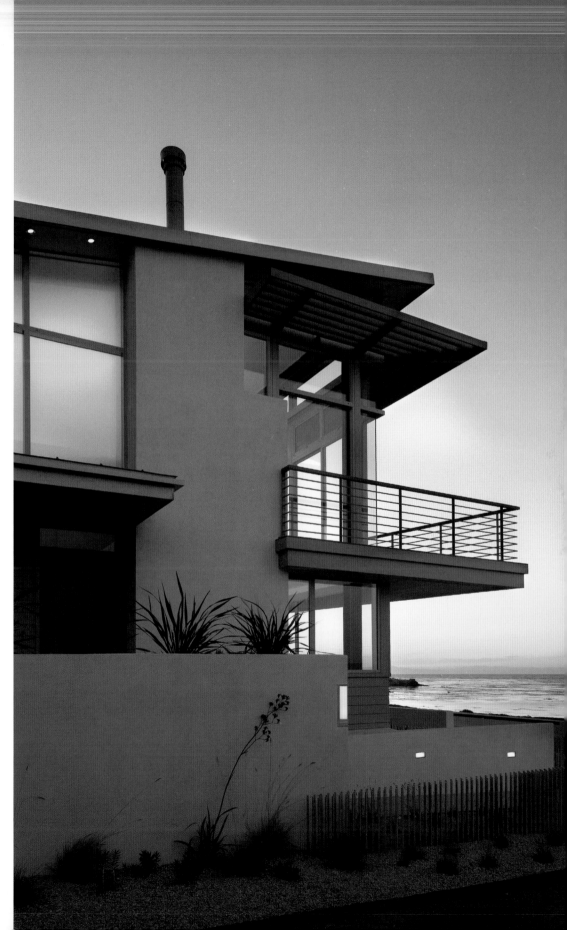

that end, they seek to draw from their clients an essence that can be translated into an interesting, sculptural form. They ask questions and listen closely, and bring to the table an ability to interpret their clients' needs and expectations.

Theirs is a partnership that is a little different from the typical office structure in which one partner does the preponderance of the design work and the other manages the business and production side of things. From the outset, Gretchen and Bill recognized that they have parallel and complementary talents, which they have parlayed to their clients' advantage. With both partners having a keen interest in design, they are able to bounce ideas off one another and gain different perspectives on their work. Often lively discussions take place over the relative merits of different design solutions, ultimately resulting in a better design.

Consistent and compatible, the partners have a common mission: to give their clients something fresh. They use forms that are thoughtful, not arbitrary. Doing the expected is something that comes hard for the award-winning duo. So they look for an angle within the client or the site that is going to bring forth an unanticipated twist or an exciting element that will engage the imagination and interest of all who see it. They call their job an adventure in raising the bar on what can be.

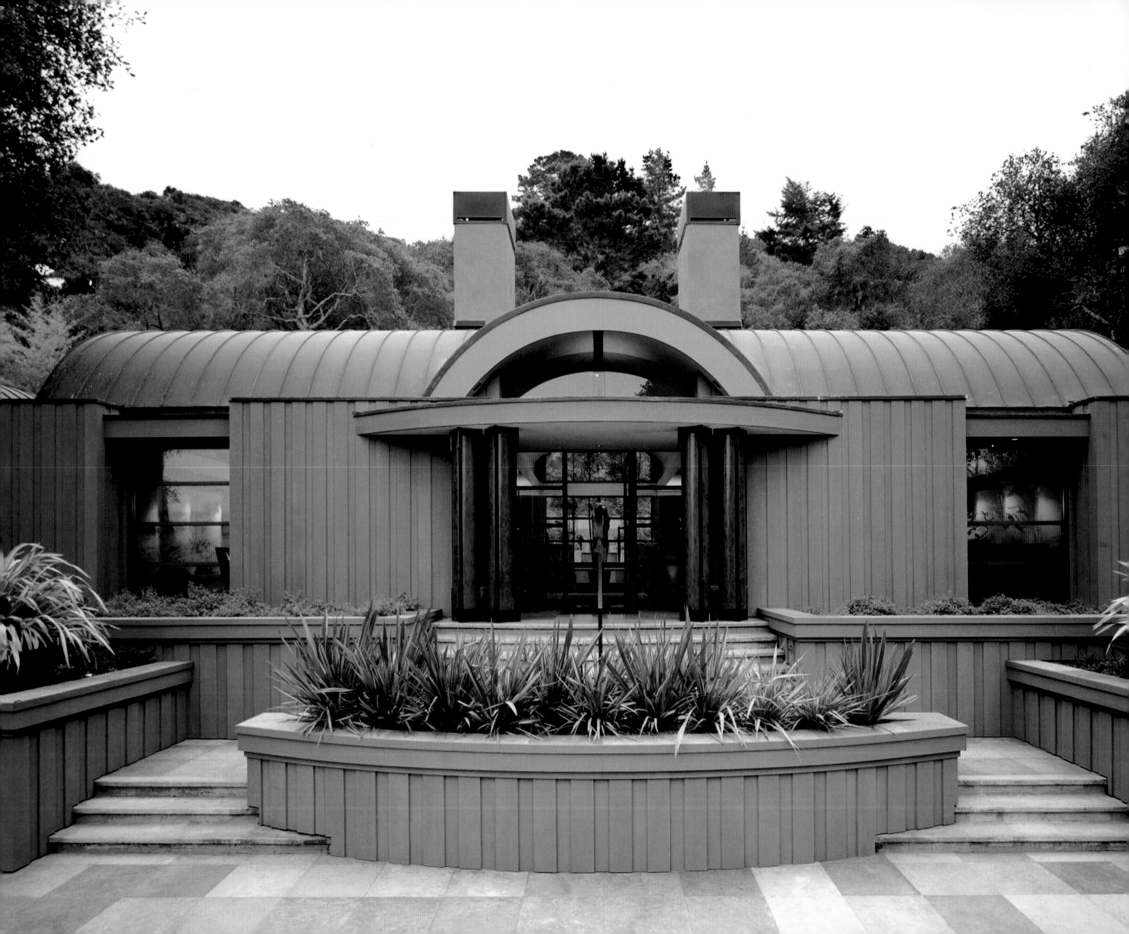

# DANIEL FLETCHER
# PHILIP HARDOIN

Fletcher + Hardoin Architects

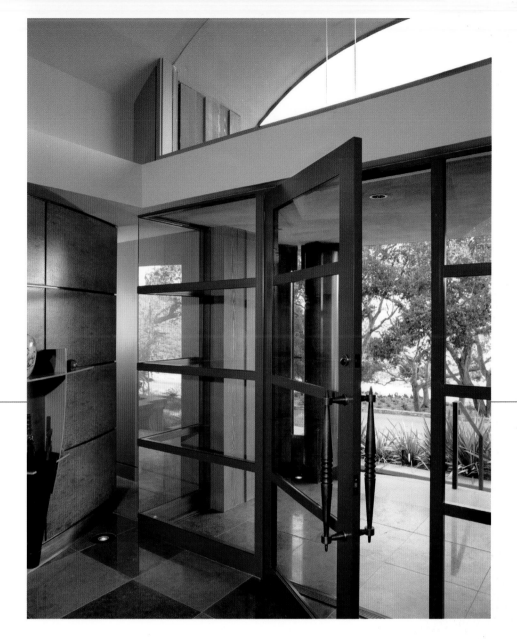

ABOVE:
In order to take advantage of the beauty of the site, an abundant use of glass walls creates a seamless transition between interior and exterior spaces.
*Photograph by JD Peterson*

FACING PAGE:
The entry into this home establishes a central point from which a series of living pavilions and exterior spaces are arranged. Exterior materials were chosen to blend with the natural rural environment.
*Photograph by JD Peterson*

Like a couture Chanel suit or a custom Porsche Carrera, the houses designed by Fletcher + Hardoin Architects are thoughtful and well-mannered. Highly refined and splendidly detailed, they exude the kind of understated elegance typically found in a member of the British Royal Family. They are awesome but not flashy, stirring intrigue and demanding respect. And they are created through a painstaking process designed to exceed the clients' expectations every step of the way.

Co-principals Daniel Fletcher, AIA, and Philip Hardoin, AIA, both are native Californians who graduated from California Polytechnic State University. They started their practice in 1988, after working together in an architectural firm in Monterey, and for nearly 20 years have been designing a range of projects, from commercial and light industrial to resorts and private residences in the United States and abroad.

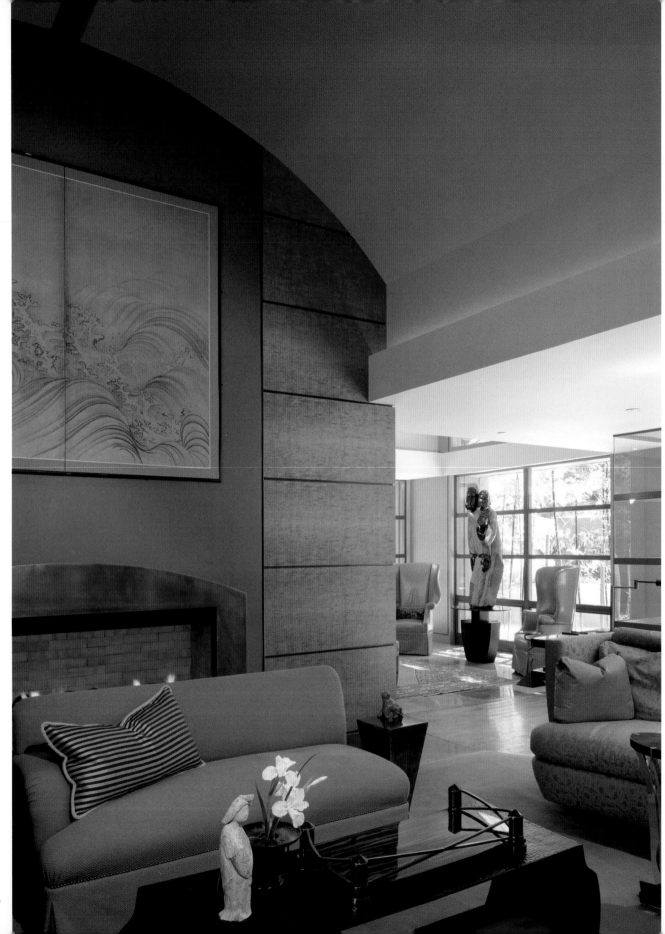

Dan is the creative force of the team and is responsible for design and space planning; Phil's strengths lie in design development, contract documents and construction administration. Theirs is a complementary partnership that yields impressive results.

Though the firm has no signature style, its buildings, whether traditional or contemporary, share a depth and a thoroughness that is easier seen than explained, even by the architects themselves. All of the firm's homes start with beautiful composition, but layers of materials and architectural detailing are what make them exquisite.

To arrive at that end, however, is a lengthy, involved process that requires getting to know the clients, prioritizing ideas and determining a hierarchy of decisions. Too many good ideas can mean none get done well, and it is the architects' jobs to take all things into consideration and determine what is most appropriate for the context, the site

LEFT:
Vaulted living areas are woven together with flat ceiling circulation elements. A rich use of interior materials continues that theme as they are used consistently throughout.
*Photograph by JD Peterson*

FACING PAGE TOP:
The distant views as seen from the kitchen are emphasized with floor-to-ceiling glass. Lower ceiling elements organize the spaces within each pavilion.
*Photograph by JD Peterson*

FACING PAGE BOTTOM:
Nestled into the hillside, the barrel-vaulted pavilions are arranged around a courtyard that has a cascading water feature as its focal point.
*Photograph by JD Peterson*

and the clients' needs and desires. Too, quality and authenticity are never far from their minds, which is why these hands-on principals maintain a small staff of just seven and remain involved throughout the construction process to ensure that the outcome matches, exactly, the clients' expectations as well as theirs. They take personal responsibility for assembling the team—interior designer, lighting designer, landscape designer—that will see a dream to fruition.

And because they are fully immersed in every project, they take on only two or three residential new jobs each year, choosing their clients as carefully as they hope their clients choose them. Though the firm has earned high praise from peers, including numerous Awards of Merit from the American Institute of Architects' Monterey Bay chapter and a Grand Award for Best Custom Residential Project from the Pacific Coast Builders Conference, the best recognition comes from repeat clients.

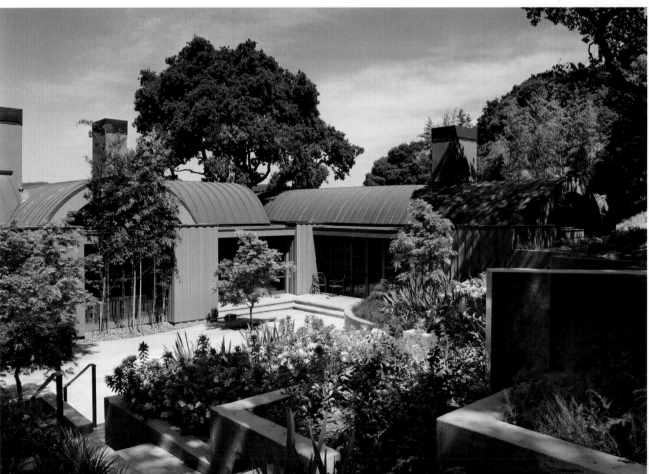

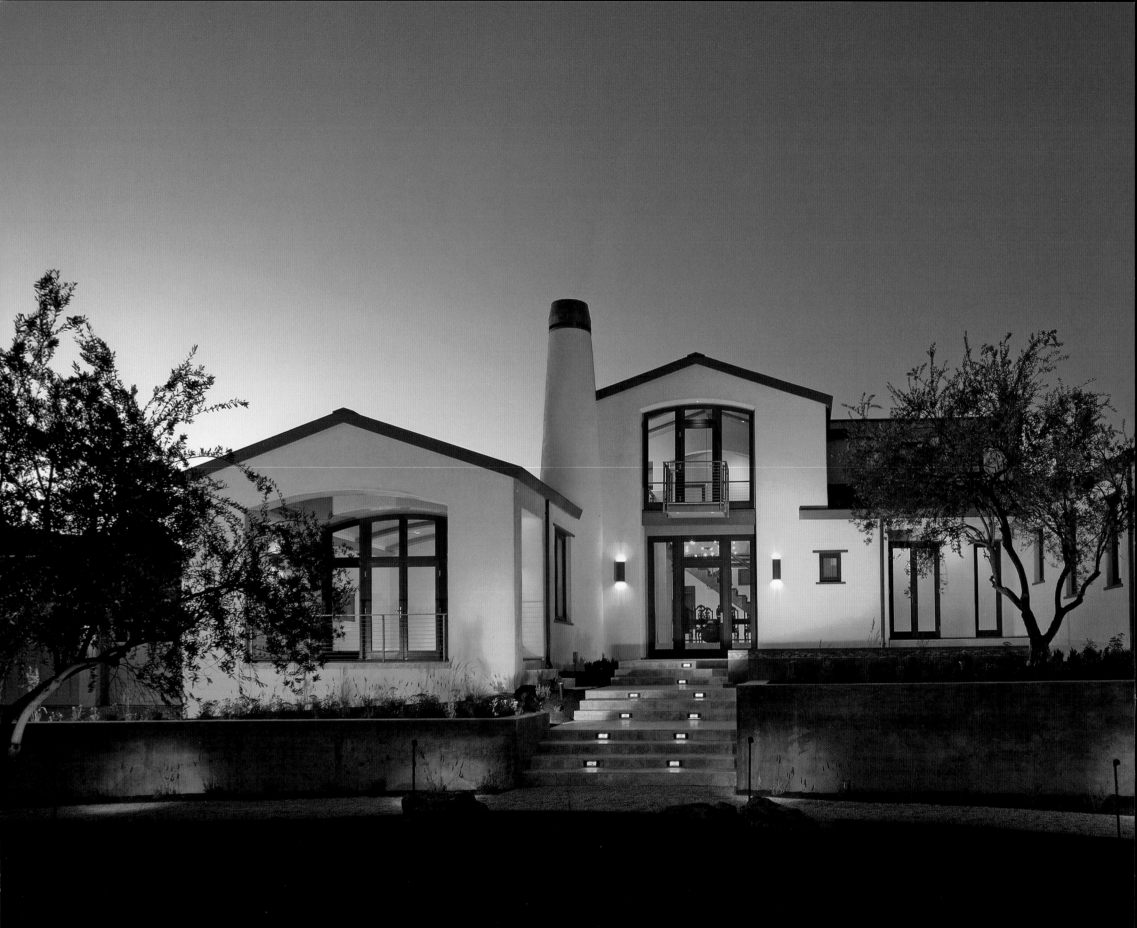

# CRAIG HOLDREN
# LORI LIETZKE

Holdren + Lietzke Architecture

In the end, the success of a house lies with its owners. They must be communicators willing to reveal their essence and be forthright and honest about their priorities; and they must be collaborators eager to engage with their architects and participate in the design process. When they are both, the results can be delightful. And that is the foremost goal of Craig Holdren, Associate AIA, and Lori Lietzke, AIA, co-principals of Holdren + Lietzke Architecture.

The ocean view from their new Cannery Row office is a delight in itself and a constant inspiration to Craig and Lori, who opened their architecture practice in 2004. They joined forces—and complementary strengths—after working together for a number of years at another area firm and today concentrate their efforts almost entirely on high-end residential work along the California coast. Craig acts as lead designer and main client liaison;

LEFT:
The arrival to this beautiful 4,446-square-foot home, located just inland of Monterey Bay, sets the stage for the exquisite interior. Spanish Colonial with a contemporary twist, the thick plaster walls and mahogany windows evoke the area's history as well as its present.
*Photograph by Scott Campbell*

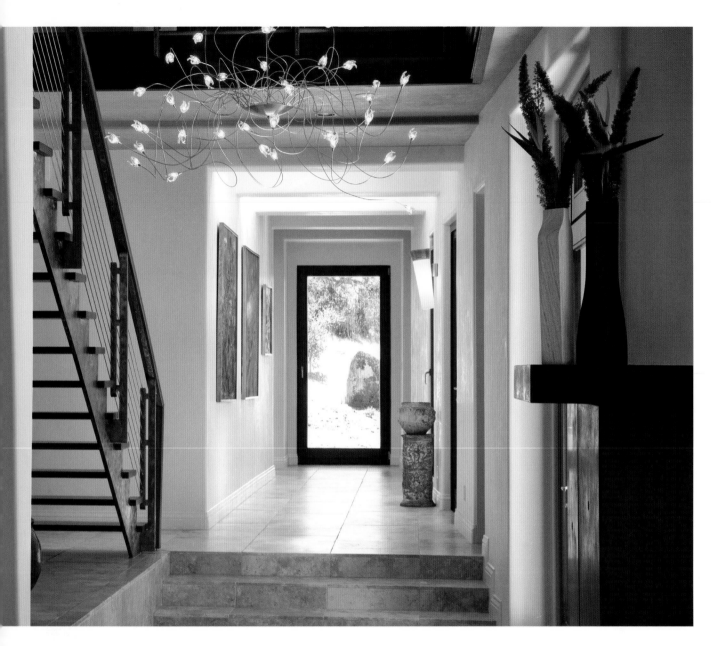

Lori oversees production and handles the area's ever-increasing bureaucratic maze with exactitude. In this way, clients receive a double dose of talent.

California natives, the architects relish the range of regional vernacular—lavish Victorian in Pacific Grove, rustic Spanish Colonial in Monterey, organic modern in Big Sur—but it is not their tack to simply repeat what has already been done. Instead, they allow the established styles to inform their designs to create houses that are 21st-century friendly. This might mean a traditionally styled house with highly contemporary detailing or an idiosyncratic floorplan with modern interconnectivity—and it always means innovation.

ABOVE LEFT:
Viewed from the entry, the slight angle to one of the gallery walls is intentional, in order to lead the eye to a large outdoor sculpture through the glass door at the end of the hall.
*Photograph by Scott Campbell*

ABOVE RIGHT:
The staircase's ground stainless steel stringers and custom rail system counterpoint the polished walnut treads and handrail.
*Photograph by Scott Campbell*

Of course, the houses capitalize on their sites. Whether it is a small urban lot in downtown Monterey or a large beachside plot in Carmel, there is magic to be found, Craig says. He sees it as his responsibility to extract information not only from his clients but also from the home's chosen context, taking cues from the natural environment. Put the two together and you have the makings for a spectacular design.

And if the pair has their druthers, it will be a Green future. Early on they agreed to steer their business toward sustainable practices, which ties to intelligent use of the home site. It also includes choosing local suppliers and opting for environmentally conscious materials when possible. It can be an interesting contradiction when designing houses upwards of 5,000 square feet, but Lori and Craig are not ones to shy away from a challenge.

They have only just begun and their emerging firm promises to be a formidable force.

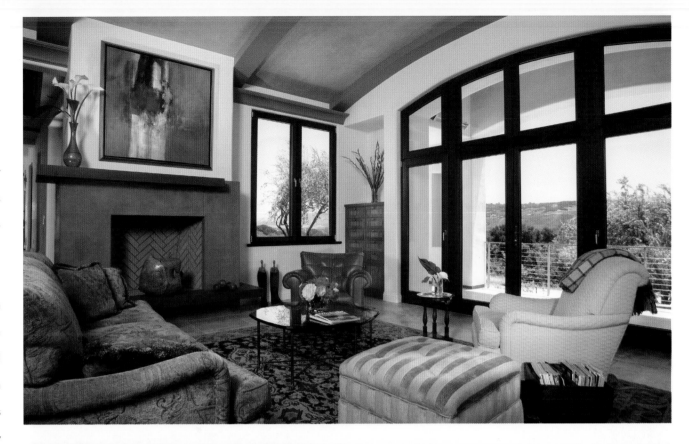

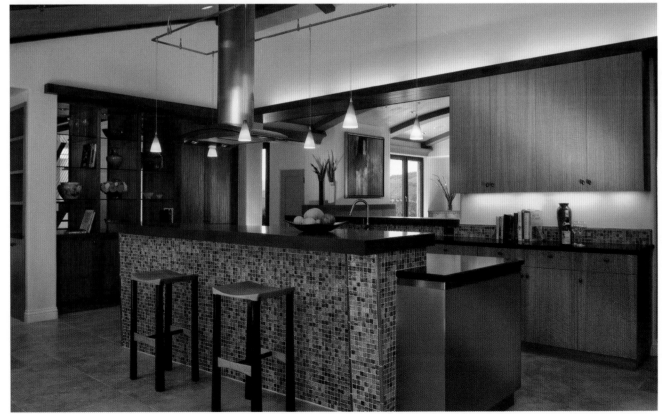

TOP RIGHT:
The relaxed family room, with its vividly colored concrete fireplace surround, showcases sweeping valley views through the custom mahogany windows.
*Photograph by Scott Campbell*

BOTTOM RIGHT:
Clean contemporary finishes and fixtures in the kitchen contrast with glass mosaic tiles that highlight the raised portion of the island. The raised countertop is polished concrete stained in warm tones to complement the rest of the room's antiqued granite countertops.
*Photograph by Scott Campbell*

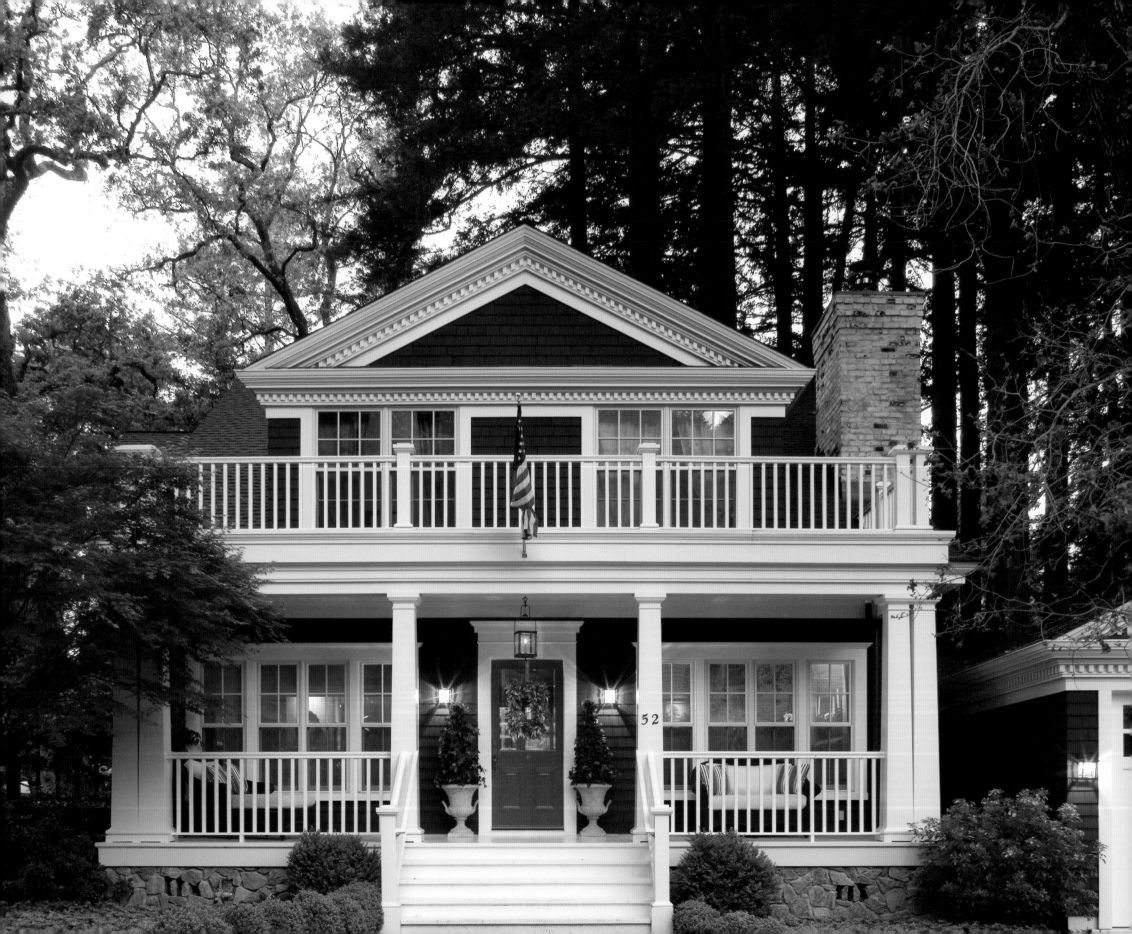

# THOMAS BATEMAN HOOD

Thomas Bateman Hood, AIA Architecture

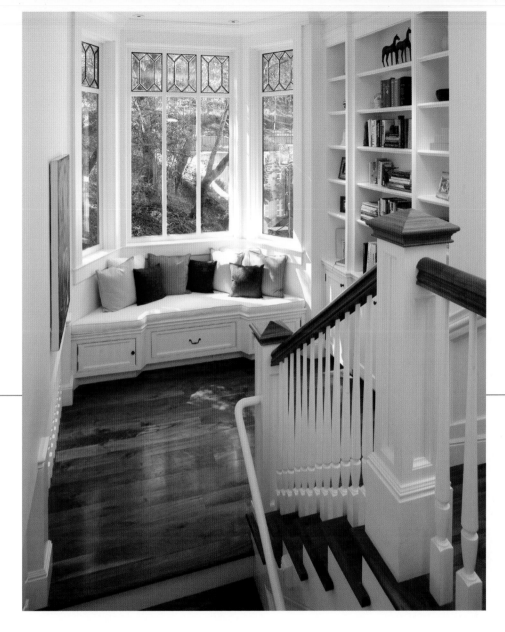

The success of art can be gauged by the reactions it generates. And the work of Thomas Bateman Hood, AIA, provokes strong ones: spontaneous group applause or awestruck chills are just a few of the ways recent clients have responded to the award-winning architect's designs.

Tom opened his first California office in Marin County, just north of San Francisco, in 1989, after doing design-build work for nearly a decade in the Chicago area. Operating out of a little studio in his backyard, Tom often held design sessions and client meetings in the courtyard of his home, surrounded by native plants and the warmth of a native stone fireplace he built himself. Clients loved the respite and the relaxed environment it fostered, and the practice grew from there. He opened a second office, in Monterey Bay, in 2004, after being awarded commissions in the prestigious Monterra® development, and moved to that area shortly thereafter.

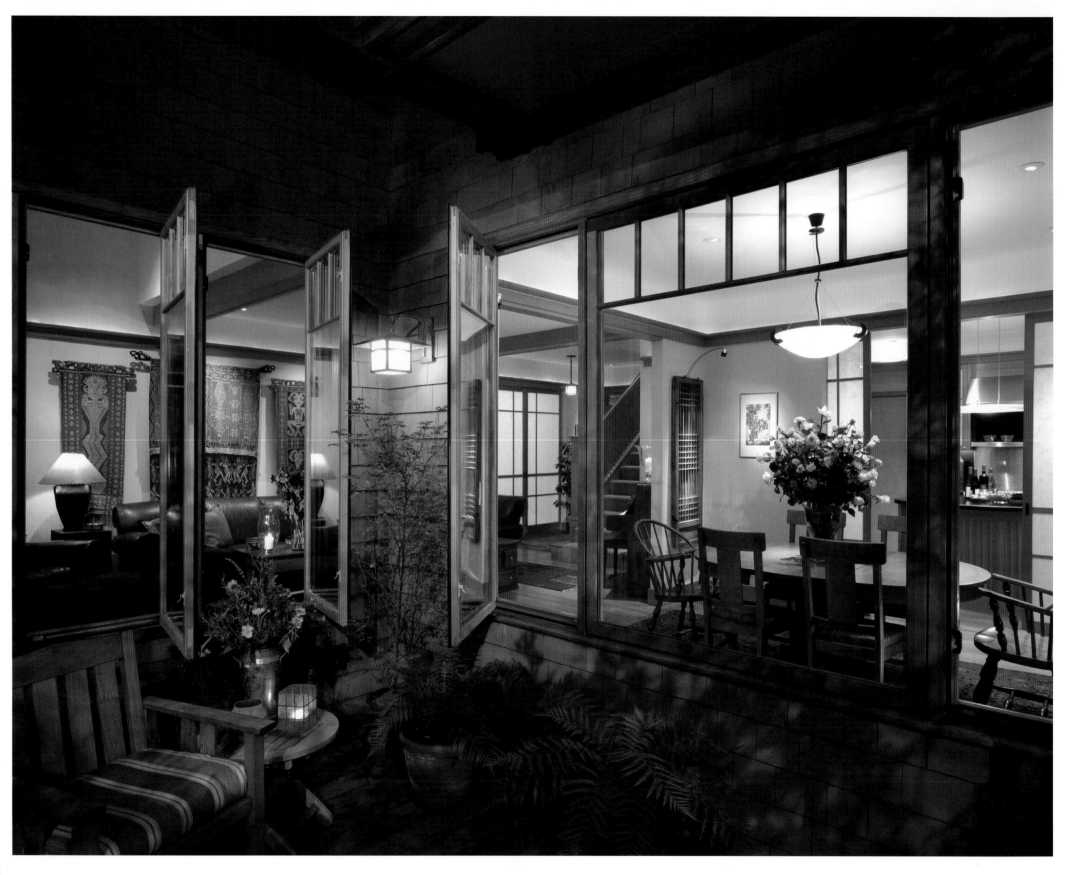

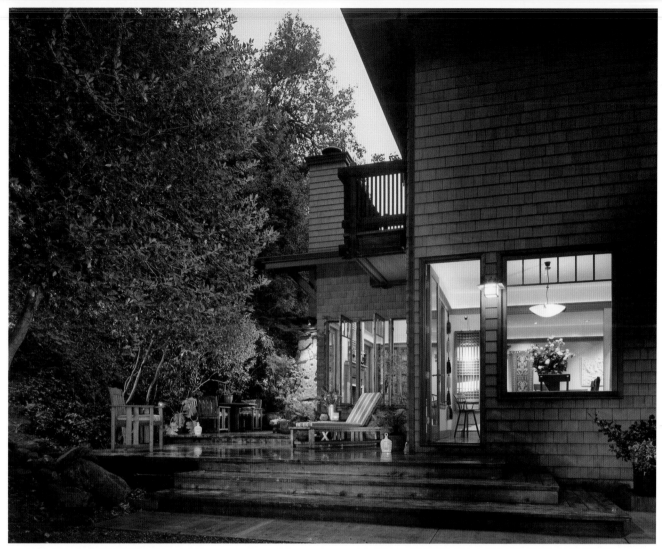

ABOVE LEFT:
Arts-and-Crafts and Japanese tonsu influences are evident in this Pullman-style service area, which is constructed of salvaged old-growth cypress. Numerous cabinets and storage areas behind tambour doors conceal personal items, as well as a coffee maker, small refrigerator and microwave oven in a convenient, tidy area open to the adjacent guest room.
*Photograph by Bruk Photographics*

ABOVE RIGHT:
An intimate multilevel deck and terrace area for entertaining is framed in captured space between this two-story residence in close proximity to the heavily wooded hillside. The native stone fireplace, spa and extensive plantings provide an inviting outdoor living space.
*Photograph by Bruk Photographics*

FACING PAGE:
The relationship between interior and exterior living spaces is celebrated with an open floorplan that flows to an outdoor room; windows visually connect the spaces. Architectural details, materials and colors provide continuity between inside and out, providing a beautiful view into the house as well as out to the deck and landscape.
*Photograph by Bruk Photographics*

The small firm specializes in residential, mixed-use projects and historic renovation, with an emphasis on Green building. And the easy-going architect is particularly sensitive to his clients, the art of his craft, and the care and handling of the sites for which he designs. Exploring design possibilities on large sites of untouched land of exquisite natural beauty is a dream come true for Tom, who says that home, for him, is a place where you are safe to be yourself; to spend time with family; and to grow, learn and revitalize your spirit.

Creating such spaces and infusing them with meaning, honesty and a sense of permanence are essential to good architecture. Likewise, the desire to design in ways that unearth a shared vision of how people wish to live is the force behind all of Tom's residential work. The art of designing homes is about paying attention and understanding priorities, Tom says. He believes that listening to his clients and responding physically to their emotions to make their lives special is an honorable challenge.

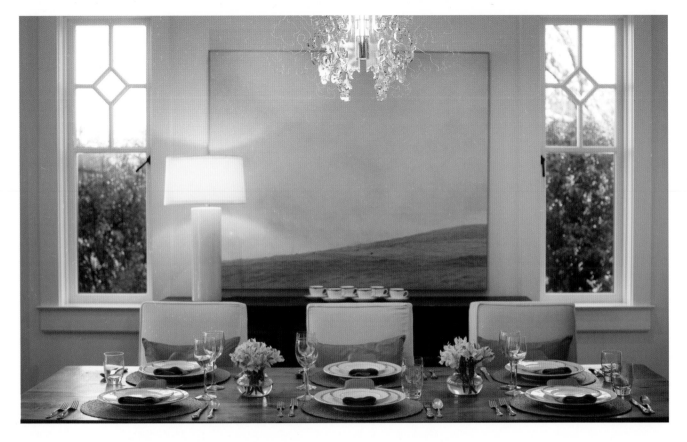

Part of meeting that challenge is getting clients excited about the design process. He does this early on through masterful drawings, original to each project and all done by hand. Where many architects delay drawings as long as possible in an attempt to work out every detail before putting anything on paper, Tom elects to produce simple floorplans and renderings as soon as he has a grasp on his clients' needs. Even before the minutiae have been worked out, he wants to give his clients something tangible to stir their senses. The next step, of course, is maintaining a high level of enthusiasm. And that is where his accomplished team comes in.

Stewardship of the land is another part of the equation. And integrating responsible building practices into each design is important to Tom. Borrowing Frank Lloyd Wright's philosophy that a house should be "of the hill" not "on the hill," Tom makes every attempt to protect the trees and native plants on job sites. His designs might incorporate the inherent qualities or topographical contours of a site, preserving the features that made the location desirable in the first place. Rather than stand out boldly from their environments, Tom's houses look as if they have always been a part of the landscape.

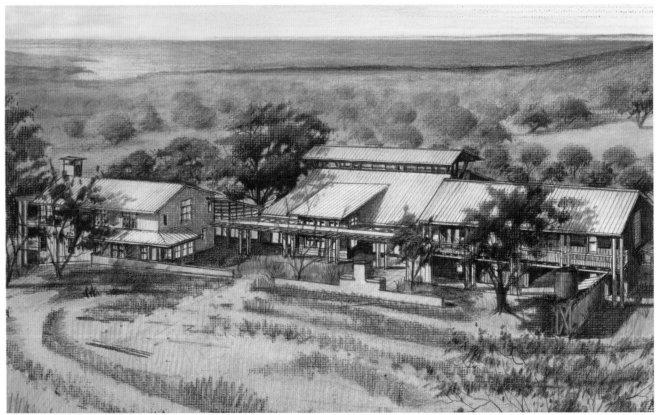

TOP LEFT:
The owners desired a formal dining space that also worked with more informal furnishings and contemporary art. The detail of the custom-crafted windows and trim varies from room to room but conveys a consistent traditional character throughout the home.
*Photograph by Bruk Photographics*

BOTTOM LEFT:
Recalling rural coastal building forms and Monterey courtyards, the 6,800-square-foot Idea House—sponsored by *Sunset Magazine* and owned by Monterra®—is comprised of three gabled buildings and walled courtyards for family living space, bedrooms, guest quarters and parking. Utilizing Green building materials and assemblies, the house is designed with photovoltaic and solar thermal energy systems. Cisterns capture runoff for all landscaping, including a restored meadow of native plants.
*Photograph by Bruk Photographics*

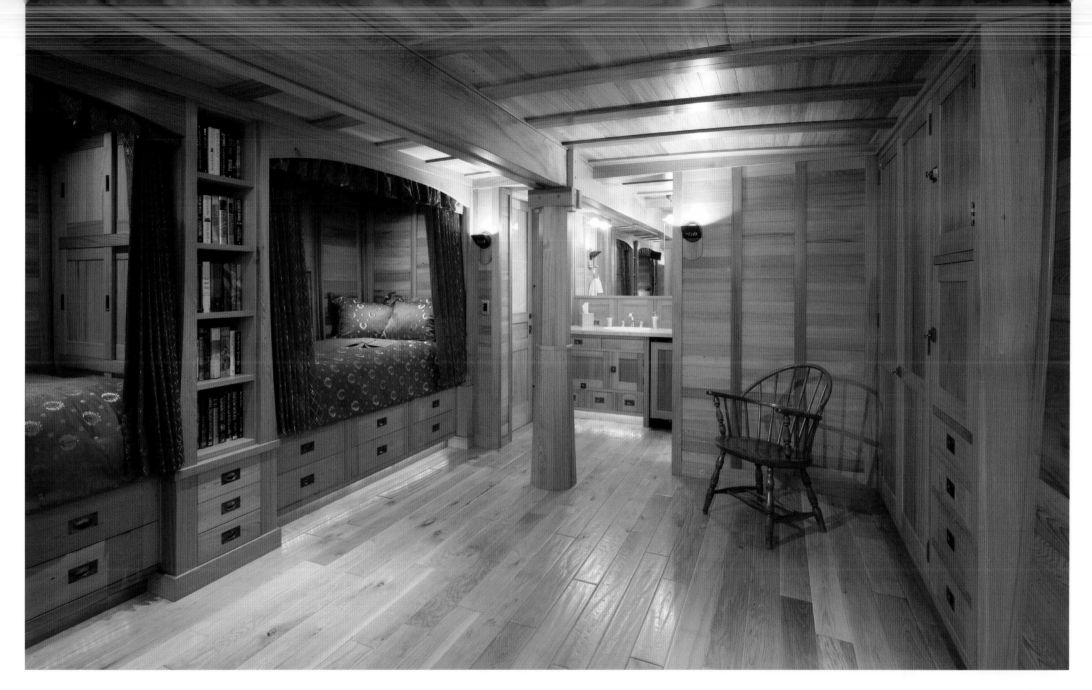

And that likely had something to do with his recent commission to design the 2008 *Sunset Magazine* Idea House, a 6,800-square-foot, five-bedroom showcase of elegant, eco-friendly design. This commission is for the group that could not contain their clapping when they saw his initial sketches for the house—which will comprise solar heating panels; reclaimed timber; a cistern to collect water during the winter for summer irrigation; a low-impact pier-and-beam foundation to reduce grading; and landscaping of native plants amidst coastal oaks. On his second meeting with the organizers, he presented conceptual plans and rendered elevations, and the group agreed: He had nailed their dreams spot on.

ABOVE:
This tiny space containing built-in sleeping berths, numerous storage drawers for blankets and personal belongings, a concealed television and secret spaces was lovingly assembled on site. Panels and custom cabinets were crafted entirely from salvaged old-growth cypress. The room's shape avoids the existing foundation, wood structure and utility lines under the main living spaces of the house. The painstaking design and construction process yielded a truly unique guest suite for weary travelers, recalling a time when journeys were often made aboard a ship.
*Photograph by Bruk Photographics*

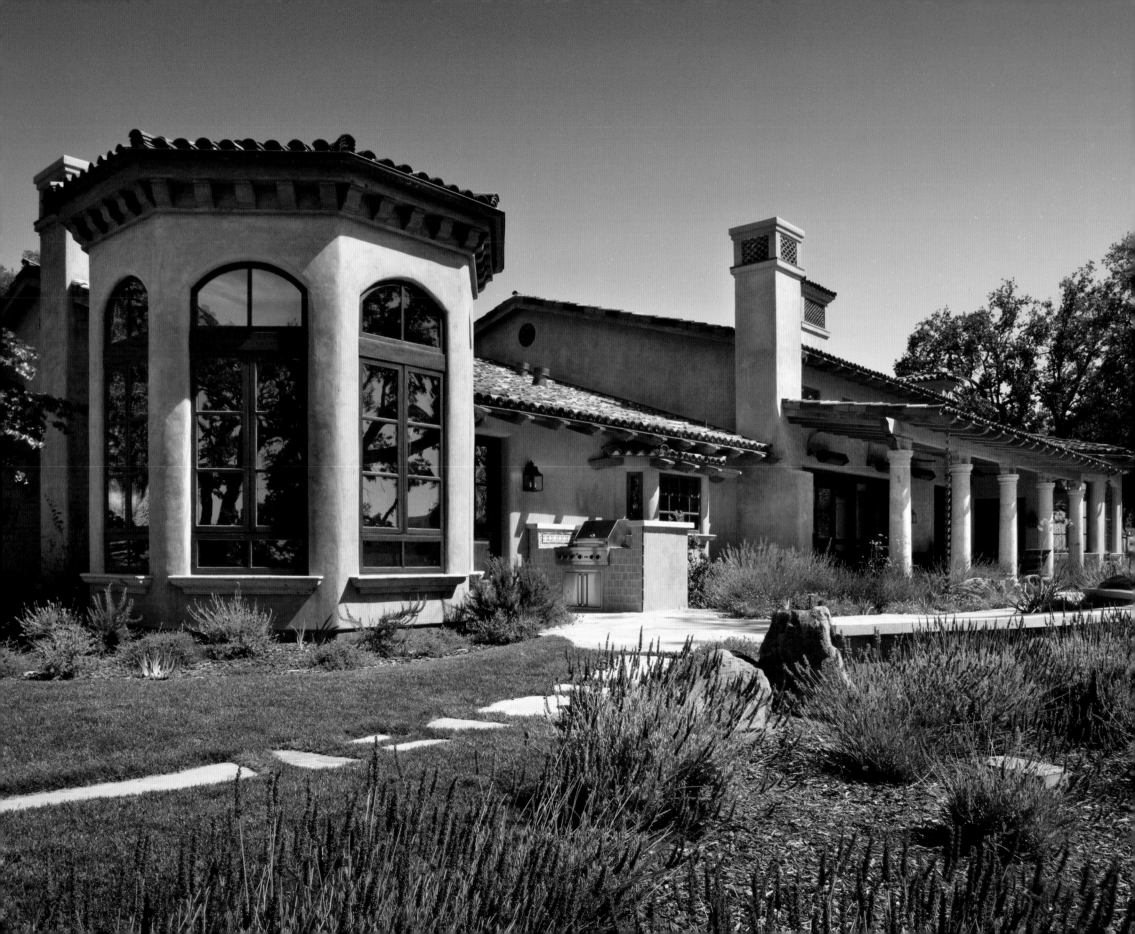

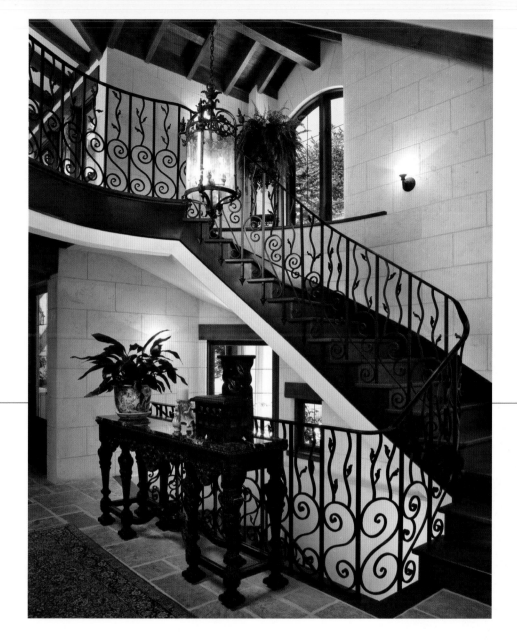

# CHRIS KEEHN

Casaterra Group

With more than 30 years of residential construction and design experience, Casaterra Group provides its clients with the most talented professionals who specialize in creating legacy homes that express the character and mood of particular vernacular styles. These styles include the authentic details that express the architecture of Southern France, the English countryside, Italian villas, Spanish Colonial, Mexican villas, French Normandy and both rustic and modern contemporary architectural styles.

Casaterra Group evolved from the successful construction firm of Keehn Construction, which since 1972 has built an impressive portfolio of custom homes and a reputation for excellence throughout the Monterey Peninsula, with homes in Pebble Beach, Carmel, Big Sur and Carmel Valley. Chris Keehn, principal of Casaterra Group, recognizes the value to his clients of bringing a team to the design-build

ABOVE:
A curved hardwood stairway with wrought iron railing adds to the charm of this English Country-style house, with travertine floors, a beamed ceiling and ArcusStone walls.
*Photograph by Rick Pharaoh Photography*

FACING PAGE:
Overlooking rolling hills and the Monterey Bay, this Hacienda-style house has cantera stone columns, integral-color exterior plaster and a barrel-tile roof.
*Photograph by Rick Pharaoh Photography*

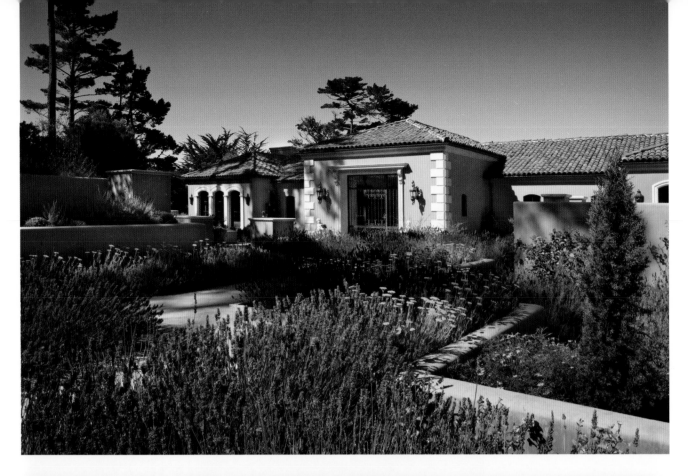

process under one umbrella. He is able to help his clients work with design professionals to develop plans infused with character and see their visions to fruition.

Do you imagine a French Provençal stone home set on a hillside? Chris has traveled to France and found a world-famous architect whose work is steeped in authenticity. Or perhaps a Mexican hacienda is more your style. He has built houses with an expert in that genre as well. Regardless of the desired style, Chris has searched far and wide for the right fit—holding every person he selects to a high design standard and then ensuring that the finished job meets a rigid set of criteria. When a client already has house plans, Casaterra applies the same exacting measures to the construction of the job. For all the homes it builds,

TOP LEFT:
Replete with a wrought iron and glass entry, travertine door trim and a rustic barrel tile roof, this Tuscan-style home enjoys a panoramic ocean view.
*Photograph by Rick Pharaoh Photography*

BOTTOM LEFT:
A variety of materials—stone, glass and integral-color plaster—were employed on the exterior walls of this oceanfront contemporary home, creating the impression that the home grew with additions over the years.
*Photograph by Rick Pharaoh Photography*

FACING PAGE TOP:
Influenced by the traditional French Normandy architectural vernacular, this home and adjacent equestrian building boast exposed timber framing, stone veneer walls, slate roofs and terracotta chimney pots.
*Photograph by Batista Moon Studio*

FACING PAGE BOTTOM:
Overlooking a Monterey Peninsula golf course, this home combines traditional and more contemporary materials with architectural massing to create a pleasing outdoor living space.
*Photograph by Batista Moon Studio*

Casaterra pays careful attention to the site itself, particularly the way the land is prepared, where the house is placed and the landscaping that follows. These considerations have the greatest impact on the aesthetics and livability of the home.

Casaterra is known for emphasizing materials and design details that echo the true character of the style of homes that it builds. This might mean aged wrought iron or an Old World appearance for stone veneer.

It is the goal of Casaterra Group to enable clients to pursue all the possibilities that will turn their dreams into realities and create the home they envision.

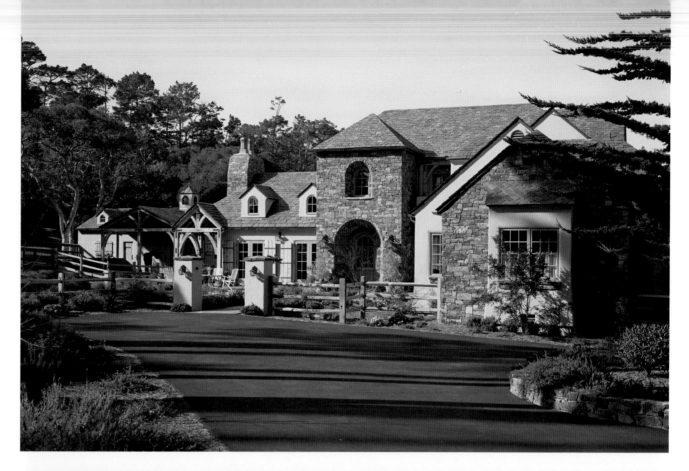

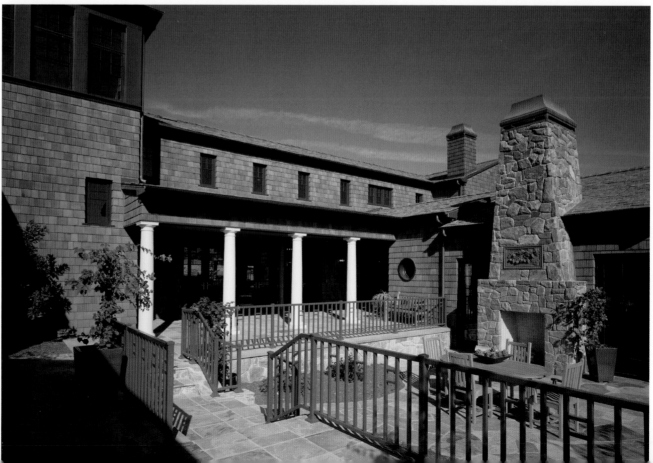

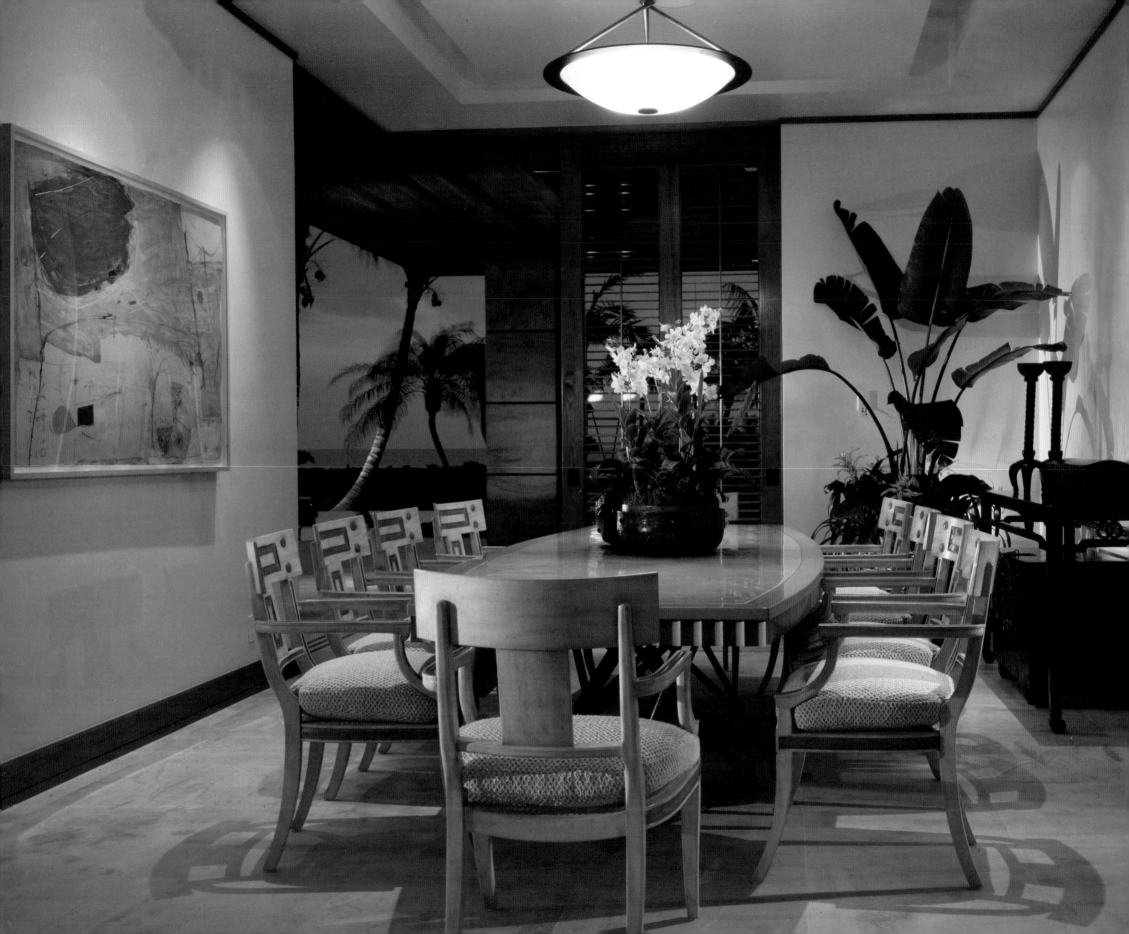

# LINDA LAMB

Lamb Design Group

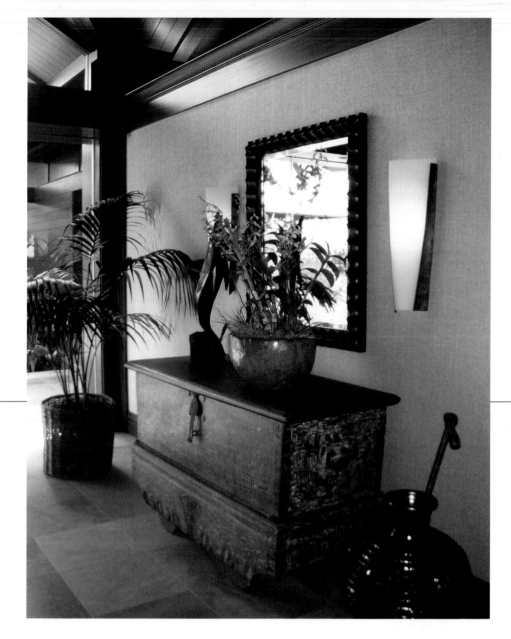

Most days are a symphony of details for interior designer Linda Lamb. When she is not juggling the deadlines of construction documents, jumping on an airplane or coordinating the shipment of containers of furniture to Hawaii or imports from Bali, she is researching or designing a custom cabinet.

But even with so many things on her plate, the California native and Monterey Peninsula resident is at once both extremely personable and extraordinarily detail driven. These qualities shine through in her work, which encompasses a full range of interior planning and design services, with an emphasis on custom residential and hospitality projects. And a trademark enthusiasm and energy infects her work.

Linda has been in the business of designing dream homes for nearly 30 years, and it is clear that design is not only her profession, it is her passion. She considers it a gift to be able to enhance and improve

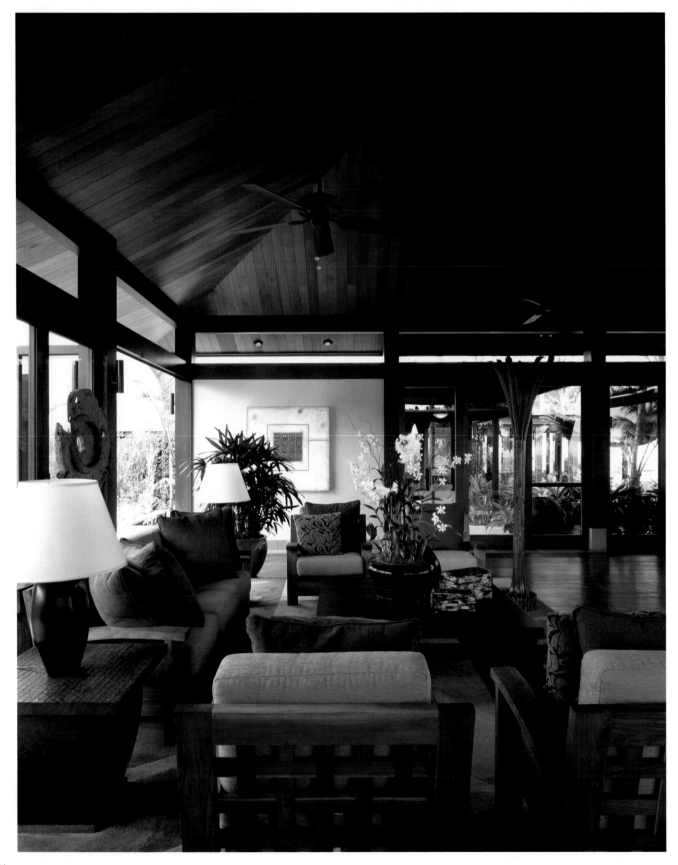

the quality of people's lives by giving them nurturing and beautiful environments and hopes that her passion shines through in her work. Design is not merely a static formula about picking furniture or fabrics, it is a much more soulful process that involves personal commitment and complete attention to every possible detail. That said, Linda believes that in order for a space to truly reflect the inhabitants, there must be a cohesive dialogue between all aspects of the architectural details and the interior furnishings.

And it is this essential dictum—the emphasis on a comprehensive environment—that pretty much sums up Linda's entire approach. Typically brought into a project in the beginning phase of planning and construction, she enjoys being part of the team of professionals, including architect, contractor and special consultants, where a synergetic collaboration of ideas results in successful, creative solutions.

Her designs are innovative yet down to earth. Recognizing that people want homes, not showcases, she tends to steer clear of edgy or trendy styles that are short lived, but rather creates those that embody real-life comfort. Linda likes to infuse natural materials and rich textures into her work, and incorporates an unexpected mix of furnishings, artwork and accessories that blend clean and classic lines with organic and often rusticated elements for interest.

LEFT:
Pacific breezes and beautiful vistas are taken in from the pavilion.
*Photograph by Katsuhisa Kida*

FACING PAGE LEFT:
Perfect weather, leisure opportunities and panoramic views abound at the pool terrace.
*Photograph by Katsuhisa Kida*

FACING PAGE RIGHT:
An interesting mix of finishes, textures and shapes highlights this custom Kona residence.
*Photograph by Ira Montgomery*

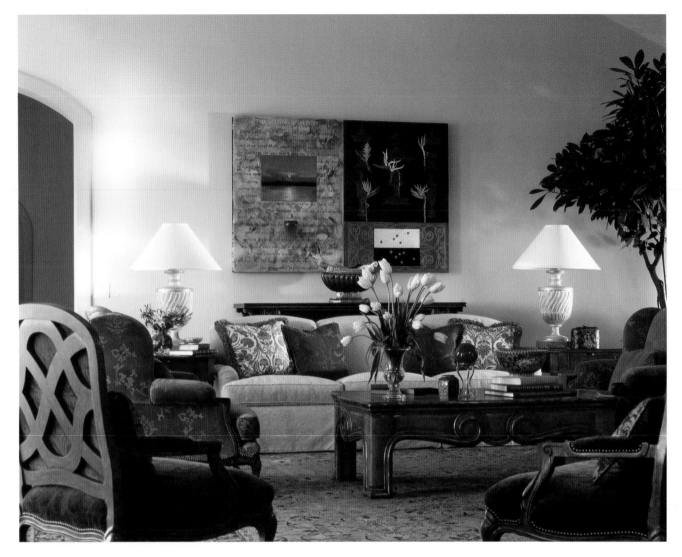

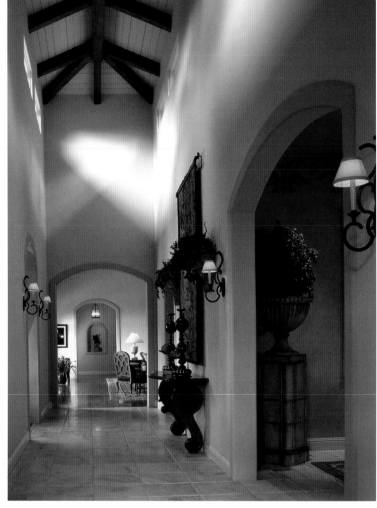

A cornerstone of her designs is the cross-cultural blend of objects that she sources from around the world. Her extensive travels give her designs an inspired sensibility and added warmth. She loves finding beautiful artifacts, treasures from other countries that infuse rooms with such texture and surprise—elements that delight the senses. With much of her current work in Hawaii and abroad—she recently completed two villas in Tuscany—it is no surprise that she makes buying trips to places like Indonesia and Europe to acquire unusual objects. She naturally borrows on the warmth and casual sophistication of her California roots, which is unwittingly an underlying theme of her designs. Above all she adheres to the belief that interiors should capture the unique spirit of a location and create an unmistakable sense of place.

Ultimately, what Linda brings to each new project is an unwavering dedication to creating spaces that reflect the preferences and needs of the client, which resonates with her passion for design.

ABOVE LEFT:
Timeless design and a rich palette inform this Mediterranean-style residence on Pebble Beach's famed 17-Mile Drive.
*Photograph by David Duncan Livingston*

ABOVE RIGHT:
The grand gallery space is appointed with an antique Aubusson tapestry and custom iron sconces.
*Photograph by David Duncan Livingston*

FACING PAGE LEFT:
Sculptural furnishings, high-lacquered finishes and clean lines provide a sophisticated ambience. Custom design elements are by Donghia, J. Robert Scott and Dakota Jackson.
*Photograph by Kyle Rothenborg*

FACING PAGE RIGHT:
Within a contemporary Kukio Resort residence on the Big Island, the upholstered J. Robert Scott bed mixes brilliantly with the vibrantly colored artwork.
*Photograph by Kyle Rothenborg*

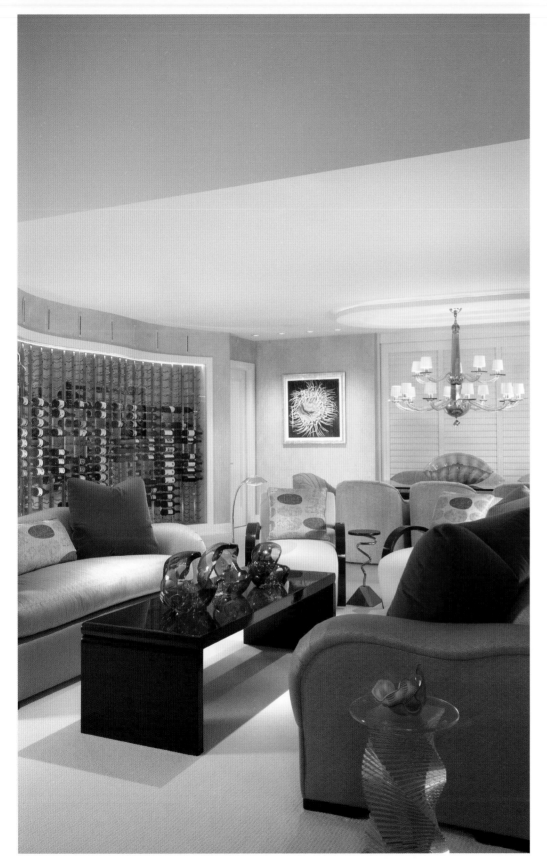

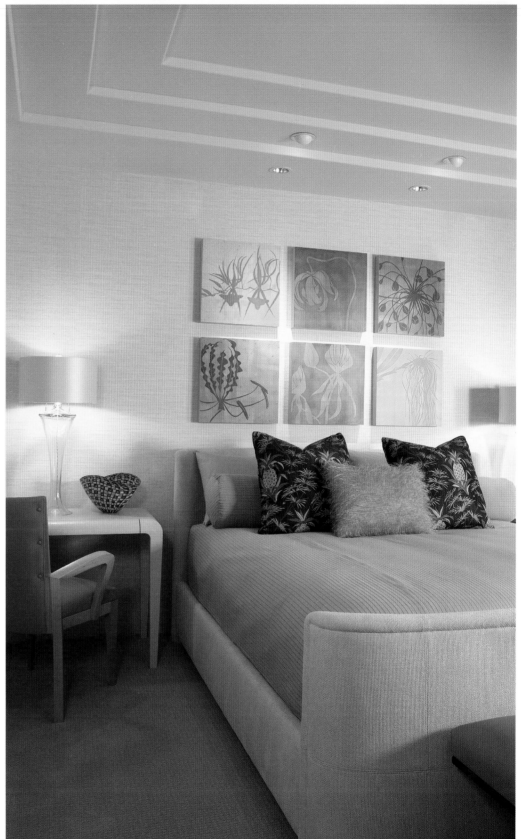

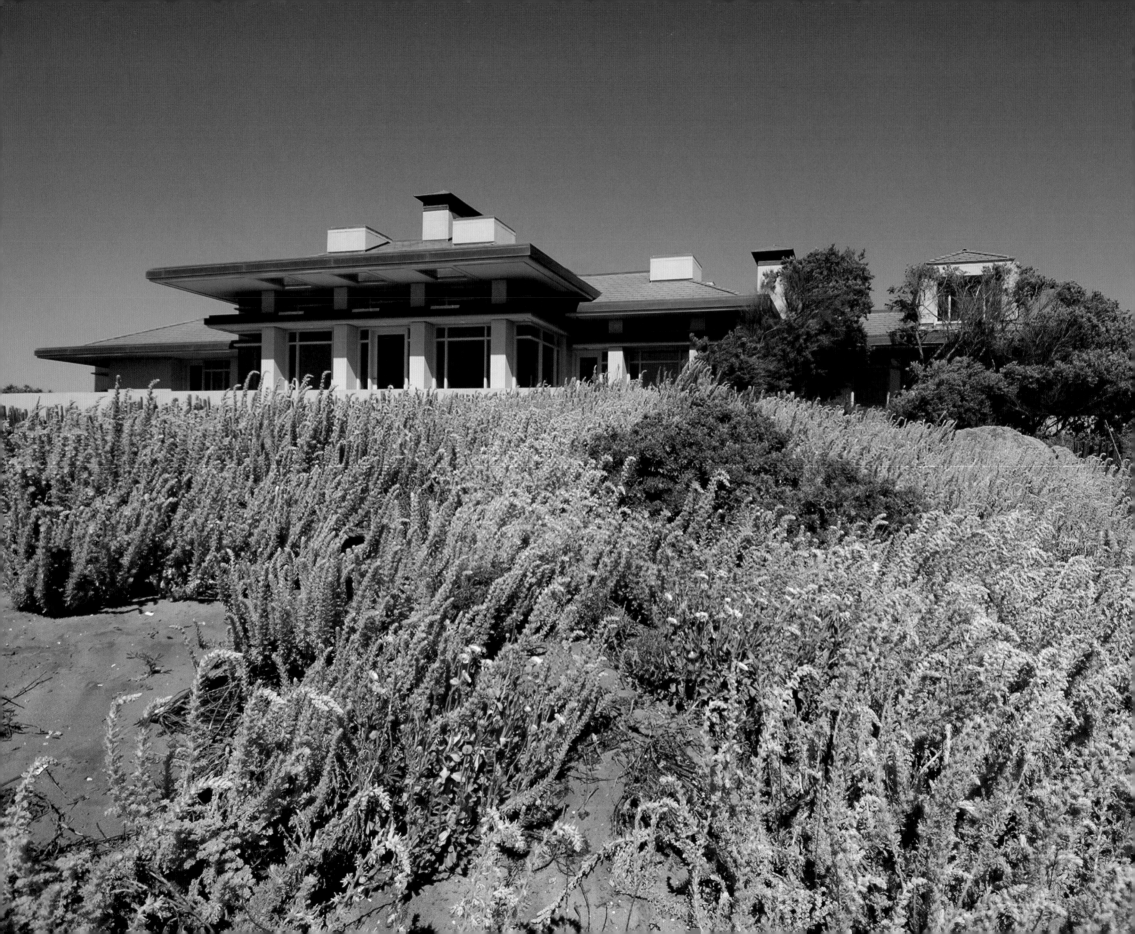

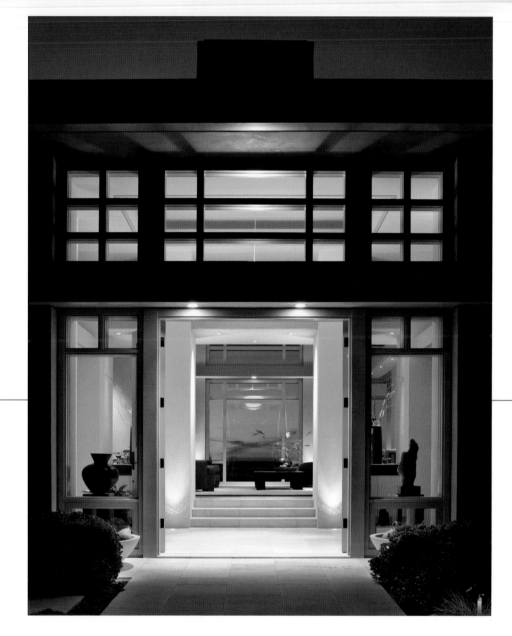

# DAVID MARTIN

Wm. David Martin, AIA & Associates

Wm. David Martin, AIA, considers it an honor to design the personal places where his clients can express their interior lives. Creating spaces that nurture and inspire is this award-winning architect's raison d'être and he approaches the task with a reverent spirit, an open mind and a unique balance of patience and enthusiasm.

For David, each new project is a celebration of the land, of the people who will inhabit it and of the creative process that gives birth to each unfolding form. He always begins with an empty canvas, allowing his designs to develop organically from an evolving appreciation of his clients' desires and dreams coupled with a deep understanding of the site and its context.

Recognizing that each client and site has unique character, David asks his clients to fill out an extensive questionnaire to facilitate his understanding of their perceptions of the site as well as their lifestyle and

ABOVE:
The east-facing entry introduces the framing and layering of ocean views, a key architectural theme that occurs throughout the house.
*Photograph by Rick Pharaoh*

FACING PAGE:
Perched high on a dune with panoramic views of the Pacific, the west-facing façade has deep overhangs and mitered glass corners to frame ocean views from every room. Four large pyramidal skylights flood interior spaces with natural light.
*Photograph by Wm. David Martin*

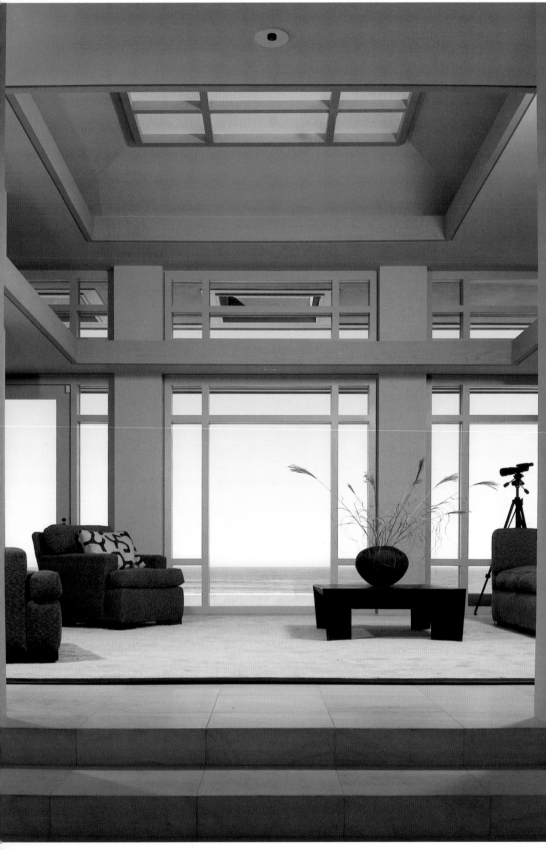

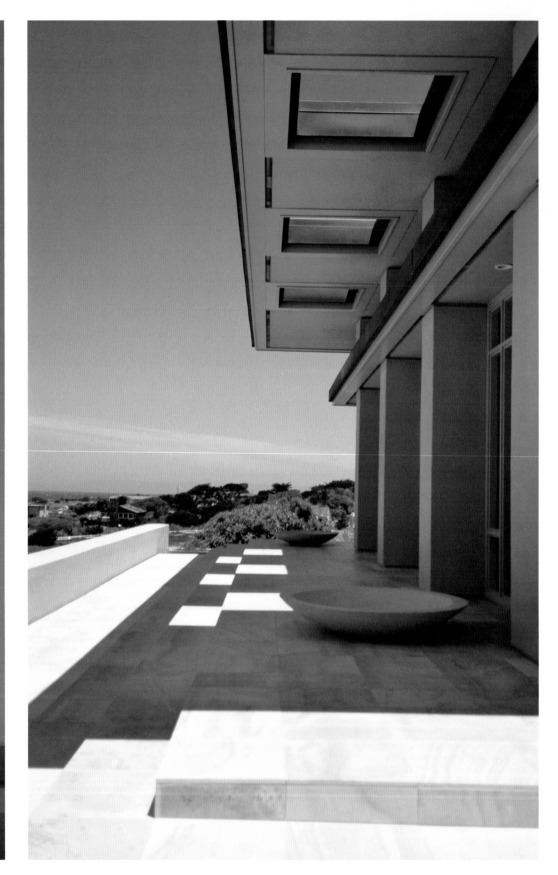

the functional, symbolic and emotional qualities of each space in their new home. He often invites clients to join him on site to connect with the earth and discover what inspirations the site might evoke for them.

Site planning and conceptual designs are explored in interactive, high-spirited design sessions with clients. Beginning with a topographic site analysis and a diagram of relationships developed from the questionnaire, David and his clients "choreograph" the sequence of exterior and interior spaces until each one "feels right." Form evolves naturally from the exploration of these functional flows and the opportunities to heighten and expand each experience of site and home.

One result of David's co-creative design process is that his clients, having been intimately involved in the conceptual development, are as committed as he is to seeing the project constructed. Another result is that David's buildings seldom resemble one another. While all of his work shows a masterful use of light, scale, proportion and Green design principles, each project is the product not of a defining style, but rather of a co-creative process that invariably yields delightful and timeless buildings to nurture and inspire all who enter.

RIGHT:
The recipient of an AIA design award, this house has a Pacific Rim interior inspired by the client's Asian art collection and was published in *Sunset Magazine* and several books, including the cover photo of *The Art of Lighting*.
*Photograph by Douglas A. Salin*

FACING PAGE LEFT:
The light-filled interior is enhanced by layered roof planes coupled with flared and lensed light wells that increase ambient interior light while reducing glare from the ocean and afternoon sun.
*Photograph by Rick Pharaoh*

FACING PAGE RIGHT:
On the west-facing terrace, openings in the 8-foot upper roof cantilever increase ambient interior light levels by allowing sunlight to be reflected onto the ceiling from the lower roof.
*Photograph by Wm. David Martin*

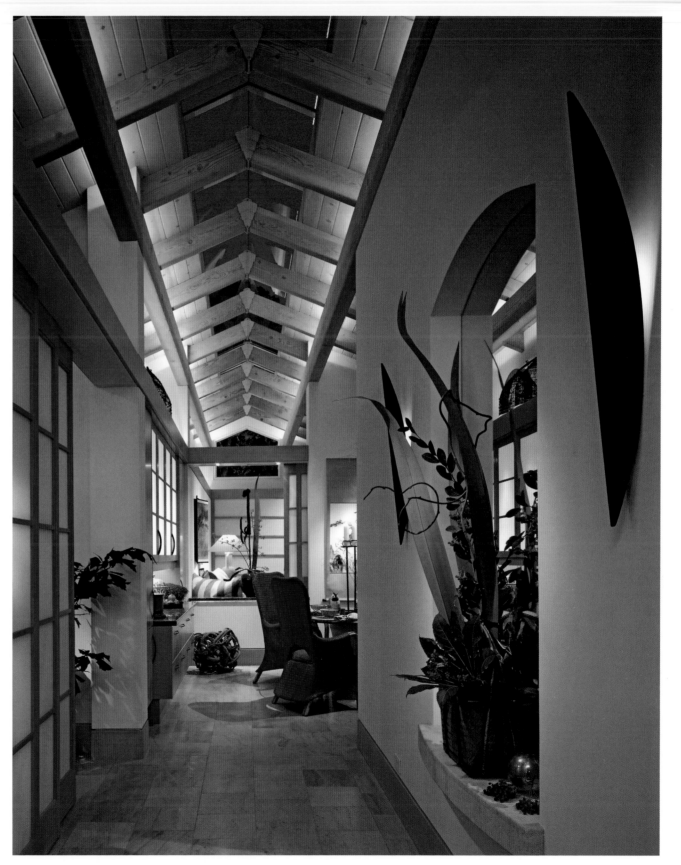

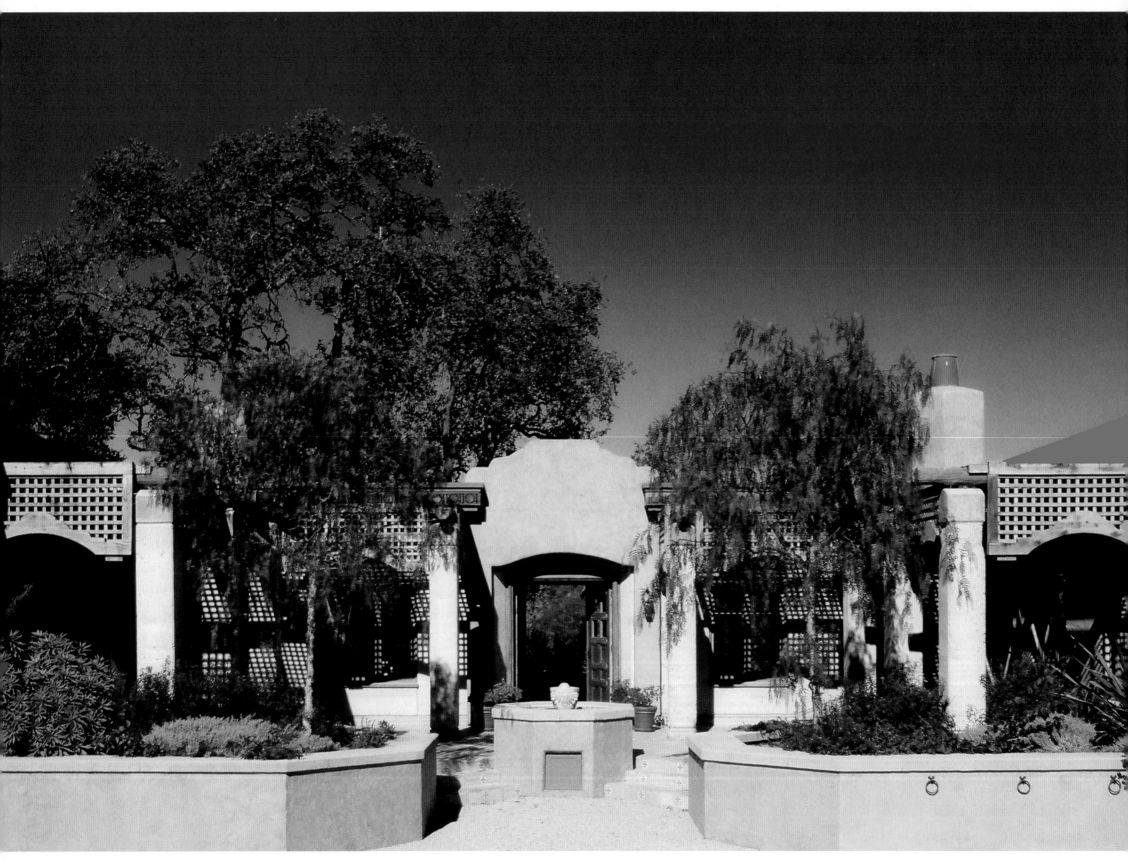

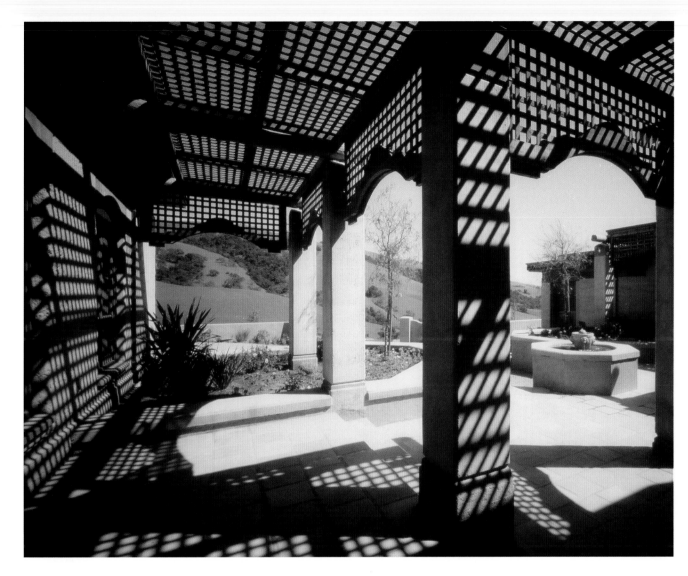

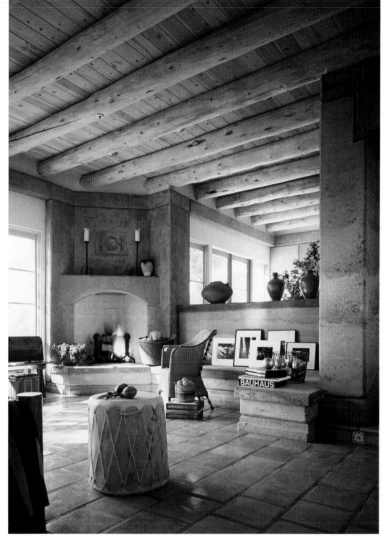

The son of a Naval aviator, David's early training in architecture included extensive world travel and living in 23 houses in eight states and four countries. He earned his Bachelor of Architecture from the University of Southern California on a Navy scholarship and served five years in the Navy's Civil Engineer Corps upon graduation.

As a young company commander with a Seabee Battalion in DaNang, Vietnam, David designed and constructed housing, hospitals and villages for refugees. He also designed a clubhouse, employing Vietnamese artisans and using indigenous materials, that was published in *Progressive Architecture* magazine.

After returning stateside and earning master's degrees in both architecture and city planning at MIT, David worked for established architectural firms, including Skidmore Owings & Merrill, before opening his own office in 1989. Although his portfolio includes large planning and urban design projects, including a new city in Saudi Arabia, Boston's Big Dig and several

ABOVE LEFT:
Rammed earth columns have concrete caps and bases and support redwood lattice sunscreens needed for shade from the intense sun high up in the hills immortalized by John Steinbeck's *The Pastures of Heaven.*
*Photograph by Douglas A. Salin*

ABOVE RIGHT:
The ultimate in organic Green design, the earth for the rammed earth walls came from the site and most of the construction materials originated within a radius of 150 miles of the site.
*Photograph by Douglas A. Salin*

FACING PAGE:
The recipient of design awards from the American Concrete Institute and the AIA, this rammed earth house was the first masonry structure designed without steel reinforcing in Monterey County since the inception of building codes.
*Photograph by Wm. David Martin*

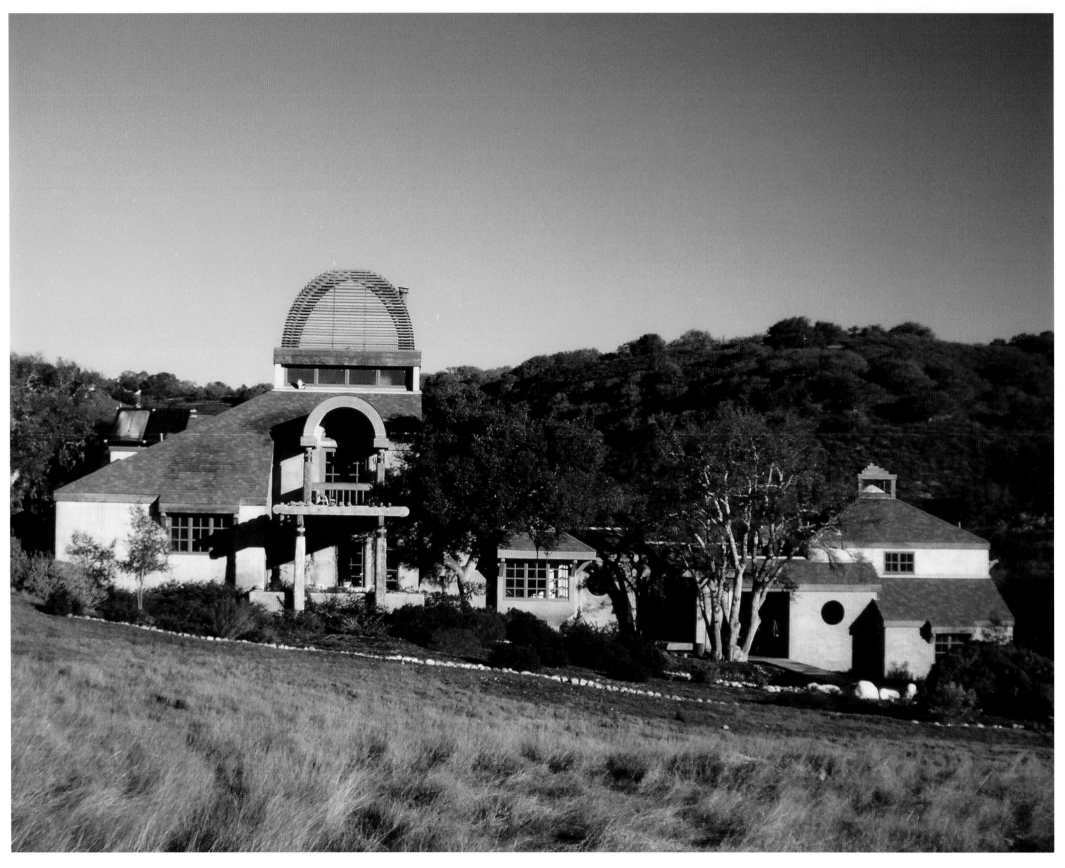

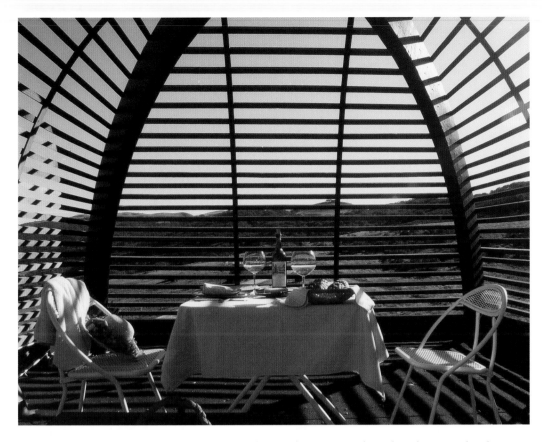

hotels, as a solo practitioner he has gravitated toward private residential work, resort development and commercial projects appropriate in scale and context to coastal communities on both East and West Coasts.

David's projects have received numerous awards and have been published in many books and magazines. Yet it is through the satisfaction and delight of his clients that he truly measures his success.

ABOVE:
The client's program called for a rooftop observatory. The budget didn't allow for glulam arches so they were bandsawed from a sandwich of leftover plywood and 4x4s.
*Photograph by Wm. David Martin*

RIGHT:
Shading from the intense Carmel Valley sun is provided by existing trees, roof projections at windows and doors and redwood trellises over outdoor rooms.
*Photograph by Wm. David Martin*

FACING PAGE:
With a very limited budget, this 1,980-square-foot passive and active solar house was designed with commonly available materials to be energy efficient and have a much larger presence than its modest size. It won an AIA design award.
*Photograph by Wm. David Martin*

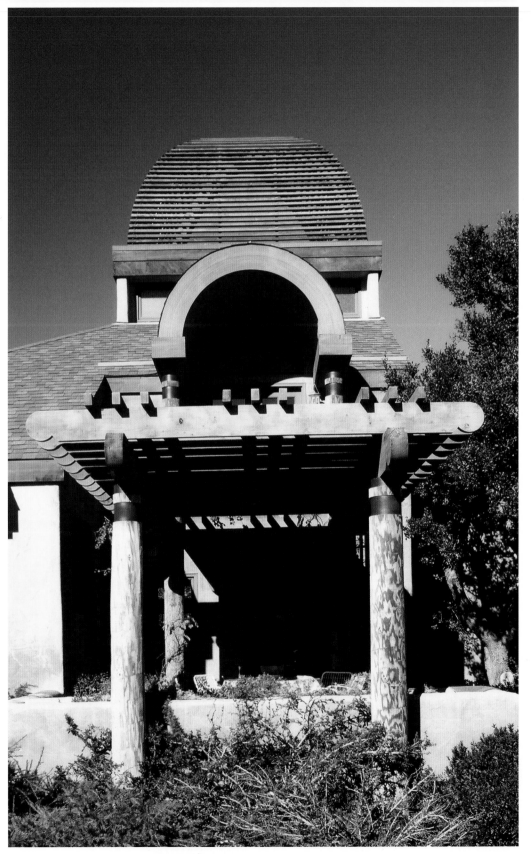

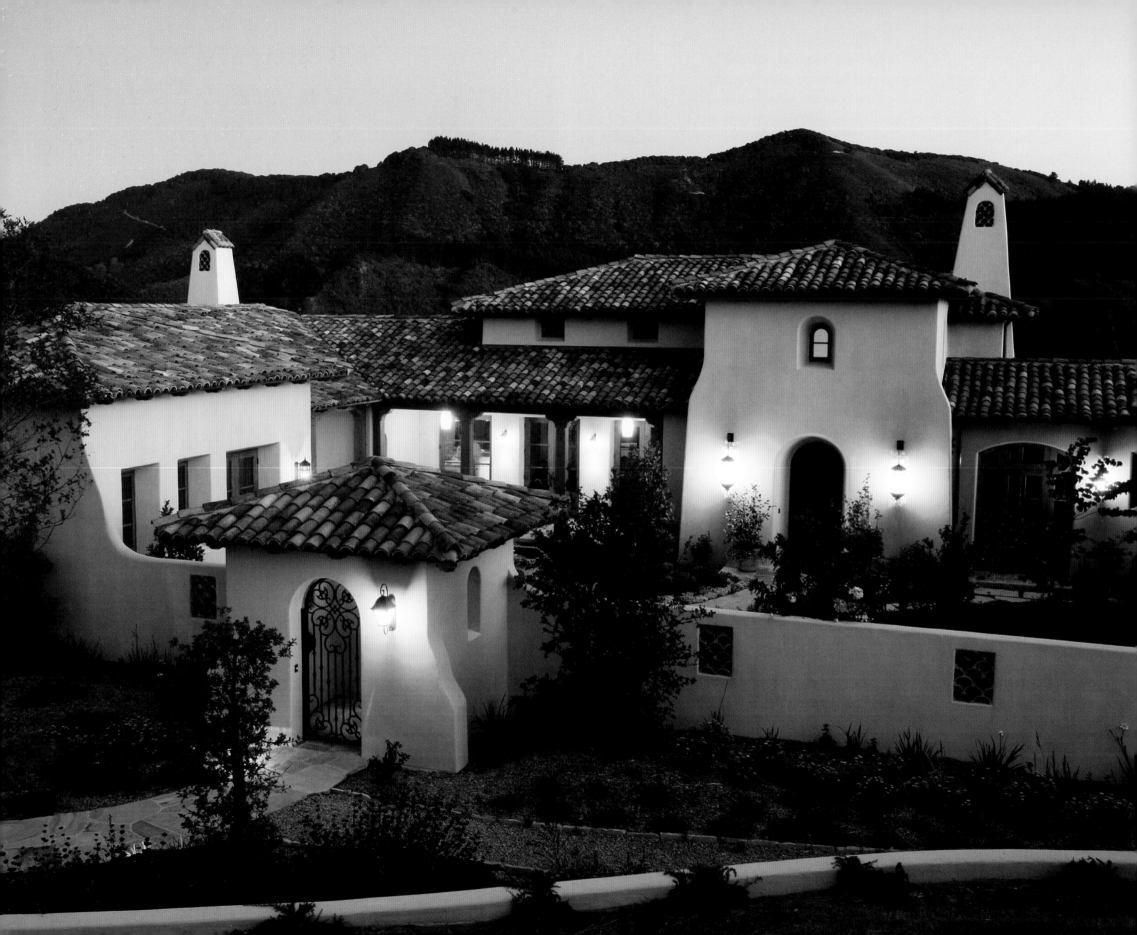

# ERIC MILLER

Eric Miller Architects, Inc.

Evolutionary, not revolutionary—that is how Eric Miller, AIA, describes his work. Evolutionary spaces are human—they are places that invite you to sit and read a book or take in a view. The award-winning architect sees himself as a conceptual artist who not only designs buildings but spaces in which people create their lives.

Drawing his ideas from three sources—the site, the client and his own creativity—Eric does not design with the intent to be trendy or fashionable but with the goal of creating homes that are timeless sensations destined to be passed from generation to generation.

In his 20 years as an architect, Eric has produced a large body of creative regional work. Based in Pacific Grove, he works all over Monterey County and has developed a specific vernacular for different locations in the region. His vision is organic and intrinsic to the location of the site.

Out of necessity, coastal homes are distinct from inland homes, with the latter being more suitable for indoor-outdoor living and the former requiring more attention to how one lives inside the home. The coast simply calls for different architecture from inland valley areas. An outdoor room on the coast, where cooler temperatures prevail, for example, requires a fireplace in order to be enjoyable. In the valley, the architect feels free to open a house up to the outside with a series of sliding glass walls—something that would be impractical nearer the ocean. Too, each area has a separate identity that has developed through the years and Eric's homes are steeped in history; his designs carry the influence of architects past.

In Pacific Grove, for example, he takes his cue from the Craftsman era and Bernard Maybeck—the prominent architect who designed the house in which Eric grew up—and Julia Morgan. Eric explains that regional Craftsman architecture is in many ways the precursor to modern architecture, which was a reaction to the frills of Victorian architecture. The Craftsman belief in structure and materials is a nice entry into modern architecture, but is anchored in the kind of human experience that infuses all of Eric's work. He adapts the ordinary Craftsman style to

LEFT:
An outdoor room with beamed ceiling and antique brick-lined fireplace affords open-air living to a Pebble Beach home.
*Photograph by Gina Taro*

FACING PAGE LEFT:
From the courtyard, an exterior stairwell, with hand-painted tile and bronze handrail, leads to the master bedroom. Deep-set arches are reminiscent of an old masonry building that has been plastered.
*Photograph by Gina Taro*

FACING PAGE RIGHT:
The entry fireplace chimney is capped with a clay tile design that is symbolic of the old California Missions. Copper gutters, which develop a rich patina over time, are used throughout.
*Photograph by Gina Taro*

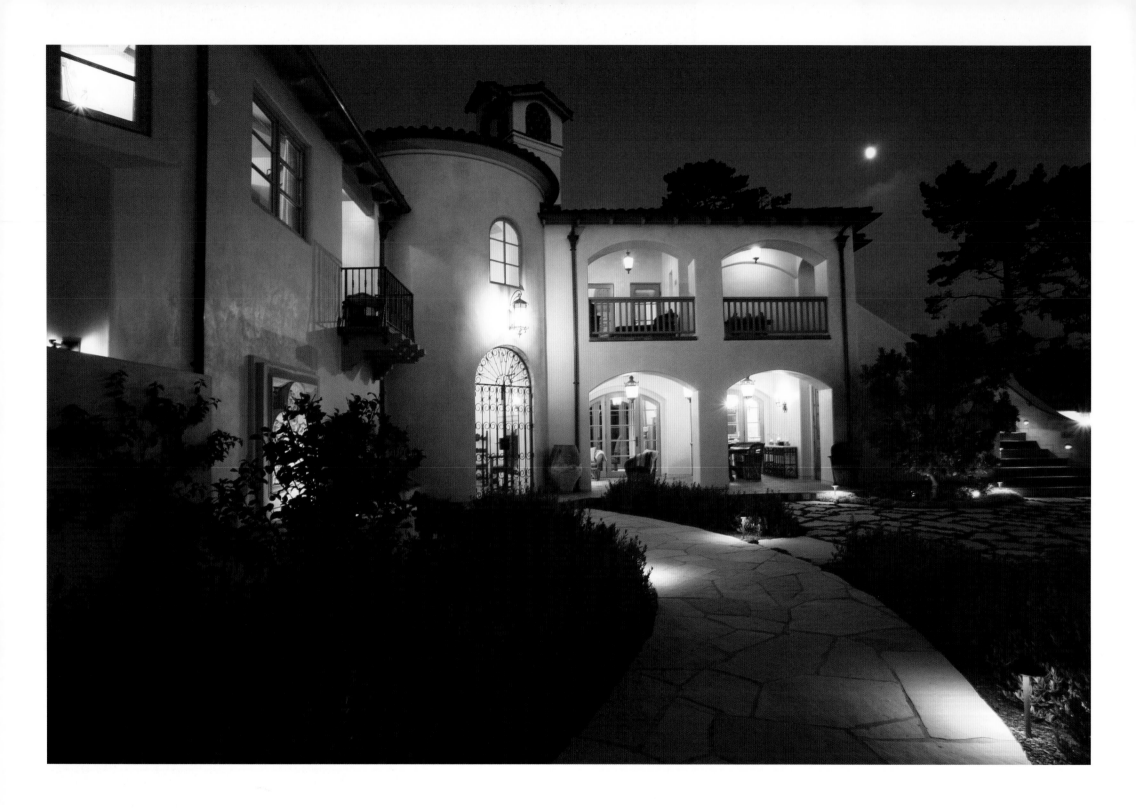

the beach by creating spaces that have free access to lush gardens and cozy courtyards.

In Carmel, he is influenced by the early Carmel artists and designs beach houses that emphasize materials that will not just weather well, but will actually develop a patina to become character-defining features with the passing of time. Materials such as stone, copper, mahogany and bronze are predominant in Eric's homes in that area.

In Tehama and Pebble Beach, Eric is inspired by 1920s' architecture, reminiscent of Addison Mizner, who designed some of the more beautiful houses along 17 Mile Drive. In these regions, Eric likes to do indoor-outdoor spaces that are holistically integrated into the house. He carefully creates hospitable outdoor rooms that make a natural connection between interior and exterior, giving them fireplaces and kitchens and welcoming conversation areas. He is also conscientious of the landscaping, preserving native plants and topography between the house and its surroundings so that they might serve as a buffer and help the home blend in.

But before any design can unfold, Eric must first understand the people who will inhabit the house he is to create. He gets to know them and finds out what they are interested in: Everything, from their

RIGHT:
A carved-limestone quatrefoil fountain with simple bronze spout adds ornamental detail to the front courtyard.
*Photograph by Gina Taro*

FACING PAGE:
This coastal fairway home features indoor-outdoor rooms. The California Mediterranean design delivers the warmth and comfort of the owner's childhood home that once occupied the site.
*Photograph by Gina Taro*

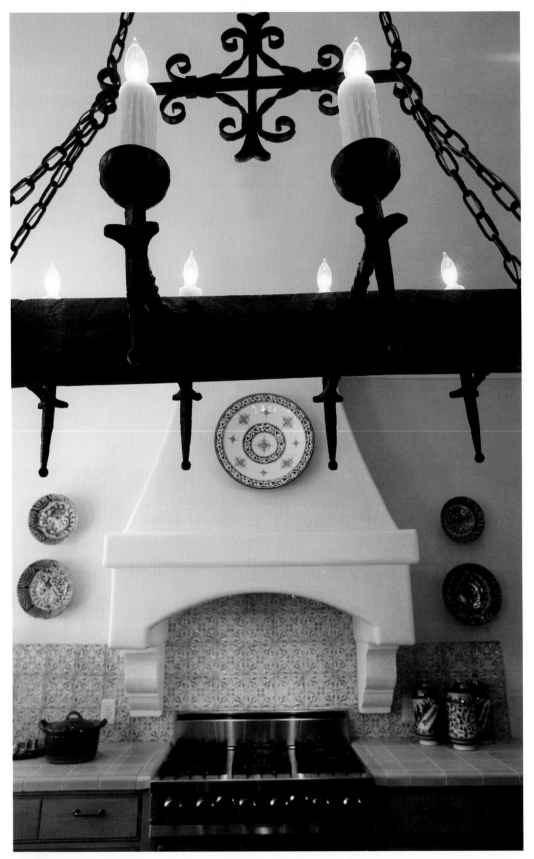
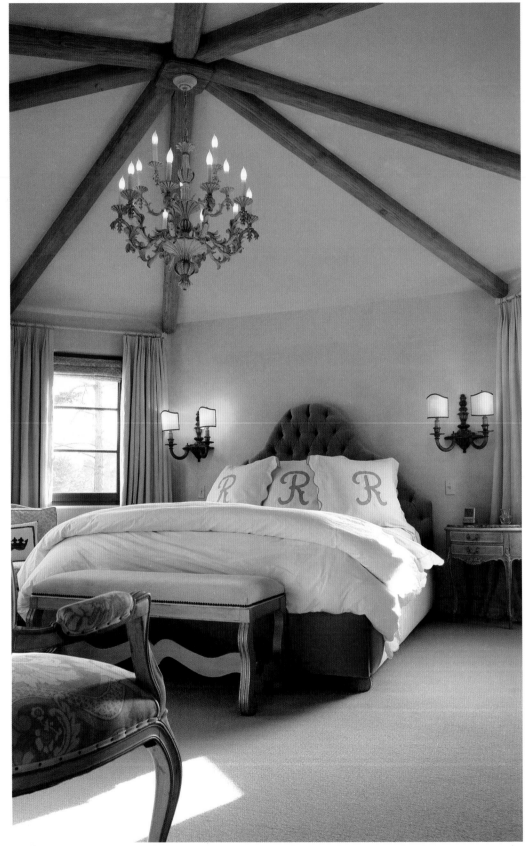

golf handicap to their art collection, is a window into who they are and the type of home that will work for them. Then he researches the site, studying its natural, unrefined features—the trees and rocks, the angles of the sun throughout the day and the views. Only then does he sit down and sketch.

The 20-person firm of Eric Miller Architects takes on only about 10 new projects per year. And though Eric does all of the design work himself, every one is a collaborative effort born of an open studio environment. The results are houses that are visually appealing heritage homes that cause people to linger.

Drive by one of these classic homes and you will stop to wonder what it is like inside; you will want to get in and know what it is like to live there. And once you are inside? There are rewards to be had. Eric's homes reveal themselves a little at a time—a surprise view here, an unexpected window angle there. He feels strongly that each room should have its own character. Perhaps a carved beam ceiling in the living room gives way to a coffered ceiling in a library or a wall niche exhibiting a favorite piece of art. Like pieces of a puzzle, each element fits together, creating a home that is unique to its owners and their lifestyle.

RIGHT:
A wrought iron gate, which yields to the front entry, is from an original Miller design that was hand-crafted in Mexico.
*Photograph by Gina Taro*

FACING PAGE LEFT:
A range with a plastered surround evokes the style of old European kitchens in which a stove was installed in the original cooking fireplace.
*Photograph by Gina Taro*

FACING PAGE RIGHT:
This hexagonal master bedroom with hand-hewn wood beams provides an unexpected complement to the rectilinear home plan.
*Photograph by Gina Taro*

# MONTERRA®

It's rolling California hills. It's pastoral valleys flanking the historic Monterey Bay. It's the Santa Lucia Mountains. It's the warmth of a winter sun and the heady expanse of a wildflower meadow. It's a doe and her fawn, a majestic falcon soaring on a thermal overhead. It's a little bit of magic. It's the exclusive gated community of Monterra®.

Situated on the Monterey Peninsula among more than 1,700 breathtakingly beautiful acres of trees as old as time lie newly released homesites ranging from two to five acres. Each site was created from a thoughtful vision that recognizes the alchemy of preserving open space while providing privacy, security and unparalleled views, enabling residents to create a home that complements the exquisite setting as well as their own personal aesthetic.

The houses there are just as thoughtful. The community's comprehensive design guidelines were developed to ensure enduring quality, integrity and beauty. And houses are designed to blend

ABOVE:
The fireplace serves as a focal point in the backyard of Roger Mills' home in Monterra®.
*Photograph courtesy of Monterra®*

FACING PAGE:
The home of Roger Mills has an idyllic courtyard, replete with an outdoor pizza oven.
*Photograph courtesy of Monterra®*

purposefully and seamlessly with the landscape, integrating natural materials with classic craftsmanship. Architectural styles have many influences, including historic Monterey and the European traditions of nearby coastal towns. All are visually diverse and unique.

The community draws those with an interest in the environment as well as an interest in neighborly interaction. Though sites are generous and the landscape is lush, it's still possible for neighbors to become friends.

All Monterra® residents enjoy a Tehama Golf Club Social Fitness Membership. And they can be found spending quality time on sun-drenched porches and covered patios, relaxing in the lap pool or outdoor hot tub, or challenging one another to a match on one of two tennis courts. Or, perhaps, they're raising a celebratory glass at Callahan's Grill, a nod to the legendary "Dirty Harry."

And, of course, Monterra® overlooks a dynamic seaside community defined by more than 400 years of vibrant cultural history. Although it feels far from civilization, just outside the privacy of its gates, Monterey and the neighboring communities of Carmel-by-the-Sea and Pebble Beach offer countless opportunities for enrichment: the world-famous Monterey Bay Aquarium, Cannery Row, award-winning restaurants, fine visual and performing arts, shopping, sightseeing and pristine white-sand beaches—not to mention golf.

From sardines to salmon, Steinbeck to Stevenson, the culture thrives, beckoning all to become part of the story, to reconnect with the land that legends have called home. More than an address, the community is a place residents will want to return for generations. It's also a lifestyle. "Living at Monterra® is a journey of self-discovery … an invitation to reconnect with nature and yourself," says Roger Mills, owner and developer of the project.

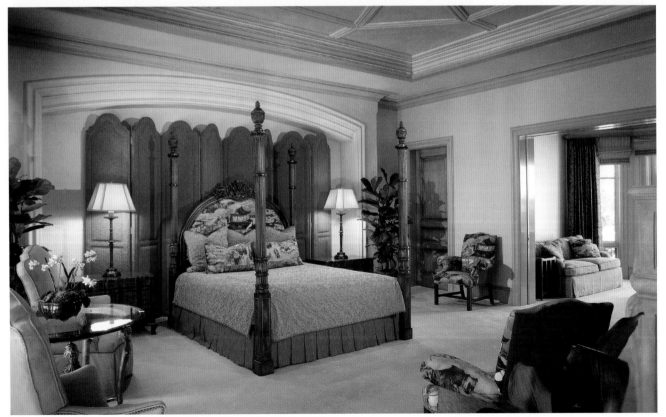

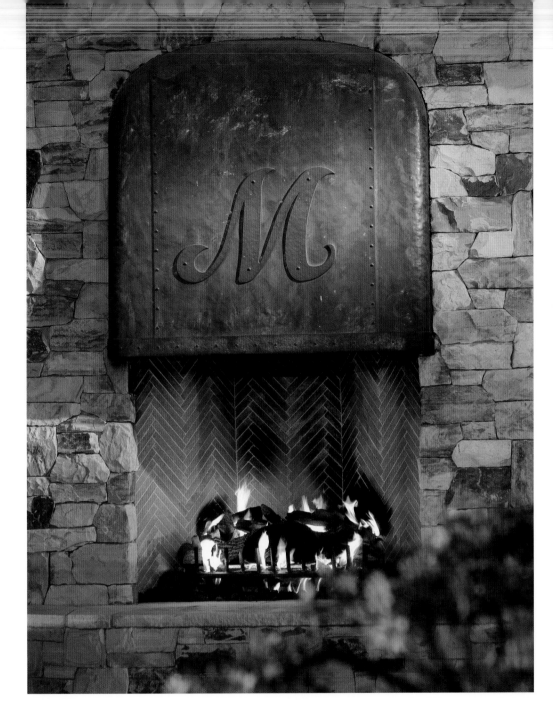

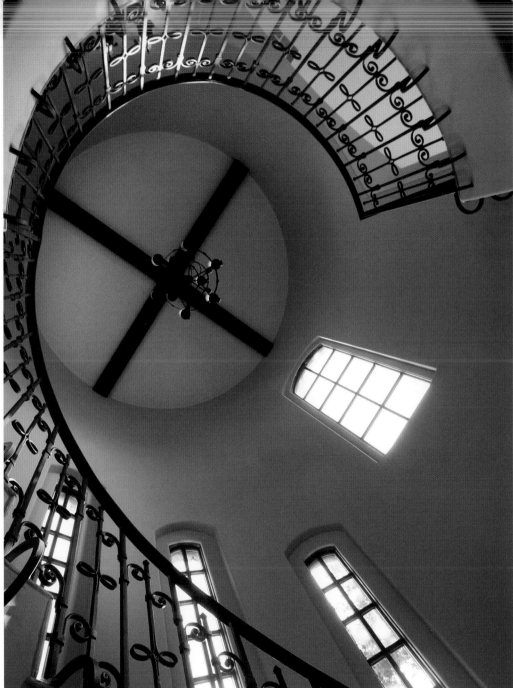

ABOVE LEFT:
The outdoor copper firelace of the Mills' home was custom designed and hand-crafted.
*Photograph courtesy of Monterra®*

ABOVE RIGHT:
Located in Monterra®, this home boasts an elegant custom staircase.
*Photograph courtesy of Monterra®*

FACING PAGE TOP:
Roger Mills' home is situated atop a hillside in Monterra®.
*Photograph courtesy of Monterra®*

FACING PAGE BOTTOM:
Exquisite details inform the Mills home's master bedroom.
*Photograph courtesy of Monterra®*

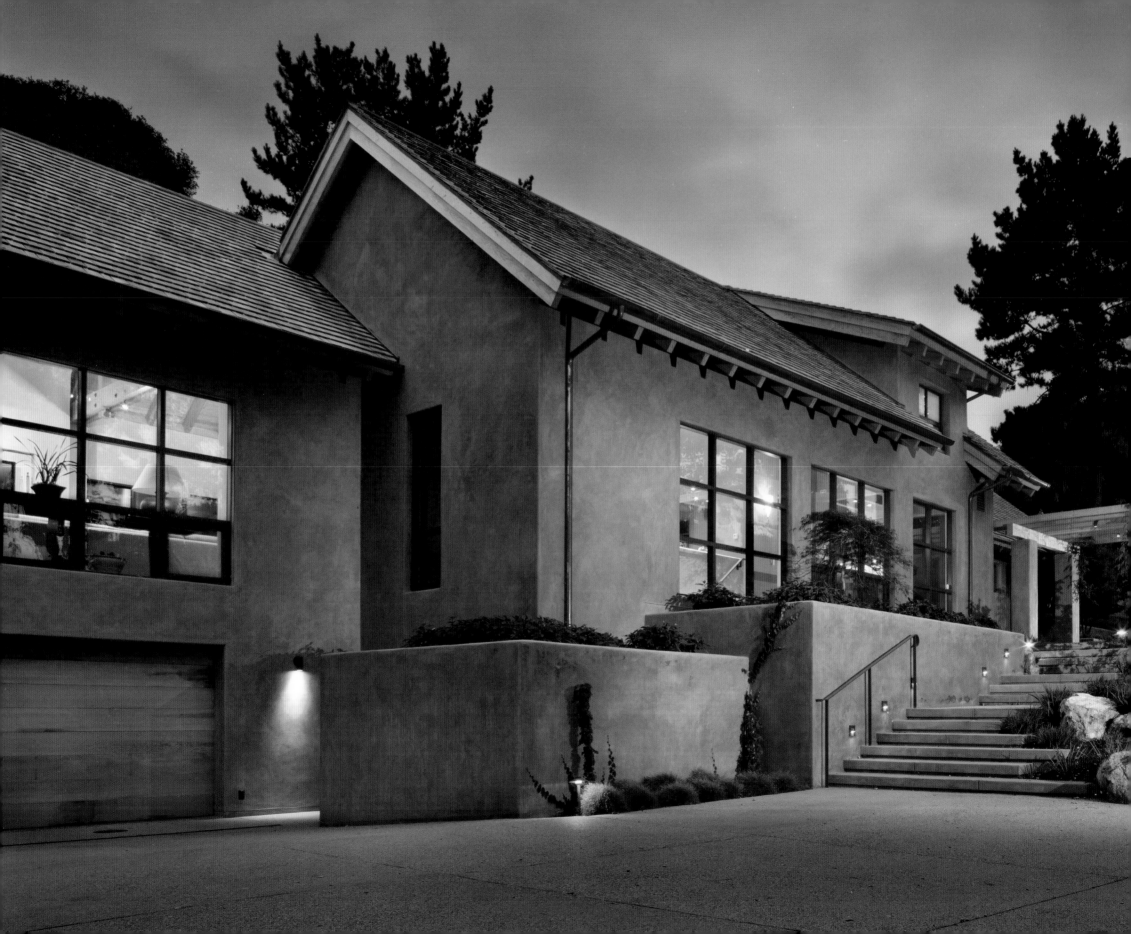

# ROB NICELY

Carmel Building & Design

To succeed you need be not just a resource but the best resource. That is Rob Nicely's business philosophy and it is the reason he has had happy clients for more than 20 years. And as president of Carmel Building & Design, he is overseeing his company's evolution to ensure that the past is the best predictor of the future.

Rob grew up doing construction north of San Francisco and entered the commercial arena shortly after graduating from the University of California, Davis. He began working with Chris Sawyer at what was then Carmel Property Services, a property management company that had a reputation for providing its clients with outstanding service and personal care. The business also had a small construction component, which Rob and Chris soon developed into the primary focus of their business. Chris retired, and Rob assumed full ownership of the business in 2006.

LEFT:
This stunning Carmel Valley residence was designed by David Allen Smith, AIA.
*Photograph by Rick Pharaoh*

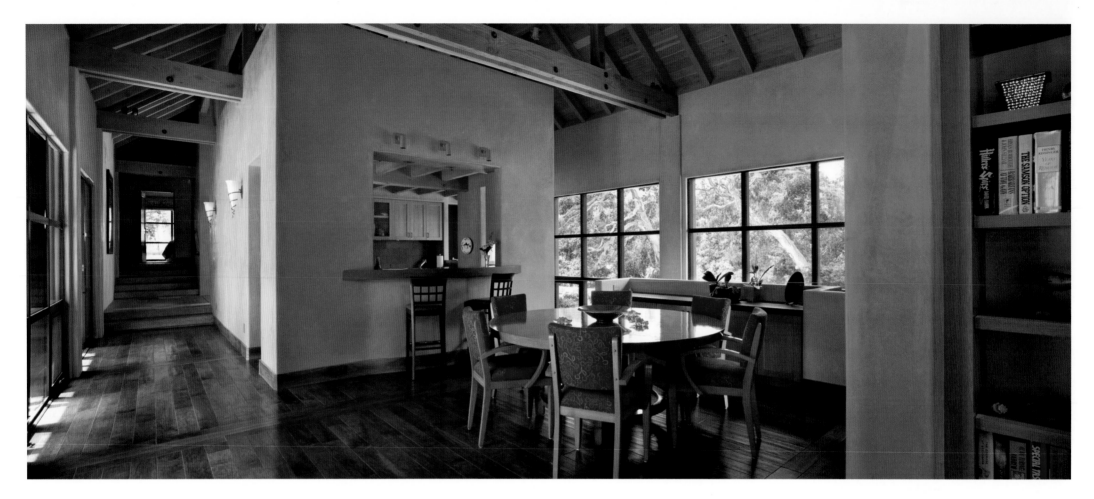

Since that time, the firm has seen a great deal of growth and today it offers a complete, hands-on home building experience from start to finish, including design, drafting, permitting, project management and construction. At its heart is a zeal for quality craftsmanship and great design. In addition, its owner has become a proponent of the Green building movement in the Monterey area.

Though Rob recognizes the natural inertia in the construction business and the liability that comes with trying something new, he feels that designers and builders are on the precipice of embracing techniques that might now be on the periphery but will soon transcend conventional practices. There is a fundamental change coming and Rob plans to be positioned to participate if not lead the way.

To that end, Carmel Building & Design has become Green certified through Build It Green, a professional nonprofit that promotes healthy, energy and resource-efficient buildings in California and fosters collaboration to accelerate the adoption of Green building practices, policies and programs. The company also recently added a full-time member to its staff of 20 who will research existing and emerging Green products and techniques and stay abreast of the state of issues and enforcement, ensuring that the team remains on the movement's leading edge. Rob also sits on the Monterey Peninsula Chamber of Commerce board of directors, which is promoting a Green agenda, and works closely with Leadership Monterey Peninsula to help people learn to live a Greener life.

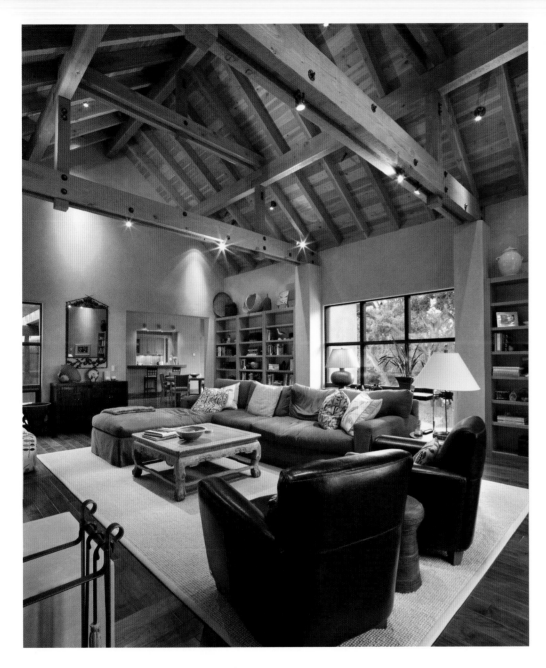

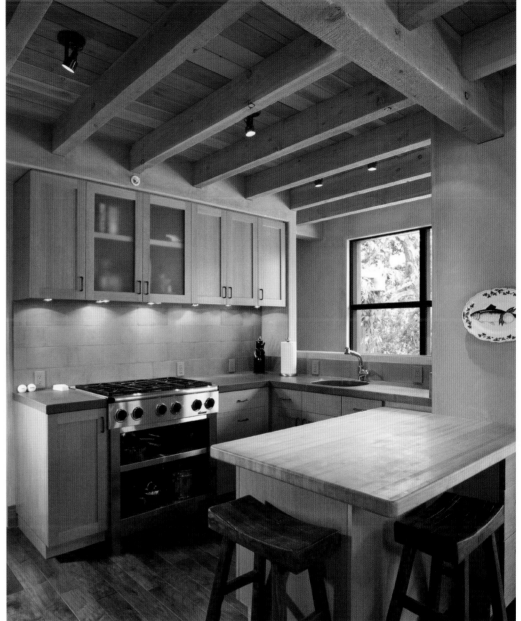

Of course, Carmel Building & Design operates with the environment in mind. On job sites it is careful to divert its solid waste stream away from landfills by setting up containers to sort castoff materials. When possible, Rob chooses products made without formaldehyde—the toxin found in most glue, insulation, plywood, particle board and carpet. Per California law, he installs low-water-use toilets and other appliances and landscaping that does not require constant irrigation. Lighting that takes less energy also comes into play. Rob sees it as his job not only to educate his clients on

ABOVE LEFT:
Like the rest of the house, the great room has open-beam ceilings made of unfinished Douglas fir framing members and roof decking. Roof framing includes compound trusses, purlins and ridge beam, rafters and through-bolts with heavy, malleable iron washers.
*Photograph by Rick Pharaoh*

ABOVE RIGHT:
Replete with custom vertical-grain white oak cabinets, stain-resistant concrete countertops and a custom concrete tile backsplash, the kitchen also has stainless steel shelves, which were specially made to fit under the cooktop.
*Photograph by Rick Pharaoh*

FACING PAGE:
The dining room and gallery feature hand-scraped black walnut floors and integral-color plaster. The plaster form in the center of the room houses the kitchen.
*Photograph by Rick Pharaoh*

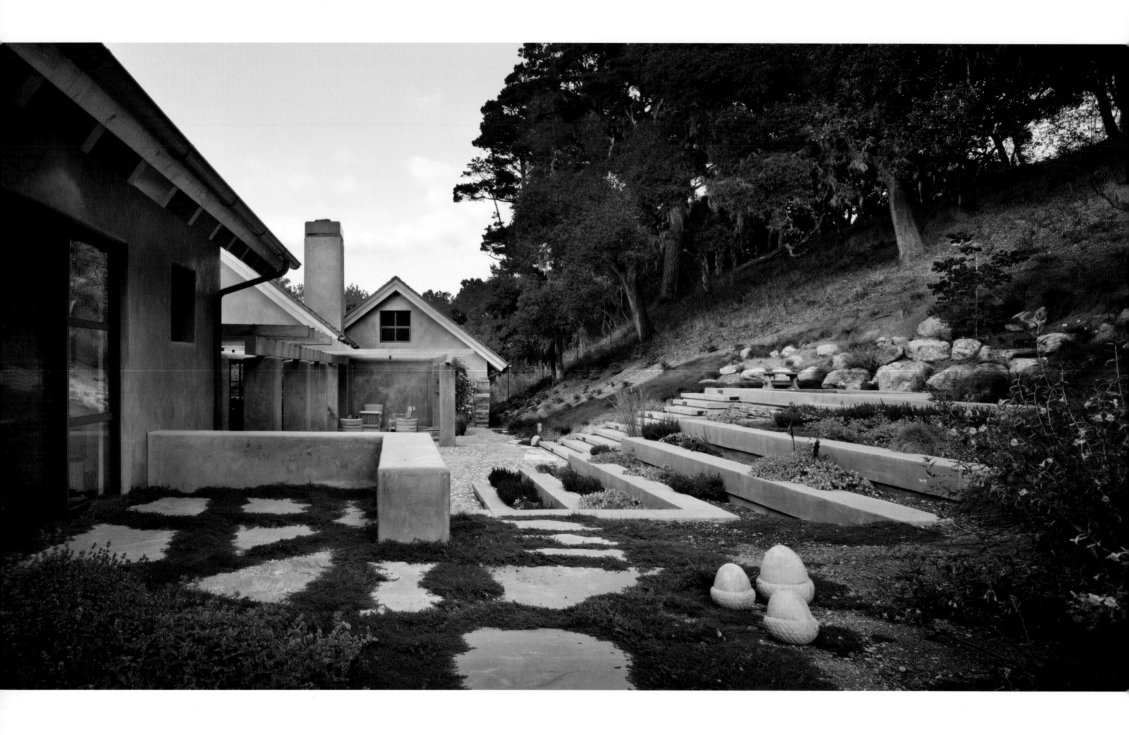

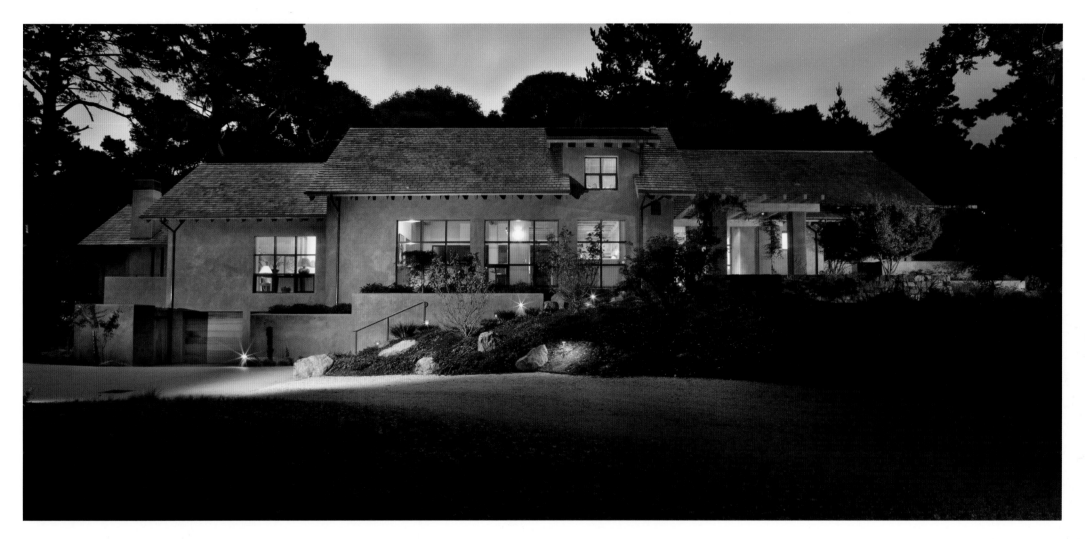

Greener living but to be a valuable resource to them and offer them enough options that they find something that excites them.

Just as the environment is never far from Rob's mind, neither is quality. A top priority for him is elegant, well-resolved projects. That means that the designer and contractor understand the client's vision and communicate it well to enough people to bring it to life. It also means having the patience to resolve problems and deliver solutions that are not forced, so that in the end what the clients get is not only what they wanted, but something even better—something not just finished but well-resolved.

This can happen only via something Rob calls "deep smarts"—which even the most extensive education cannot convey. It is a feeling, born of instinct and honed by experience. And with his rare combination of technical expertise and artistic sensibility, Rob has them.

ABOVE:
The result of a well-planned, well-executed building project is a home that is a welcome addition to its environment and gives its owners a profound sense of joy and connection to place.
*Photograph by Rick Pharaoh*

FACING PAGE:
Tito Patri's landscape architecture employs geometrical elements in conjunction with natural shapes to help the house relate comfortably with its surroundings.
*Photograph by Rick Pharaoh*

# ANDREA BARTHOLICK PACE

Andrea Bartholick Pace Interior Design

From her backyard design studio, Andrea Bartholick Pace looks across Monterey Bay to the Santa Cruz Mountains in the distance. Her cozy workspace, which she refers to as The Art Womb, has skylights, large windows for abundant natural light and French doors for an open feel. Nestled among the plants and curved terracotta courtyard of her garden, it is a gathering spot for her designer and artistic friends, and it is here that she creates the serene interiors she is well known for.

Dressed in a uniform of faded jeans and casual slides, Andrea is the kind of no-pretenses person who seems like an instant friend—which works to her advantage as she gets to know her clients. And just because she designs in a small office—there are two others besides herself—doesn't mean she does not do larger projects. Her portfolio includes an extensive list of residential and several small luxury resorts, including the exclusive Bernardus Lodge, open since 1999.

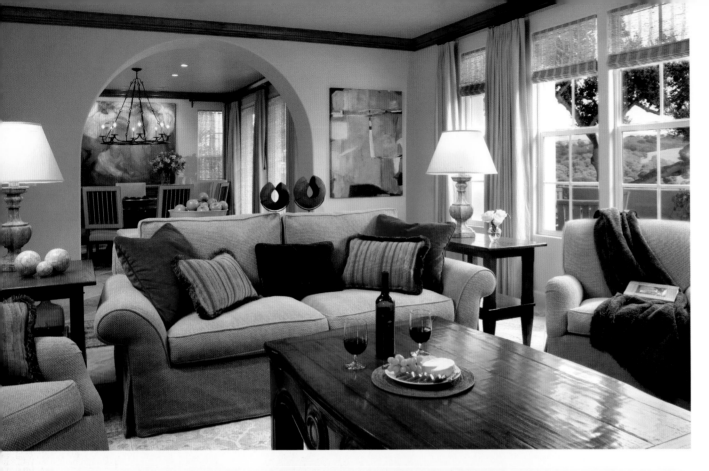

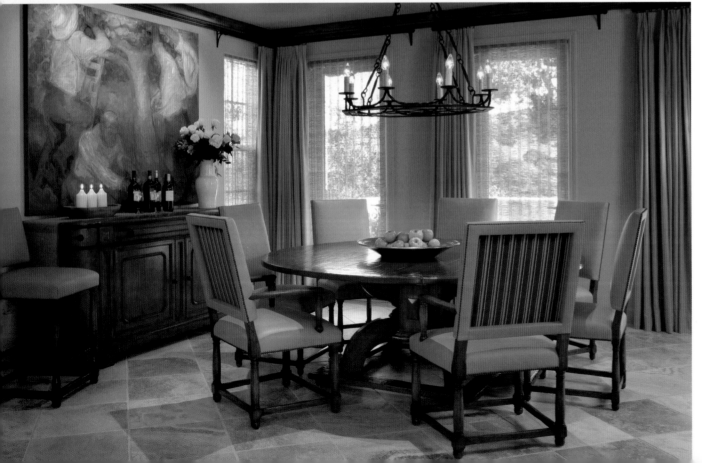

Whether contemporary California or Old World rustic, Andrea's designs are infused with layers of rich color and texture—her passion for which was fostered by considerable time spent traveling throughout the remote villages, historic cities and archaeological sites of Mexico. After 20 years in the Carmel area, the designer has done everything from beach cottages to horse ranches to a small luxury resort in the wine country of Carmel Valley. And though they can vary in style, her interiors have one thing in common: They are all warm and welcoming spaces perfect for relaxing with family and friends.

Her own family is important to her, and her 12-year-old daughter is one reason she only accepts projects in Carmel and the surrounding areas. Keeping it local is important in another way as well: Andrea often sources furnishings, fabrics and accessories for her interiors from businesses within her own community. She makes a point of including the work of local artists in many of the homes she designs and takes every opportunity to introduce her clients—many are from out of town—to her favorite shop owners and restaurants. In the true spirit of a small town, they often return the favor by sending her referrals.

Andrea grew up around design. Her father was a renowned Seattle architect who was responsible for the award-winning restoration of the Pike Place Market. She earned her Bachelor of Fine Arts in interior design from the University of Washington and spent two years apprenticing for one of Seattle's most prominent interior designers before relocating to the Carmel area in 1987. She opened Andrea Bartholick Pace Interior Design in 1994.

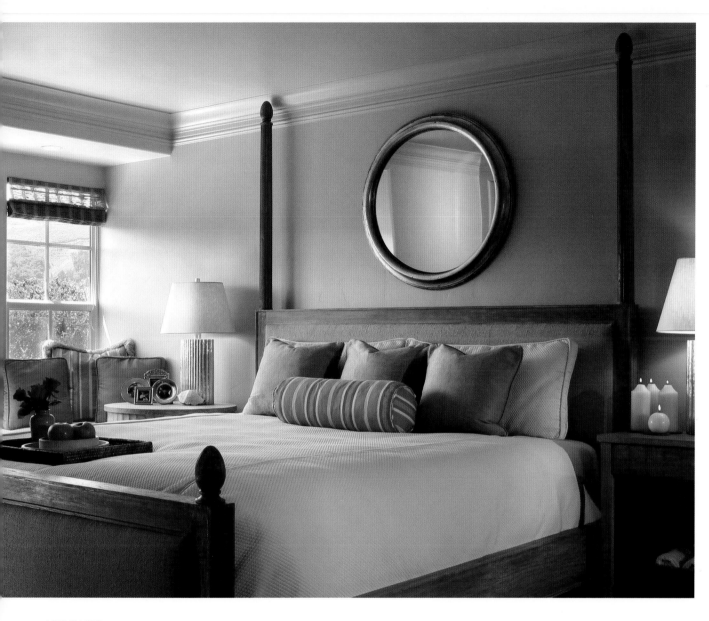

ABOVE LEFT:
Clean lines and soft accents inform the décor of the master bedroom in a Carmel residence.
*Photograph by Rick Pharaoh*

ABOVE RIGHT:
A focal point of the bedroom, artist Tracey Adam's painting provided inspiration for the room's color palette.
*Photograph by Rick Pharaoh*

FACING PAGE TOP:
The living room of a private residence in Monterey has been tastefully adorned. The painting is by Marie Louise Raouff.
*Photograph by Rick Pharaoh*

FACING PAGE BOTTOM:
Replete with a painting by Frank Troia, the graciously sized dining room is ideal for gatherings large and small.
*Photograph by Rick Pharaoh*

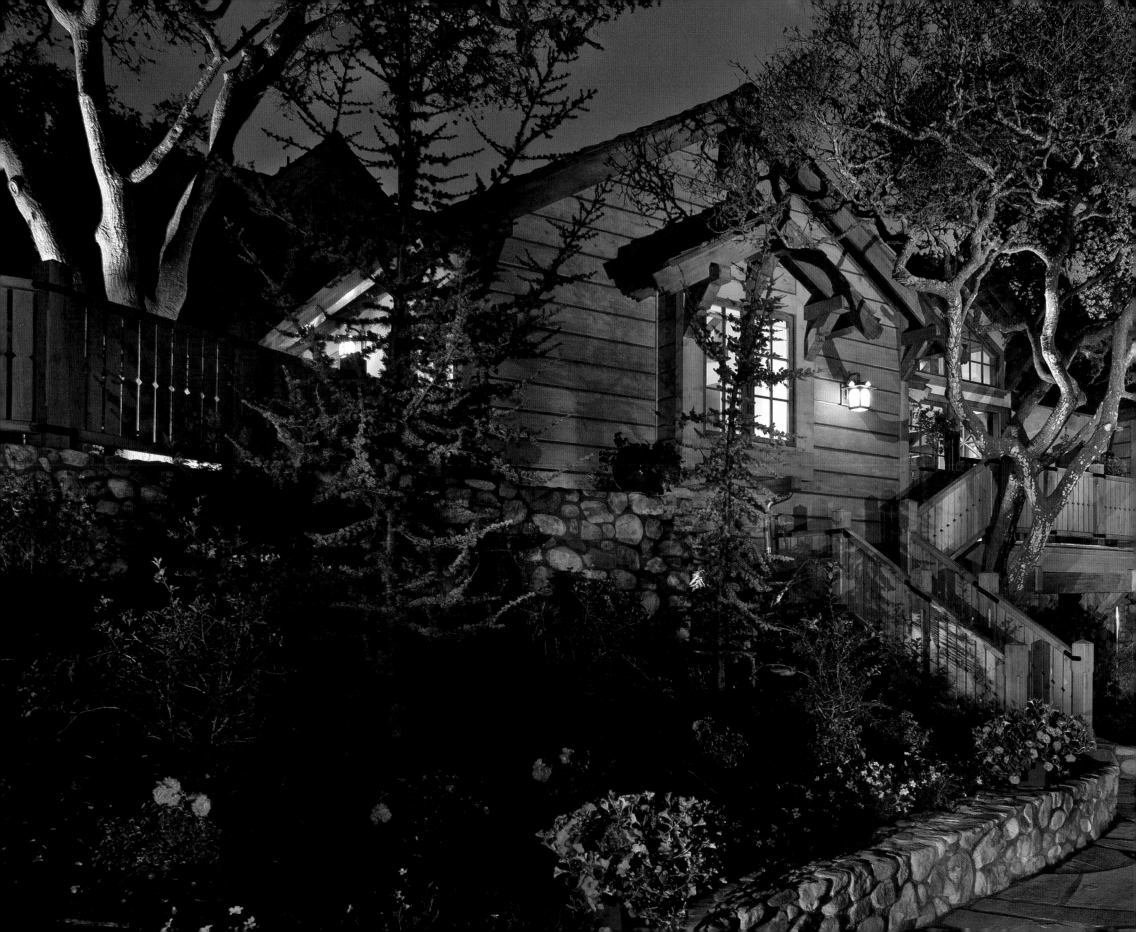

# AL SAROYAN

Saroyan Masterbuilder

Talk to Al Saroyan, AIA, and you quickly get the feeling that he is a man with exceedingly high standards. Walk through one of his homes and you find out just as fast that you have never seen anything crafted better. In short order, you will discover that Al's 35-year career as an architect and masterbuilder has been a relentless pursuit of perfection.

And that is the architect's philosophy in a single word. If he is going to do something, he is going to do it right, and that means refusing to rest until he is certain that every house he builds pushes the envelope in terms of craftsmanship and detail work.

Best known for his extraordinary custom homes in Carmel, Al jokes that he works just half a day: 7 a.m. until 7 p.m. He is pretty much always on the job. A hands-on principal who not only does all of the preliminary design work himself, he also personally visits every job site—some every day. That

LEFT:
Enveloped by mature-growth trees and native shrubbery and constructed of naturally stained wood with stone accents, the home has lodge-like character.
*Photograph by Peter Malinowski*

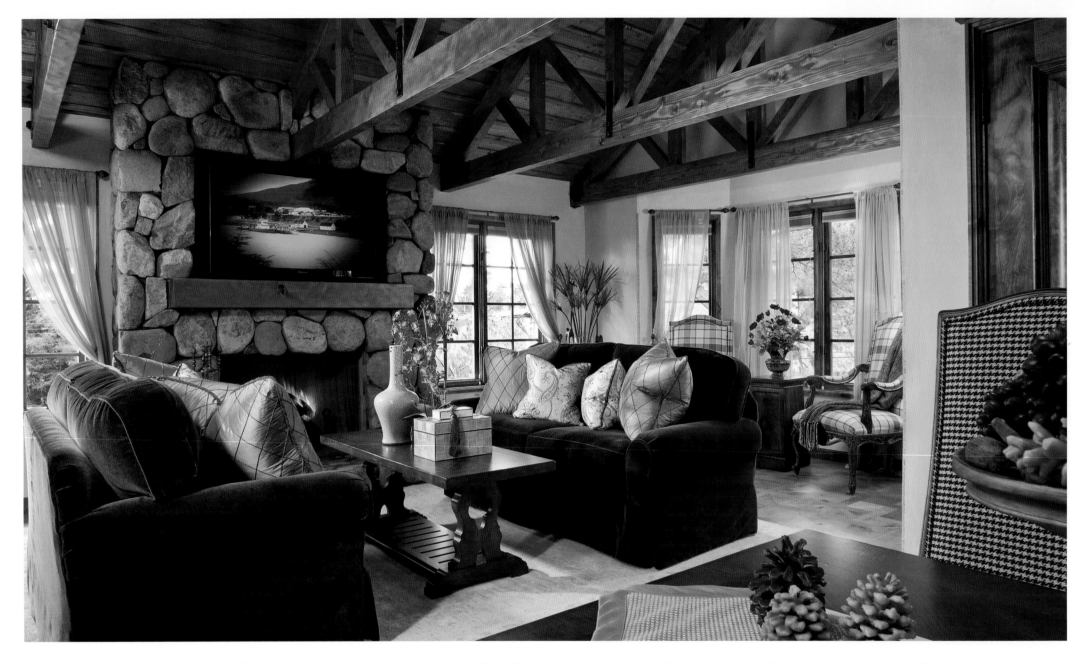

is one reason he has limited his firm's work to a 10- to 15-minute drive from its Sandy City office. Constant scrutiny and feedback are essential to the success of a project, and Al maintains direct control over every aspect of every project, from start to finish, relinquishing the keys to his clients only after the last tree is planted or the final picture is placed.

For Al, to design a project and hand the plans over to another builder is unthinkable. He calls design an evolution, and he is not about to walk away and let another's mistakes creep into a house that bears the Saroyan name. That is not the path to excellence, and that is not the definition of a masterbuilder.

He started his business on the premise that architecture and construction cannot be separated. It is for this reason that he employs a dedicated team of craftspeople—painters, tile setters, stonemasons, woodworkers. The firm maintains its own cabinet shop, and in almost every case custom builds all of the major elements of a house rather than purchases them. For example, they

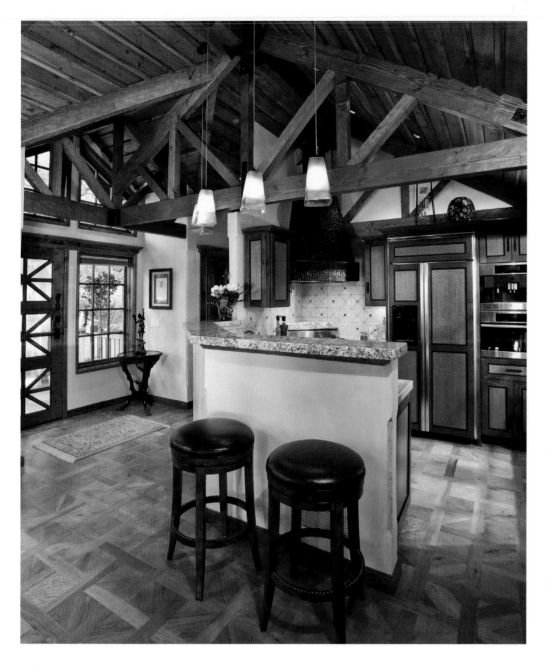

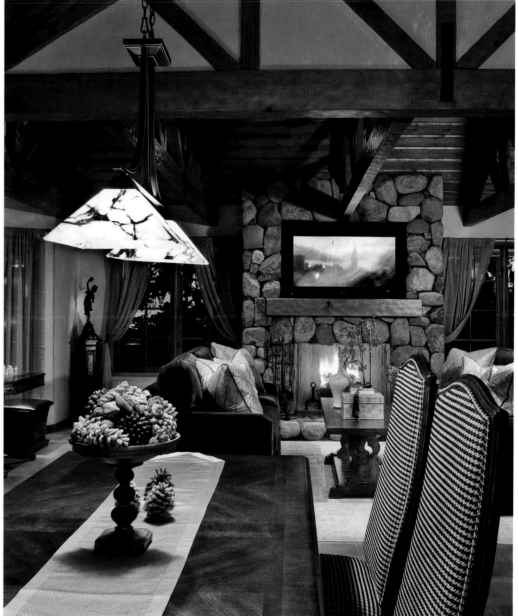

will design and build doors to complement the style of the project—the company works in a range

of styles—and perhaps even the style of the flooring in the room where it will hang, both of which

might have burlwood inlaid by hand.

Though hand-selected subcontractors are used for things like plumbing, electrical and roofing,

all of the fine detail work is done by in-house artisans who are skilled at more than one specialty.

A painter might also be a finish carpenter; a tile setter might also do stone work, so that if he is

ABOVE LEFT:
A 7-foot-tall, hammered-copper hood adorns the cooking alcove and eating bar.
*Photograph by Peter Malinowski*

ABOVE RIGHT:
The adjoined dining room and living space offer views of Carmel Bay and sunsets from all living areas. An elevator leads to the large home theater and wine cellar.
*Photograph by Peter Malinowski*

FACING PAGE:
The elegant river stone fireplace serves as the focal point to this living room, which features heavy, open-timber trusses that direct one's attention up, around and through the windows to enjoy views of the surrounding wooded area.
*Photograph by Peter Malinowski*

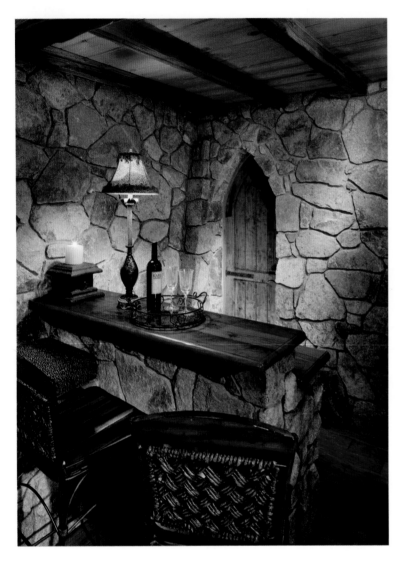

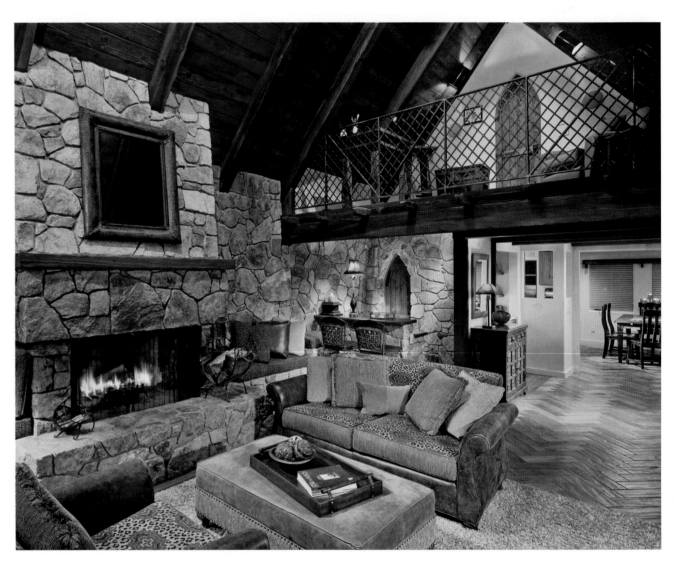

ABOVE LEFT:
The wet bar includes a walnut countertop with a pointed-arched custom door to the stone wine cellar.
*Photograph by Douglas A. Salin*

ABOVE RIGHT:
The living room offers a large fireplace and full wall of granite stonework with a voluminous beamed ceiling and studio loft.
*Photograph by Douglas A. Salin*

FACING PAGE:
In an enduring style, this Carmel cottage blends Old World craftsmanship with present-day technology.
*Photograph by Douglas A. Salin*

not working on a bathroom he is building an outdoor fireplace. Extensive cross-training is an efficient way to work but it also allows people to grow in their skill sets and help develop new techniques born of varying perspectives. Rarely do craftsmen at Saroyan Masterbuilder leave, as they are continually facing new and rewarding challenges within their specialties. As a result, the craftspeople at the firm are among the area's more talented—a boon for clients seeking only the best.

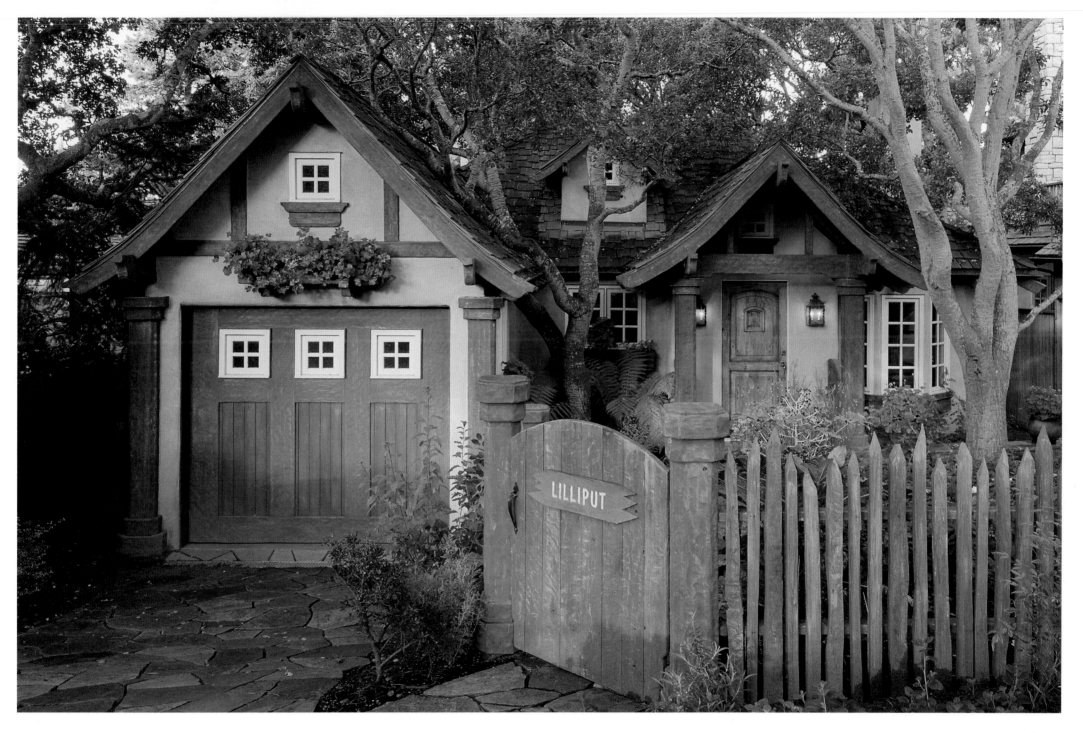

Al graduated from Cal Poly School of Architecture and received his architect's license in 1974. He built his first house that year and has been designing and building high-end residential projects ever since. Whether new construction, major remodeling or historic renovation, his pride in the work of Saroyan Masterbuilder and its commitment to superior quality and Old World craftsmanship is evident. And its future?

Albert Saroyan III is following in his father's footsteps. He also earned his degree at Cal Poly and is focusing on construction management, working in lockstep with Al. People who know both father and son say that Albert, at 27 years old, is a building wiz kid with a keen eye for detail. Al calls him his "secret weapon" for continuing the legacy of the masterbuilder concept.

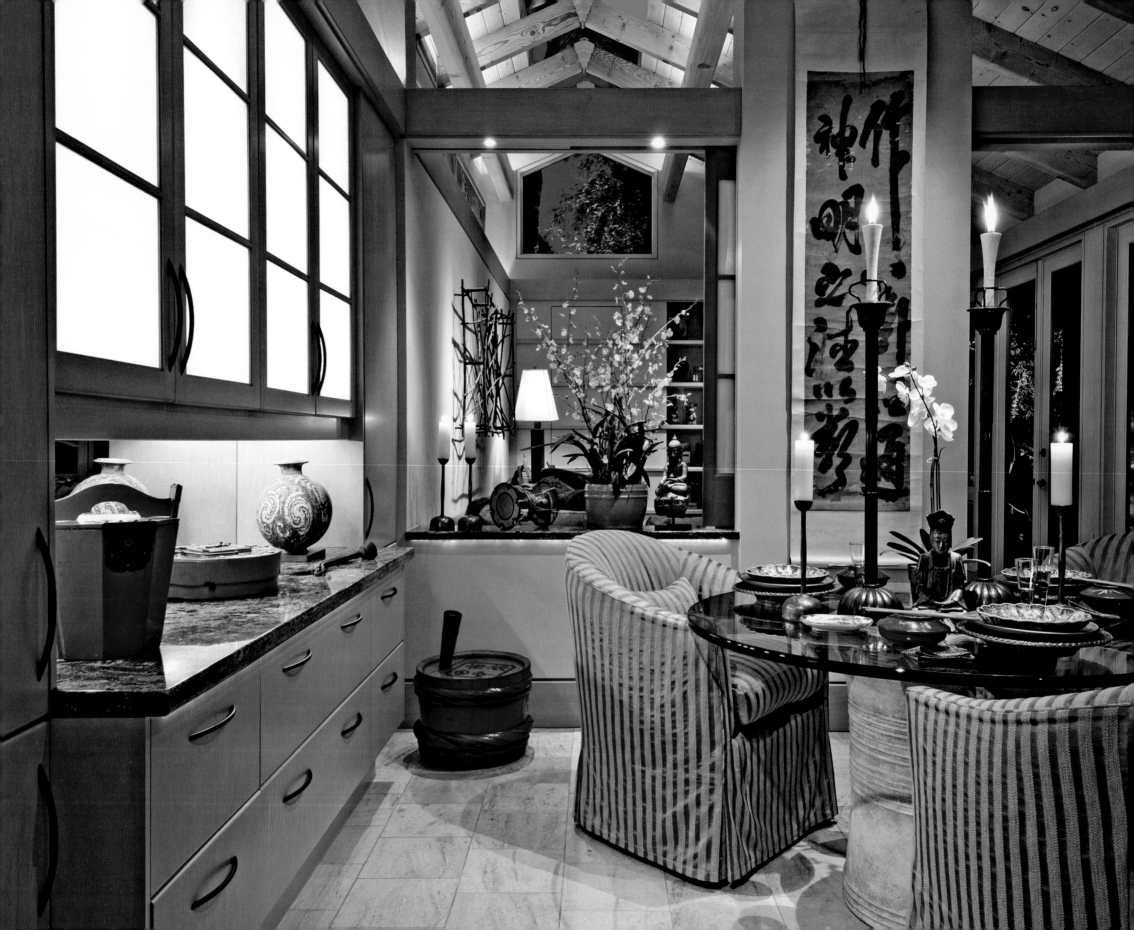

# JOHN J. SCHNEIDER

Schneider & Associates

Never say never. Patience is a virtue. Less is more. These platitudes ring true for John Schneider, ASID.

The interior designer—who attended Loyola University, the University of Cincinnati and the prestigious Art Center College of Design—swore to stay away from residential design. Yet after cutting his architecture teeth on commercial spaces in Los Angeles and teaching design to college students, he took a step toward that very thing when his parents were building a home in Pebble Beach. That was 1987, the year that he moved to the Monterey Peninsula. It apparently suited him well.

John grew up among wealthy families who lived in homes that he describes as "architectural wonders of exquisite craftsmanship." He remembers sleeping balconies and secret passages—the kinds of things

ABOVE:
Heirloom botanical pressings paired with vintage Biedermeier lend a mystical balance to this crisp, contemporary Pebble Beach home.
*Photograph by Mary E. Nichols*

FACING PAGE:
Serenity and utter contentment describe the emotions one feels while dining in this Asian-inspired Carmel home.
*Photograph © 2007 Douglas A. Salin, www.dougsalin.com*

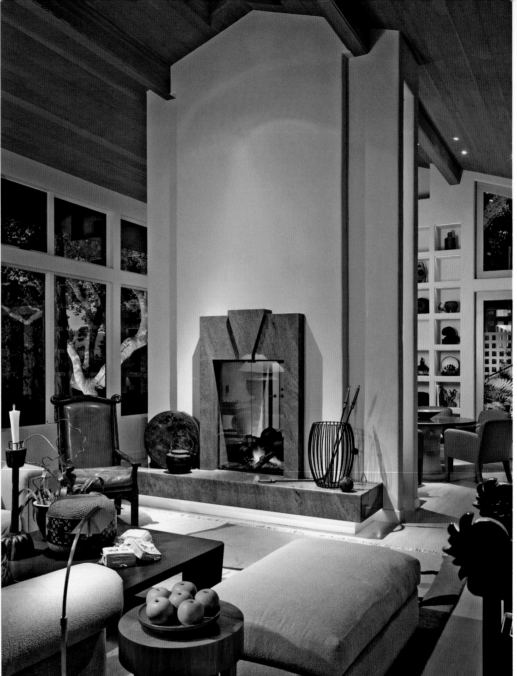

that intrigue and enchant a child—and he attributes that magical time with sparking his interest in the field that would become both his passion and profession.

John's designs run toward minimal elegance, a counterbalance of the hectic world in which we live. He sees home as a place of rest and refuge, an escape from the overload of workaday life. His interiors are intimate yet airy spaces that reflect today's casual lifestyle. They comprise practical rooms that are not just beautiful but functional and easy to care for. Though his personal preference

is for hard-line contemporary, he recognizes that it is not a style that suits most people, and he loves creating eclectic homes as well. The common threads in all of his interiors are fine detailing, muted colors, abundant light and restful blank spaces, something he considers a luxury.

And he has learned a lot from residential work. It has taught him to be patient and to listen between the lines. He has become an expert at sizing up who people are and distinguishing between what they say they want and what their hearts truly desire. As an example he tells of a female client who

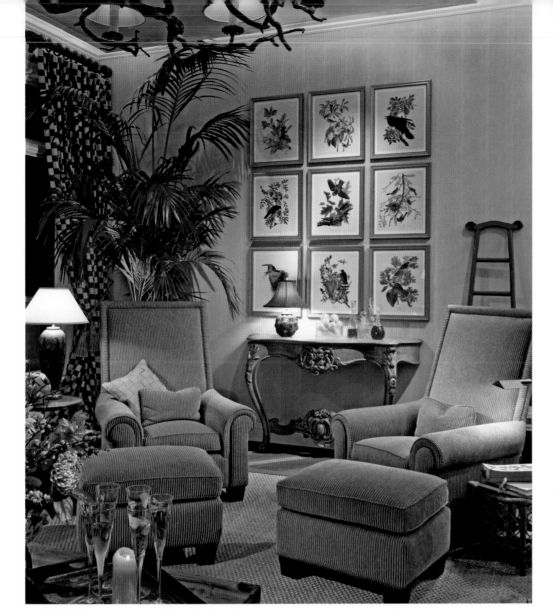

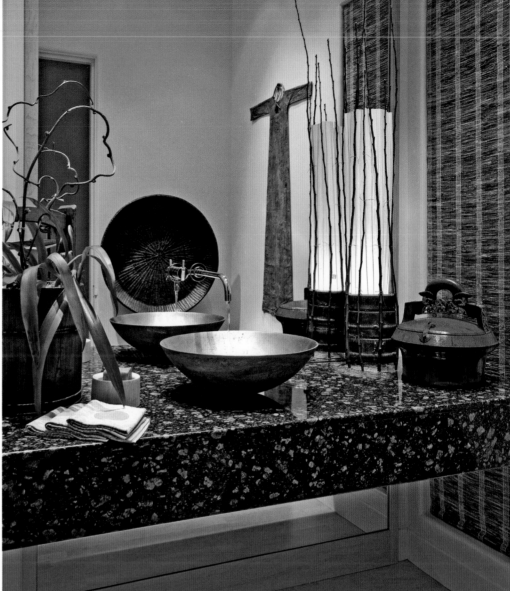

asked him to design for her a Country French house but then demonstrated a heavy proclivity for Asian design. The project resulted in a very zen-like award-winning house, much to the client's delight. Often a designer's job is to bring clients a little farther forward than they will go on their own, John says. In order to do this, however, he must gain their trust and demonstrate an ability to balance comfortable ideas with those that are new.

John's best clients are those who not only expect something extraordinary but embrace it when they see it. It is his greatest desire to expand his clients' experiences beyond what they can imagine—and to give them even more than they dreamed for.

ABOVE LEFT:
A pair of over-scaled club chairs creates the relaxed elegance the residents sought for the grand salon of their Atherton residence.
*Photograph © Douglas A. Salin, www.dougsalin.com*

ABOVE RIGHT:
One may experience a ritual of total purification in the powder room. The white bronze vessel basin adds a calming Japanese aesthetic.
*Photograph © Douglas A. Salin, www.dougsalin.com*

FACING PAGE LEFT:
Avid art collectors relax in their renovated vintage waterfront Seattle home. Tailored lines and neutral tones enhance the Mapplethorpe print above the fireplace. The two "rescue" tables are by designer Marc D'Estout.
*Photograph © Douglas A. Salin, www.dougsalin.com*

FACING PAGE RIGHT:
This contemporary Carmel home exudes perfect balance. Pacific Rim inspiration and dramatic valley views make the great room an enjoyable place in which to spend time.
*Photograph © Douglas A. Salin, www.dougsalin.com*

# TRENT SHEARN

Trent Shearn Building & Design

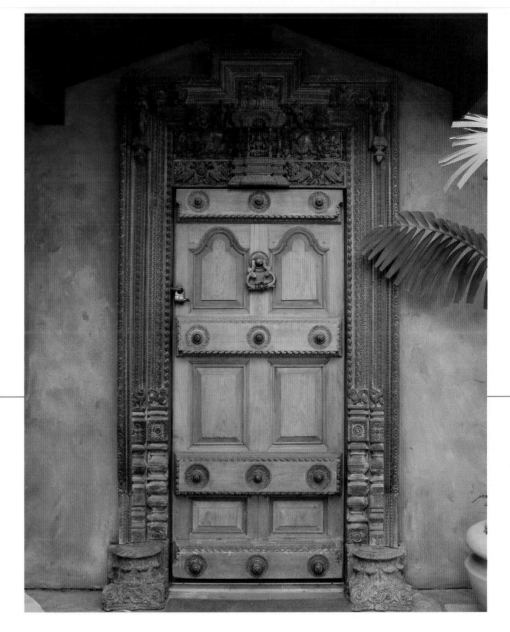

Daring. Dramatic. Distinguished. Just a few of the ways to describe Trent Shearn's work.

Truly, the houses the 58-year-old designer and builder creates are like nothing you have ever seen. From a 10,000-square-foot stone-and beam residence called Victorine Ranch Estate—the first house he designed and built in the Carmel area—with a Frank Lloyd Wright feel, to the transformation of a deteriorating 100-year-old log cabin into a modern-day Craftsman-style Pacific Grove masterpiece, from a fairytale version of the quintessential Hugh Comstock-style cottage to a majestic Tibetan-influenced palace incorporating thousands of hand-carved artifacts, Trent's designs stretch the boundaries of the imagination.

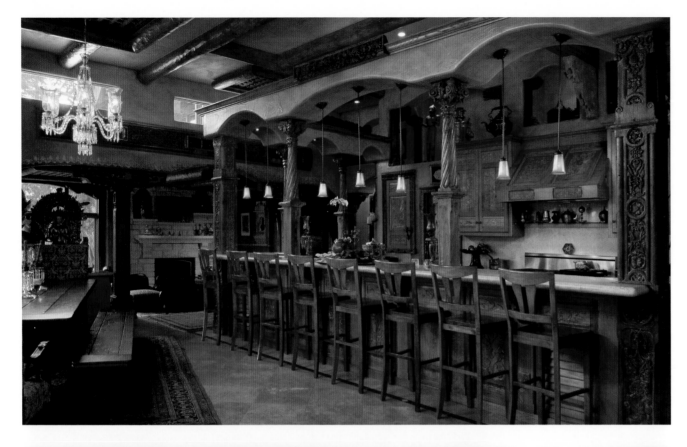

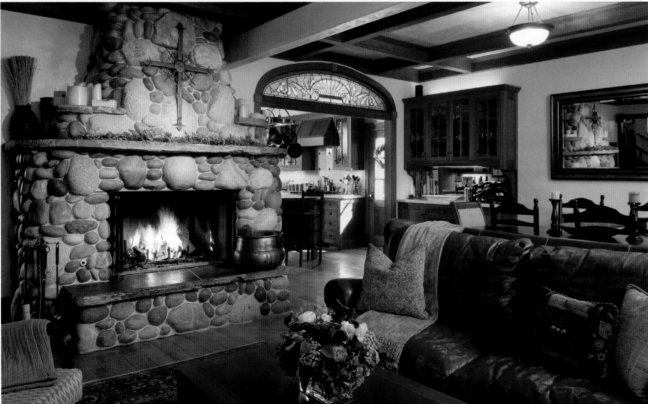

Born and raised in California, Trent discovered his affinity for building in architecture school and earned a contractor's license at a young age. He spent his early years in Sonora, the Mother Lode region of California, doing historic Western and Victorian restoration before moving to Tahoe, where for a decade he built beautiful lakefront homes. It was the Victorine Ranch project in Big Sur that drew him to Carmel in the late 1980s, and he has called it home ever since.

His lighting company, StoneLight Works, sprung from that project. While working on the house, he grew dissatisfied when he could not find light fixtures of the right scale and style. So what did he do? He made his own from hand-forged iron, hand-blown and stained glass and semiprecious gemstones. He calls them "architectural jewelry" and travels several times a year to personally install them for his clients. The one-of-a-kind chandeliers and sconces transcend the ordinary. (Lights not shown.)

TOP LEFT:
Hand-carved teak cabinets, 400-year-old artifacts, fossilized countertops and limestone floors create a unique ambience for the adjoining great room, dining area and kitchen.
*Photograph by Rick Pharaoh*

BOTTOM LEFT:
An award-winning historical restoration, this Pacific Grove log house has a Craftsman-style interior with a river rock fireplace and an antique, stained glass archway.
*Photograph by Rick Pharaoh*

FACING PAGE TOP:
Boasting a Bernard Maybeck interior, this historical log home was rebuilt partially in place and then moved to another location and restored circa 1910.
*Photograph by Rick Pharaoh*

FACING PAGE BOTTOM:
Replete with a freestanding guest cottage, the main residence was built in the original Hugh Comstock timber-framed style and has an ocean wave roof.
*Photograph by Trent Shearn*

That is something that can be said for all of his high-end residential work. Trent is an uncommon man who designs uncommon things. After completing that first Carmel house, he began the renovation of a circa-1900 log cabin, the oldest log house structure in Monterey County. Other builders advised to tear it down, but Trent worked with the historical society in Pacific Grove to save it. He had a vision of a Craftsman-style interior with copper-embossed and coffered ceilings, marble bathrooms and built-in old-growth redwood cabinetwork, adopting some of the elements of Bernard Maybeck. Later, he designed and built a whimsical fairytale bungalow. With its ocean wave roof, timber-framed exterior, and arched doors and windows, it is the dreamy stuff of children's storybooks—reminiscent of the Cotswold area in England, where he spends time each year researching Old World architectural styles and detailing.

But the house he designed and built for Peterson Conway is, perhaps, his crowning achievement to date. With 300-year-old teak pillars from a mosque in Afghanistan, doors that date back to 17th- and 18th-century India, and ceilings that were once in a maharaja's palace, the 8,500-square-foot house is a marvel. Trent equates it to the inspirational Hearst Castle. He remembers well the daunting task of selecting the artifacts from more than two warehouses of antiquities, creating a building that is both arresting and intriguing.

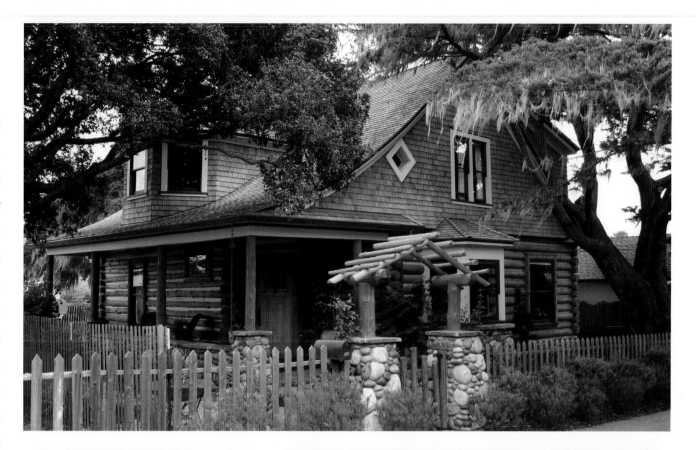

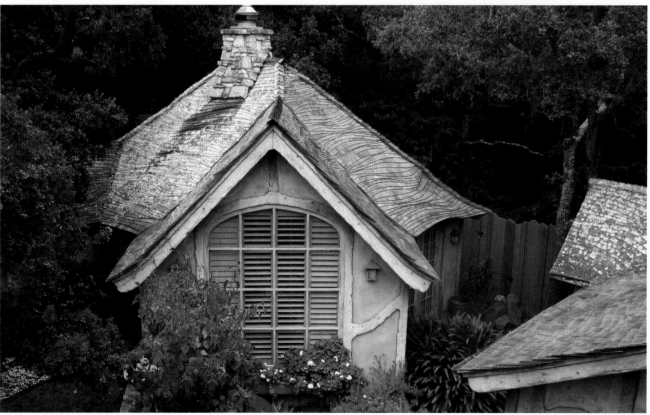

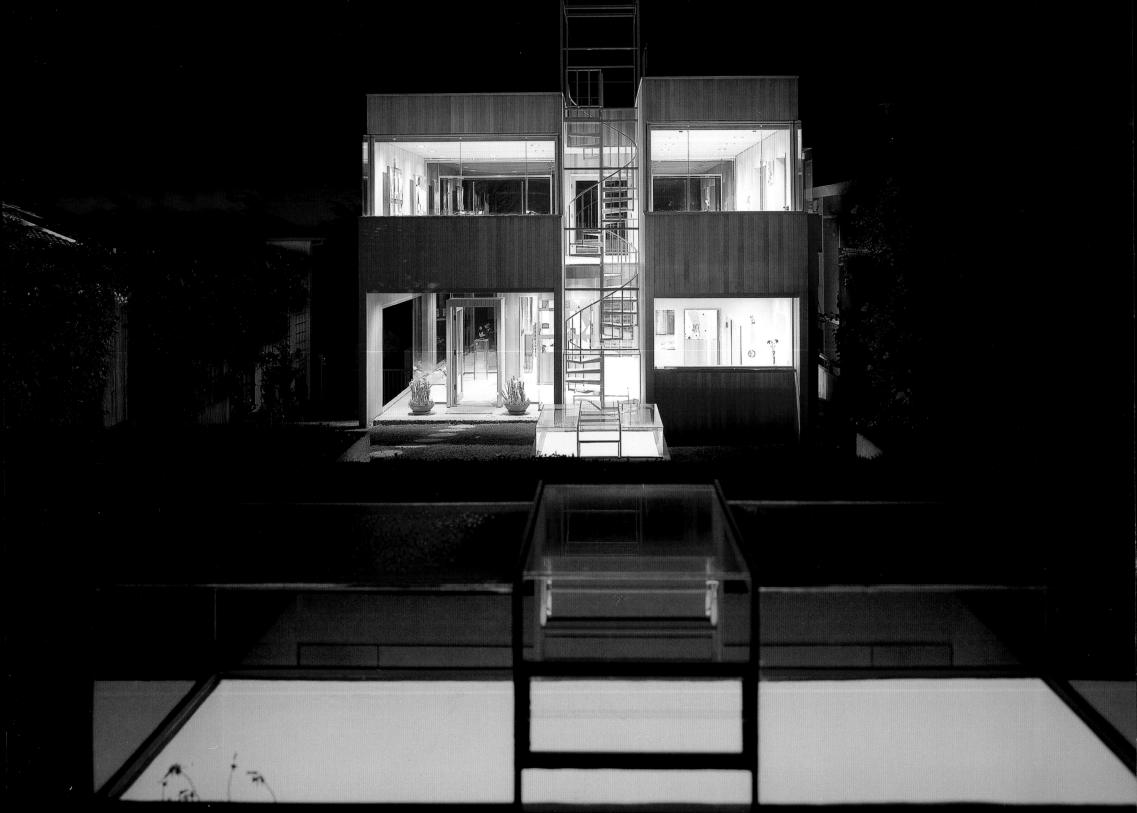

# JOHN THODOS

John Thodos AIA Architect

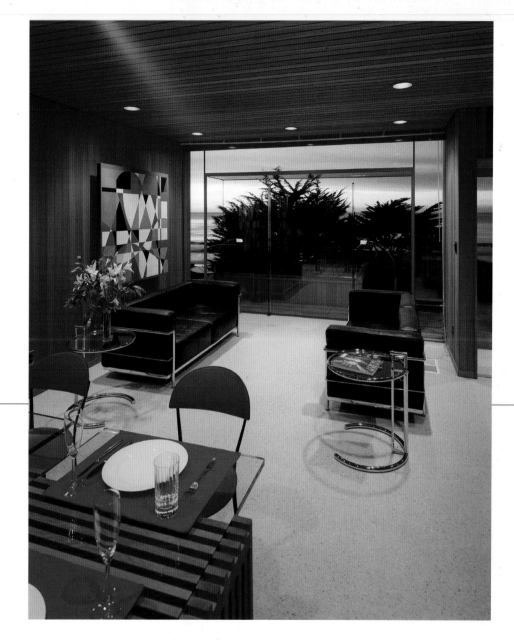

Creation is a patient search. Le Corbusier is famous for saying it. And John Thodos, AIA, knows what it means to live it. At 72, he has been searching—and creating—for nearly 50 years.

After working for nearly a decade with major Portland architecture firms, John opened his first office in 1969, earning a reputation as a high-end modernist doing small commercial and light industrial buildings. He moved to Carmel in 1989 with his wife and childhood sweetheart, Judy, and turned his focus to residential work, crafting custom homes in the place he calls paradise.

Though his architecture is thoroughly modern, it is far from cold or sterile. John creates warmth with copious use of wood and takes advantage of natural light and impressive views with massive spans of

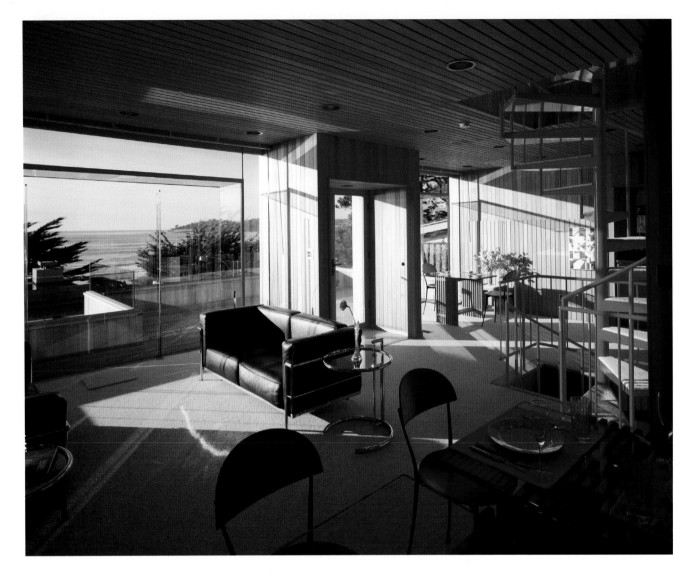

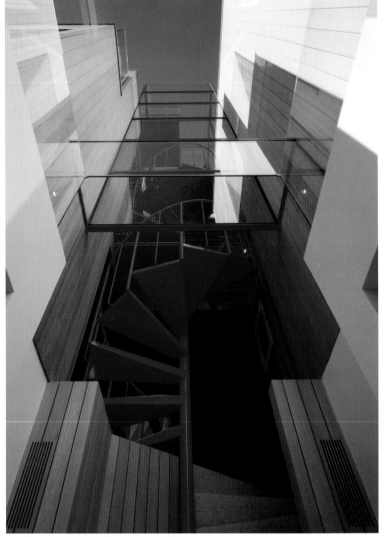

glass. So fond of the latter material is he that he invented a virtually seamless way of joining panels at right angles so that he could use it uninterrupted in two or three sides of his designs.

Though his designs are different, outrageous architecture is not John's goal. He simply wants to create architecture that is exciting and pleasurable and makes people stop and think. His desire is to create not just buildings, but something beyond—spaces and solids and voids assembled as art form. With 14 awards from the American Institute of Architects, he has spent a lifetime doing just that.

ABOVE LEFT:
From the upper level of the light-filled home, the design takes advantage of breathtaking views of Carmel Bay.
*Photograph by Wayne Thom*

ABOVE RIGHT:
The Ferrari red spiral stair not only services the upper level and opens to the upper deck but also adds a sculptural element to the design.
*Photograph by Wayne Thom*

FACING PAGE TOP:
The scale of the furniture designed by the architect complements the scale of the house. John's bright primary color paintings provide bold accents.
*Photograph by Wayne Thom*

FACING PAGE BOTTOM:
The interior of the home is lined with the same rich Canadian red cedar as the exterior siding, creating a seamless transition from outside to inside.
*Photograph by Wayne Thom*

Part of his secret is to push beyond an initial thought. While some architects might stop at their first solution, that is just the start for John, who likens his art to that of making the Greek pastry baklava. It is a meticulous process, a gradual building up of thin layers of various ingredients that yields a glowing end result that is utterly delightful—much like the architect himself.

The son of Greek immigrants, John grew up in Portland and attended architecture school at the University of Oregon after asking himself how he wanted to spend his retirement years. It might have seemed a strange concern for a boy of 18, but it exhibited a wisdom beyond his age and proved to be a career choice that has filled the architect's cup to overflowing. Though friends and family expected he would become a doctor, John says that being an artist was never a choice. It's just what he is.

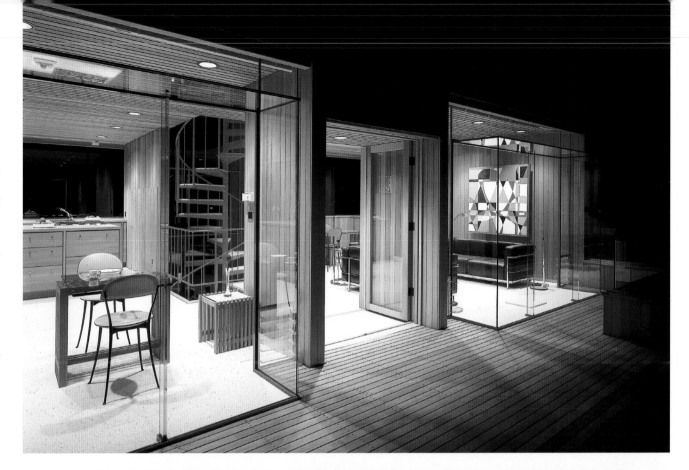

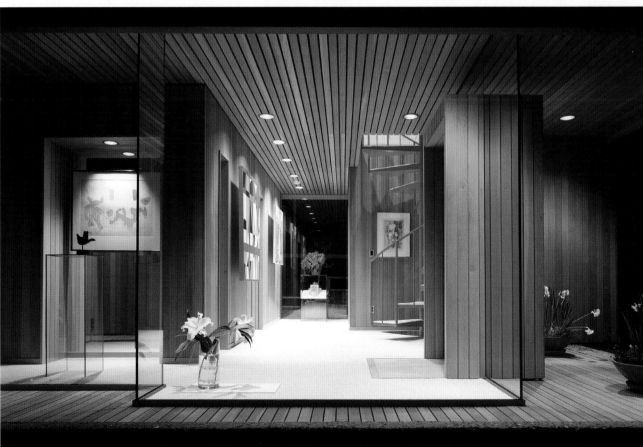

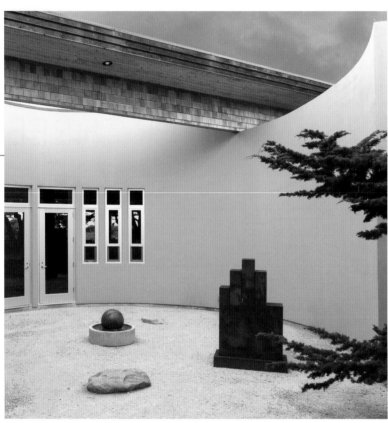

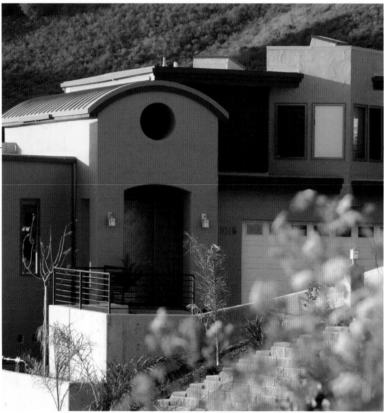

David Einung Custom Home Design, page 249

Jeff Schneidereit Architects, Inc., page 257

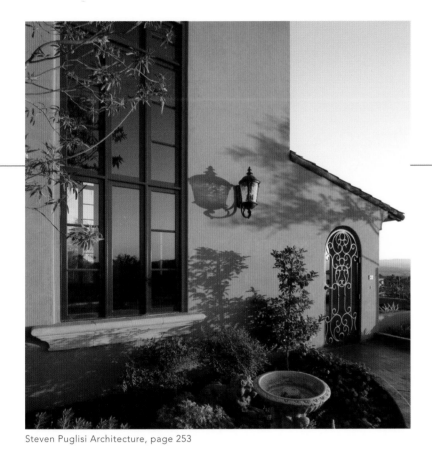

Steven Puglisi Architecture, page 253

SAN LUIS OBISPO

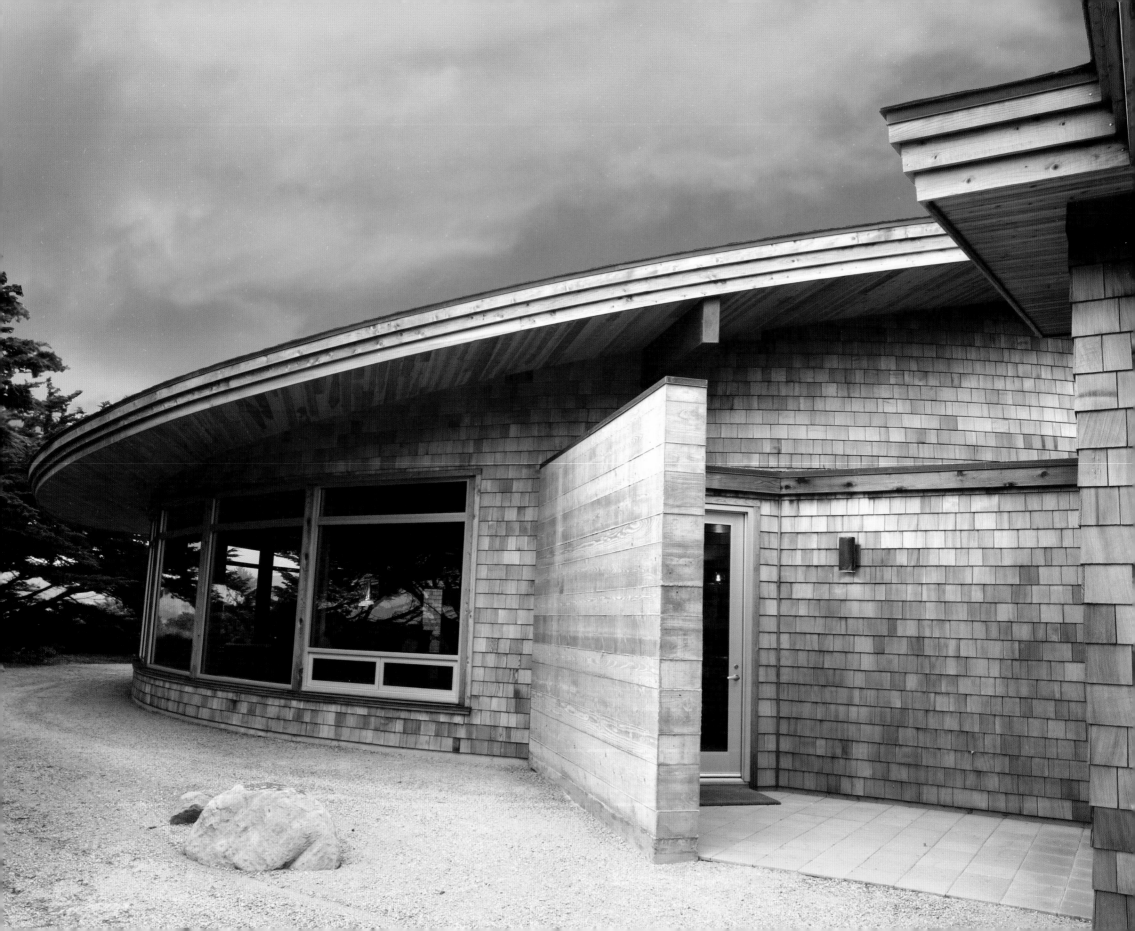

# DAVID EINUNG

David Einung Custom Home Design

David Einung avoids espousing any overarching theory about architecture. Every one of his projects is unique and he looks at each client as an opportunity to create something new. When asked by one reporter what he might design given no restraints, David quickly answered "nothing," explaining that architecture is a response to a set of design solutions as they work within a set of constraints.

He feels that if they are done right, homes not only work well but more importantly work transparently, allowing clients to enjoy the beauty of their houses as a natural fit with their lives and work.

Designing from the inside out, David starts every project with a concept for a floorplan, beginning with the where and what for each room and building from there. He keeps an open mind along the way,

ABOVE:
Approaching the transparent and inviting entry wall of the house, guests enjoy a pathway experience through the native grasses and chaparral of the forest floor.
*Photograph by Elliott Johnson*

FACING PAGE:
Concrete abutments anchor the glass walls of the great room as the sloped and curve roof leans into the winds of the Pacific Ocean.
*Photograph by Elliott Johnson*

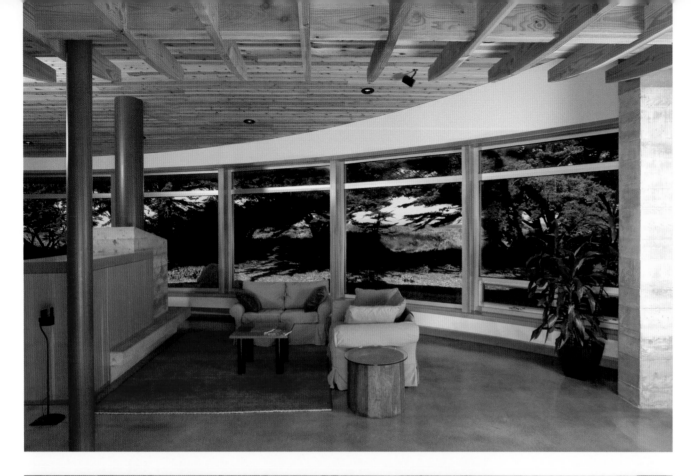

permitting his projects to lead him down new paths and often allowing a counterintuitive approach to guide an opportunity for real impact.

This impact, David believes, should be up front, as the home first presents itself. That is why he likes for the houses he designs to have a strong sense of entry or pathway, creating a dramatic and welcoming viewpoint. He wants people who approach his houses to be captivated and intrigued by the first impression, to be drawn into the house and then continue this feeling as they move through the house experience.

But it is those who will reside in David's houses who get the most consideration. Though the designer has a deep fondness for the clean lines and serene forms of modern architecture, he has, through the years, designed homes in most every style. Look through his body of work, a portfolio of no less than 140 houses, and you will find that there

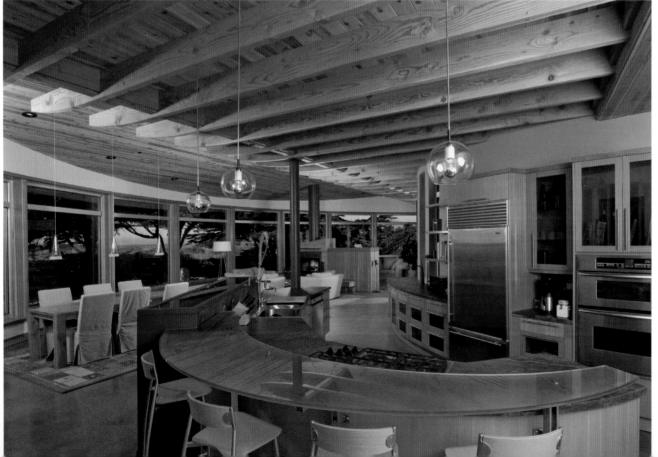

TOP LEFT:
Upon entering the house, views of the Pacific Ocean are seen through the sculpted Cypress Pines that surround the open space of the great room.
*Photograph by Elliott Johnson*

BOTTOM LEFT:
The pathway through the house is completed by the kinetic forms of the open kitchen; this offers a view of the whole pathway, great room and views beyond. Kitchen and interior design by Michele Fanning; Design collaborative of San Luis Obispo.
*Photograph by Elliott Johnson*

are none that can be labeled "classic bungalow" or "classic French." That is because David's designs are a blend of the tastes of his clients and the regional influences of Cambria and the Central Coast. He evolves classic styles to fit the personality of the homeowner and the context of the site. That is the thing he loves about residential design: the opportunity to create an intimate and personal composition unique to each client.

Designing houses has been David's profession and passion for the last 25 years. He designed his first in 1975, after leaving architecture school for the construction business. He turned his focus solely to design in the early 1980s, and as the Central California Coast began to grow in popularity so did demand for his designs. Though most of David's work is in Cambria, he now resides in San Luis Obispo city and has work in almost every community in the region.

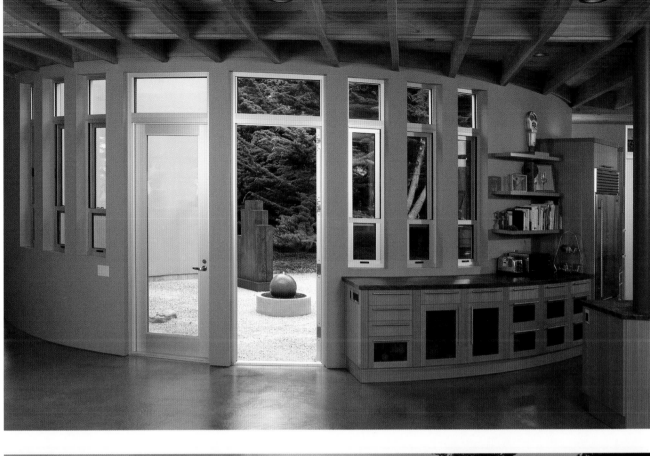

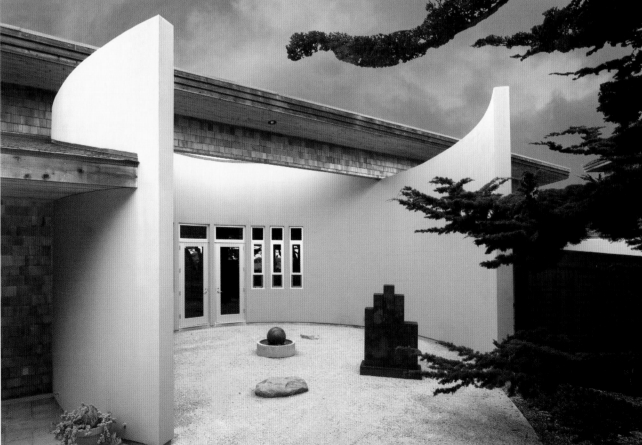

TOP RIGHT:
The core of the great room surrounds the zen garden space. The simple form of this exterior space is used to balance the wildness of the Pacific views on the opposite walls.
*Photograph by Elliott Johnson*

BOTTOM RIGHT:
From the back patio the zen garden is seen as the sculptural core of the house. Home built by James Glitch Construction of Cambria.
*Photograph by Elliott Johnson*

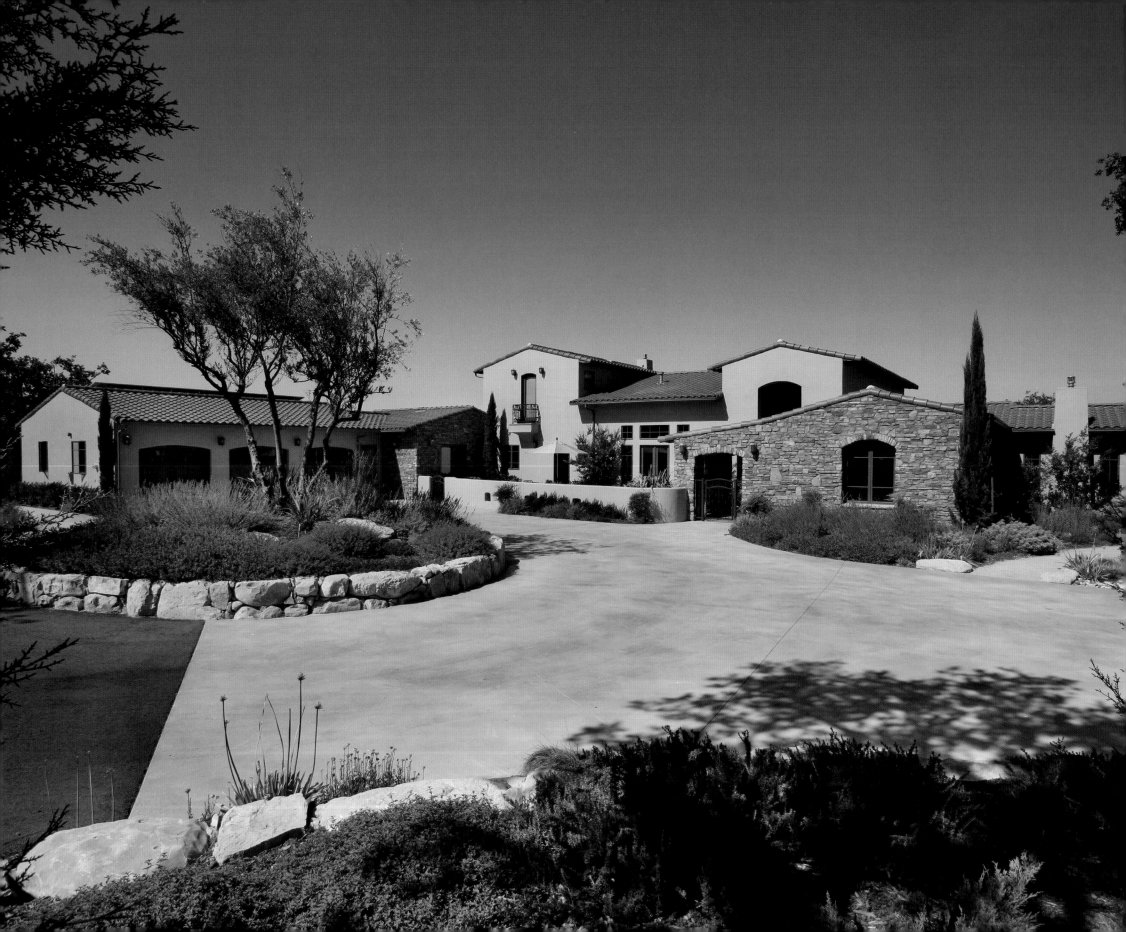

# STEVEN PUGLISI

Steven Puglisi Architecture

There is a sign on the door that reads "Architectural Therapy." This is your first clue to the often tongue-in-cheek personality of Steven Puglisi, AIA: He is a professional who understands that the process of creating a custom home can be a trying one that requires patience and communication but that with considerable effort can also yield beautiful rewards.

Steven started his boutique design practice in 1991 after developing his design talents as a partner in one of the largest architectural and engineering firms on the Central California coast. Three years ago, he expanded his offerings to include a full range of architectural services in both the commercial and residential arenas, though he prefers the latter. He finds residential buildings more challenging and commissions for private homes more intimate. And, of course, there is nothing better than a great client to allow an architect to show off his talent.

ABOVE:
Floor-to-ceiling windows—through which views of the expansive terrain are enjoyed—nicely punctuate the stucco façade.
*Photograph by Ron Bez*

FACING PAGE:
The central landscape element creates pleasing circulation patterns for the entry of this graciously sized Santa Ysabel Ranch residence.
*Photograph by Ron Bez*

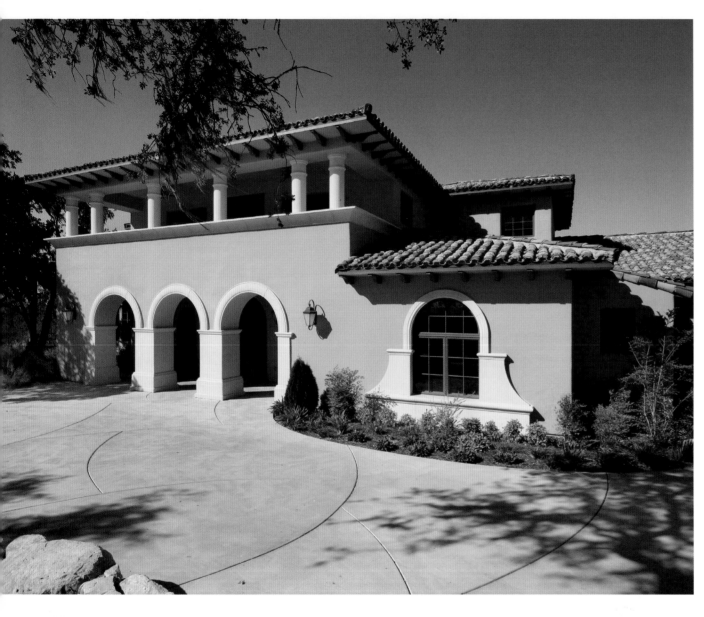

ABOVE LEFT:
In the Spanish Revival style, this San Luis Obispo residence is replete with a variety of roof elevations and arched openings.
*Photograph by Ron Bez*

ABOVE RIGHT:
Details have been distilled to their essence. Even the eave of this second-floor covered balcony has Spanish Revival character.
*Photograph by Ron Bez*

Getting personal with clients is step one in successful design, and Steven starts every job with a number of sit-down meetings to discuss clients' lifestyles, likes and dislikes and dreams for their new homes. Equal time is spent with building and planning officials to ensure that his clients' desires be realized.

Steven uses in equal measure his wit and formidable drawing skills to execute his commissions. Trained to draw by two stellar artists, Ray Bressler and Cal Poly professor Richard Yaco, Steven finds drawing the quickest vehicle between mind and paper and laments that architecture students today see more emphasis on computer-generated drawings versus hand-drawn sketches. His drawings, however, are exquisite works of art that convey warmth to the clients, which, in turn, generates excitement.

Like his drawings and his speech, Steven's designs are concise and to the point. Whether classic or contemporary, elegance and authenticity are the ultimate goals. When you see architecture that rings true to its origins, no one has to tell you. You just know it. And that is something Steven is always striving for in his work.

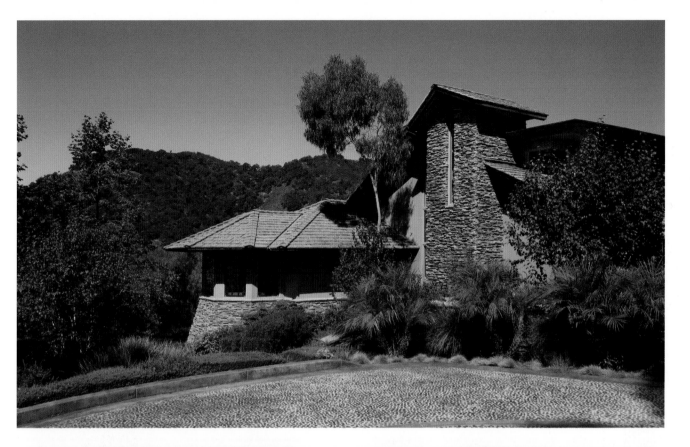

TOP RIGHT:
This private residence is nestled into the natural landscape of the exclusive Bassi Ranch community.
*Photograph by Ron Bez*

BOTTOM RIGHT:
The transition from outdoors to the home's interior is subtly made through this open-air entry corridor.
*Photograph by Ron Bez*

# JEFF SCHNEIDEREIT

## Jeff Schneidereit Architects, Inc.

For Jeff Schneidereit, AIA, architecture is a backdrop for life. Not only his own, but the lives of his clients as well, for he has spent 16 years designing and building spaces where people can live their dreams in ways they never imagined.

No matter the style, every project starts with listening, one-on-one interaction and personal conversation. For Jeff, that is the foundation of successful design: Make people feel comfortable and that is how you will find out how people live, what they need and what their hearts desire.

He recalls a recent client who brought in a mundane sketch, a drawing that was unexceptional but otherwise sufficient. Knowing he could give the client much more than a satisfactory house, Jeff started with the basic concept and altered it by turning the central floor area into a large domed cylindrical room from which the other rooms radiate. Leaving the space open and avoiding confining hallways infused the whole house with unexpected drama.

ABOVE:
Hand-forged steel railings frame the staircase as an etude in movement.
*Photograph by Mike Larson*

FACING PAGE:
Anchored into the hillside, this house frames ocean views with curves and free forms.
*Photograph by Mike Larson*

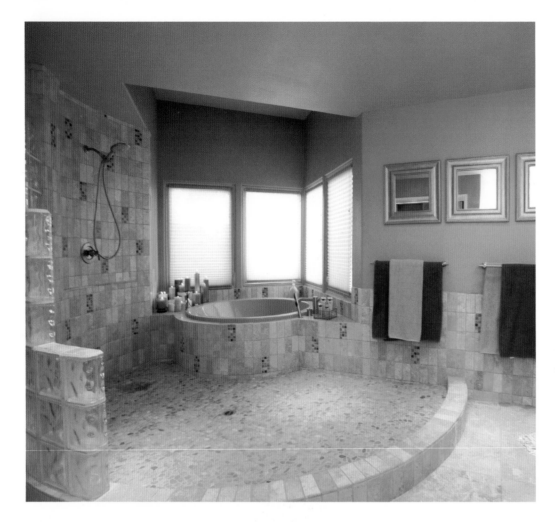

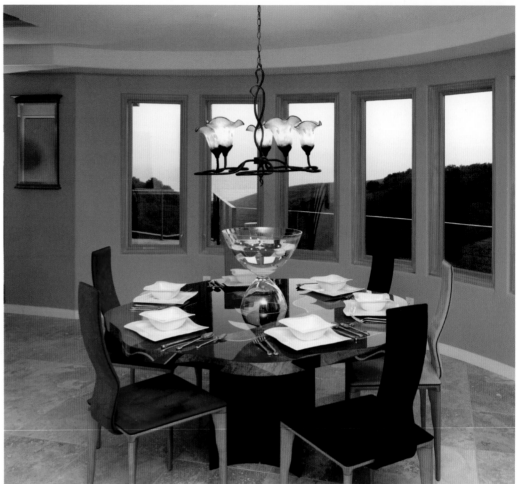

Round rooms and curves in what would otherwise be square spaces are a sort of hallmark of Jeff's work. He likes this out-of-the-box approach because it presents a host of alternative design opportunities, not always obvious. Helping the client and contractor envision and interpret the myriad possibilities is the reason the architect acquired his contractor's license.

The homes that Jeff designs, 10 to 15 each year, mostly along the California coast, are contemporary infused with the warmth of tradition. Varying rooflines and overhanging eaves create visual interest; free-flowing rooms and staircases lend views to other spaces in the house. Visitors find themselves drawn in to explore striking design and relish the sense of comfort and security.

The architect prefers his homes to be organic, and he tries to inspire his clients to go Green where possible. While anyone can specify all Green materials, Jeff tries to take it one step further by incorporating reclaimed materials. And he has put his money where his mouth is in his own downtown Templeton studio: The interior millwork incorporates the redwood fencing that once surrounded the lot.

Encouraging people to be themselves and pushing them toward creative solutions is the architect's most important job. He strives to offer his clients alternatives that defy the status quo in order to give them something truly memorable—dream homes.

ABOVE LEFT:
Like ripples in a pool, natural materials spread lavishly in this bathroom.
*Photograph by Mike Larson*

ABOVE RIGHT:
The dining room is wrapped in a majestic view of ocean and hill.
*Photograph by Mike Larson*

FACING PAGE:
A Templeton house provides breathtaking views of the vineyards below.
*Photograph by Mike Larson*

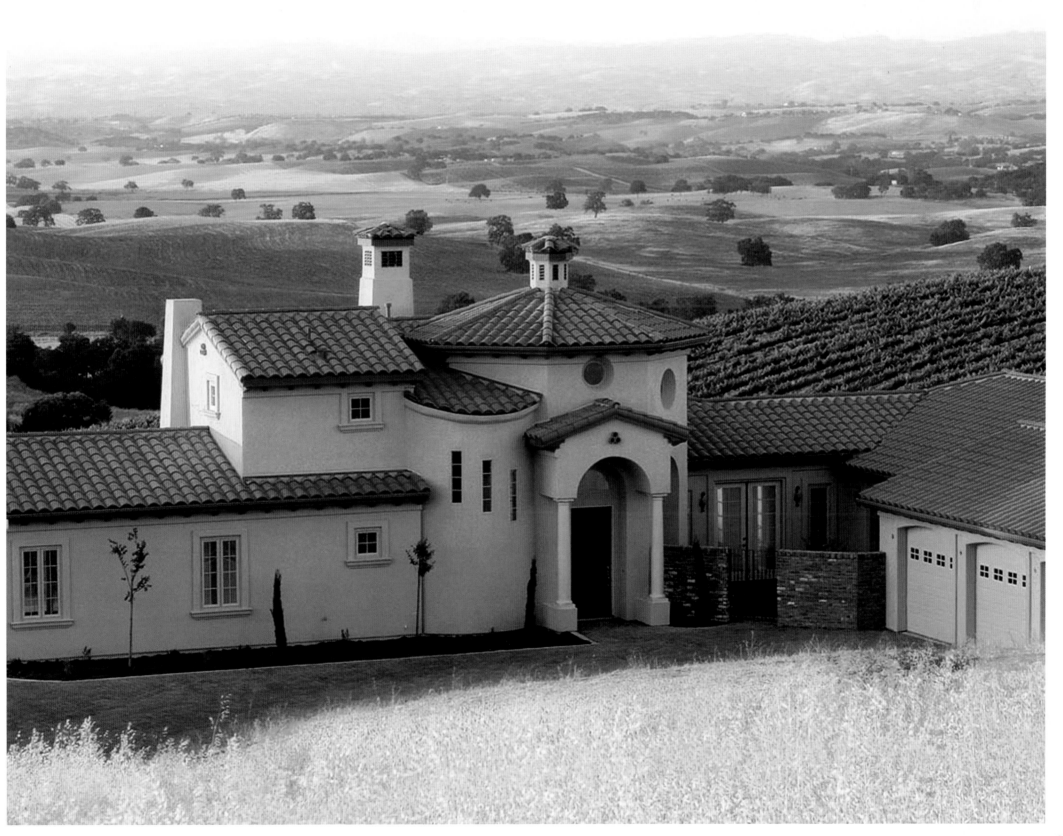

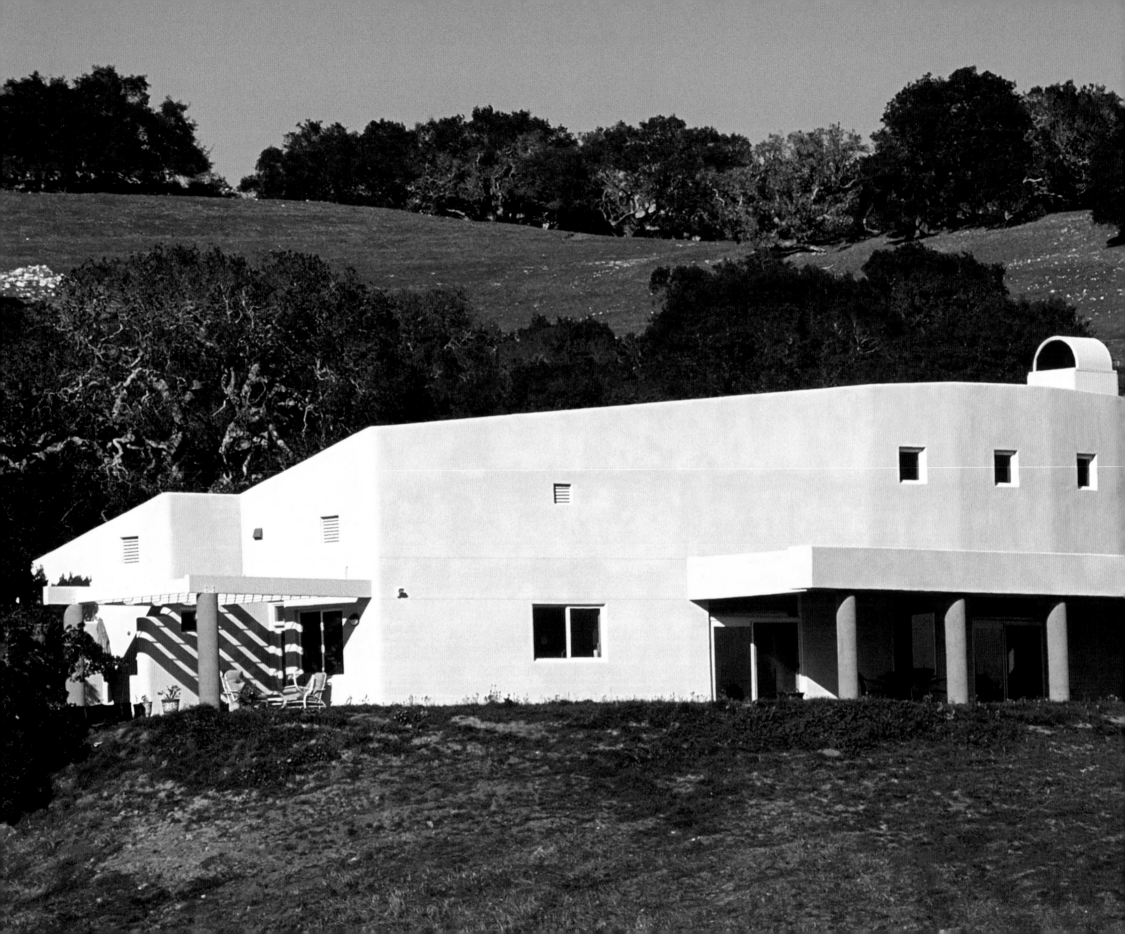

# DON WEST

Don West Architect

Talk to Don West and you discover right away the kind of architect he is: forthright and genuine with an unpretentious manner that corresponds with his buildings. He has the wisdom of age and more than 40 years' professional experience, and he is fast to get down to brass tacks. His job as he sees it is to know as much about his clients as possible—before he sets out to design their houses.

Educated at the University of New Mexico and in business for himself since 1975, Don names among his influences the highly regarded architects Luis Barragán and Edward Larabee Barnes. He appreciates their minimalist techniques, and that regard shows in his own work. "They boil it down to the simplest terms," he says. "The constant struggle of art is to eliminate all but the essential, to get rid of the affectations and solve problems in the most direct way possible. If you do that, you get poetry."

FACING PAGE:
This Morro Bay residence is nestled harmoniously into the natural landscape.
*Photograph by Steven Finson*

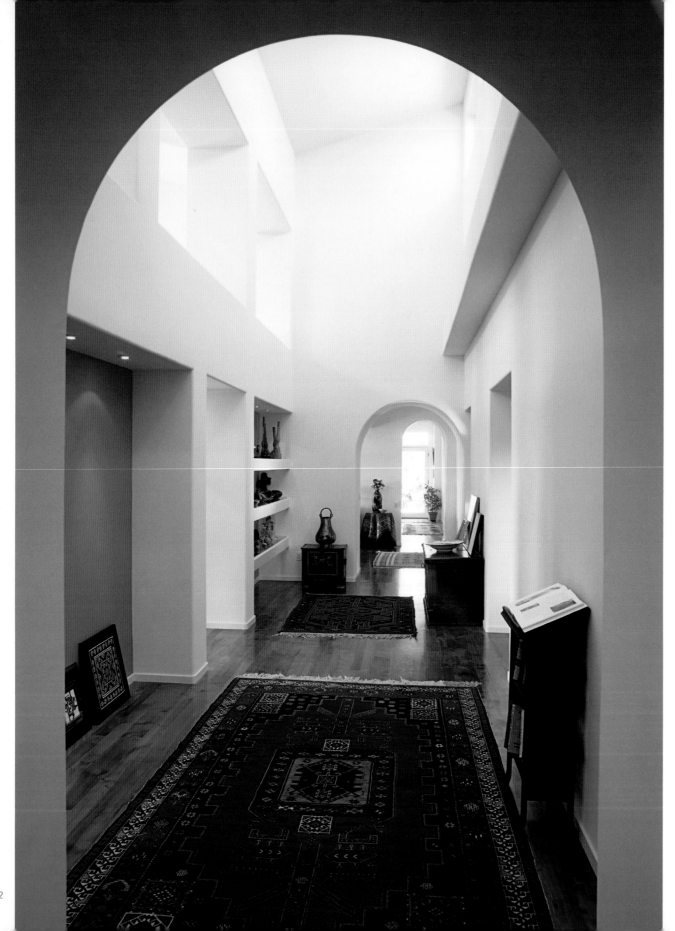

The most direct way possible can sometimes involve a little different approach than one might expect, however, Don likes to take his time getting to know his clients, spending many hours talking with them and delaying actual design work as long as possible. Oftentimes, he explains, clients go to an architect with a lot of preconceived ideas about what they would like incorporated into their houses. They have a set of solutions and want them arranged in an intelligent, cohesive fashion, without first identifying the problems unique to their project. But that's not what Don does.

Instead, he likes to get to know his clients through intimate conversations about philosophy, art, movies, fashion, literature and travel—and takes his cues from there. "Those things reveal the true nature of who they are; I want to tap into their true value systems so that I can give them a house that exceeds their dreams." Once that is done, Don can easily decipher how they feel about light, space, texture and color—the big environmental issues that he will design around—and apply original thinking and attention to detail to create custom homes that are exciting, functional and durable.

The veteran architect's analytical approach requires patience on the part of both himself and his clients. And it's a technique that yields compellingly good architecture.

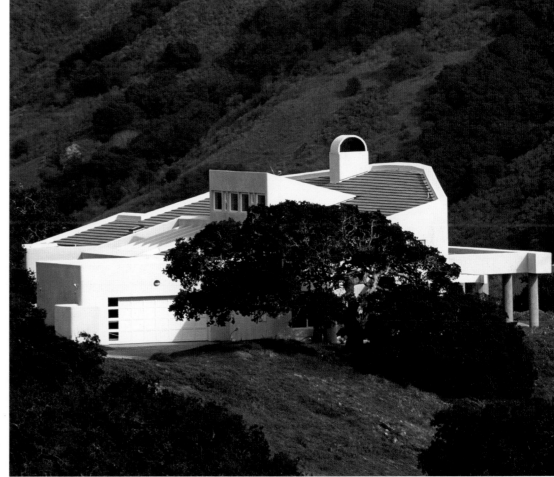

ABOVE LEFT:
The kitchen of this Pismo Beach home has a clever layout and contemporary finishes.
*Photograph by Joseph Kasperovitch*

ABOVE RIGHT:
Expansive vistas are enjoyed from within this Morro Bay private residence.
*Photograph by Steven Finson*

FACING PAGE:
Natural light streams through the clerestory of this Morro Bay home. The hallway's clean, straight lines are punctuated by rounded archways.
*Photograph by Steven Finson*

A child draws Santa Barbara's El Presidio at one of the Kids Draw Architecture sessions.
*Photograph by Cass Ensberg, AIA*

The president of the Architectural Foundation of Santa Barbara, Brian Hofer, leads an architectural walking tour through the historic "Street in Spain" near El Paseo.
*Photograph by Cass Ensberg, AIA*

A variety of enlightening art exhibitions is presented in the Architectural Foundation Gallery throughout the year.
*Photograph by Cass Ensberg, AIA*

# ARCHITECTURAL FOUNDATION OF SANTA BARBARA

Few cities can claim architecture as unique as Santa Barbara's: a hearty blend of Moorish, Spanish Baroque, Spanish and Portuguese Colonial, Andalusian and other historical Mediterranean styles, plus aspects borrowed from Hopi and Pueblo adobes and a smattering of Cape Cod cottages, California bungalows and Victorian grande dames. The result is a diverse and consistently pleasing aesthetic.

And that aesthetic is part of the area's draw. From the previous century through today, people have chosen to make Santa Barbara their home in order to pursue a particular quality of life, and the preferences of those residents influenced the appearance of the area, which in turn attracted more like-minded people. Therefore, the premium placed on good architecture has been something of a self-perpetuating phenomenon. Of course, it does not hurt that the city often referred to as the American Riviera is among those in the United States with the greatest number of architects per capita. It also has the Architectural Foundation of Santa Barbara (AFSB).

The Architectural Foundation of Santa Barbara is located in the historic Acheson House, built in 1904.
*Photograph by Sylvia Abualy*

Guided by architects and other volunteers, children sketch landmark buildings with the Architectural Foundation of Santa Barbara's popular Kids Draw Architecture program. The Santa Barbara Mission was built in 1786.
*Photograph by Cass Ensberg, AIA*

AFSB members share their message on location at the 1782-built El Presidio de Santa Barbara.
*Photograph by Cass Ensberg, AIA*

Founded in 1983, the Architectural Foundation of Santa Barbara is a nonprofit community outreach organization that promotes awareness of and appreciation for design in general and the city's architecture specifically, and provides education about both to the public at large. The American Institute of Architects of Santa Barbara is a professional organization that was instrumental in founding the AFSB and is comprised of architects and landscape architects, as well as engineers, developers, contractors and others with a passion for good architecture and design. Located in the historic Acheson House, AFSB has just one full-time staff member and is otherwise run entirely by volunteers—30 to 40 concerned individuals dedicated to educating people about the importance of the built environment.

The AFSB achieves its mission through a diverse array of programs serving both North and South Santa Barbara County. These include an art gallery devoted to exhibiting high-quality artwork that explores the relationship between architecture and fine art; the very successful Kids Draw Architecture program, which brings together children and architects to sketch landmark architecture and produces a stunning annual calendar; three annual college scholarship programs—AFSB issues about 30 scholarships each year that help local students further their education in architecture, landscape architecture and related disciplines; intimate downtown Sabado and Domingo walking tours; and the Built Environment Education Program— widely known as B.E.E.P.—a statewide initiative that provides an extended studio-type experience in design and problem solving for elementary students in Santa Barbara County schools.

Always in search of ways to expand, grow and involve new people, the AFSB invites you to visit its website (afsb.org) to learn more or sign up to share your passion for great design.

Talented college students receive scholarship awards from the Architectural Foundation of Santa Barbara in a presentation ceremony at the Cota Street Studios.
*Photograph by Cass Ensberg, AIA*

# PUBLISHING TEAM

PUBLISHER: Brian G. Carabet
PUBLISHER: John A. Shand
EXECUTIVE PUBLISHER: Steve Darocy
REGIONAL PUBLISHER: Carla Bowers
DIRECTOR OF DEVELOPMENT & DESIGN: Beth Benton
DIRECTOR OF BOOK MARKETING & DISTRIBUTION: Julia Hoover
PUBLICATION MANAGER: Lauren Castelli
ART DIRECTOR: Michele Cunningham-Scott
SENIOR GRAPHIC DESIGNER: Emily Kattan
SENIOR GRAPHIC DESIGNER/WEB DEVELOPER: Ben Quintanilla
GRAPHIC DESIGNER: Jonathan Fehr
GRAPHIC DESIGNER: Ashley Rodges
EDITORIAL DEVELOPMENT SPECIALIST: Elizabeth Gionta
MANAGING EDITOR: Rosalie Z. Wilson
EDITOR: Katrina Autem
EDITOR: Amanda Bray
EDITOR: Anita M. Kasmar
EDITOR: Ryan Parr
EDITOR: Daniel Reid
MANAGING PRODUCTION COORDINATOR: Kristy Randall
PRODUCTION COORDINATOR: Laura Greenwood
PRODUCTION COORDINATOR: Jennifer Lenhart
TRAFFIC COORDINATOR: Jessica Adams
ADMINISTRATIVE MANAGER: Carol Kendall
ADMINISTRATIVE ASSISTANT: Beverly Smith
SALES SUPPORT COORDINATOR: Amanda Mathers

PANACHE PARTNERS, LLC
CORPORATE HEADQUARTERS
1424 Gables Court
Plano, TX 75075
469.246.6060
www.panache.com

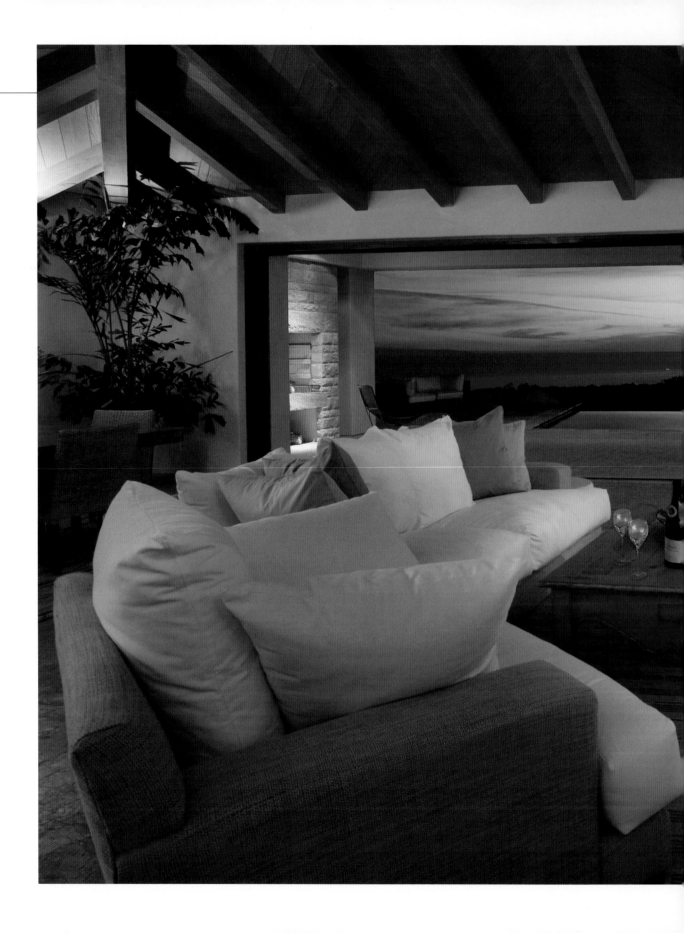

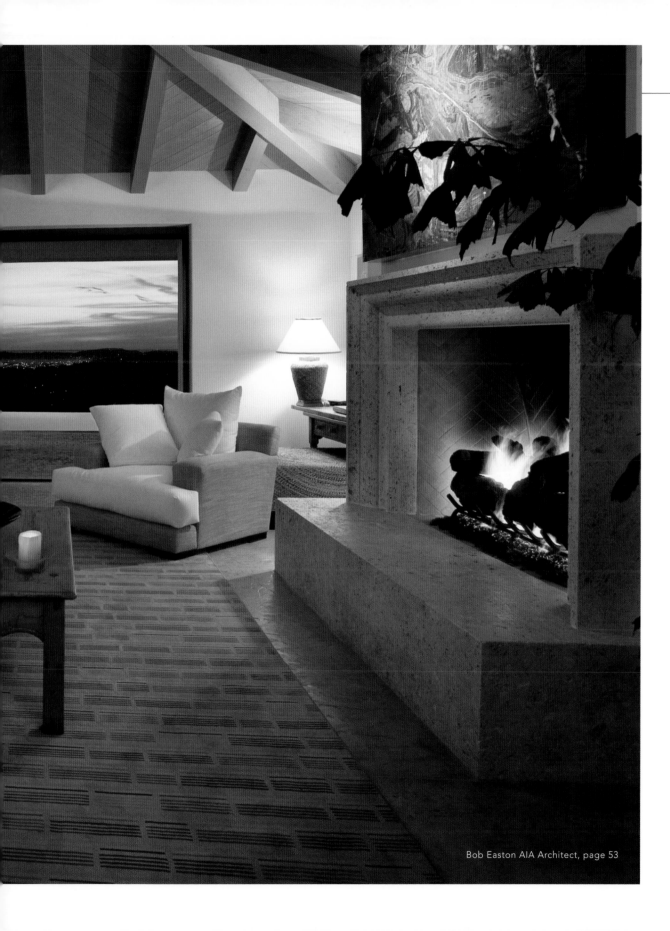

Bob Easton AIA Architect, page 53

# PUBLISHER'S NOTE

In creating this unbelievable book over the past year, I've had many good fortunes. I had the opportunity to develop friendships with amazingly talented people, learn about their lives' work and be awed by their forward-minded views. I also had the benefit of traveling along California's majestic coast, taking in one of the most scenic places in the world. The craggy coastline of Monterey, the beautiful curves of Santa Barbara's south coast, the quaintness of the Hansel and Gretel Cotswold cottages of Carmel-by-the-Sea … it's no secret where the architects, designers and builders of *Dream Homes* glean their inspiration.

A heartfelt thanks to the people who have made this publishing journey so remarkable—everyone featured in the collection and especially Peter, my supportive husband.

*Carla Bowers*

# INDEX

# FEATURED ARCHITECTS, DESIGNERS & BUILDERS

# THE PANACHE COLLECTION

## Dream Homes Series

Dream Homes of Texas
Dream Homes South Florida
Dream Homes Colorado
Dream Homes Metro New York
Dream Homes Greater Philadelphia
Dream Homes New Jersey
Dream Homes Florida
Dream Homes Southwest
Dream Homes Northern California
Dream Homes Carolinas
Dream Homes Georgia
Dream Homes Chicago
Dream Homes Southern California
Dream Homes Washington, D.C.
Dream Homes Deserts
Dream Homes Pacific Northwest
Dream Homes Minnesota
Dream Homes Ohio & Pennsylvania
Dream Homes Coastal California
Dream Homes New England
Dream Homes Los Angeles
Dream Homes Michigan
Dream Homes Tennessee

## Additional Titles

Spectacular Hotels
Spectacular Golf of Texas
Spectacular Golf of Colorado
Spectacular Restaurants of Texas
Elite Portfolios
Spectacular Wineries of Napa Valley
Spectacular Wineries of New York
Distinguished Inns of North America

## City by Design Series

City by Design Dallas
City by Design Atlanta
City by Design San Francisco Bay Area
City by Design Chicago
City by Design Charlotte
City by Design Phoenix, Tucson & Albuquerque
City by Design Denver
City by Design Los Angeles

## Perspectives on Design Series

Perspectives on Design Florida
Perspectives on Design Dallas
Perspectives on Design Atlanta
Perspectives on Design New England

## Spectacular Homes Series

Spectacular Homes of Texas
Spectacular Homes of Georgia
Spectacular Homes of South Florida
Spectacular Homes of Tennessee
Spectacular Homes of the Pacific Northwest
Spectacular Homes of Greater Philadelphia
Spectacular Homes of the Southwest
Spectacular Homes of Colorado
Spectacular Homes of the Carolinas
Spectacular Homes of Florida
Spectacular Homes of California
Spectacular Homes of Michigan
Spectacular Homes of the Heartland
Spectacular Homes of Chicago
Spectacular Homes of Washington, D.C.
Spectacular Homes of Ohio & Pennsylvania
Spectacular Homes of Minnesota
Spectacular Homes of New England
Spectacular Homes of New York
Spectacular Homes of British Columbia
Spectacular Homes of Ontario
Spectacular Homes of London

Visit www.panache.com or call
**469.246.6060**

PANACHE PARTNERS, LLC

Creating Spectacular Publications
for Discerning Readers